The Art and Culture
of Early Greece,
1100–480 B.C.

The Art and Culture of Early Greece, 1100–480 B.C.

Jeffrey M. Hurwit

CORNELL UNIVERSITY PRESS

ITHACA AND LONDON

First published 1985 by Cornell University Press
First printing, Cornell Paperbacks, 1987

Library of Congress Cataloging in Publication Data

Hurwit, Jeffrey M., 1949–
 The art and culture of early Greece, 1100–480 B.C.

 Bibliography: p.
 Includes index.
 1. Arts, Greek. 2. Greece—Civilization—To 146 B.C.
I. Title
NX551.A1H87 1985 700'.938 85–4204
ISBN-13: 978-0-8014-9401-7 (pbk. : alk. paper)
ISBN-10: 0-8014-9401-X (pbk. : alk. paper)

Printed in the United States of America

Paperback printing 10

*To my mother
and to Martha*

Contents

Maps

Preface

This book presents a synthesis of Archaic culture: it seeks to place the art and architecture of early Greece in its literary, historical, and intellectual contexts. It thus differs from the many books about Archaic Greece that have appeared lately, which have tended to concentrate either on Archaic history and society (with a little art thrown in) or on individual genres of Archaic art (with hardly any history or literature thrown in at all). Though Archaic art is my focus and I offer a definition of the Archaic style, the book is not intended to be an exhaustive survey of all genres and regional styles (it concentrates, for instance, on Athens, a bias that in some circles is frowned upon these days). Rather, I am concerned about origins: the origins of representation, of epic poetry, of the polis, of the stone temple, of mythological narrative art, of lyric poetry, of monumental stone sculpture, of philosophy, of tragedy, of the so-called optical revolution, of democracy, and even of the Classical style.

I began research on the book while a Morse Fellow of Yale College, and I thank Yale University for that splendid opportunity, as well as for funds (in the form of an A. Whitney Griswold Faculty Research Award) that helped support travel abroad. The list of friends and scholars who offered advice, information, and encouragement (sometimes without realizing it) is long, but at the top are Victor Bers, John Herington, Esther Jacobson, J. J. Pollitt, Heinrich von Staden, William G. Thalmann, and especially Andrew Stewart, whose generosity and criticisms have been invaluable to me. I also thank Lowell Edmunds and Mary Sturgeon, who read the book in manuscript for Cornell University Press and made many helpful comments. These scholars are responsible for much of what is good here and have saved me from many errors; those that remain are mine alone.

For supplying photographs and granting permission to use them, I gratefully thank the following institutions and individuals: the American School of Classical Studies, Athens (Margot Camp, Agora Excavations; Nancy Bookides, Corinth Excavations); J. Ch. Balty, Musée Royaux d'Art et d'Histoire, Brussels; Trustees of the British Museum; Managing Committee of the British School at Athens; Maria Brouskari, Athens; Miriam E. Caskey; H. W. Catling, British School at Athens; Cornell University Press; Deutsches Archäologisches Institut, Athens; Deutsches Archäologisches Institut, Zentrale, Berlin; Ecole Française d'Athènes; Friedrich W. Hamdorf, Staatliche Antikensammlungen und Glyptothek, Munich; S. R. Hayward, British Museum; Hirmer Verlag, Munich; Institut Royal du Patrimoine Artistique, Brussels; Joan R. Mertens, Metropolitan Museum of Art; Nationalmuseum, Stockholm; Francesco Nicosia, Soprintendenza Archeologica della Toscana, Florence; Oxford University Press; Alain Pasquier, Musée du Louvre; D. Plummer, British Museum; M. R. Popham, Oxford; the Portland (Oregon) Art Museum; Bridget Power, Museum of Fine Arts, Boston; Thomas Schäfer, Athens; Margot Schmidt, Antikenmuseum, Basel; Claude Seillier, Musée des Beaux-Arts et d'Archéologie, Boulogne-sur-Mer; William Kelly Simpson, Museum of Fine Arts, Boston; John Travlos, Athens; University of Massachusetts Press; Vereinigung der Freunde Antiker Kunst, Basel; Cornelius Vermeule, Museum of Fine Arts, Boston; and Hans Walter, Salzburg.

I also thank J. J. Pollitt for kindly granting permission to use his translations of Diodoros Siculus; all other translations are my own.

All dates are B.C. unless I have indicated otherwise, and I hope dedicated preface readers will forgive me if I do not include an account of how I decided to transliterate Greek into English. Bracketed numbers throughout the text refer to illustrations.

Finally, I thank the staff and editors of Cornell University Press, especially Bernhard Kendler and Barbara Salazar, for their patience and skill; Betsy VanderSchaaf for expertly typing most of the manuscript; and, above all, my wife, Martha, who has put up with me during the many years of writing and revising and who, for her understanding and support, deserves much more than mere thanks.

JEFFREY M. HURWIT

Eugene, Oregon

Abbreviations

AA	*Archäologischer Anzeiger*
AJA	*American Journal of Archaeology*
AM	*Mitteilungen des Deutschen Archäologischen Instituts, Athenische Abteilung*
AMA	H. Schrader et al., *Die archaischen Marmorbildwerke der Akropolis* (Frankfurt am Main, 1939)
AntK	*Antike Kunst*
AR	*Archaeological Reports*
Austin, *Archery*	N. Austin, *Archery at the Dark of the Moon* (Berkeley, 1975)
BCH	*Bulletin de correspondance hellénique*
Beazley, *ABV*	J. D. Beazley, *Attic Black-Figure Vase-Painters* (Oxford, 1956)
Beazley, *ARV*²	J. D. Beazley, *Attic Red-Figure Vase-Painters*, 2d ed. (Oxford, 1963)
Beazley, *Development*	J. D. Beazley, *The Development of Attic Black Figure* (Berkeley, 1951)
Beazley, *Paralipomena*	J. D. Beazley, *Paralipomena* (Oxford, 1971)
Boardman, *ABFV*	J. Boardman, *Athenian Black Figure Vases* (London, 1974)
Boardman, *ARFV*	J. Boardman, *Athenian Red Figure Vases: The Archaic Period* (London, 1975)
Boardman, *GO*	J. Boardman, *The Greeks Overseas*, 2d ed. (London, 1980)
Boardman, *GS*	J. Boardman, *Greek Sculpture: The Archaic Period* (London, 1978)
Brann	E. T. H. Brann, *The Athenian Agora*, vol. 8, *Late Geometric and Protoattic Pottery* (Princeton, 1962)
Brouskari	M. S. Brouskari, *The Acropolis Museum: A Descriptive Catalogue* (Athens, 1974)
BSA	*British School at Athens, Annual*
Carter	J. Carter, "The Beginning of Narrative Art in the Greek Geometric Period," *BSA*, 67 (1972), 25–58
CJ	*Classical Journal*

Coldstream, *GG*	J. N. Coldstream, *Geometric Greece* (New York, 1977)
Coulton	J. J. Coulton, *Ancient Greek Architects at Work* (Ithaca, N.Y., 1977)
CP	*Classical Philology*
CQ	*Classical Quarterly*
Diehl	E. Diehl, *Anthologia Lyrica Graeca* (Leipzig, 1949–52)
Dinsmoor	W. B. Dinsmoor, *The Architecture of Ancient Greece* (London, 1950)
Fittschen	K. Fittschen, *Untersuchungen zum Beginn der Sagendarstellungen bei den Griechen* (Berlin, 1969)
Fränkel, *EGPP*	H. Fränkel, *Early Greek Poetry and Philosophy* (New York, 1975)
GRBS	*Greek, Roman, and Byzantine Studies*
Greek Renaissance	R. Hägg, ed., *The Greek Renaissance of the Eighth Century B.C.: Tradition and Innovation* (Stockholm, 1983)
Humphreys	S. C. Humphreys, *Anthropology and the Greeks* (London, 1978)
JdI	*Jahrbuch des Deutschen Archäologischen Instituts*
Jeffery, *AG*	L. H. Jeffery, *Archaic Greece* (New York, 1976)
JHS	*Journal of Hellenic Studies*
Kirk and Raven	G. S. Kirk and J. E. Raven, *The Presocratic Philosophers* (Cambridge, 1957)
Lobel and Page	E. Lobel and D. Page, *Poetarum Lesbiorum Fragmenta* (Oxford, 1955)
Moon	*Ancient Greek Art and Iconography*, ed. W. G. Moon (Madison, Wis., 1983)
Nagy, *Best*	G. Nagy, *The Best of the Achaeans* (Baltimore, 1979)
PCPS	*Proceedings of the Cambridge Philological Society*
PMG	D. Page, ed., *Poetae Melici Graeci* (Oxford, 1962)
Pollitt, *Ancient View*	J. J. Pollitt, *The Ancient View of Greek Art* (New Haven, 1974)
Pollitt, *Art and Experience*	J. J. Pollitt, *Art and Experience in Classical Greece* (Cambridge, 1972)
ProPhilSoc	*Proceedings of the American Philosophical Society*
RA	*Revue archéologique*
Ridgway, *AS*	B. S. Ridgway, *The Archaic Style in Greek Sculpture* (Princeton, 1977)
Ridgway, *SS*	B. S. Ridgway, *The Severe Style in Greek Sculpture* (Princeton, 1970)
Robertson, *HGA*	M. Robertson, *A History of Greek Art* (Cambridge, 1975)
Schefold, *GH*	K. Schefold, *Götter- und Heldensagen der Griechen in der spätarchaischen Kunst* (Munich, 1978)
Schefold, *ML*	K. Schefold, *Myth and Legend in Early Greek Art*, trans. Audrey Hicks (New York, n.d.)
Schweitzer, *GGA*	B. Schweitzer, *Greek Geometric Art* (London, 1971)
Snodgrass, *AG*	A. Snodgrass, *Archaic Greece* (London, 1980)
TAPA	*Transactions of the American Philological Association*
Travlos, *PDA*	J. Travlos, *Pictorial Dictionary of Ancient Athens* (New York, 1971)
West	M. L. West, *Iambi et Elegi Graeci* (Oxford, 1971)

Abbreviations

The Art and Culture
of Early Greece,
1100–480 B.C.

1

Archaios

On a slab of the frieze that ran within the Temple of Apollo at Bassai, in a remote and mountainous part of the Peloponnesos, a second-rate Classical sculptor carved a melodramatic episode from the Battle of Lapiths and Centaurs [1]. A naked Lapith pulls a centaur off a nearly naked woman while her pudgy companion, caught in the torrent of her own drapery, calls for help with a gesture that seems too fervent. Everyone overacts. But one figure is unlike the rest. She is half their size and, though her face resembles the face of the disheveled woman who limply and desperately clings to her, she does not react to the surrounding violence. She is rigid and frontal, her dress hangs down undisturbed, and the hair that frames her expressionless face is neatly and tightly curled. She is a statue, and the sculptor made that clear by alluding to an artistic style that had ended more than half a century before he worked: the Archaic style.

In the first century A.D., an itinerant sage and miracle worker named Apollonios of Tyana visited the great sanctuary of Zeus at Olympia. One of the countless dedications he saw in the precinct was a bronze statue of Milon of Croton, a six-time Olympic wrestling champion of the late sixth century. The statue does not survive, but Apollonios' biographer records the conversation the wise man had with his guides about its *schēma* (form or design). The statue stood with its feet close together, its left hand clutching a pomegranate, and the fingers of its right hand extended straight out. The natives, Apollonios was told, believed it stood that way because Milon could not be budged once he planted his feet, and his grip could not be broken. Apollonios diplomatically granted the wisdom of that interpretation but offered his own: the fingers were the way they were (and by extension the statue stood the way it did) because of "the ancient [*archaia*]

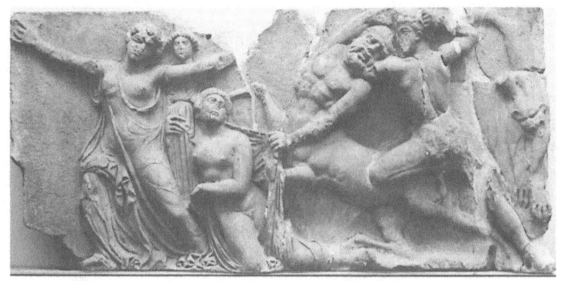

1. Detail of the Centauromachy frieze from the Temple of Apollo at Bassai, around 420. Photo courtesy of the Trustees of the British Museum.

way of statue making."[1] To ask why Milon stood as he did, Apollonios realized, was to ask the wrong question. The schema of an Archaic statue had nothing to do with the person it was meant to be.

In the course of researching his guidebook to Greece around A.D. 174, Pausanias toured Phigalia, a town near Bassai, and saw in the public square a stone statue of Arrakhion, another Olympic champion. Pausanias points out that it is "old-fashioned [archaios] in many ways, not least in its form [schēma]. The feet do not stand far apart and the arms hang close to the sides down to the hips."[2] The Arrakhion does not survive either, but its schema is repeated in numerous Archaic statues, such as the standing nude youth (or kouros) from Volomandra in Attica [2], carved around the same time Arrakhion competed in his last Olympics.

From the Classical period on there was never any difficulty either in recognizing the Archaic style or in artistically quoting it. Pausanias became so used to seeing Archaic statues on his travels that he even felt capable of distinguishing local artistic schools. But to copy or recognize what was archaios was not necessarily the same thing as liking it. When the Bassai sculptor recalled certain Archaic traits for the statue he depicted, he did so not to pay homage to "old-fashioned" sculpture but to distinguish the stone image from the "live" figures posturing around it. Making it archaios

1. Philostratos, The Life of Apollonios of Tyana, IV.28.
2. Pausanias, Description of Greece, VIII.40.1.

The Art and Culture of Early Greece, 1100–480 B.C.

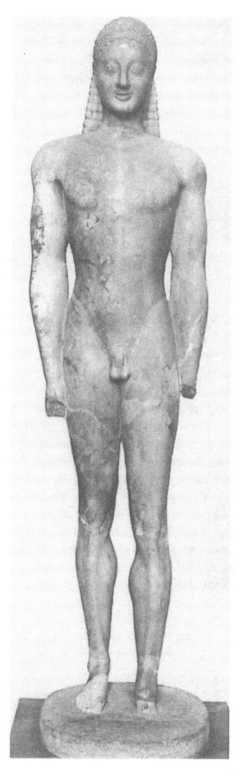

2. *Kouros* from Volomandra, Attica (Athens NM 1906), around 560. Photo courtesy of Deutsches Archäologisches Institut, Athens.

3. Archaistic base from Corinth, late first century A.D. Photo by Ioannidou-Bartziotou, courtesy of American School of Classical Studies at Athens: Corinth Excavations.

Archaios

[17]

was a sure way of making it inanimate.[3] And while some ancient commentators on art found something positive to say about the Archaic, and while Hellenistic and Roman sculptors often glamorized it by producing stylistically nostalgic works called "archaistic" [3, cf. 9], most ancient sources are unenthusiastic about it. One critic went so far as to say that no work of art we would call pre-Classical had anything to commend it except its antiquity.[4]

But whether ancient authors looked kindly upon the Archaic style or not, they knew what it was and roughly how long it lasted. When Apollonios, Pausanias, and others used the word *archaios*, they meant not simply that the statues they described were "old" (the Parthenon sculptures, after all, were also "old" by the time they wrote, yet are never called *archaios*) but that they had certain characteristics in common which set them apart from later works. They could use the word pejoratively, in the sense of "antiquated." But they used it in a stylistic and in a chronological sense as well. That is how "Archaic" is used today.[5]

It is easier to recognize the Archaic style than to define it; perhaps that is why Pausanias never identifies "the many ways" (besides its stance) in which the statue of Arrakhion was *archaios*. But any definition would have to include at least the following characteristics:

1. *A reliance on schemata.* The shapes, postures, movements, and gestures of Archaic figures are limited and typical, and so are the situations in which they find themselves: the Archaic artist, in other words, generalizes. Archaic standing, running, or flying figures may differ in proportions, modeling, or anatomical detail, but they stand, run, or fly in essentially the same way [4, 5]. Behind all *kouroi* lies a stereotype to which they conform—something not unlike a Platonic idea [2, 7, 109]. The schema or stock image excludes the atypical and thus seeks to give manageable shape to the endless complexity and irregularity of natural forms. The schema is a way to ensure the availability of fixed visual formulae with which to create and which the viewer can immediately "read." A world of schemata is a world of order and convention. It may be without spontaneity, but it is also without accident.

2. *An impulse for pattern.* This trait is related to the reliance on schemata but is best seen in the artificial and usually symmetrical rendering of such details as musculature, drapery, and hair [6, 7]. Nature is as controlled by

3. The statue, incidentally, represents Artemis, and the women's frantic supplications worked: on another slab of the Centauromachy frieze, Artemis (with her brother Apollo) comes to the rescue, but this time she is perfectly Classical in style.

4. Quintilian, *Institutio Oratoria*, XII.10.3

5. For a fuller treatment of *archaios*, see J. J. Pollitt, *The Ancient View of Greek Art* (New Haven, 1974), 154–58.

4. Early Black Figure amphora by the Nettos Painter (Athens NM 1002), around 620–10. Photo: Hirmer Fotoarchiv, Munich.

Archaios

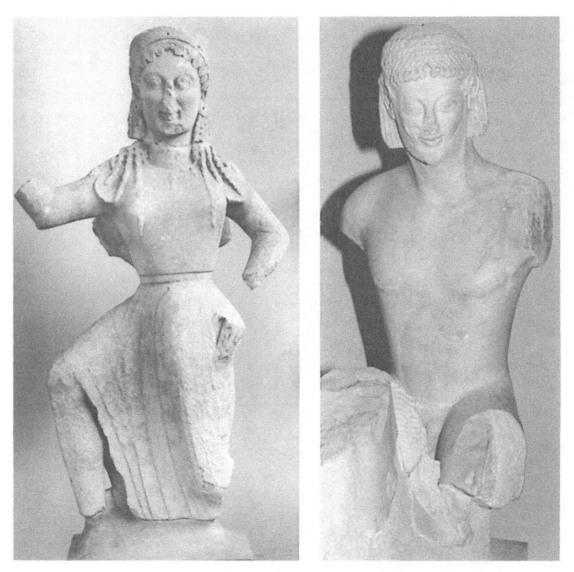

5. *Nikē* (Victory) from Delos, by Archermos, dedicated by Mikkiades (Athens NM 21), around 550. Photo courtesy of Deutsches Archäologisches Institut, Athens.

6. The so-called Rampin Rider (Acropolis 590, head in Louvre, 3104), around 550. Photo: Jeffrey M. Hurwit.

pattern as it is by schema, but it was, in fact, the tension between the real appearances of things and the desire to pattern them that gave Archaic art a history. It was once widely assumed that Archaic Greek artists consciously strove for naturalism, as if they knew what that was and somehow disapproved of their own schematic, patterned creations. Now it is true

The Art and Culture of Early Greece, 1100–480 B.C.

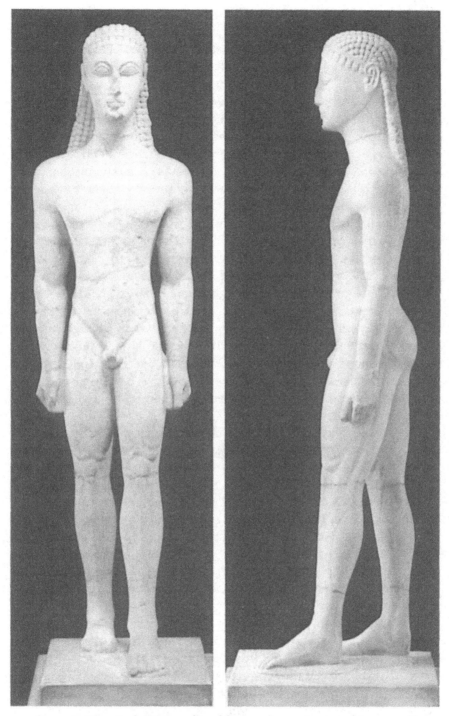

7. *Kouros* in New York (Metropolitan Museum 32.11.1), around 600–590. Photos courtesy of Metropolitan Museum of Art, Fletcher Fund, 1932.

that Archaic art became increasingly naturalistic and that it ended with a partial conquest of appearances. It could be, however, that concessions to nature were made almost grudgingly, that Archaic art headed toward the naturalistic *despite* an obstinate struggle to maintain the rule of schema and pattern.

The vital roles that schema and pattern play in Archaic art can be considered symptoms of a larger Greek demand for regularity and order which extends beyond the realms of representational art into architecture, poetry, and philosophy and beyond the limits of the Archaic period itself. The language of Homer is highly ordered: its formulae were originally patterns for the ear. Hesiod's *Theogony* imposes patterns on gods and heroes by putting each in his genealogical place, and his *Works and Days* moves from a particular instance of injustice to universal truths and patterns of human activity. Archaic poetry in general is full of literary schemata or conventions, and Archaic poets express thought and meaning through the harmony of opposites. Archilochos detected a *rhysmos* (pattern) even in the rise and fall of human fortunes. The philosophers of Miletos attempted to fit nature to preconceived patterns and so to extract order from apparent chaos. Pythagoras (or his followers) ordered the world through number. The urge to impose *kosmos* (order) on the nature of things is not peculiar to the Archaic mind—in Xenophon's *Oikonomikos* Sokrates reports that all things, even pots and pans, look more beautiful when they are kept in order, and even the space between them looks beautiful[6]—but is nonetheless particularly characteristic of it.

3. *The domination of surface and plane.* Archaic art accepts the surface—the curving surface of a vase, the surface of a statue, even the four vertical sides of the uncarved stone block—as the foundation of form. This respect for the surface leads, in sculpture, to the so-called law of frontality: freestanding statues face front rigidly and do not bend; they are quadrilateral, with the surfaces of the original block still implicitly bounding them [7]. In painting, figures and compositions evenly adhere to the surface or are arranged on planes uniformly parallel to the surface [14]. No matter how many overlapping planes there are, the Archaic image is regulated by the surface and is essentially flat. The surface may be activated, but its authority is not overthrown.

4. *Linearity.* Lines matter, and they serve the rule of the surface. The depiction of form begins with the outline, and lines isolate each part within the form. The parts do not fluidly merge into one another but are bluntly juxtaposed, almost as if they were meant to be counted to make sure they are all there. The principal features of an Archaic statue, for instance, are clearly defined by sharp ridges and shallow grooves. They therefore lie

6. VIII.19–20.

upon or close to the surface, as if the sculptor were reluctant to chisel too deeply. The surface does not rise and fall like flesh but is divided up; muscles are not modeled, they are plotted [8]. The Archaic painted figure is a silhouette, and details are incised or drawn with single, sharp strokes. The eye has hard, independent tracks to follow, not paths of light and shade to interpret [14]. Archaic vase painting is, in fact, not really painting at all; it is draughtmanship.

5. *Ornamentality*. The Archaic style is highly decorative, and Archaic art in large measure serves decorative purposes. Embellishment and lavish display, not simplicity and austerity, are Archaic ideals. The impulse to make things not only patterned but also intricate, variegated, and rich—the impulse for what Archaic poets (who also liked to embellish) called

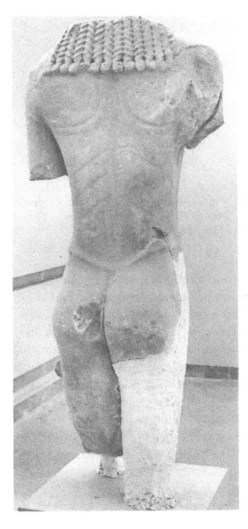

8. *Kouros* from Sounion (Athens NM 3645), around 600–590. Photo courtesy of Deutsches Archäologisches Institut, Athens.

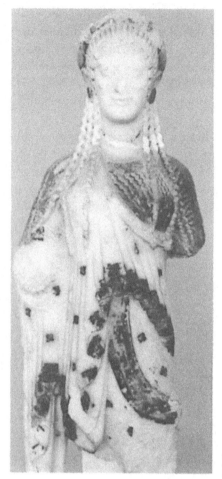

9. *Korē* from the Athenian Acropolis (Acropolis 675), around 510. Photo: Jeffrey M. Hurwit.

poikilia[7]—is perhaps best seen in the standing draped female figures known as *korai* (maidens) [9]: they are not merely elaborately and colorfully clothed—displaying ornament almost for its own sake—but were, like other Archaic sculptures, adornments for sanctuaries (where they were, above all, pleasing gifts to the gods) and graves. The ornamental impulse can be detected elsewhere—for instance, in a nearly irresistible urge to animate the inorganic. Horses stand on the lids of jars in place of plain handles, small flasks can have the heads of lions or women for spouts [10], Ionic temples seem nearly alive with lush vegetation carved in stone, and bronze cauldrons sprout sirens and the heads of lions and griffins around their rims and shoulders [11]. The opposite tendency, to convert

7. See B. H. Fowler, "The Centaur's Smile: Pindar and the Archaic Aesthetic," in Moon, 159–70 (esp. 161–62).

The Art and Culture of Early Greece, 1100–480 B.C.

the organic into the inanimate, is also Archaic: a knobbed handle, a utensil, grows from the griffin's head where a curled topknot had been.

6. *Explicitness and impassivity.* Little in Archaic art can be considered subjective or implicit. Actions are usually shown at their violent climaxes. Archaic artists depicted Herakles wrestling the Nemean lion [12] or shooting the Stymphalian birds; Classical artists depicted him afterward, exhausted and contemplative [13] or quietly handing the birds over to Athena. Archaic artists showed the Greeks in the act of sacking Troy [75, 153]; the most famous Classical representation of the myth showed Troy already sacked (cf. Pausanias X.25–27). Although there is plenty of violence and death in Archaic art, there is almost no pain or suffering. (Incidentally, the same can generally be said of the death passages in the *Iliad* as well: heroes fall and their armor clatters around them, but life is over quickly and usually without anguish.) The face of the vanquished often resembles the face of the victor: the one does not seem hurt, the other does not seem proud [14]. Archaic figures are not very emotional: grief, desire, fear, and happiness are expressed not through facial distortions or glances of eyes but through conventional gestures that serve as informing signs. A woman touches her head; therefore she mourns [30]. An old man or a centaur

10. Protocorinthian aryballos (Louvre CA 931), around 650. Photo: M. Chuzeville, by permission of Musée du Louvre.

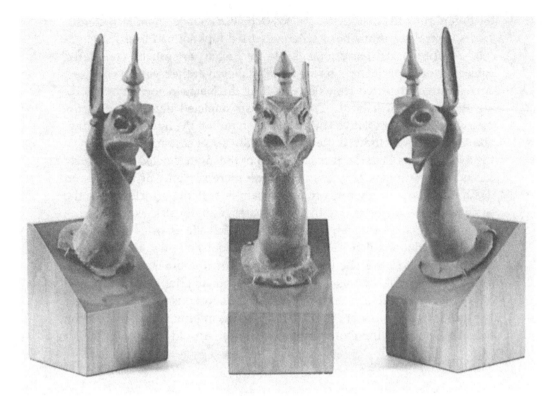

11. Bronze griffin protomes (MFA 50.144), around 650. Photo courtesy of Museum of Fine Arts, Boston, William F. Warden Fund.

touches the chin of a warrior or hero brandishing a sword; therefore he pleads for his life [77]. In other words, motivation and response do not seem to come from within the figures. The world of Archaic art is populated by mannequins. With few exceptions, what cannot be expressed formally and conventionally does not exist.

Correlatively, the Archaic artist shows little interest in characterization or the depiction of mental life. The Archaic figure is rarely given the opportunity to contemplate what he must do or what he has just done, but it is a rarer figure that appears to contemplate at all. The figure does not ask to be probed. It is simply there to be confronted objectively. It has no innerness, no spiritual core, just an exterior; it does not, perhaps it cannot, seem aware of itself. The infamous "Archaic smile" [2, 9] lends many statues (and painted figures, too) an unfortunate air of smug self-satisfaction, but some statues' smiles would probably dissolve if we could look at them from far below, as many were meant to be seen. The Archaic smile remains inscrutable, but one thing it probably is not is a self-conscious sign of joy or well-being: dying warriors, funerary *kouroi* and *korai*, and sphinxes, the

The Art and Culture of Early Greece, 1100–480 B.C.

very symbols of death, all wear it. If some smiles were intended to compensate for originally steep angles of viewing, and even if others were meant to suggest that the figure was somehow alive, the smile nonetheless acts in general as an obstacle barring the spectator from penetrating the stone surface in search of a sentient being. There is such a thing as an Archaic grimace [113], but it is rare and not truly Archaic at all: it is a precocious sign of the coming Classical interest in pathos and emotions of the moment.

One or two things more about the qualities of *archaios*. Because of such traits as its dependence on schemata and the authority of surface and plane, Archaic Greek art has regularly been placed in the broader category of "conceptual art," alongside Egyptian art, the art of "primitive" peoples all over the world, and even the crude products of crayon-wielding children. Any category that broad has its flaws, and so does the theory that conceptual artists, since they clearly do not reproduce visual experience, must work from such nonvisual sources as "memory images" or "abstract concepts." Still, the terms "conceptual art" and "conceptual image" are so ingrained that they are hard to avoid. They need not be avoided if they are used simply to describe a kind of art that does not aim to capture appearances and so deceive the eye, but to present the human form (for

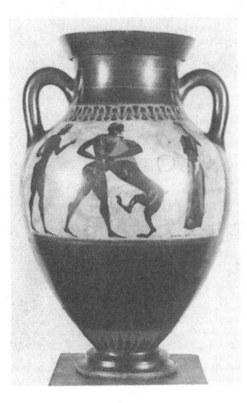

12. Black Figure amphora (Portland 32.829), around 540. Photo courtesy of Portland Art Museum, Portland, Oregon.

Archaios

instance) in such a way that it is characteristically, even minimally, human. The typical Archaic schema for a man [14] has a frontal eye in a profile head, the head atop a frontal torso, and the torso atop profile legs because each individual part was considered most recognizable that way; each part thus contributes to the legibility of the whole, and legibility is the principal demand Archaic art places upon itself. The common idea that the concep-

13. Metope from the Temple of Zeus at Olympia (Olympia Museum), around 460. Photo: Jeffrey M. Hurwit.

The Art and Culture of Early Greece, 1100–480 B.C.

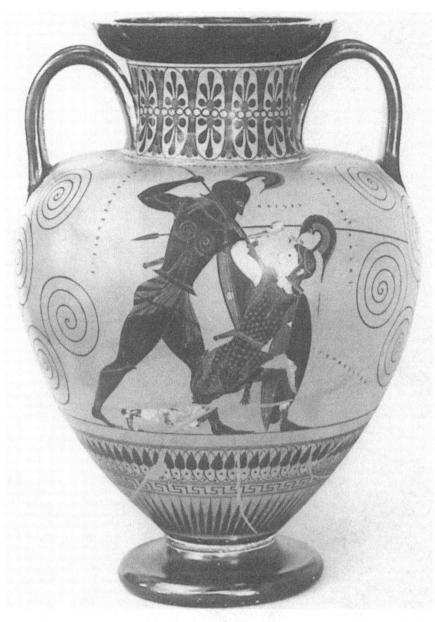

14. Black Figure amphora by Exekias (BM B210), around 540–30. Photo courtesy of the Trustees of the British Museum.

tual artist draws what he knows rather than what he sees is therefore not correct, for he knows much more than he draws. Both the Egyptian relief sculptor [15] and the Archaic Greek vase painter realized human beings have two eyes, yet they chose to depict only one: once was enough to make the point that their figures could see. The idea that the conceptual artist

15. Relief panel from the Tomb of Hesi-re, Saqqara (Cairo Museum), around 2750. Photo: Hirmer Fotoarchiv, Munich.

The Art and Culture of Early Greece, 1100–480 B.C.

does not imitate human beings but creates substitutes for human beings may be closer to the truth.[8] That is, perhaps, one reason why Archaic statues can say, through inscriptions carved on them or on their bases, "I am . . ." or "So-and-so dedicated me . . ." [79]: the words bestow a consciousness on the statue that the Archaic style cannot, and so obscure the boundaries between art and reality.

There may be bad conceptual artists, but conceptual art (as our own century has succeeded in teaching us) is not inherently bad because of its distance from the natural appearances of things. Archaic Greek art should not be considered the work of artists unable to do better any more than Giotto should be blamed for not painting like Titian. Artistic conditions and expectations change, but art does not necessarily improve. Certainly there were ancient writers who thought so and faulted craftsmen of the past for not matching those of their own time: if Daidalos (the archetypal Skilled One) were alive today and made statues like those that made him famous, says the fourth-century author of a pseudo-Platonic dialogue very unplatonically, he would be laughed at.[9] And there have been modern scholars who, if they would not laugh at a born-again Daidalos, explain Archaic art as a vigorous but experimental and technically inferior prelude to Classical art, as if each Archaic sculpture or vase painting were a progress report on the road to Perfection, as if the Archaic artist tried to be Classical and failed—which is no explanation at all. The Archaic style is neither defective nor preparatory (at least it is preparatory only in the sense that every style prepares for its successor). It is not an incompetent way of imitating the truth but a rational and consistent way of analyzing the truth, even of making up the truth. Archaic art is not a mirror. It is a prism.

According to most histories of Greece, the Archaic period ends and the Classical period begins with the momentous (and for Athens catastrophic) Persian War of 480/79. According to many histories of Greek art, the Archaic style ends in the same year, as if that crisis of history suddenly relieved a crisis in art. Ancient writers did not pin down the year so precisely, though 480 corresponds well enough with their implications that the old-fashioned way of image making gave way before the time of Polygnotos of Thasos, who was painting in the 470s and became the leading figure in Early Classical art. But in fact the styles we detect in art and the periods we impose upon history do not always neatly coincide, and the

8. See E. H. Gombrich, *Meditations on a Hobby Horse and Other Essays on the Theory of Art* (London, 1978), 2–8.

9. *Hippias Major*, 281D–282A. The real Plato has Sokrates trace his ancestry to Daidalos and admire his statues (*Euthyphro*, 11B; *Republic*, VII.529E), and the schematic, conceptual, and (for Plato's purposes) changeless art of Egypt comes in for some high praise (*Laws*, II.656D).

Archaios

series of revolutionary artistic events that transformed the Archaic into the Classical—the dissolution of the schema, the contradiction of the surface through foreshortening, the repeal of the law of frontality, the investigation of character—began several decades before the Persians burned Athens and the Greeks destroyed the Persian fleet in the waters of Salamis. It is therefore important to distinguish the Archaic style, which ends (or begins to end) before 480, and the Archaic period, which does not. Even so, dating the end of the style to "before 480" is less problematic than dating its start.

Archaios means "old" because the word from which it is derived, *archē*, means "beginning" or "origin." For some ancient authors, Archaic art simply began when the arts began, with the creations of such legendary craftsmen as the Telkhines of Rhodes and Daidalos. Other writers were more specific: Pliny says the art of sculpture was born in the first Olympiad (776–773).[10] Modern art historians have recognized the pointlessness of trying to identify the one year in which the Archaic style began and, like Pliny, reasonably choose different starting points for different media. Thus Archaic sculpture is said to begin around 650, which (despite Pliny) is a good year if one means large-scale sculpture in stone, while Archaic vase painting is often said to begin around 720, which is another good year if one is talking about the art of Corinth. But even earlier there was an artistic event of such immense significance that it lays claim to being the true *archē* of Archaic art: the establishment of the human figure as the central image of the first continuous pictorial tradition of early Greece. In fact, with that event Greek art was set upon a course that was never interrupted until Greek art ceased to be.

It happened in Athens just before the middle of the eighth century, and it happened at approximately the same time that the first monument of Greek literature took something like its final shape across the Aegean Sea in Ionia. The first great Greek artist, who is called the Dipylon Master, and the first great Greek poet, who might as well be called Homer, were contemporaries, or so we think. One worked with clay, a potter's wheel, and a brush, the other with a lyre, his memory, and just possibly some pen and ink. Their creations, a huge vase [37] and a huge epic, changed forever the cultural environment of early Greece and made it Archaic. And yet, though the Dipylon Master and Homer stand at the source of Archaic art and poetry, they were themselves the culminations of traditions that spanned the dimmest of all Greek historical periods, and it remains to be seen whether one of those traditions, or both of them, somehow reached back to a bronze age of heroes.

10. Pliny the Elder, *Natural History*, XXXVI.11.

2

Origins and Promises:
Poet and Painter in the Dark Age

"I will tell you but one thing more: keep it in mind.
Whenever I yearn to destroy some city
whose men have been dear to you,
do not in any way check my wrath, let me be,
since I now grant you this willingly, though with a reluctant heart.
Beneath the sun and starry heaven
there are many cities of earth-born men,
but of them all holy Ilios was most honored in my heart,
and Priam, and the people of Priam of the ash spear . . ."

And then replied the ox-eyed one, Lady Hera:
"Three cities are most dear to me:
Argos, Sparta, and Mycenae of the wide ways.
Destroy them whenever they become hateful to your heart."
[*Iliad*, IV. 39–47, 50–53]

So Zeus and Hera trade demolition rights to the cities of mortals and the *Iliad* seems to hint that the destruction of Late Bronze Age (Mycenaean) Greek kingdoms would follow, even compensate for, the sack of Troy. Naturally, historians and archaeologists have looked for causes other than divine wrath for the collapse of Mycenaean civilization. An invasion of backward, aggressive Dorians, conflicts between rival Mycenaean kingdoms or bloody wars of succession within them, uprisings of downtrodden subject populations, slight wind shifts and catastrophic drought—all these theories and more have been offered to explain what may always elude a single explanation: the disintegration of the wealthy, monumental, and homogeneous culture of Mycenaean Greece and the onset of the Greek Dark Age.

The disintegration began around 1200, and it began at the top, with the Mycenaean palace and the elaborate but fragile network of royal and priestly officials, public servants, military officers, merchants, craftsmen, and scribes which sustained and was sustained by it. The palatial bureaucracy formed the highest and heaviest stratum in a highly stratified society, yet the palace was also the ordered center of Mycenaean life. When for whatever reason the palace burned, the center failed to hold and the Mycenaean kingdom fell in upon itself. Only the routine of the lowest stratum, the peasant farmer and shepherd, is likely to have gone on much as before.

Palaces could burn in a day, but in fact the descent from the Mycenaean heights took time. The inhabitants of Greece in the twelfth century were still Mycenaeans and they continued to do most things in the Mycenaean way. But there were far fewer of them,[1] and substantial numbers of those who remained abandoned their homes and fled to other parts of the mainland, or to Crete, or to Cyprus. What they did they did less well, and the list of what they stopped doing altogether in the course of the twelfth century is long and impressive. There was no need for monumental stone defenses [16] or for architects to build them when there was no longer a palace to defend. Without royal halls to decorate, the fresco painter was obsolete. Without princely tastes to satisfy or princely wealth to afford such luxuries, the examples and quality of work in gold, silver, and ivory rapidly fell off. And without a centralized system of collection, storage, and distribution, the palace scribe had nothing to record. Using a syllabary script known as Linear B, Mycenaean accountants scratched clay tablets to list the great quantities of agricultural produce, textiles, bronze weapons, and so on kept within the palace walls and to record the holdings of land outside them. The need for Linear B and the persons who knew it ceased when those walls no longer stood whole and the bureaucracy no longer functioned. Within a generation or two of the destruction of the Mycenaean palaces, the art of writing, like other palatial arts, was forgotten. Do not mourn the loss of Linear B too much: it was not a literary script but a cumbersome shorthand known only to a handful of specialists in each palace. As precious as they are, the tablets are coarse notations, not chronicles, much less literature. Even so, total illiteracy is a clear sign of cultural recession and a classic symptom of a darkening age.

Despite the violent end of many sites, the abandonment of many others, the severe depopulation, and the sharp decline in material skills, the

1. V. Desborough, *The Greek Dark Ages* (London, 1972), 18, estimates that the population of Greece may have decreased in the twelfth century by a phenomenal 90 percent.

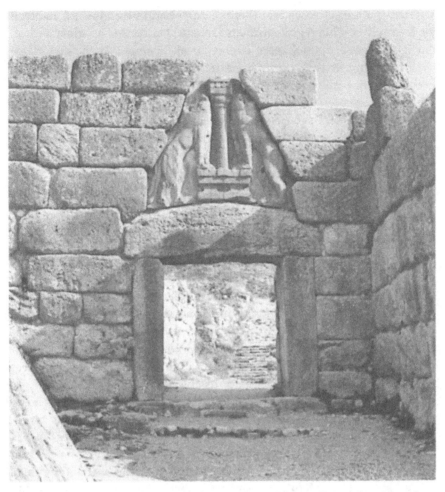

16. Lion Gate at Mycenae, around 1250. Photo: Hirmer Fotoarchiv, Munich.

twelfth century was not yet the worst of times, at least not everywhere: it was more a twilight than a dark age. Athens, though it seems to have expected an attack, did not fall. The citadel of Mycenae itself did not suffer its final disaster until around 1125. New Mycenaean communities, evidently founded by refugees, thrived at Lefkandi, on Euboia, and at Perati, in eastern Attica. And vase painting, the vital sign of this century and several more to come, experienced a brief but remarkable revival—or several revivals, since various regions of Greece (the Argolid, the Aegean Islands, Lefkandi) produced their own lively idiosyncratic styles.[2] Yet the differences matter above all. The stylistic fragmentation of twelfth-century pottery indicates that the once uniform culture of Mycenaean Greece had

2. See Desborough (above, n. 1), pl. 1 and p. 32.

suffered shattering blows and that the parts had to turn inward and fend for themselves. This regionalism also meant that darkness, when it came, did not descend upon Greece evenly or all at once. At the end of the twelfth century in Attica, for instance, some of the last Mycenaeans still lived at Perati, while not twenty miles to the west, in Athens, lived some of the first "Submycenaeans." The Greek Dark Age really began with them.

The Submycenaean period (1125–1050) *was* the worst of times.[3] As its name implies, Submycenaean culture was partly derived from Mycenaean, but in those parts it was utterly and sadly derivative, and in the other parts (such as the type of grave and the number of corpses that could be laid in it) there was discontinuity. The changes are not signs of cultural energy. The Submycenaeans were listless survivors, and perhaps because of their inertia as much as their poverty they paid little attention to their dead. Submycenaeans could be buried wearing finger rings, hair ornaments, and garments fastened with straight pins or fibulae (safety pins), but grave offerings, when they occur, are meager: only about 160 pots in all were taken from the 220 graves in the major Submycenaean cemeteries on Salamis and in the Athenian district known as the Kerameikos, and as pots they are not much to look at [17]. Even the one technological advance often placed before the end of the Submycenaean era—the full development of ironworking—may have been less an advance than a hard necessity. Iron was known in the Aegean as early as the fifteenth century, but it was difficult to extract and thus rare enough to be regarded as a precious metal. Bronze was the only utilitarian metal of the Mycenaean Age. But bronze required copper (which is very rare in Greece) and tin (which does not exist in Greece at all), and the importation of one or both of these metals from outside the Aegean area was seriously disrupted by the troubles that befell the entire eastern Mediterranean after 1200—the miseries of the Mycenaean kingdoms had company. In the early Dark Age, Greek smiths had little choice but to exploit the one ore Greece itself had to offer in some quantity: iron ore.[4] Thus a certain self-sufficiency developed in one branch of Dark Age industry, but it was probably involuntary and born of isolation. One wonders whether the Dark Age smith would have considered his own forging of iron a step forward or back. Later poets, at any rate, forgot the precious status iron once enjoyed: the dull gray metal became a symbol of cultural regression.

The Submycenaean period did not last long; the Dark Age it initiated endured. And yet by the middle of the eleventh century the cultural de-

3. Sp. Iakovidis, in "The Chronology of LHIIIC," *AJA*, 13 (1979), 454–62, argues that the Submycenaean era lasted only from c. 1075 to c. 1050.

4. See Jane C. Waldbaum, *From Bronze to Iron: The Transition from the Bronze Age to the Iron Age in the Eastern Mediterranean* (Göteborg, 1978), and T. A. Wertime and J. D. Muhly, eds., *The Coming of the Age of Iron* (New Haven, 1980).

17. Submycenaean vases from the Kerameikos cemetery, Athens, around 1100–1050. Photo courtesy of Deutsches Archäologisches Institut, Athens.

scent that started with the fall of the Mycenaean palaces seems to have come to a halt and the slow and at times limping ascent toward a new kind of culture seems to have begun. The Dark Age had three centuries to go, but those centuries were characterized less by degeneration than by transformation, origins, and promises.

In the Protogeometric period (1050–900) Dark Age Greece acquired its first cultural trend setter in the cluster of small villages that was Athens. But a community at Argos (whose craftsmen knew how to extract silver from lead) did not lag far behind. And Lefkandi (whose economy by the end of the tenth century was at least partly based on a flourishing bronze industry, whose potters may have been responsible for the first Greek exports to the eastern Mediterranean since the end of the Bronze Age, and which certainly imported a large number of Near Eastern objects)[5] must have been a particularly prosperous and cosmopolitan place. It was, moreover, a Protogeometric event—an event that transformed the very nature and boundaries of Greece—that later tradition remembered best: the Ionian Migration. The tradition cannot be true in all its details. The migration

5. Coldstream, GG, 41. For recent discoveries of Eastern objects at Lefkandi, see M. R. Popham, E. Touloupa, and L. H. Sackett, "Further Excavations of the Toumba Cemetery at Lefkandi, 1981," BSA, 77 (1982), 213–48, especially pls. 31–32.

Origins and Promises

The Greek World

across the Aegean was not really a single, massive movement of people at all but a diaspora that began just before 1050 (for what it is worth, the chronological inscription known as the Parian Marble dates the foundation of Ionia to 1077) and that lasted for generations, and the "Ionian people" probably came into being because of the migration, not before it. Still, the tradition says that Greeks from various areas of the mainland filtered through Athens, found Athenian leaders, took to the sea, and settled the center of Asia Minor's west coast, a region that would be called Ionia (other waves of migrants settled Aeolis, the northwestern corner of Asia Minor, with the island of Lesbos, at roughly the same time). Mycenaeans had once inhabited such places as Miletos. But for the first time Greece faced in upon the Aegean from both sides, and the sea became a Greek lake: to sail across it was to sail from one part of the Greek world to another. Although later Greeks did not share our conception of a dark age set between two ages of brilliance, the memory of the Ionian Migration could still loom fairly large in their minds and even figure in their politics (if only as propaganda or pretext). Athens and Ionia (and especially Miletos, its leading city) traced their special relationship back to it, and Athenians and Ionians spoke Greek nearly alike. Nearly five centuries after the migration began, Solon, an Athenian poet and lawgiver, called Athens "the oldest land of Ionia." The sixth-century tyrants of Athens implicitly appealed to a similar sentiment when they expropriated two of the greatest Ionian achievements—the *Iliad* and the *Odyssey*—and built them into the great national festival of the city. And when toward the end of the Archaic period the Athenians were asked to go to the aid of their Ionian kin, they did, and (as we shall see) paid a terrible price.

The Early and Middle Geometric periods (900–760) constituted a less dark age. Greek communities experienced flushes of a prosperity they had not known since the collapse of the Mycenaean world. Graves again tell most of the tale: there are burials now that are not merely rich—ninth-century graves at Lefkandi are notable for the quantity of gold rings, beads, and bands they contained—but ostentatious. Just before 850 on the north slope of the Areopagos in Athens, mourners cremated the body of an aristocratic woman, hurled dozens of fine vases into the fire, filled an amphora with her ashes, and before burying it deposited in it her precious worldly goods: a pin of iron and bronze, bronze pins and rings, gold rings, ivory seals, a necklace of faience and glass beads, and two large gold earrings decorated with filigree and granulation—work calling for skills that no Greek had possessed for three hundred years [18]. Nine vases were placed in the pit around the urn. The most striking is a painted chest whose lid supported five model granaries[6]—perhaps a terra-cotta boast

6. Coldstream, *GG*, fig. 13a.

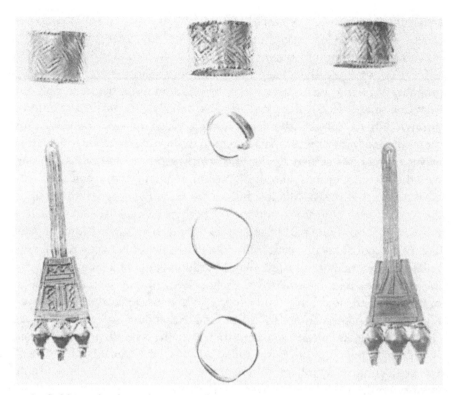

18. Gold jewelry from the grave of the "Areopagos Lady" (Agora J. 142-J. 148), around 850. Photo courtesy of American School of Classical Studies at Athens: Agora Excavations.

that this lady had not missed a meal in her life and would not miss one in her afterlife, perhaps a symbol of her estate's ability to produce five hundred bushels of grain a year; a sign, in short, of class consciousness as well as wealth.

The gold, faience, and ivory finds from ninth-century Athens and Lefkandi indicate that these two communities at least had renewed and secured contacts with the source of those materials, the Near East. Greece now began to look far beyond the Aegean once again. Some enterprising Greeks did more than look. They visited, if they did not inhabit, Tarsos in Cilicia in the late ninth century. A few Greek traders, apparently led by Lefkandiots and Cycladic islanders, seem to have been among the earliest settlers of Al Mina, a trading post founded around 825 on the Levantine coast, at the mouth of the Orontes River; and there they competed with Cypriots, Phoenicians, and others for the wares and resources of the interior. By the early eighth century Greeks used Tell Sukas, some fifty miles south of Al Mina, as another port of call, and Athenians in particular expanded their activities in eastern waters. But even before Greeks sailed

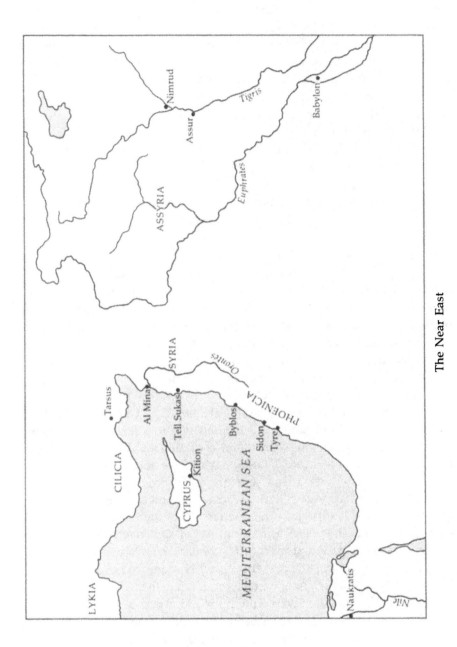

The Near East

to the Levant, Levantines sailed the other way, encouraged, perhaps, by political turmoil at home. The ivory in the Areopagos Lady's tomb was clearly imported, though it may have been worked in Athens by an Athenian; her faience necklace was imported ready-made; but her massive gold earrings were probably the work of a Phoenician jeweler who came to Athens to stay (or of an Athenian apprentice), and jewelry under strong Phoenician influence was also found in the rich early-eighth-century grave of a priestess at Eleusis. One or two Phoenicians may have settled in Athens, but an entire guild of Oriental goldsmiths seems to have set up shop at Knossos, in Crete, in the last half of the ninth century. The master jeweler was buried with two jars of finished goldwork [19] and gold and silver scraps in an old swept-out Bronze Age tomb at Tekke before 800, but his workshop carried on after the turn of the century.

The glitter of gold tends to pierce the dark better than the finish of most artifacts, but the darkness had not yet passed from Greece. One reason is that excavations, whatever the amount of gold they may uncover, cannot reveal enough about institutions, and it was the emergence of the institution known as the polis ("city-state" is the conventional, if imprecise, translation, meaning an autonomous, indivisible political entity that focused on a town but included surrounding agricultural lands) that finally dispelled the darkness. Dark Age Greece was a land of small communities that barely qualified as communities. It is sobering to consider one (controversial) estimate that the population of the Protogeometric Athenian hamlet that buried its dead (along with the finest Greek vases of the time) for 150 years in the Kerameikos may not often have exceeded fifteen people.[7] Though that estimate is probably low, the fact is that the Dark Age Greek was simply not Aristotle's "political animal." A Greek belonged to a family and a household (oikos) and beyond that to a tribe that could cut across villages and regions. The demise of the tribal order, based on kinship and rural lords (basileis), and the rise of the polis, based on geography and aristocrats, was a slow and uneven process, and it is virtually untraceable. The Dark Age is dark because we know so little about it, and here the darkness is especially impenetrable. Yet there are hints, even in the Dark Age, that the polis was coming. At Lefkandi a remarkable apsidal building was constructed around 1000—remarkable for its early date, its size (about 50 by 10 m), the presence of what seems to have been a peristyle, and its function: to honor and accommodate the worship of a founding hero and his gold-bedecked wife, buried in graves beneath the floor.[8] The hero and heroine may have been those of Lefkandi's "first family" rather than of the community as a whole, but the Lefkandi heroon antici-

7. A. M. Snodgrass, *Archaeology and the Rise of the Greek State* (Cambridge, 1977), 33–34.
8. See M. Popham, E. Touloupa, and L. H. Sackett, "The Hero of Lefkandi," *Antiquity*, 56 (1982), 169–74.

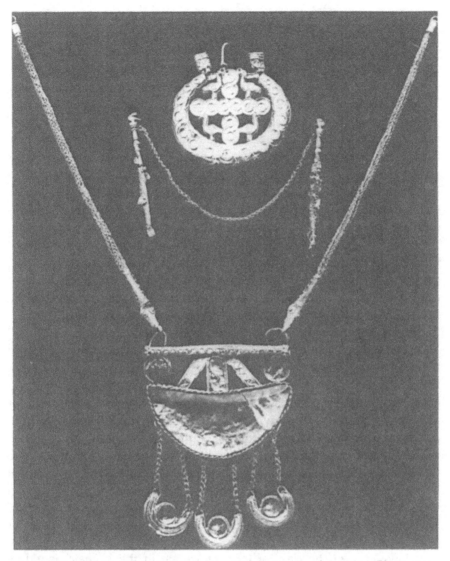

19. Jewelry from a tomb at Tekke, near Knossos, around 825–800. Photo courtesy of the British School at Athens.

pates by almost three hundred years the rise of hero shrines in the late eighth century, a phenomenon closely linked to the consolidation of the true polis. The earliest sign that a community had the will to defend, and so physically define, itself was the construction of an impressive fortification wall around the humble thatched cottages of Old Smyrna, at the border between Ionia and Aeolis, around 850. The wall does not by itself certify that Smyrna had become a true polis, but it does suggest that its people had developed a corporate sense, and that was a necessary step. Euboia provides yet another hint. Two centuries after its *heroon* was built,

around 800, Lefkandi was wrecked, and though it was not yet abandoned, some survivors decided to move to a well-harbored site to the east: Eretria. One of the first structures they built was a U-shaped cottage (Building H) set on a stone foundation and buttressed by wooden posts inside and out [20]. The walls were perhaps made of laurel boughs, for the building stood in the sanctuary of Apollo Daphnephoros (the Bringer of Laurel). It was probably the first in a series of temples on the site, but if it was not a temple, it was itself an architectural votive offering, a replica of the first temple of Apollo at Delphi, made of laurel, which is preserved only in legend.[9] Temple or votive offering, Building H played a sacred role in the life of the new and thriving town. It was the symbol of the link between an emerging polis and its divine patron, a focus of shared belief, and a justification of community.

Athens is a special case because it was especially large: the Athenian polis would eventually incorporate all of Attica. Theseus, it was said, had unified Attica in a heroic age. If he did, it had to be unified again. The countryside beyond the villages at Athens was virtually deserted in the Protogeometric period. The second unification (*synoikismos*) seems, however, to have begun by around 900. A cult of Zeus the Rainmaker was probably established on Mount Hymettos by the end of the tenth century. And it is possible that the working of silver at Laurion and Thorikos, in southeast Attica, helped support the economy of ninth-century Athens, and may even explain the wealth of such graves as the Areopagos Lady's [18]. But there were rich burials elsewhere in ninth-century Attica, and the *synoikismos* probably did not reach full speed until the beginning of the eighth century, when the Athenian population exploded, the separate hamlets that had constituted Athens coalesced into one town, and the surplus Athenians sought *Lebensraum*. It was then, perhaps, that aristocrats encouraged poorer people to cultivate the deserted countryside of Attica, offering protection and patronage in return for a percentage (a sixth?) of the fruit of their labors. The *synoikismos* of Attica in the late Dark Age may thus have created the class of farmers known in the Archaic period as "sixth-parters" (*hektemoroi*) and it is ironic that in time their unhappy fate would come close to tearing the Athenian polis apart.[10]

At all events, the fragmented, depopulated, and impoverished village society that followed the collapse of the Mycenaean world was by the first decades of the eighth century being transformed into a new political and economic reality. The transformation continued even after the darkness finally lifted. But one of the great promises of the Dark Age was that the

9. Pausanias, X.v.9; see C. Bérard, *AntK*, 14 (1971), 59–73.
10. Cf. W. G. Forrest, *The Emergence of Greek Democracy* (New York, 1966), 149–50. For a different view of the *synoikismos*, see C. G. Thomas, "Theseus and Synoicism," *Studi Micenei ed Egeo-Anatolici*, 23 (1982), 337–49.

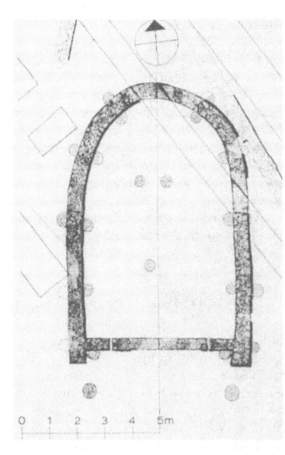

20. Plan of Building H in the Apollo sanctuary (Daphnephoreion) at Eretria, around 800. From P. Auberson, *Antike Kunst*, 17 (1974), 62, fig. 1, reproduced by kind permission of Vereinigung der Freunde antiker Kunst, Basel.

polis would become what the palace had been long before: the center of Greek culture and life and the foundation of order.

Ages of Gold and Silver preceded the Bronze, according to a myth the epic poet Hesiod tells in his *Works and Days,* and a nonmetallic generation of heroes followed. Then came another age of men upon the nourishing earth, an age Hesiod deplores: his own.

> If only I did not belong to this fifth generation
> of men, but had died before, or been born after.
> For now is an age of iron. By day men know no
> end to toil and woe, by night they waste away.
> And the gods will give us hard anxieties.
>
> [Ll. 174–78]

Because there happens to be some metallurgical truth in Hesiod's Five Ages of Man, it is customary to equate his gloomy picture of the Age of Iron with the Dark Age of Greece. But the grim images the words "Dark

Age" evoke are probably misleading: it is, again, we that are in the dark, and any age Hesiod lived in would probably have seemed iron-gray, iron-dull, and iron-hard to him. In fact, Hesiod lived at a time (the late eighth century) when the darkness had already lifted. And even Hesiod (who goes on to predict, like an Old Testament prophet, that the Iron Age will only get worse) nonetheless concedes that good things will coexist with the bad. He does not say what those good things are. It is unlikely that he means migrations across the Aegean or foreign trade or the emergence of the polis. But one of the things he must have considered good was the struggle of justice (*dikē*) against violence (*hybris*). Another must have been the instrument he himself placed in the service of justice: epic poetry. And the development of dactylic hexameter verse—his own poetic means and that of Homer just before him—was another of the great promises of the Dark or early Iron Age.

The Origins of Hexameter Epic

The three and a half centuries after the end of the Bronze Age may be only dimly visible, but they were not silent. In their diminished circumstances Dark Age Greeks consoled themselves—and self-consciously established associations with the former age—with stories about their mightier predecessors, heroes who by themselves could easily lift boulders no two "men of today" could lift (*Iliad*, V.302–4), but who nonetheless acted so that these lesser men could remember them (*Iliad*, XXII.304–5). The stories no doubt took many forms: simple folktales, for instance, passed on from parent or grandparent to child in hearthlight or at bedtime. But the most significant (though not necessarily the most common) vehicle of remembrance and consolation was the traditional narrative song, the oral epic poem. The archaeologist's pick and whisk broom may document the relative material impoverishment of the Dark Age, but other tools have measured the period's imaginative richness and its poetic accomplishments.

Oral poetry is a performing art. More, it is an art in which the poetic process itself, the very act of composition and not simply the delivery, is oral. This does not mean there can be no forethought, but to a large degree poetic creation lies in the performance. An intimation of this conception of poetry may even exist in the *Iliad* itself. When a poet (oral or otherwise) describes an imaginary work of art at length, it is reasonable to suspect that he may be less interested in visual art than in alluding to his own poetic task: he is being self-reflexive, he is dissembling. The *Iliad* takes 130 lines to describe the miraculous shield of Akhilleus (XVIII.478–608). It is by far the most important artifact in a poem crammed with them. But what is actually

described is not the shield as a finished product, suitable for a museum display case, but Hephaistos, the lame divine craftsman, as he is making it.[11] The description of the shield is the description of a performance, a process, and it ends when Hephaistos is finished. Similarly, the audience of an oral poet does not experience the oral poem as a completed work—as a whole text—but the poet as he sings it. The oral poem exists only as long as the singing lasts (or, in a way, not even so long, since each line, each phrase, vanishes in the air once it is uttered). It is irrecoverable, unless it is remembered verbatim (whether that feat is possible is open to question) or happens to be transcribed by an extraordinary member of the audience: someone who is literate. Oral poetry has existed in the twentieth century in such places as Yugoslavia and Africa, and scholars with pen, paper, and tape recorders have preserved some of it. But in the nonliterate, non-electronic Dark Age there were no such people. The prehistory of Homeric epic is thus necessarily obscure: for once the oral poem was written down and "fixed," once it materialized, its life as a truly oral poem ceased.

The *Iliad* and the *Odyssey* exist in a material form: they are texts. Their relationship to the long oral tradition that led to them remains, as we shall see, unclear, and so the revolution in Homeric studies that Milman Parry began in 1928 has in reality proved rather less than is sometimes claimed. It has demonstrated not that the *Iliad* and *Odyssey* as we have them were orally composed, but that they *resemble* orally composed poems. On the basis of close studies of Homeric diction and impure analogies with Yugoslavian oral poetry of the 1930s, Parry, Albert Lord, and a host of followers have concluded that Homer used a vast inherited reservoir of stock formulae that covered almost every conceivable action, situation, or idea and that fitted specific positions within the dactylic hexameter line. The function of these formulae was purely metrical. They were learned and memorized, and they, not the single word, were the basic units of oral composition. Once something was sung "right," there was no need to sing it any other way. And, over time, formulae that exactly repeated the content and metrical patterns of already existing formulae were economically discarded. As short as an epithet-noun phrase ("swift-footed Akhilleus," "black ship," "crafty Odysseus") or as long as a full hexameter line ("when early-born rosy-fingered Dawn appeared") or an entire speech or scene, the formula reduced the demands placed upon the oral poet, who, it is assumed, improvised on the spot, spewing forth formulae almost without having to think.

The brilliant light Milman Parry shed upon the traditional, formulaic qualities of Homeric poetry has tended to blind some scholars to the cre-

11. G. Lessing first made this observation more than two hundred years ago in *Laocoön* (1766), chap. 18. So, too, we come upon Helen in the process of weaving scenes from the Trojan War into cloth on her loom (III.125–28).

ative powers still left to the poet. Stated in the extreme, the theory of oral formulaic composition makes the oral poet a mechanical man and the *Iliad* and *Odyssey* in some sense vast, predetermined formulaic systems. Because formulae and even themes were passed down from one bard to another, questions of artistic individuality and originality are irrelevant and therefore excluded. So, when Helen fails to spot her brothers in the Trojan plain and Homer briefly tells why—"life-producing earth already covered them in Lakedaimon" (*Iliad*, III.243–44)—there is, the theory goes, no intended irony, no pathos. There is only metrical utility, only the mechanical inevitability of a completely formulaic tradition. Not only is the poet not responsible for the poignant ashes-to-ashes, dust-to-dust contrast between "life-producing earth" and the dead brothers it holds, but the contrast would not even have occurred to the poet or his audience. This, I think, is nonsense.

The theory is still a theory, and not all scholars are convinced either that the Yugoslavian parallels are valid (they prefer to set the *Iliad* beside the works of Vergil, Milton, and Dante rather than the works of Avdo Mededović) or that the Homeric poems are totally formulaic.[12] The particular phrase that is translated "life-producing earth," for instance, does not occur elsewhere in the *Iliad*. If it occurs only once, is it a formula at all? If it occurs only once, could it not have been specifically chosen or invented to convey pathos? Still, most scholars accept these elements of the theory: the language of Homer is to a large extent traditional and formulaic; and even if Homer was not entirely dependent on what he inherited, the complexities and refinements of the formulae he used presuppose a tradition of dactylic hexameter epic that is older than the eighth century. The question is, how much older?

Greek poetry existed virtually from the moment there were Greeks— that is, from the moment there was a Greek language. There is some evidence that the celebration of heroes and their fame (*kleos*) was among its oldest themes,[13] but even without it there is no reason to believe that the inhabitants of Mycenaean Greece behaved any differently from other peoples of the eastern Mediterranean with whom they came in contact, peoples who had their own epics (such as *Gilgamesh*). If the Mycenaeans lacked heroic poetry, they would have been exceptions in the world they knew. And if the Mycenaeans had heroic epic, it was undoubtedly orally performed and orally transmitted (it is, again, not likely that Linear B, the preserve of a few bureaucrats, was or could have been used to write poetry). Mycenaean bards certainly had lyres to pluck as they chanted heroic tales. A lyre player, evidently performing at a banquet the way Phemios

12. For critiques of extreme Parryism, see Austin, *Archery*, 11–80, and R. Finnegan, *Oral Poetry* (Cambridge, 1977), 69–72.

13. See M. L. West, "Greek Poetry, 2000–700 B.C.," *CQ*, n.s. 23 (1973), 187.

21. Silver vessel with siege scene from Mycenae, 1550–1500. Photo: Hirmer Foto-archiv, Munich.

and Demodokos do in the *Odyssey*, was painted on the throne-room wall of the so-called Palace of Nestor at Pylos, and an ivory lyre was buried with a Mycenaean warrior-prince at Menidi, in Attica (it is hard not to think of Akhilleus, the lyre-playing warrior par excellence, who himself sings the fame of men at *Iliad* IX.186–88). And Bronze Age Aegean art provides some idea of the sort of heroic exploits Mycenaean singers could have celebrated. As it happens, the siege or raid against a coastal city is a venerable and recurring image in works of art in a variety of materials—faience, fresco, stone, and silver [21]. Such sieges and raids were facts of life in the Bronze Age Aegean, so these representations need not be illustrations of tales heard in song rather than depictions of the kinds of event Aegean peoples knew about at firsthand. Yet there is something traditional, even formulaic, in this long series of images. And it is not impossible that there was a very old story about the siege of a city that Bronze Age bards, as well as artists, repeated and adjusted over time, and that after a band of Mycenaeans besieged and sacked a small citadel called Troy around 1200, the new adventure was inflated to fit the old story.[14] In a sense, the tale of the

14. See T. B. L. Webster, *From Mycenae to Homer* (New York, 1964), 61:

Origins and Promises

Trojan War was familiar and patterned even before the trifling event on which it was based took place.

There are other reasons for supposing that the oral tradition that culminated in the *Iliad* reached as far back as the Mycenaean Age. The one that has received the most attention is the existence of genuine "Mycenaean relics" in the *Iliad*. The soporific Catalogue of Ships (II.494–759) may be based on a composition of the twelfth century, after the disintegration of the Mycenean world began but before the process was complete. That is arguable. But the Mycenaean credentials of a few artifacts mentioned in the *Iliad*—the boar's-tusk helmet, the tower shield, the silver-studded sword— are impeccable. The credentials of the great gold cup Nestor has at Troy (XI.632–37) are not impeccable, but its similarities to a vessel found at Mycenae (and dating to around 1550) are close enough to suggest that knowledge of a particular type of cup survived the Bronze Age. What is more, such objects as the silver-studded sword and the tower shield were obsolete long before the fall of the palaces. Memory of them—perhaps even memory of Ajax, who is the only hero who carries his shield "like a tower" and who therefore may himself be a relic of very early Mycenaean saga—must have been transmitted through the last centuries of Mycenaean greatness.[15] The most economical way to account for this transmission is to assume a tradition of Mycenaean heroic poetry that in turn descended through the Dark Age to Homer.

This does not mean that Mycenaean poetry was sung in the highly structured dactylic hexameters of the *Iliad* and *Odyssey*, for dactylic hexameter is not the only form heroic epic could take. It is true that the formula for "silver-studded sword" (*phasganon argyroēlon*) is probably of Mycenaean origin and that it fits neatly into the hexameter line. It is possible, however, that it was not chosen for its metrical utility but, on the contrary, that dactylic hexameter itself came into being because it best suited such preexisting traditional language. That is, the formula determined the meter, the meter did not determine the formula. Gregory Nagy has argued that regular, traditional phraseology and its built-in rhythms generated a meter to encase them, not the other way around, and that dactylic hexameter verse, far from being an abstract frame or mold with which the very first Greek bard began before uttering a sound and into which he plugged appropriate formulae, was itself the outcome of a lengthy period of evolution.[16] It was only after a considerable development

15. One thirteenth-century representation of a tower shield has been found, on a potsherd from Tiryns; see E. Vermeule and V. Karageorghis, *Mycenaean Pictorial Vase Painting* (Cambridge, Mass., 1982), 229, X.19.1 (a boar's-tusk helmeted warrior carries such a shield beside a warrior with a figure-8 shield). But Vermeule and Karageorghis note the scene's "surprisingly traditional" character, and one wonders whether this depiction of a tower shield might not itself be a reminiscence, an archaism, based on much earlier images.

16. G. Nagy, *Comparative Studies in Greek and Indic Meter* (Cambridge, Mass., 1974).

that dactylic hexameter took on an independence of its own, became "abstract," and began to admit phrases that fitted and to exclude phrases that did not. There is no telling when dactylic hexameter assumed control over the tradition that had engendered it. If it did so in the Mycenaean period, it was late in the period, and it is just as likely that hexameter asserted its supremacy after the Mycenaean Age ended.[17] If so, dactylic hexameter verse and the complex formulaic systems that dovetail with it were products of the Greek Dark Age, and an impoverished material record should not obscure a poetic event of such staggering dimensions.

The Dark Age even exerted more control over the furniture and milieu of the Homeric world than did the Bronze Age. Though the epics purport to describe the society of Mycenaean Greece, the society they in fact describe corresponds to nothing historical: no Greek ever lived the way Homer says the Akhaians did. Homeric society—the worlds of Akhilleus and Odysseus—is a composite, a fiction of overlapping details and circumstances drawn from those periods through which the oral tradition passed. The stratigraphy of Homer is not easy to make out; but the stratum of Mycenaean memories and relics, though it is there, is thin, while the Dark Age stratum appears to be deeper. Phoenicians have sailed (and Phoenician or Sidonian wares have been imported) from the ninth or eighth century directly into tales of the late Bronze Age, where they do not belong. The Mycenaean palace is remembered not as the hub of a vast, bustling bureaucracy equipped with tablet upon tablet of Linear B, but as a country manor: manure is heaped up before the doors of Odysseus' fair hall on Ithaka (*Odyssey*, XVII.296–99). Phaiakia is a marvelous place, but King Alkinoos seems to rule (nominally) a town like Old Smyrna rather than a Bronze Age citadel like Mycenae, and he seems to be more of a chairman of a board of *basileis*, country squires. On the shield of Akhilleus, a king supervises a harvest, but he is a *basileus*, not a glorious king of men; and we hear that there are many *basileis* even on Odysseus' Ithaka. Iron is a good test case. Again, the metal was known to the Mycenaeans, but to them it was precious: they made rings out of it. So when Akhilleus awards a lump of rough iron in the funeral games of Patroklos, the prize is not in itself inconsistent with Bronze Age knowledge of iron or the value the Mycenaeans placed upon it: in fact, a twenty-pound lump of meteoric iron was found (partly worked) in the Bronze Age villa of Haghia Triadha, on Crete.[18] But Akhilleus' suggestion that the iron prize will supply tools for five years to some lucky shepherd or plowman is inconsistent with Mycenaean practice: iron seems to have replaced bronze as the principal working metal only in the tenth century. It is also inconsistent when Pandaros'

17. For a different view, see G. C. Horrocks, "The Antiquity of the Greek Epic Tradition," *PCPS*, 26 (1980), 1–12.
18. See Waldbaum (n. 4), 19.

arrow and Akhilleus' sacrificial blade are referred to generically as "iron," and when Hera's fabulous gold, silver, and bronze chariot has an iron axle. And when in the *Odyssey* Athena claims to be on her way to trade a ship's load of iron for bronze, implying that bronze is more valuable (as it was in the Dark Age), Iron Age commerce has anachronistically intruded into the Heroic Age.

The Dark Age atmosphere of the epics sometimes seems so pervasive that some scholars argue it is the Mycenaean fossil or memory that is the real anachronism, the real intrusion. But attempts to break down Homeric society and weigh its bronze and iron parts do not accomplish very much. The society is artificial, an amalgam that is at the same time historically unsound and poetically explicable. The oral tradition that produced it was fluid and receptive to the changing conditions of the centuries it traversed and to the changing material cultures of the people who transmitted it by singing and remembering. So, in Book XXII of the *Iliad*, when Akhilleus finally drives his spear, heavy with bronze, into Hektor's throat, Hektor with his dying breath can scornfully call him iron-hearted. That may be irresponsible archaeology, but it is an excellent rebuke.

If no Greek ever inhabited a world exactly like the one the Homeric heroes inhabit, no one ever spoke Greek quite the way the Homeric heroes speak it—no one, that is except performing bards. Homeric society is artificial, and so is the Homeric dialect: it is, in fact, an amalgam of several dialects.[19] The Ionic dialect predominates, however, an indication that the crucial phase in the formation of dactylic hexameter epic—the Dark Age phase—took place in Ionia. The migrations transferred the stuff of epic as well as people across the Aegean, and there, far from any shadows cast by ruined Mycenaean citadels (though closer to Troy), epic took shape; perhaps, somehow, that distance was necessary. The Greeks who stayed behind on the mainland still had heroic tales to tell each other, but we do not know what form they took or that they took a poetic form at all: myth does not require meter. In fact, mainland Greeks may not have encountered dactylic hexameter epic until the Dark Age ended and it was imported from Ionia fully formed. Thus Athens appears to be in a strategic but odd position. For if Athens was the fount of the Ionian migrations, it had at least something to do with the transmission of epic, or the raw material of epic, to the coast of Asia Minor. Yet despite this early and important (if indirect) contribution to the history of the genre, Athenians play an insignificant

19. The most problematic element is the Aeolic. The presence of Aeolisms in Homeric language has led some scholars to conclude that the *Iliad* is at least partly based on an Aeolic epic, originating either in Thessaly before the great migrations or in Aeolis (which, incidentally, included the Troad) afterward. See West (n. 13), 189–91, and R. Drews, "Argos and Argives in the *Iliad*," *CP*, 74 (1979), 111–35. But see now D. G. Miller, *Homer and the Ionian Epic Tradition: Some Phonic and Phonological Evidence against an Aeolic 'Phase'* (Innsbruck, 1982).

role in Homer (so insignificant that the Ionians almost seem like ingrates), and Athens is not known to have produced oral poets or oral poetry of its own. The tradition of hexameter epic, if it ever existed in Athens before the migrations, left with them, or else withered away.

Dark Age Ionia thus deserves the credit for dactylic hexameter epic, whatever its Mycenaean roots may have been. Dark Age Athens' principal contribution to the origins of Archaic culture lay in an entirely different field. For it was there that a virtually lost art was rediscovered or reinvented: the art of image making.

The Origins of Representation

Greeks kept telling tales and singing heroic songs after the onset of the Dark Age; the generally bleak conditions of the era may even have encouraged them to seek solace in the predictability of myth and assurance in the developing formulae and rhythms of epic. But Greeks did not keep drawing pictures. Even during the stylistic fragmentation of the twelfth century, Mycenaean craftsmen frequently decorated vases with animals and human figures [22], and eighth-century craftsmen would superintend a population

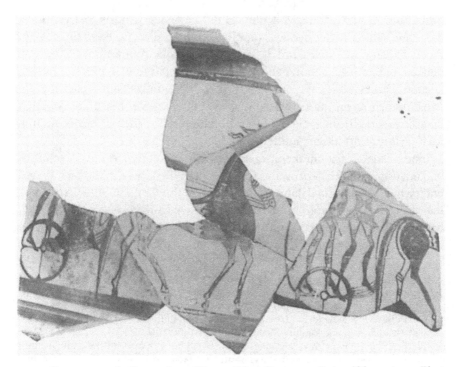

22. Fragments of a krater from Tiryns (Nauplion 14 336), twelfth century. Photo courtesy of Deutsches Archäologisches Institut, Athens.

explosion in paint [42]. But in between came an age that was not merely dark but virtually imageless. In the first part of the Dark Age (the Submycenaean and Protogeometric periods), the Greek vase painter seems to have lost the will to represent and then to have forgotten how. Ironically, one reason was the suddenly prominent role he had to play.

In the Mycenaean age, vase painting was a minor and derivative art.[20] Vases were mass-produced, and the vase painter left the imaginative labor to others—the fresco painter, the ivory carver, the goldsmith—and drew upon their richer, finer work for inspiration and subject matter. Even after his models began to fade in the twelfth century, his pictorial response could still be energetic. But by the beginning of the Dark Age his customary sources of inspiration were irretrievably remote: he was on his own. The vase painter became the leading craftsman of his time by default and he was unprepared to lead. Still, the loss of palatial stimuli may have been only part (though the greater part) of the problem. The *meaning* of images may have been lost, too: the elaborate hunting expeditions and processions of chariots and warriors of Late Bronze Age art simply did not speak to the inhabitants of the Dark Age. In addition, pictorial vases cost more than plain pots, and the typical Dark Age consumer could not afford them. The market, as well as the purposes and the inspiration, for pictures dried up. And yet even cheap schematic human figurines of terra cotta, which were turned out in vast numbers in the same Mycenaean shops that produced vases and which depended less on finer models, also ceased to be made on the early Dark Age mainland.[21] The need to make human images in three dimensions for use as votive offerings or as companions in tombs—basically a religious need—gave out as abruptly as the impulse to make them in two dimensions on the surfaces of vases. For whatever reason or combination of reasons, human figurines and pictures—the idea of representation itself—simply no longer mattered.

There were occasional pictorial incidents in the early Dark Age, but most of them occurred on Cyprus and Crete, not on the Greek mainland. Were it not for the fact that the island of Euboia hugs the flank of Greece so closely that it can be considered a part of it, the early Dark Age mainland would have yielded nothing pictorial at all. As it is, a few sketchy animals of uncertain species cavort along the sides of a so-called bird vase (of Sub-

20. See G. Kopcke, "Figures in Pot-painting before, during, and after the Dark Age," in *Symposium on the Dark Ages in Greece* (New York, 1977), 32–50.

21. R. V. Nicholls has made a strong case for the continued manufacture of *animal* figurines on the Dark Age mainland, and thus also for the continuity of cult; see "Greek Votive Statuettes and Religious Continuity, 1200–700 B.C.," in *Auckland Classical Essays Presented to E. M. Blaiklock*, ed. B. F. Harris (Auckland, 1970), 1–37. But the case for the manufacture of *human* figurines on the mainland in the eleventh and early tenth centuries is, in my opinion, weak. The discovery of a crude human figurine at Lefkandi, datable to about 875–850, does little to strengthen it; see *BSA*, 77 (1982), 215 and pl. 29e.

The Art and Culture of Early Greece, 1100–480 B.C.

23. Detail of a hydria from Lefkandi (Skoubris tomb 51), with confronting archers; around 1000. Photo courtesy of M. R. Popham and the Managing Committee of the British School at Athens.

mycenaean date) from Lefkandi, and two limp archers take aim at each other on an imported Middle Protogeometric hydria, or water jar (imported from where is unknown), found at the site [23].[22] The spineless, concave, crouching(?) men duel with tiny bows held in tiny arms, and there is no sense of tension or malice. Their symmetry is flaccid, and they suffer the indignity of not even occupying the front of the vase. All in all, they are not much. But they are the only painted human figures we have at the moment from the Greek mainland in the first 250 years of the Dark Age. They are intriguing only because they are so alone. Perhaps they represent the last flickering of a dying Bronze Age pictorial tradition.[23] They hardly constitute a Dark Age tradition all by themselves, nor do they signal a pictorial renaissance. They are isolated, stray events in an otherwise pictureless age. They are without influence and are therefore without consequence.

In eleventh-century Athens there was not even the random pictorial event, and Athenian pot painters turned wholly to the abstract; rather, they lapsed into it. The dreary Submycenaean style, with its miniaturized and degenerate versions of Mycenaean shapes [17] and its completely derivative ornament, was the first result. The very best pots the Submycenaean craftsman could manage—the pots the dead took with them to the grave—are usually squat and sometimes lopsided, and handles often do

22. See M. R. Popham et al, *Lefkandi I: The Iron Age* (London, 1979–80), pls. 254b, 270d, e.
23. Their large eyes and tufted hair recall the eyes and hair (or helmet crests) of two chariot-borne warriors on a twelfth-century potsherd from Mycenae; see Vermeule and Karageorghis (n. 15), XI.1B. Yet could they have been inspired by such works as the bronze amphora recently found in the *heroon* at Lefkandi, which has relief figures of hunters with bows and animals around its rim (see Popham et al. [n. 8], pl. XXIV)?

Origins and Promises [55]

not exactly match or fit. The widest diameter is a critical dimension in the architecture of any pot, and on Submycenaean pots it usually sinks below the middle of the body, as if the weight of gravity were too much for the clay to resist. When the Submycenaean took up his brush, he seems to have been too weary or too indifferent to do much more than hold it against the pot as it slowly turned on the wheel, producing horizontal bands of varying widths. When he mustered the energy, he could draw concentric semicircles, wiggles, hatched triangles, and wavy lines, but neatness did not count. Submycenaean is a style of exhaustion.

It is partly the contrast with Submycenaean that makes the Attic vase painter's next achievement, the Protogeometric style, look so good [24]. But it is more than that: Protogeometric vase painters turned abstract decoration into a tool of analysis and produced a style of order and rigor. Around 1050 Attic potters raised the widest diameter of the vase to the middle of the body and even above to the shoulder, slimming the form. They developed a better glaze and used a faster wheel than the Submycenaean potter had, and the speed gave the Protogeometric vase a smoother and crisper contour. They balanced the convex profile of the body with the concave profile of the neck. They continued to paint horizontal lines and bands, but used them to set off and emphasize the principal parts of the vase—on an amphora, the neck, the shoulder, and the belly. And even the juncture of handle and body is accented by stripes that follow the seam and then gracefully fade away. The Submycenaean pot is a pot; the Protogeometric pot is a vase.

The Protogeometric vase painter concentrated on the shoulder of the amphora, perhaps because with its sharply receding contour it seemed the most "active" part. At any rate, it was there that he placed the characteristic ornament or emblem of the new style: the concentric semicircle. The motif itself was not new, but the way it was drawn was. The Mycenaean and Submycenaean had drawn it freehand, with all the irregularity that unaided flesh is heir to. The Protogeometric vase painter brought the motif under strict mechanical control by affixing a multiple brush (which, like several pencils held together, produces parallel lines at one stroke) to a compass. The device made the reproduction of identical ornaments as easy as twisting one's wrist—halfway for a concentric semicircle, all the way around for a concentric circle—or so it is usually thought.[24] And while horizontal bands divide the Protogeometric vase into its component parts, the semicircle and circle serve other purposes: they intimate volume. The semicircle is the two-dimensional equivalent of the hemisphere, and it is found exclusively on the

24. See, however, H. Eiteljorg II, "The Fast Wheel, the Multiple Brush Compass, and Athens as Home of the Protogeometric Style," *AJA*, 84 (1980), 445–52.

24. Protogeometric belly-handled amphora (Kerameikos 1073), around 975. Photo courtesy of Deutsches Archäologisches Institut, Athens.

shoulder of the Protogeometric amphora, where it interprets the vase's upper half. The circle is the two-dimensional equivalent of the sphere, and it is used most successfully on the belly, where it implies the full volume of the vase.

Although the idea of the multiple brush evidently came from Cyprus, the idea of attaching it to a compass was Attic. So was the idea of interpreting the vase as a constructed object, as the sum of its parts. And so was the idea of establishing a sympathetic relationship between the ornaments on

Origins and Promises [57]

the surface of the vase and the swelling space beneath it. The style did not take long to spread to large parts of Greece and, for the first (but not the last) time, other regional styles have to be measured against Attic technical standards and precision and against the Attic articulation of a nearly chordlike harmony of part, ornament, and whole. Protogeometric is an austere, stable, and conservative style: once established in the late eleventh century, it changed very little in the course of the tenth. But there is the sense that the Protogeometric vase painter has both imposed order on his art and founded an enduring attitude toward form. Greek art has now really begun.

Even with its bands and semicircles most of the surface of the Protogeometric amphora is vacant, yet there is still no room for a pictorial form. Imagelessness seems less of a fault in Protogeometric than in Submycenaean: in the earlier style it signals the impoverishment of the imagination, in the later style it tends only to emphasize the successful negotiation of the abstract. The figure has no role to play in the Protogeometric definition of structure and its intimations of volume. But one or two vase painters discovered another role for it, and, in fact, Attic Protogeometric is not completely imageless after all. Around the middle of the tenth century, a long-legged, rubbery silhouette wandered onto the belly of an amphora from the Kerameikos [25]. It is nothing but a few quick arching brushstrokes, but it is unmistakably a horse. And it is a sign of the power of the pictorial form that it seems to undermine its vast abstract environment rather than to be overwhelmed by it. In the competition for the spectator's notice, the array of concentric semicircles and wavy lines does not stand a chance even against a tiny, hoofless silhouette that stands coyly off center. The horse, then, repeatedly attracts the eye. But it is really not an impertinent comment on the abstract, nor is it an idle sketch. The vase it adorns held human ashes, and the horse symbolizes the aristrocratic rank of the dead, a man wealthy enough to afford the expenses of a horse and therefore exalted enough to ride it above the shoulders of other men as a *hippeus* (knight). It is also possible that the horse alludes to the ritual procession known as the *ekphora* [cf. 49] and is an abbreviation for the team that drew the funeral wagon to the pyre. In either case, the horse is a functional, ennobling device, not a doodle.

This horse and the two or three other Attic Protogeometric horses extant were drawn by artists who had never drawn a horse, or any other pictorial form, before. It may be that the painter of the hydria from Lefkandi [23] had not drawn a figure before either, and he is to be commended for his effort. But the implications of the Attic Protogeometric horse are much greater. The Lefkandi archers lead nowhere. The Attic horse, as rare as it is, as inconspicuous as it is, is the prelude to a continuous pictorial tradi-

25. Protogeometric belly-handled amphora (Kerameikos 560), around 975–950. Photo courtesy of Deutsches Archäologisches Institut, Athens.

tion, and it forecasts a decisive end to the representational hiatus of the Dark Age Greek mainland.[25]

25. On a late Protogeometric Attic vase exported to Lefkandi, two birds are painted beneath the handles (*AR*, 1981–82, 16, fig. 29b, and *BSA*, 77 [1982], pl. 29a–c). By the beginning of the ninth century, then, two of the three most important subjects of Attic Geometric art—the horse and the bird—were already introduced. The third—the human figure—would not appear on Attic vases until later in the ninth century.

Horses were fashioned out of clay in addition to being drawn on it in tenth-century Athens, and Protogeometric craftsmen also made terra-cotta stags (the animal would not join the vase painter's figural repertoire until the early eighth century). These figurines reinforce the sense that image making had begun to matter once again. The making of human images, however, apparently had not: no really convincing human figurine from Protogeometric Athens is known. But there is something half human from late-tenth- or early-ninth-century Lefkandi [26]. Human-headed terra-cottas appear elsewhere in the Dark Age Aegean, but they are novelty vases, and none of them can be compared with this statuette. Its legs and human parts are solid, its equine body is a hollow cylinder turned on a potter's wheel, and it is covered with geometric patterns. Its ears are elephantine, its brow is furrowed, and it seems to smile the first "Archaic smile." It once carried something over its left shoulder and its left knee is intentionally gashed. It is a centaur—at least, if it came from a later era there would be no hesitation in labeling it as such or in reconstructing it as wielding a branch or tree, the normal weapon of the species. Skeptics may doubt whether we can really call such a man-horse a centaur this early. But there is no good reason not to call it one, though we cannot be certain which

26. The centaur from Lefkandi, around 900. Photo courtesy of M. R. Popham, by permission of the Managing Committee of the British School at Athens.

The Art and Culture of Early Greece, 1100–480 B.C.

centaur the Lefkandi terra-cotta was meant to be: Cheiron, the wise tutor of heroes (and the best bet—the centaur's right hand has six fingers, apparently a sign of wisdom in antiquity), or the malevolent Nessos or one of the wine-loving beasts of Mount Pholoe or one of the lustful creatures who spoiled the Lapith wedding reception [cf. 93 right]. Whoever it is, there is little doubt that the statuette refers beyond everyday life—the realm of the Protogeometric horse—to a world of pure imagination, to fantasy, possibly to heroic myth. The gash on the Lefkandi centaur's left knee suggests it has been in a fight. The craftsman who made it may not have had in mind a combat drawn specifically from epic poetry rather than a vernacular folktale about (for instance) Herakles, who will be the centaurs' most deadly foe in Archaic art and who, incidentally, once wounded the good Cheiron in the knee by mistake.[26] Poets, again, did not have a monopoly on legend. But even if it is not Cheiron (I think it is), and even if it does not allude to epic (who knows?), the Lefkandi centaur is just as promising as the earlier Attic Protogeometric horses. For it is not only the first masterpiece of early Greek sculpture, it is also the first indication that the Greeks, who always told heroic tales, would eventually become obsessed by the urge to illustrate them and superintend a revolutionary change in the meaning of images.

The Attic Protogeometric horse and the Lefkandi centaur thus promise a lot. But these are, as yet, only promises, and for the next two hundred years Greek art remains overwhelmingly abstract. In some ways it is hard to draw a clear line between Protogeometric and the succeeding Geometric style: a few major vase shapes and a few minor ornaments span the transition, a late Protogeometric tendency to bathe pots in rich, shiny black glaze persists, and the overriding concern of the Protogeometric painter—the analysis of shape through surface design—remains the same. It is the nature and principal tools of analysis that change, and they change abruptly. The concentric semicircle vanishes and the shoulder of the vase is, in the Early Geometric period (900–850), ignored. What counts now are the two major building blocks of the vase, the neck and the body, and their separate but equal contributions to the architecture of the vase are acknowledged by ornamental friezes or panels at their center [27]. Emphasis, then, has shifted significantly. Both Protogeometric and Geometric interpretations are based on the idea that the vase is the sum of its parts. But different parts are stressed, and the Geometric vase painter rejects the Protogeometric intima-

26. Apollodorus, *Library*, II.5.4. Cheiron, after he was wounded, wished to die, but could not do so until he dealt away his immortality. Since the Lefkandi statuette was a funeral offering (actually, its head and body were found in two separate graves), one wonders whether this centaur may not have been a symbol of immortality, or even of the welcoming of death. Cf. Fittschen, 104–11, who argued even before the discovery of the Lefkandi centaur that centaurs were originally spirits of death.

27. Early Geometric II amphora (Kerameikos 254), around 875–850. Photo courtesy of Deutsches Archäologisches Institut, Athens.

tion of volume through curving line. New motifs are in order, and the Geometric artist at once invents them: the battlement and, above all, the meander—"tectonic" motifs that are nothing but right angles, that simultaneously reflect the horizontal fields they occupy and the vertical construction of the vase, and that continuously turn back upon (and thus reassert) themselves.

Early Geometric ornament has nowhere to go but up and down, but it is almost infinitely expandable, and in the Middle Geometric period (850–760) it gradually and rigorously begins to spread. The shoulder is once again recognized as a third principal part of the vase, but its active contour is stabilized with large meanders, swastikas, or other rectilinear patterns. But the Geometric painter did not stop there. Although the largest and most elaborate patterns are always reserved for the middle of the neck, the shoulder, and the belly—the three centers of Geometric gravity, so to

speak—decorative panels and bands expand over so much of the surface that by the end of the Dark Age the vase seems tightly wrapped in an intricate abstract tapestry (and Geometric textiles would be an excellent place to look for the sources of painted ornament, had any survived).

Pictorial forms would simply have gotten in the way of this relentless expansion. They are not subject to the same control as the triangle, zigzag, or meander (at least not yet) and tectonic principles do not naturally encourage their insertion. For all that, the horse finds its way onto a few ninth-century (that is, Early and Middle Geometric I) vases, though it is just as rare as it was in the tenth century. And when it does appear, the continuous, curving lines of the boneless Protogeometric horse are immediately straightened out (the body is horizontal) and segmented (the legs acquire joints), as if in a concession to the angular Geometric motifs next to them [28]. In any case, the horse is virtually the only creature known on Attic painted pottery before 800, with one potent exception: woman.

Around 850 or 825, a tall, impressive krater (the kind of bowl used to mix wine and water at aristocratic feasts) was placed over the grave of an aristocrat in the Kerameikos. It was a status symbol, and what is left of it is densely covered with virtually the full range of Middle Geometric design [29]. Even the concentric circle is there, though unlike the Protogeometric version it is set in a box, it circumscribes a cross, and it is therefore given a horizontal and a vertical axis: it is converted into a tectonic motif. But the painter was moved to add something new, and he put it in an irregular

28. Drawing of a panel on the neck of an Early Geometric I amphora (Athens NM 18045), c. 900–875. From J. L. Benson, *Horse, Bird, and Man: The Origins of Greek Painting* (Amherst, Mass., 1970), pl. IX.1, by permission of University of Massachusetts Press.

29. Fragmentary Middle Geometric I krater (Kerameikos 1254), around 850–825. Photo courtesy of Deutsches Archäologisches Institut, Athens.

area where no regular Geometric ornament could neatly go. In the odd space below the handle, he drew a horse. But above the handle, in a corner just outside the borders of a bewildering abstract land, he drew the silhouette of a nude woman bending her arms over her head and tearing her hair in lamentation [30]. Formally the horse and the woman have nothing to do with each other: they are separated by the handle and they even face in opposite directions. The artist did not, then, draw a true composition or scene—there is no conception of an organized picture space—but two discrete (if not totally unrelated) symbols, one of rank or ritual, the other of grief. In any case, the mourner is the first human figure to appear on an Attic vase since the Bronze Age and the first on any mainland vase since the Lefkandi archers [23], about two centuries before.

We are surrounded by images. Children are encouraged to draw them almost as soon as they are able to hold a crayon. Pictures hang on our walls, museums are built to store and give public access to them, they

30. Drawing of figures on the krater shown in fig. 29. From J. L. Benson, *Horse, Bird, and Man: The Origins of Greek Painting* (Amherst, Mass., 1970), pl. XXXII.4, by permission of University of Massachusetts Press.

The Art and Culture of Early Greece, 1100–480 B.C.

illustrate our magazines and books, we go to cinemas to watch them move and talk, and electronic tubes bombard us with them in our living rooms. Nothing seems more natural or mundane than making or looking at pictures. So it may be difficult to imagine a time when that was not the case, or to comprehend the colossal effort it took to draw the first little Protogeometric horse, when image making was new in Athens, or the first Geometric human figure, when image making was almost new. One of the most important questions posed by Dark Age art is: How did these figures come to be drawn at all? Generations had gone by in Athens without them and the field belonged completely to the abstract. Why did they appear again? Two very different kinds of answer can be offered. One theory is that the artist who is ignorant of pictures can derive all the inspiration necessary from his own mental or visual experience. The other theory is that the pictorially ignorant artist requires the example and instruction of another work of pictorial art in order to make a new one. The first has been called the *tabula rasa* (clean slate) theory; the second might be called the "artistic precursor" theory.

There are actually several *tabula rasa* theories. Since it is hard to find many periods in human history or many cultures in which images play no part (some cultures prohibit them, but the repression of image making only confirms the strength of the impulse) and since the earliest representations of many different and distant cultures are similar in their "conceptual" conventions, it is often assumed that the pictorial impulse (and perhaps even the impulse to make images in a certain way) is simply inherent in human nature. The urge to make pictures is an instinct, and instinct is its own explanation. There is something to this idea; but although it might account for the first Attic horse or the first Attic human figure, it would mean that from about 1100 to about 950 Attic vase painters either lacked that basic human instinct or refused to give in to it, and that from 950 to 800 they did not give in to it very often.

Another *tabula rasa* theory holds that the first figures were pictorializations of abstract ornaments; that is, they were the result of projection, the psychological process that operates when we see faces in gnarled tree trunks or butterflies in inkblots or (like Shakespeare's Antony) dragons in the clouds.[27] In some traditional abstract motif, the projection theory states, the vase painter suddenly recognized the form of a horse or a woman and merely had to adjust the ornament and add a few lines to turn the pattern into a picture. Thus the Protogeometric horse [25] was projected onto the concentric semicircle (and its tail and back legs do seem concentric) and the torso of the Middle Geometric mourner [30] was suggested by the triangle. Projection seems a plausible explanation for a

27. See E. H. Gombrich, *Art and Illusion* (Princeton, 1969), 105–9, 182–91.

number of events in the history of art, such as some examples of Palaeolithic cave art or even some of the earliest paintings of figures in the Neolithic and Bronze Age Aegean. But it could be that the Dark Age Attic vase painter somehow decided on his own to draw a figure and, once he made up his mind, simply based his representation on one of the limited number of abstract patterns he had repeatedly drawn before, so that what appears to have been projection was quite a different process indeed. And in the case of the Middle Geometric I mourner, projection seems a particularly unlikely explanation. She is much less abstract, and far more curvaceous and naturalistically proportioned, than her descendants will be. Though the torso of the Geometric human figure is eventually reduced to an isosceles triangle [40], it did not start out that way, and the early Greek tendency to turn organic forms into pattern was at least as strong as its opposite.

There is, finally, the theory that the first Attic figures were inspired specifically by the funerary and memorial functions of the vases they were drawn upon, and that they were drawn from life. The vase painter suddenly desired to turn his observations of nature and ceremony (in which his vases played an important part) into solemn commemoration. The first figures are surely intended to exalt the dead and preserve ritual: the ennobling symbolism of the horse and the grief of the mourner are eternal. But that does not necessarily mean that the figures themselves were created impetuously, and almost miraculously, out of nothing, or that the vase painter's only models were real horses and real women.

The several *tabula rasa* theories, whatever their differences, share the premise that the first figures were the result of spontaneous generation, almost of revelation. The artistic precursor theory dispenses with that premise and substitutes another: confrontation with another pictorial tradition. That is, an image has its origins not in instinct, projection, or the observation of nature, but in another image. The creation of representational art is not random or accidental; it is inseparable from artistic influence. And, the theory goes, the necessary stimulus could have come from either the mighty Orient or Greece's own Bronze Age past, or possibly both.

Scholars who think that most of what is new and good in early Greek art must have been Oriental first can find comfort in the presence of a Phoenician goldsmith in mid-ninth-century Athens and in an imported Phoenician bronze bowl used to close the mouth of an Attic cremation amphora [31] in a grave beside (and contemporary with) the one marked by the monumental vase bearing the first mourner. The bowl is embossed with a circular parade of women who hold flowers and grab bulls, goats, and lions by the tail. Few Athenians could ever have seen (let alone created)

31. Phoenician bowl (detail) from Kerameikos grave 42, around 850. Photo courtesy of Deutsches Archäologisches Institut, Athens.

anything like the representation on that bowl before. The impact on the Athenian imagination of even one such figured import could therefore have been tremendous, and the idea of representing the human figure might have occurred to an Athenian craftsman (a vase painter, say, or an engraver of fibulae) only after a confrontation with such a marvelous work from the East.[28] Yet the transfer of ideas is hard to prove or trace, and the style and subject of the naked, tall Middle Geometric I mourner have nothing to do with the clothed, pudgy women on the Phoenician bowl. If Athenians got the idea of representation from Eastern imports, they at once developed their own style and iconography. Another possible source for the Attic mourner has been located in the art of New Kingdom Egypt, where similarly curvaceous (but once again draped) women strike similar poses. But Attica had not yet received its first Egyptian imports, and no Greek had to go to Egypt to see women pulling at their hair in ritualized (and therefore bearable) sorrow. And even if the instruction of Eastern or Egyptian models could account for the first Attic human figure, it cannot

28. It should be emphasized, however, that despite the large number of Near Eastern imports in Dark Age Lefkandi, Lefkandiot vase painters remained indifferent to representation (the hydria with archers is, again, an import). The instruction of Near Eastern art did not *inevitably* lead to Greek image making.

Origins and Promises

account for the first Protogeometric horse, which was drawn at a time when Athenian contacts outside Greece were all but nonexistent.[29]

If the art that prompted the first Attic representations was not foreign, it may have come from Attica's own soil: Dark Age discoveries of Bronze Age works of art could have provided the stimulus to draw pictures.[30] Chance finds of Mycenaean artifacts were unquestionably made all over early Greece, and the collapse of Bronze Age tombs would have revealed richly figured contents to awestruck Iron Age eyes. The farmer's plow could have churned up Mycenaean objects or the builder's spade hit upon Mycenaean remains, just as a blacksmith of Tegea, according to a tale in Herodotos (I.68), accidentally disturbed an ancient grave thought to have been Orestes'. As we shall see, Geometric (and later) pottery was deposited in or just outside Mycenaean tombs, and Mycenaean objects have been found in Dark Age (and later) contexts. A Late Protogeometric or Early Geometric Attic potter-painter made a miniature tripod cauldron in terra-cotta and decorated it with a triglyph frieze lifted directly from the Mycenaean ornamental repertoire.[31] Eighth-century potters made cups with high, flaring handles that are for all the world like Bronze Age kantharoi. A seventh-century Corinthian potter copied a kind of Mycenaean vase that had not been made for four hundred years, and seventh-century stonecutters on the island of Melos had Minoan seals in front of them as they carved their own. Nothing, then, precludes the possibility that tenth- or ninth-century Athenians similarly came upon Bronze Age artifacts—artifacts with pictures of horses [22] or perhaps even scenes of mourning. Such a confrontation may have jarred them into making images again (as well as strengthened Dark Age communion with a better, heroic age).[32] But although Geometric horses with their stiff joints and bent legs often look like Mycenaean horses [cf. 28 and 22], the Protogeometric horse [25] does not, as it should if it were copied from a newly found Mycenaean vase. And al-

29. If there was any place in the Greek world where image making survived in the Dark Age, it was Crete. But the remarkable Cretan series of representations (which includes scenes of hunting, "snake goddesses," sphinxes, lions catching a helpless man, and now a Subminoan or Protogeometric ibex painted on an amphora from Ayios Ioannis [AR, 1980–81, 42, fig. 81]) is at the moment enigmatic and chronologically imprecise. For that reason, it is best to express amazement at what ninth-century Cretan artists could do but to concentrate on Athens, where, after a true hiatus in image making, the implications of anthropocentric art were continuously pursued.

30. See J. L. Benson, Horse, Bird, and Man: The Origins of Greek Painting (Amherst, 1970). Benson also suggests the Egyptian parallel for the Middle Geometric I mourner (pp. 92–93).

31. Schweitzer, GGA, pl. 209.

32. A horse-taming scene on a possibly Attic Middle Geometric I/II fibula found at Lefkandi has, according to Coldstream, "no Mycenaean precedents" (GG, 64 and fig. 19b). But a krater fragment from twelfth-century Mycenae preserves a warrior holding the reins of a similarly stiff-jointed horse; see Vermeule-Karageorghis (n. 15), XI.7.

though very late Mycenaean and Geometric vase painters used a similar schema for the human being (frontal chest, profile legs), it is not clear that the similarity is the result of the direct influence of one tradition upon another, across an imageless gap, rather than of two independent solutions to the problem of representing three-dimensional figures on a two-dimensional surface, or of two independent evaluations of the most characteristic aspects of the human form. In any case, the artistic precursor theories make the Dark Age pictorial artist wholly dependent on what was imported from (or seen in) the East or what was found in the Greek ground: the first figures were not free inventions but almost clinical responses to stimuli.

In sum, the *tabula rasa* theories grant the Dark Age artist inventive powers he is usually denied (just as it is possible to see in the Dark Age bard not a mechanical transmitter of fully formed dactylic hexameter epic but its principal developer). If they are correct, Mycenaean and Dark Age pictorial art belong to two separate traditions. The artistic precursor theories, on the other hand, outline intelligible processes of artistic borrowing known to have operated later in Greece. The theory of Mycenaean influence is particularly attractive because of the association it establishes between Bronze Age and Dark Age art: if correct, it means that the recovery of Mycenaean artifacts not only gave pictorially ignorant artists the idea of representation but also provided them with a ready-made store of images. There was discontinuity in image making, but when image making resumed, it was, like epic itself, essentially formulaic. According to the Mycenaean precursor theory, Mycenaean and Dark Age pictorial art essentially belong to the same (interrupted) tradition.

Of the two kinds of theory, one of the precursor theories (Mycenaean or Near Eastern) stands the better chance of being right. But even those theories do not tell the whole story: they address the "how" of the issue but not the "why." The importation of Near Eastern objects or the rediscovery of Mycenaean ones may have been a precondition for the rebirth of representation, but neither was probably sufficient in itself to cause the rebirth. The rise of an aristocracy that was just beginning to be conscious of itself must be added to the mix. The first Dark Age images, after all, decorated the goods, urns, and grave markers of the upper class: the artists who made them may have been inspired by imports or antiquities, but they made them to serve the purposes of the aristocrats who paid them. These images were emblems meant to convey the self-importance of a class that was beginning to lead Greece out of a humble and relatively impoverished era. Horses and mourners were symbols of status meant to shore up the aristocracy and impress either the lesser members of the aristocratic household (*oikos*) or the aristocrats of rival *oikoi*. An enduring

pattern of using art had been established. In short, a tradition of image making now began because images had *meaning* again. They had acquired a social function: they served the aristocratic ideal.

At all events, the Dark Age set Greek art on an irreversible course, and in the human figure Greek art found its proper subject. Though she dangles, secluded, at the edge of a vast labyrinth, the Middle Geometric I mourner [29, 30] announces the start of a competition between the abstract and the representational that would last for the next century and more. The abstract had a lot on its side, but it was up against a force of incalculable power: the self-consciousness of human beings, the pleasure they derive from looking at images of themselves.

The potency of the human figure was, then, a Dark Age discovery, but its promise, like the other Dark Age promises of polis and epic, was not yet fulfilled. Abstract decoration had yet to give up its center and arrange itself around the human figure. The human figure had not yet taken formal dominion over art. And so, while the enduring basis of Greek attitudes toward form was laid as early as the Protogeometric period, Archaic art had not yet truly begun.

3

The Idea of Order, 760–700

Akhilleus' Shield

The fabulous shield Hephaistos makes in Book XVIII of the *Iliad* recapitulates some of what has already happened in the poem and prepares for some of what will happen. Early in the description, there is a scene of unresolved conflict. In the agora (assembly or assembly place) of a city at peace one man refuses to accept compensation from another for a murder. We think back upon Akhilleus' enormous inflexibility nine books earlier, when he rejects Agamemnon's bribe to return to battle, and Ajax, a simple hero frustrated by a complex one, rebukes him: it is normal practice, he says, for a man to accept payment even when a brother or son has been slain (IX.632–36). We also think ahead to Book XXII, when Akhilleus brutally refuses to bargain with Hektor, the slayer of Patroklos: the states of irresolution on the shield and at this point in the epic are comparable. On another part of the shield a city is besieged: old men and women sit on its walls just as cicada-like elders perched on the walls of Troy in Book III and as they perch again in Book XXII, when they look down upon Hektor's nightmarish flight from death. And outside the city at war a dead warrior is dragged by the feet through battle in grim rehearsal for Akhilleus' mutilation of Hektor's corpse. Much of the *Iliad* reverberates on the god's handiwork.

But there are critical differences between the images on Akhilleus' shield and the poem that describes it. With the exceptions of Athena, Ares, Strife, Uproar, and Death, the cities and figures Hephaistos makes have no names. Hephaistos' art deals not with the particular but with the timeless and universal (gods and personifications can turn up any time, anywhere). The shield, then, does not merely mimic the *Iliad:* it generalizes it. Else-

where harvesters scythe grain in the field of an anonymous rural lord (*basileus*), and two lions tear a bull to shreds, and we have the feeling we have read (or in our mind's ear heard) such things before: Trojans and Akhaians have mowed each other down like reapers (XI.67–71) and heroes are always being compared to lions. But the primary reality of Hephaistos' metal painting is a pastoral reality to which the rest of the epic can only allude in similes—a parallel reality "outside" the *Iliad* that is brought in only for the sake of comparison. On one level, the shield of Akhilleus inverts Akhilleus' epic. On another, the world of the shield is larger than the world of the *Iliad*: it contains wrath, war, and death like the epic, but also civil arbitration (which is the way to settle disputes in a polis), peace, and everyday life. As we peek over his shoulder, Hephaistos makes a world not of heroes but of archetypes.

Circles (lines that have no beginning and no end) and oppositions dominate the structure of the shield. At its center are earth, heaven, and sea. Constellations wreathe the heavens, and one of them, Arktos (the Bear), revolves constantly in the same place in the sky, never sinking into the sea, never breaking the circle. Around the rim is Ocean, a circular frame. And between these cosmic boundaries of center and circumference lies human society, with its polarities and antitheses. The city at war is there because the city at peace is there, as if neither could be properly defined or fully understood without its opposite, and even within the city at peace there is the social contrast of blood feud and wedding ceremony. Antithesis is basic to the structure of the shield and to Archaic thought in general, from Homer to Pindar.[1] Next there is plowing and reaping, a grape harvest and singing, herding and the assault of lions. Finally there are youths and maidens dancing, first in circles, then in straight lines—a choreography of opposites—and as they move the only simile in the description of the shield returns us to the world of craft: the skilled and easy circling of the dancers is compared with a potter who bends over his wheel and spins it between his hands. The charmed dance made by the divine artificer is compared with the action of a mortal craftsman, and the image is of total control over incessant motion. The dancers and the potter's wheel, like the constellation Arktos at the shield's center, spin round and round yet are fixed in place. Their movement is confined and perfect. Their limits are precise. There is closure.

In addition to being a clue to the nature of Homer's own oral poetic traditional performance, the shield of Akhilleus is Homer's ideal work of art. It is an artifact of universals, opposites, constants (what is more regular than the rhythm of spring plowing and summer harvest?), and boundaries. Its figures perform almost magically in a world that coheres. It is the

1. See Fränkel, *EGPP*, 54, 525–27.

cosmos according to Homer but it is also a poetic affirmation of *kosmos*—a word that would in time mean "world" only because it meant "order" first. The poet (or poetic tradition) who through Hephaistos created the shield committed himself (or itself) to *kosmos*. And this idea of order was the great and pervasive idea of the first real phase of Archaic civilization: the Late Geometric period (760–700). Order—the disruption of it in the *Iliad*, the restoration of it in the *Odyssey*—is perhaps the weightiest of Homeric concerns, and it is order that Homer's very language of formulae insists upon. The demand for order is no less resolutely expressed in the structures of Geometric art—a rich but rigid world of visual formulae—in the middle of the eighth century. And whatever its precise origins, the polis was both the social expression of this "ordered temperament"[2] and its reinforcement, its support, its anchor.

The Polis Detected

Greek poets and historians were fond of saying that the polis consisted not of houses, stone walls, timber, roads, and dockyards, but of men.[3] The city-state, in other words, was an idea, the equivalent of a particularly intense communal or corporate spirit. Archaeologists can dig up houses and walls but they cannot excavate ideas, and none of the handful of eighth-century towns whose plans we have was beyond all doubt the urban center of a city-state in its strict, "classical" sense. Nor can we point to a specific spot on a map and say that this is where Greeks first became political animals—creatures of a polis. But we can wave broadly at Ionia and Euboia (and perhaps Corinth), for the polis probably appeared there before it appeared elsewhere. And we can be reasonably confident that, despite signs of urbanization in the Dark Age, the institution fully emerged only toward the middle of the eighth century—the Dark Age was not really over until it did.[4]

The formulation of the polis in the hearts and minds of Late Geometric Greeks—or some Late Geometric Greeks, since not all did live in poleis—cannot be precisely documented, but a few passages in Homer seem to divulge its existence. At the beginning of Book VI of the *Odyssey*, for instance, Odysseus, cast by wind and wave upon the shore of the island of the Phaiakians, awakens to the shrieks of girls playing ball. Standing be-

2. The phrase is Norman Austin's; see *Archery*, 130–71, for perceptive comments on order in Homer.

3. For instance, Alkaios, Z 103 (Lobel and Page); Aeschylus, *Persians*, ll. 348–49; Thucydides, VII.77.7.

4. This does not mean that the polis was the only kind of state Archaic Greece ever knew: another was the *ethnos*. See Snodgrass, *AG*, 42–44.

fore the princess Nausikaa with nothing but a leafy branch to cover him, he flatters her. He then gets to the point: he tells her she is the only person he knows in "this polis and land" (l. 177) and asks for directions to the *asty* (l. 178). Most of the time *polis* and *asty* mean the same thing in Homer: town or city. Here, separated by only three words in the Greek, they do not. The *asty* is out of sight: it is, Odysseus rightly assumes, where the Phaiakians live. It *is* a spot on the map, and eventually we learn what it looks like: it is surrounded by a towered wall, it is flanked by harbors, it is reached by a narrow causeway lined with ships, it has a stone-built agora and a fine precinct (or shrine or temple) of Poseidon (ll. 262–67). But for Odysseus the Phaiakian polis is more than that. He knows he is in it though he is far from the town. It encompasses the *asty* and also the countryside and the coast. The connotations of the word are less topographical than political. *Polis* here implies the existence of a social structure combining an urban center with rural lands, and the use of the word acknowledges the growth of an institution no Bronze Age hero could have known. Still, Homer was no political scientist, and most of his other uses of the word are at least ambiguous. The emergence of the polis is better detected in two of its physical symptoms: the monumental temple and the colony.

There were social organizations of some sort before there were poleis (they were above all organized around the households, or *oikoi*, of aristocrats and *basileis*), and there were altars and sacred buildings before there were poleis, too. But the first temples did not look appreciably different from normal dwellings: the horse-shaped Building H at Eretria [20] was significant for its presumed allusion to the legendary temple of Apollo at Delphi and for its function within the new Eretrian community, but it was, in the end, just a hut. Around the same time it was built, a twenty-five-foot-long apsidal temple dedicated to Hera of the Heights was built beside the tiny harbor at Perachora, across the gulf from the several villages that then were Corinth. A terra-cotta model [32] found in a nearby votive deposit may be a replica of Hera's temple, or it may reproduce the home of the supplicant who sought the goddess's protection by offering it; we simply cannot tell. Small, one-room temples like those at Eretria and Perachora took planning and financing, but they did not take much. They may have been built as a matter of public policy, but they were hardly more than cottages set apart—the products of a humble, perishable "folk architecture" in which the houses of gods were practically indistinguishable from the houses of the folk who honored them.

The distinction came to be important, and it was first made in a sanctuary on the Ionian island of Samos. Hera was the patron deity of the place, and she had had an open-air altar there as early as the tenth century. The archaeological evidence (and thus the chronology) is questionable, but most scholars believe that Hera acquired her first house sometime in the

32. Reconstruction of a terra-cotta model of a temple or house from Perachora, around 750–725. From H. Payne, *Perachora* (Oxford, 1940), vol. 1, pl. 9b, by permission of Oxford University Press.

first half of the eighth century. Certainly it was like no other house in Greece [33]. It was purely rectangular—the curving wall would in time be banished from early Greek sacred architecture—and it was by contemporary standards tremendous: 100 feet (32.86 m) long.[5] This hundred-footer, or *hekatompedon*, was, however, only 20 feet (6.5 m) wide. The temple was a closed tunnel, a narrow shed with a row of posts down the middle and a stone base for the wooden cult statue set slightly off center at the back. The building was straight and unadorned, and its starkness did not, in the end, satisfy. Sometime in the second half of the century (and possibly at its very end) the builders of Samos offered relief: they placed about forty wooden columns on stone bases in a rectangle around the long room, and with that it ceased to be a plain shell. This portico or peristyle was a tentative affair (possibly it was added during an overhaul of the roof). It was an architectural afterthought, but that fact itself is a clue to its meaning. The portico was not structurally necessary or functionally significant.[6] It could not have afforded either pilgrims or the partly stone, mostly mud-brick walls of the building much more protection from the elements than overhanging eaves, and the space between it and the walls was too shallow to form a

5. Another hundred-footer was built later in the eighth century alongside Building H at Eretria. In plan the shape of a gigantic bobby pin, this temple—Building L—was the last important statement of early curvilinear architecture.

6. Coulton, 31. For a differing view, see Dinsmoor, 47; cf. H. Walter, *Das Heraion von Samos* (Munich, 1976), 48.

33. Plans of the two phases of the first temple of Hera (Hekatompedon I) on Samos, eighth century. From H. Walter, *Das Heraion von Samos* (Munich, 1976), figs. 32 and 39, by kind permission of Dr. Walter.

processional way or useful sacred zone. Architectural utility does not completely explain this peristyle. We are left with aesthetics—and a will to define. Like the unprecedented size of the temple itself, the colonnade was meant above all to impress. It elaborated, dignified, and identified the goddess's house, and from now on the peristyle would clearly and immediately distinguish divine architecture from human (although not all Greek temples would be peripteral, virtually all peripteral buildings were temples). Any peristyle—even a primitive wooden one like the Samian Hekatompedon's—also mediates between the open space of the surrounding sanctuary and the closed space of the box it in turn surrounds. Half air and half solid, the colonnade is an expansion of the hall (or cella) and a transition to it, a permeable boundary that defines but does not seal off, that lets

light pass and casts shadows on blank walls, and that by distributing identical forms all around the building tends to equalize its four sides. Finally, the peristyle establishes a pattern of shaft and gap and its rhythm exerts control over the sanctuary and its landscape. The pilgrim is compelled to take the measure of the place through the more or less regular repetition of manmade posts. In this light, the invention of the peristyle was an architectural expression of the Geometric idea of order and of the broader Archaic insistence on pattern in all things.[7]

The temple builders of Samos may have been only half aware of the aesthetic implications of the peristyle, but their simple wooden portico nonetheless established some of the fundamental propositions of the Archaic temple. It was at Samos that temple architecture formally became an architecture of the exterior, an architecture of solids, of planes and mass. And it was at Samos that the temple first became monumental. Though it had some stone in its walls, the Hekatompedon was not particularly durable, and it is possible to argue that truly monumental architecture required much less wood, mud brick, and thatch and much more immutable stone (and roof tiles to boot). But durability is only one measure of monumentality. Some of the greatest Geometric monuments are, after all, brittle pots [37, 49]: they are monumental because they are huge. A limitation in materials did not limit the Samian builder's sense of scale, thwart his will to impress, or weaken his desire to break fundamentally with the cottage architecture of the past. The Hekatompedon was simply much more of a house than any cult statue needed. The reason must be that it was built not merely to shelter a statue or even to glorify Hera, but to impress upon the Samians their own unity, to give physical expression and focus to belief, purpose, and community. It is hard not to see in the construction of this first great Greek temple the public policy and pride of a Late Geometric polis fully formed.

One of the strongest antitheses in the *Odyssey* is between the Phaiakians, masters of good living and hospitality, and the race of Kyklopes, whose most notorious member, Polyphemos, is an antisocial brute who dines on six of Odysseus' men. The contrast pits a sophisticated, almost effete people blessed by nature (cf. VII.113–32) and by the advantages of civilization (epic poetry, to name one) against primitive one-eyed beings who have no laws, no knowledge of agriculture, and no agora in which to meet and talk,

7. Contra, Walter (n. 6), 49. A. Mallwitz has recently concluded that the peristyle of the first Hekatompedon on Samos cannot be certainly dated to the eighth century and that the first clearly datable peristyles belonged to early-seventh-century temples at Isthmia and Argos. In his view, the Samian peristyle was an imitation of a northeast Peloponnesian—and post-Geometric—invention. See "Kritisches zur Architektur Griechenlands im 8. und 7. Jahrhundert," *AA*, 1981, 599–642. The whole problem of the peristyle's origins is now complicated by the discovery of the very early (tenth-century), surprisingly large, and peripteral *heroon* at Lefkandi.

who live off their flocks, wild grains, and grapes, and who dwell by them-
selves in caves (IX.106–15). By contemptuously listing their deficiencies,
Odysseus essentially defines what barbarity is—and, implicitly, what a
polis is not. But perhaps the most damning thing of all—the thing that
"much-wandering Odysseus" can barely comprehend—is that the Ky-
klopes do not know how to build or sail ships, and so have failed to settle a
splendid island lying not far off their coast. Men used to crossing the seas,
he says, would have built upon that island,

> For it was not a bad place, and could bear fruits of all season.
> There were meadows by the edge of the grey sea,
> watered and soft. The vines were thick and hearty,
> the plowland smooth; abundant crops could ever
> have been reaped in season, since the earth beneath was rich.
> There was a harbor so fine there was no need for
> ropes, or anchors, or moorings,
> and those ashore could wait until the sailors'
> heart urged them on and fair winds blew.
> And at the head of the bay bright water flowed,
> a spring below a cave, and poplars grew all around.
>
> [*Odyssey*, IX.131–41]

Odysseus has just surveyed the primitive Kyklopean way of life from the
perspective of a man who knows the virtues and bonds of the polis, and he
now describes a deserted island from the perspective of a potential, even
eager colonist. These perspectives are related: the consolidation of the city-
state and the rise of the Greek colonial movement were virtually simul-
taneous, and each phenomenon may to some degree have spurred the
other.[8]

The principal direction of eighth-century colonization was westward, to
South Italy and Sicily. Greeks had been there before, in the Mycenaean
Age. But the Dark Age severed contacts with the west (which is not to say
that it obliterated memory of them) and they were not renewed until the
opening decades of the eighth century (800–770), when some telltale Geo-
metric pots made their way to Etruria and Campania (the region around
the Bay of Naples). They were left behind by intrepid Greek seamen who
had only recently learned to negotiate the formidable Straits of Messina,
which must have seemed like the *Odyssey's* Skylla and Kharybdis to them
(as late as the nineteenth century whirlpools in the straits turned British

8. There may be another hint of this relationship in the *Odyssey*, for the Phaiakians found-
ed their wonderland-polis after being chased out of their original homes by the Kyklopes; see
VI.4–10. That is, they were colonists themselves, and in settling their island they acted much
the way Late Geometric Greek colonists must have acted: they built walls, homes, and
temples, and distributed arable land outside the town.

men-of-war completely around). These Greeks—adventurers and small businessmen at once—were Euboians, the same pioneers who had begun to sail off in significant numbers to the east only a little while before. The Greek world was rapidly expanding, and Euboia, with its principal cities of Chalkis and newly founded Eretria, was at its center.[9]

The Euboians must have been encouraged by their preliminary contacts in the west, for around 770 they planted a permanent settlement on the island of Ischia (Pithekoussai), off the Bay of Naples (as it happens, Ischia was one of those places visited by Mycenaeans many centuries before, and it is not impossible that the Euboians were aware that they were retracing Bronze Age steps, mimicking the heroic folk of their legends and poetry). Ischia is a rugged place, pushed up from beneath the sea by eons of volcanic action. The promontory that the Chalkidians and Eretrians chose to settle was flanked on one side by a small harbor and on the other by a broad beach. Eighth-century ships and seamen would have fared well there. But there was little good land to plow, and all in all Ischia was not much like the kind of island Odysseus, in his colonial mood, would have liked. What it had in its favor was its location: Ischia lay near the iron ores of central Italy. Crucibles, bellows, iron slag, and unprocessed ore found on the slopes of the acropolis and lead, bronze, and iron debris discovered in a metalworking quarter on a nearby ridge confirm why the Euboians came: to trade and manufacture. Other finds suggest the identity of visitors (or at least of peoples with whom the Euboians had dealings elsewhere): vases from Italy, Corinth, Argos, Crete, Athens, Rhodes, and the Levant (as well as from Euboia); scores of seals brought from northern Syria or Cilicia; scarabs from Egypt; and a fragment of a vase that was made on Ischia but that was inscribed by a visiting Phoenician.[10] Ischia, the first and at the same time most distant of eighth-century Greek settlements abroad, was an industrial town at the western edge of a vast international commercial network.

The Euboians first sailed west to trade, not to settle, then settled in order to trade more efficiently. Because of its heavy mercantile and industrial flavor, Ischia may not even count as a true colony: it ranks somewhere between the typically agrarian *apoikia* (home away from home, colony) and the purely commercial *emporion* (a place for exchange). The same can be said of Kyme, founded by Chalkidians on the mainland opposite Ischia

9. A poetic inversion of reality may account for the curious reference to Euboia in the *Odyssey* (VII.321–23): Euboia is the most distant place Phaiakian seamen have visited. The poet has put the island that was at the center of the eighth-century world at the extremity of his epic world.

10. Another vase from Ischia bears both Greek and Aramaic letters. See P. Kyle McCarter, "A Phoenician Graffito from Pithekoussai," *AJA*, 79 (1975), 140–41; S. Segert, "Vowel Letters in Early Aramaic," *Journal of Near Eastern Studies*, 37 (1978), 111–14.

around 750. But on their way to and from these distant settlements, Greek seamen learned something of the lands they sailed by. They apparently did not think much of the South Italian and Sicilian natives: when Sikels appear in Homer, for instance, they are slaves and servants. But the Greeks thought a good deal of the fertile valleys and plains the Sikels inhabited, and what they learned literally in passing soon served them well. In a sense, the settling of Ischia and Kyme offered a model for the far greater colonial movement that began in the last third of the eighth century.[11] This time Greeks went west not for ore but for land.

It is almost but not quite enough to say that the colonization of South Italy and Sicily—Magna Graecia, Great Greece—was the result of too many Greeks and too little Greece at home. Land hunger was surely the major cause of the movement that started in 734, when a certain Thoukles led a band of Chalkidians—once again, Chalkidians—to the east coast of Sicily, founded Naxos, and set up an altar to Apollo the Guide, and in 733, when Archias led some Corinthians to the island, drove away the Sikels, and founded Syracuse.[12] Stories suggest that certain Greek cities simply had too many mouths to feed.[13] Colonization was the best (that is to say, most orderly) means of easing an agrarian crisis that occurred remarkably soon after the polis itself came into being—or while some poleis were still coming into being. All the same, this colonial movement was not monolithic or even panhellenic. Athens, the place that has yielded the best evidence of a population boom in the eighth century,[14] did not yet have to rid itself of Athenians: there was still room enough for all in Attica. Similarly, Argives, Boiotians, and Thessalians, inhabitants of large and fertile plains, do not figure in this colonial movement. Even colonies traditionally founded for agrarian reasons could serve other functions as well. Rhegion, settled largely by Chalkidians in flight from famine back home, was a strategic place: together with Zankle, another Chalkidian colony across the Straits of Messina, it controlled the trade routes to central Italy. At least one colony—the last Geometric colony in the west—was founded out of political expediency. Sparta, which had (or had conquered) plenty of land, established Taras around 706 to eliminate an embarrassing and politically dangerous element in its population: the illegitimate sons of wives left

11. See Snodgrass, *AG*, 41.

12. Thucydides, VI.3.

13. Eretria may have been one such city; see Plutarch, *Quaest. Gr.*, 11. For some cautionary remarks about overpopulation as a colonial stimulus, see C. Starr, *Economic and Social Growth of Early Greece, 800–500* (New York, 1977), 43–45.

14. The "best evidence" is not indisputable evidence: see J. McK. Camp, "A Drought in the Late Eighth Century B.C.," *Hesperia* 48 (1979), 397–411, who argues that Athens suffered from drought and famine in the late eighth century, and A. Snodgrass, who reiterates (most recently) in *Greek Renaissance*, 169–71, his theory of a population boom. Are the two positions really mutually exclusive?

alone too long by their warrior husbands. Taras, Rhegion, and Syracuse were settled for various reasons. The Late Geometric colonial enterprise was not a simple thing.

A Greek colony was completely autonomous. Economic and religious ties with the mother city (*metropolis*) were often strong but bonds of citizenship between colonist and homeland were severed once the colony was established, and the colony need not even have been a political replica of its founding state (or states, since the populations of many colonies were drawn from several sources). Still, the act of colonization was in some sense an act of reproduction. The choice of an appropriate site and of an *oikistes* ("one who sets up home abroad") such as Thoukles or Archias, the selection or conscription of a suitable number of colonists, and the fitting of ships to carry and supply them required planning and authority on a scale that only a cohesive, mature polity could ensure. Certainly the *need* to send forth colonies could have stimulated a few communities to forge a stronger corporate sense than they had had before, and the very process of organizing the colony could have suggested new political patterns or reinforced developing ones at home.[15] But colonization essentially presumes a high concentration of will, effort, and resources. Like the rise of monumental temple architecture, it implies the existence of the polis.

Another kind of corporate effort testifies to the maturation of the city-state in the Late Geometric period: warfare. Human nature being what it is, there were conflicts in Greece before the middle of the eighth century [34]. But it was only in the century's second half that wars became organized, important, and perhaps destructive enough to enter historical memory. Around 730, for instance, Sparta began its long assault of Messenia: the war lasted twenty years, Sparta won, and defeated Messenians joined famished Chalkidians in the colonization of Rhegion. Sometime after 720 Megara fought Corinth, won its independence, and established its boundaries. And before the end of the century (the precise date is uncertain), Eretria and Chalkis, once partners in the settling of Ischia, came to blows over the small but rich Lelantine plain between them. We do not know which polis won the war (Chalkis is the better guess). We think that Lefkandi, located uncomfortably between the two contestants, was destroyed in its course. But we are told that the war tore Greece in two. "On this occasion," wrote Thucydides three centuries after the fact, "the rest of the Greek world joined one side or the other."[16] The great maritime states of Euboia enlisted their trading partners as allies—Samos and Corinth, for instance, aided Chalkis, Miletos and possibly Athens aided Eretria. The history of this war and this period is largely inference, but it appears that

15. Cf. Snodgrass, *AG*, 41–42.
16. I.15. See now, however, S. D. Lambert, "A Thucydidean Scholium on the 'Lelantine War,'" *JHS*, 102 (1982), 216–20.

34. Middle Geometric II skyphos (Eleusis 741), 800–760. Photo courtesy of Deutsches Archäologisches Institut, Athens.

the political landscape of Greece (and some enduring alliances between poleis) had taken shape.

The landscape, however, was fragmented. By the end of the Geometric period Greece was divided into scores of discrete parts that acted in unison only rarely, and never for very long. But running against or alongside this sharp, polis-based localism was a strong current of panhellenism—the sense that a Greek was a Greek, that all Greeks shared a common heritage,

culture, and language that distinguished them from the Sikels, Phoenicians, and other *barbaroi* (those who spoke *bar-bar*, or nonsense sounds) with whom they were increasingly coming into contact. Their eighth-century confrontation with both the sophisticated East and the western "frontier" made them more aware of their own difference and gave shape to their Greekness. And it was the late eighth century that saw the rise of two sanctuaries that essentially became monuments to panhellenism: Delphi and Olympia.[17] Delphi and its oracle of Apollo began their history as purely local attractions, but Eretria at the beginning of the century and a few of the western colonies (Naxos, for instance) may have been founded on Apollo's advice. His advice was good, and by century's end his shrine drew pilgrims and offerings from all over the Greek world and beyond.[18] Olympia, too, originally attracted visitors only from its own vicinity, but in the course of the eighth century Argives, Corinthians, Athenians, and others began to dedicate costly objects to Zeus and Hera, the deities of the place. The most magnificant of these offerings were monumental bronze tripod cauldrons [35] typically set up by aristocrats who had won events in the Olympic Games (founded, according to one ancient calculation, in 776). Each aristocrat competed for himself, not for his polis. It is still worth noting that even the panhellenic ideal was agonistic: the Greeks expressed their unity every four years by competing with one another.

The unity of the Greeks was expressed in the Late Geometric period in one more—and incalculably forceful—way: in Homer's heroic songs. There was no such thing as a Greek nation-state, but Homer was nonetheless the Greek national poet. Despite its predominantly Ionian character, the artificial language of the *Iliad* and *Odyssey* transcended the diversity of local dialects and so could be heard, as a Homeric imitator puts it, "throughout the well-inhabited poleis of men" (*Hymn to Apollo*, 175). The content of the poems was, moreover, apparently the least localized—thus most panhellenic—of the various traditional sagas that must then have been current.[19] The sheer size and success of the *Iliad* and *Odyssey* helped to define the Greek cultural self-consciousness—or perhaps they were successful precisely because they defined that self-consciousness and did so on a monumental scale. The songs of Homer are for us, first and foremost, traditional heroic tales that are also artistic masterpieces. For Late Geometric Greeks they were that, too, but they were also storehouses of values and ethics and textbooks of conduct (at sacrifices and in athletic contests, for instance). They are full of information detailing what it was to be

17. For the rise of panhellenic sanctuaries, see C. Rolley, "Les Grands Sanctuaires panhelléniques," in *Greek Renaissance*, 109–14.

18. Cf. Herodotus, I.14. For the dubious nature of most colonization oracles, see J. Fontenrose, *The Delphic Oracle* (Berkeley, 1978), 137–44.

19. See Nagy, *Best*, 7–8 (§14n4).

35. Reconstruction of monumental bronze tripod cauldron (1.55 m. high) from Olympia, late eighth century Photo courtesy of Deutsch Archäologisches Institut Athens.

Greek.[20] Perhaps more than anything else, the *Iliad* and *Odyssey* definitively told the early Greeks who they were.

Homeric Questions

In the thirteenth book of the *Iliad* (l. 658) a minor Trojan ally named Pylaimenes mourns the death of his son—a trifling event were it not for the fact that eight books earlier (V.576–79) Pylaimenes had been quite thoroughly slain himself. Pylaimenes' notorious resurrection can be explained in one of two ways: either Homer simply forgot whom he had killed off five thousand lines earlier, or the poet of Book XIII was not the poet of Book V. To admit that Homer nodded in the later book but to claim that his listening audience would not have noticed anyway (especially since they could not flip back through the pages of a written text to check up on him) was once the choice of a school of scholars known as the unitarians. To be a unitarian was to believe in the fundamental unity and integrity of the Homeric epics. It was to believe that each poem (or both of them) was the product of a single controlling intellect. To maintain, on the other hand, that the *Iliad* and *Odyssey* were the creations of many minds, and therefore to doubt even the reality of a poet called Homer, was the choice of a rival school of scholars known as the analysts. To be an analyst was to devote one's philological energies and skills to the tidy dissection of each epic. It was to search the poems for contradictions, inconsistencies, and interpolations that, taken together, "prove" that the *Iliad* and *Odyssey* were really patchwork poems, stitched together from shorter lays. The epics were botched concatenations produced by editorial committees, or they were accretions produced by many Homers, who added episode after episode to some original core. They were anything but inherently unified works of art.

The question of unity—the Homeric question par excellence—is not asked so much anymore, at least not in the same way. The debate between unitarians and analysts lost its edge because of Milman Parry's argument that, while the Homeric epics and their language cannot be divorced from a lengthy oral tradition shaped by many voices before Homer's, one gifted singer, equipped with a prodigious store of formulae, could have given the poems the forms in which we have them, more or less. The "more or less" is itself an important issue. But today the Homeric question has generally yielded to the Parry question, which is a question not of artistic unity but of genius and originality. What can those words mean in the context of an oral formulaic tradition? Is it possible to detect a personal design in the

20. See Eric A. Havelock, *The Greek Concept of Justice* (Cambridge, Mass., 1978), 106–14.

poems? Who or what should get the credit for the masterpieces known as the *Iliad* and *Odyssey*? Was Homer the genius? Or was his tradition?[21]

These are not the only questions Homeric scholars have to ask themselves. When, for instance, were the *Iliad* and *Odyssey* composed? Majority opinion: in the second half of the eighth century. Which epic came first? Since antiquity the almost universal response has been the *Iliad*: one ancient critic even supposed that the *Iliad*, full of energy and action, was the work of Homer's vigorous early years, while the *Odyssey*, less intense and "mostly narrative," was the work of Homer's more leisurely and contemplative old age. But did, in fact, one poet compose both poems? The most likely answer, in my view, is no. It is not just that similes are used less often in the *Odyssey* than in the *Iliad*, or that the structures of the poems differ so much (the plot of the *Odyssey*, which weaves together the story of Telemachos, Odysseus' own recollection of his fabulous adventures, and his triumphant return, is more complex than the linear design of the *Iliad*, yet it lacks the *Iliad's* satisfying sense of an ending). It is not just that their landscapes are (necessarily) so different, or that the *Odyssey* seems to reflect genuine late-eighth-century experience (colonization, the rise of the polis, the growth of a Greek sense of identity in the face of *barbaroi*) in a way the *Iliad* does not. And it is not just that the heroes are so different (within the *Iliad* itself Akhilleus and Odysseus hardly see eye to eye) or that the moods of the epics differ (the *Iliad*, pervaded by absolutes and harsh truths, is a highly concentrated poem about fate, choice, and the fame that is the hero's only compensation for death, while the *Odyssey* is more expansive in its outlook and is concerned primarily with identity, survival, restoration, and justice). It is rather that the *Odyssey* seems to be a response to the *Iliad*, even a critique of it. Certainly, it is also an elegy for the heroic world the *Iliad* describes: in Book XI of the *Odyssey*, the great heroes of the *Iliad*—Akhilleus, Agamemnon, Ajax—appear again, but as shades in the underworld, and in Book XXIV the poet gives details of Akhilleus' funeral, a kind of last farewell. But at times the *Odyssey* appears to question the very premises of the *Iliad*. The eerie song the Sirens sing (XII.184–91) is nothing but the song of Troy (an *Iliad?*) and it kills those who hear and are not restrained. In the realm of the dead, Akhilleus repudiates the decision that Patroklos' death forced upon him in the *Iliad*:

> Do not speak sweetly of my death, shining Odysseus.
> I would rather be bound to work the land
> of some impoverished man, whose livelihood is scant,
> than to rule over all the descended dead.
>
> [XI.488–91]

21. See, for instance, Nagy, *Best*, 5, 78–79.

Now even in the *Iliad* Akhilleus says he values life over fame (IX.401–9), but spoken in Hades to the living Odysseus these words refute the principal motive for heroic action: immortal glory (*kleos*) is not adequate recompense for death after all.

But perhaps the crucial difference between the two poems is the *Odyssey's* self-reflexiveness, its own concern with the poetic task. Though in the *Iliad* artistic activity is a guise or metaphor for poetic activity (Hephaistos is a performing artist when he makes the Shield; Helen, at III.125–28, weaves the saga of Troy into cloth), epic performance is specifically referred to only once, when Akhilleus himself, detached from the society of heroes, sings the fame of men (IX.189). In contrast, poets and poetry form a major theme of the *Odyssey:* in a sense, the *Odyssey* is *about* poetry. There are the bards Phemios and Demodokos and their songs, of course. There is Telemachos' sharp defense of poetry, the first in Western literature (I.345–52). There is Odysseus himself, who not long after praising all bards (VIII.479–81) proceeds to tell one-sixth of his own epic (Books IX–XII). Odysseus is often compared to a poet, but nowhere with greater self-conscious force than at the climactic moment of the *Odyssey*, when the hero strings his bow and a simile fuses the identities of hero and bard:

> As a man skilled in the lyre and song
> stretches a new string easily upon a peg,
> holding the twisted gut at both ends,
> so then Odysseus strung his great bow without trouble,
> and with his right hand tried the cord:
> it sang sweetly, like a swallow's song.
> Sickening anguish gripped the suitors then,
> and the skin of all turned pale. . . .
>
> [XXI.406–13]

As he performed those lines the Homer of the *Odyssey* momentarily became Odysseus, his lyre became the hero's weapon, and the notes he plucked sang out the suitors' death. This intrusion of poet and poetry into the *Odyssey* is completely foreign to the tone of the *Iliad*, where the poet is invisible or else humble (cf. II.488–93) and where the value and effects of poetry are practically ignored. The contrast may well be explained by the simple fact that the composer of the *Odyssey* operated in a poetic milieu far different from that of the composer of the *Iliad* (assuming the *Iliad* did come first): he worked in a world that for the first time contained a poetic masterpiece, and he had to match it.[22] The mere existence of the *Iliad* altered the

22. See J. Redfield, "The Making of the *Odyssey*," in *Parnassus Revisited*, ed. Anthony Yu (Chicago, 1973), 141–54, and *Nature and Culture in the Iliad* (Chicago, 1975), 35–41, and now W. G. Thalmann, *Conventions of Form and Thought in Early Greek Epic Poetry* (Baltimore, 1984), 157–84.

literary environment and challenged succeeding poets to rethink their art and subject. It was anxiety that forced the poet of the *Odyssey* to eulogize and respond to the *Iliad* and make his own labor a theme.

The list of Homeric questions goes on. How many lines could Homer (let us continue to use the same name for both poets) recite or compose at one sitting? On what sort of occasions did he perform?[23] Was Homer blind? Thucydides, who was not gullible, thought he was, believing that the author of the seventh-century *Hymn to Apollo*[24] was Homer himself:

> Now may Apollo and Artemis be gracious,
> and farewell, all you maidens. But remember me
> hereafter, whenever any man upon the earth,
> some much-suffering stranger, comes here and asks:
> "Maidens, which singer who frequents this place
> is sweetest and in whom do you most delight?"
> Then answer all in one:
> "A blind man. He lives in rugged Chios
> and his songs will be best hereafter."
>
> [Ll. 165–73]

Demodokos, the Phaiakian bard, was blind, too, and that circumstance has tempted some scholars to recognize in him a Homeric self-portrait. But blindness is conventionally associated with wisdom and insight in ancient (as in later) literature—it is almost a prerequisite for insight—and the tradition of a sightless Homer is really without foundation. Besides, the poets of the *Iliad* and the *Odyssey* were simply too fond of things that shine.

If Homer could see, could he read and write? This is the last great Homeric question, and it needs to be asked because it was toward the middle of the eighth century that the Greeks, who had been illiterate for about four hundred years, created their alphabet. What they did was to appropriate twenty-two letters of the Phoenician (northern Semitic) script, change the values of some to vowels (the Phoenicians had only consonants), and invent a handful of letters of their own.[25] The Greek debt to

23. See G. S. Kirk, *Songs of Homer* (Cambridge, 1962), 274–81, and Thalmann (n. 22), 118–19.

24. The *Hymn to Apollo* is perhaps the earliest of the thirty-three so-called Homeric hymns, which may have been sung as prefaces to epic recitations.

25. As Kevin Robb has written, "the Phoenician sign stood for a consonant *plus any vowel,* the vowel being supplied from context by a reader. The Greek sign, and this for the first time in the history of writing, stands for an abstraction, the isolated consonant" ("Poetic Sources of the Greek Alphabet," in *Communication Arts in the Ancient World,* ed. Eric A. Havelock and Jackson A. Hershbell [New York, 1978], 31; italics in original). By the same token, the new, visible distinction between consonant and vowel in Greek is a manifestation of an analytical impulse, a desire to break down wholes (in this case syllables) into their component parts, which seems particularly Geometric and Greek.

Phoenicia is clear from (among other things) the Greek word for book or writing materials, *byblos,* which is taken from the name of a Phoenician city. But where was the debt first incurred? Many scholars favor Al Mina, the Levantine emporium where Greeks and Phoenicians lived side by side (despite the fact that there is no writing from eighth- or seventh-century Al Mina), but cases could also be made for Cyprus, Rhodes, Crete, Athens, Euboia, and even Ischia. Most scholars have also assumed that the Greeks learned to write for the same reasons that Phoenicians wrote: to keep commercial records. The trouble is that there is no evidence to back up the assumption: there are no Phoenician or Greek mercantile inscriptions of around or before 700, and there is no such thing as an eighth- or seventh-century Greek numeral.[26]

Two of the earliest examples of written Greek are, in fact, poetic, and probably the older of them comes from Athens. It was scratched on the shoulder of a cheap, plain Late Geometric jug sometime after the vase was made (in the Dipylon Workshop), around 740 [36]. It is not certain that it was an Athenian that scratched it, and the crudity of the lettering suggests that the author was not a practiced scribe in any case. But he was a fairly practiced poet. There is one complete verse and it is in dactylic hexameter, the meter of epic: *"hos nun orcheston panton atalotata paizei"* (He who of all the dancers now performs most lightly . . .). A dozen uncertain letters follow, doubtless reading something on the order of "shall have me" (or "this vase"). At all events, the diction as well as the meter is Homeric: *atalotata* ("most lightly") echoes the use of the word *atala* to describe the dancers on Akhilleus' shield (*Iliad,* XVIII.567).

The author of a slightly later inscription had far better penmanship and was evidently a more accomplished (and more witty) poet besides. The lines are again scratched on a vase—a simple cup made in Rhodes but buried with its owner on Ischia around 720.[27] The first line is possibly prose, possibly an iambic trimeter, but the second and third are certainly dactylic hexameters, and the sense is this:

> I am Nestor's cup, good to drink from.
> Whoever drinks from me will at once be seized
> By desire for fair-crowned Aphrodite.

It is possible, of course, that the owner of the cup really was named Nestor. But the name rings a loud bell, and the ironic allusion (made in grandiose epic language on the surface of a very plain cup) is probably to the monu-

26. For a recent review of the evidence, see A. Johnston, "The Extent and Use of Literacy," in *Greek Renaissance,* 63–68.

27. See P. A. Hansen, "Pithecusan Humor: The Interpretation of 'Nestor's Cup' Reconsidered," *Glotta,* 54 (1976), 25–43.

36. Late Geometric I oinochoe from the Dipylon cemetery (Athens NM 192), around 740. Photo courtesy of Deutsches Archäologisches Institut, Athens.

The Art and Culture of Early Greece, 1100–480 B.C.

mental gold cup of Nestor, king of Pylos, which is described in the *Iliad* (XI.632–35). If it is, the epic (or part of the epic) had been heard as far west as Ischia by around 720: "Homer" traveled fast.

To judge from the extant evidence (which is about all we can judge from) it looks as if the need to jot down lines of poetry, not commercial accounts, was one reason for the invention of the Greek alphabet (and its all-important vowels)[28] in the middle of the eighth century. Another, probably, was the need to record ownership of personal property.[29] But in any case, we have to ask whether it is likely that a poet in Athens around 740 or some wag on Ischia around 720 could write hexameters and Homer, their rough contemporary, could not. It would help if there were some pointed allusions to writing in the *Iliad* and *Odyssey*, but there are none, except for VII.175 of the *Iliad,* where Greek heroes crudely make their marks on lots (literacy is hardly implied here), and VI.168–70, where Glaukos relates that his ancestor Bellerophon was sent to Lykia with a tablet engraved with "many deadly signs"—deadly because they ordered Bellerophon's murder. These signs are probably not the oral tradition's dim recollection of a Bronze Age script such as Linear B but an eighth-century poet's acknowledgment of the existence of a contemporary alphabet—something still generally mysterious, something that might prove deadly to the oral tradition itself.[30] Yet it should be stressed that composing in the *style* of an oral poet and conceiving of poetry as a process are not necessarily incompatible with being literate. There is no reason why Homer, a performing bard, could not have known how to write.

We have no idea whether a full-length late-eighth-century manuscript of the *Iliad* actually existed. To be sure, writing 15,000 hexameters on leather scrolls or wooden tablets would have been a far more awesome task than scratching a couple of verses on a jug or cup, but the task would not have been much easier in the seventh or sixth century when papyrus was more common. Still, if it is just possible to imagine a Late Geometric text of Homer, we do not need to imagine one. Perhaps Homer wrote down only a few critical passages (the programmatic first seven lines of the *Iliad*, for instance), or a broad outline of scenes or episodes, or notes to prompt and remind him—something on the order of "Call the wife of Meleagros Kleopatrē" (her name means the same thing as Patroklos', and just as her tears at IX.590–96 move her prideful husband to fight, so will Patroklos' weeping at the beginning of Book XVI move Akhilleus to act). Such notes

28. Because of the special nature of Greek meter—the rhythm depends on the quantity of syllables as determined by the length of the vowels the syllables contain—the best explanation for the invention of vowels is that they were essential to the proper writing of poetry. Business ledgers did not need them. See Robb (n. 25), 29–32.

29. That is Johnston's argument (n. 26).

30. See W. Burkert, "Oriental Myth and Literature in the *Iliad*," in *Greek Renaissance*, 51–53.

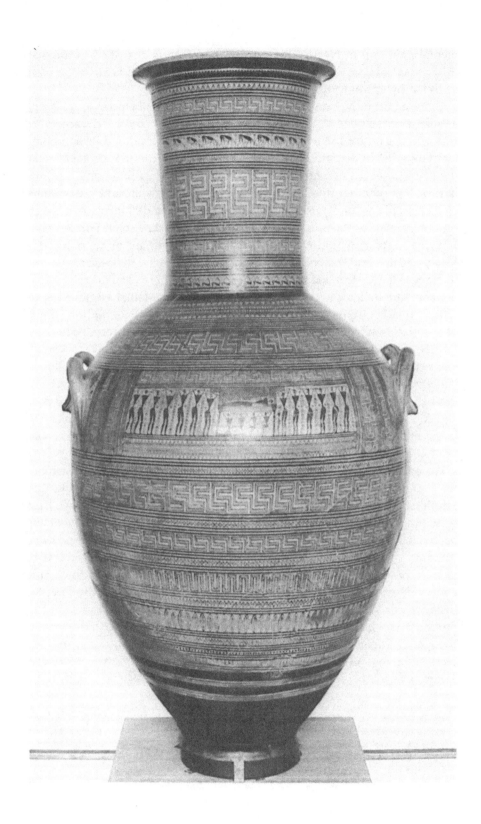

The Art and Culture of Early Greece, 1100–480 B.C.

to himself would not have altered Homer's traditional formulaic language. They *would* have made his performance less than spontaneous, his *Iliad* less than improvised, less than purely oral. They would have allowed Homer to compose a far more intricate and internally allusive epic than sheer extemporaneity could permit, and a far more monumental one as well: there is every reason to believe that the *Iliad* and *Odyssey* were exceptional in their lengths as well as in their quality,[31] and their size seems a poetic manifestation of the general Late Geometric impulse for monumentality [cf. 33, 35, 37]. No matter how much they resemble oral poems, then, the *Iliad* and *Odyssey* were not typical of the epics sung in the eighth century: that is why they and not some other poems were preserved in the first place. Their uniqueness, or a portion of it, is best explained by their poet's knowledge and use of writing, by his increased ability to *plan*.

The genius of Homer and the beginnings of Greek literacy were contemporary. It is likely that they were also inseparable. The alphabet, perhaps invented so that poetry might be made visible and tangible, enabled one great poet (or two) to transcend his (their) own merely audible tradition.[32] That, I think, is one answer to the Parry question.

Formula and Foreground: Homer and the Dipylon Style

Just before the middle of the eighth century, one of Athens' leading families awarded an important commission to one of the city's handful of potter's workshops. A noblewoman (the family's matriarch?) had just died or was about to die, and a gigantic vase was required to stand over her grave in a cemetery not far from the later city gate known as the Dipylon (Double Door). The vase could receive libations poured by mourners, but its function was essentially commemorative: it was both the sign (*sēma*) of the noblewoman's tomb and her memorial (*mnēma*), a monument of remembrance.

Tradition determined the type of vase it was to be [37]. In the preceding centuries, when Athenians generally cremated their dead, the ashes of

31. See Jasper Griffin, "The Epic Cycle and the Uniqueness of Homer," *JHS*, 97 (1977), 39–53.

32. See A. Parry, "Have We Homer's *Iliad*?" *Yale Classical Studies*, 20 (1966), 175–216. For an opposing view, see G. S. Kirk, *Homer and the Oral Tradition* (Cambridge, 1976), 129–45.

37. Late Geometric I belly-handled amphora (1.55 m. high) by the Dipylon Master (Athens NM 804), around 750. Photo courtesy of Deutsches Archäologisches Institut, Athens.

e buried in belly-handled amphorae [24].[33] Now, when inhu-
become the preferred form of burial, the remains of women
th such amphorae rather than in them. There is no way of
:ther the aristocrat who arranged the funeral provided the
ny other specifications concerning size or decoration; he
_ps, have been a rare patron if he did not. At all events,
although large vases had marked graves before, no earlier Greek potter
had ever undertaken a task so monumental as this. He began by throwing
prepared clay on his wheel and directed the rising, spreading form as an
apprentice spun the wheel by hand. The vase was actually too large to be
thrown all at once, so the potter made it in sections. That task done, he
literally built the vase, binding the parts together with a clay slip, carefully
smoothing the seams. He left undisguised the sharp angle where the swell-
ing egg-shaped ·body meets the cylindrical, slightly flaring neck. The
finished product stood just over five feet tall (1.55m)—the scale of a human
being—and it was constructed according to a precise proportional scheme:
it is twice as tall as it is wide, the neck is half the height of the body. The
master potter lastly added two double-looping handles and set the monu-
ment aside to dry and stiffen. Then he turned master draftsman and, with
a fine solution of clay and water that would turn dark only after the vase
was fired, began to paint.

A lot had happened in Attic vase painting since the Middle Geometric I
mourner took her inconspicuous and independent place beyond the bor-
ders of a complex geometric world [29]. That first Attic human figure
precipitated a mighty confrontation between the pictorial and the abstract,
and in the following decades the pictorial slowly gained strength. During
the Middle Geometric II period (800–760) figures were not only painted on
vases but also engraved on the flat catch plates of gold brooches (fibulae).
Counting these engravings, the Attic repertoire of images expanded to
include horses, birds, deer (standing or grazing), a family of pigs, a goat, a
lion, and ships (the vehicle of much Athenian prosperity in those years).
But the crucial development in Middle Geometric II picture making was the
final acknowledgment of the inherent attractions of the human form.

Human beings no longer appear alone: they are grouped with other
human beings and the relationships between them begin to be described.
That is, while the Middle Geometric I mourner and the nearby horse are
merely forlorn abbreviations of human activity (in that case, a funeral),
Middle Geometric II artists represent true "scenes." Broad-shouldered

33. The ashes of men were placed in neck-handled amphorae [27]; kraters [29] were also
associated with male burials, probably because of their association with the male-dominated
symposium.

men tame a horse with whip and reins.[34] Rubbery-limbed warriors fight on land and sea, defending and attacking beached ships: some hurl spears, some crouch and take aim with bows, some duel with swords, some fall and die [34]. Such scenes are often ambiguous in content and in the representation of space (some figures hover in midair), but they are surprisingly energetic and are thus early manifestations of the characteristically Attic impulse for dynamic narrative. They also record the kinds of action that undoubtedly won Athenian aristocrats considerable glory in the early eighth century and that made them more like the heroes epic poets were singing about. One battle completely girds the belly of a monumental krater in New York—the *mnēma* of a nobleman who died around 770—and it may stand for ("illustrate" would be the wrong word) a glorious episode in the life of the deceased or even the occasion of his death [38].[35] On a decorative band above, in the middle of the handle zone, there is a badly damaged representation of a *prothesis* (the highly patterned ritual that included the lying in state of the corpse), the first of hundreds in Geometric art. A mourner kneels atop the funerary couch at the feet of the dead. Below the bier is a file of birds and lower still, in a separate register, are five mourners. There are more figures below the handles of the vase: this is the large, aggrieved company that the Middle Geometric I mourner [30] had to suggest all by herself. In fact, these figures look like her direct descendants: their arms curl over their heads, their contours are fluid and fleshy. But unlike her, the Middle Geometric II figures have passed from the edge of the abstract labyrinth to its very center. They have acquired a frame, a secure place, and have been brought within the ordered Geometric world. With that move the Dark Age of Greek art came to an end. The human figure never gave up the center again.

And yet there was a problem. If the Attic vase painter had concluded that the future lay in pictures, he was not yet clear how (or whether) to integrate them with their abstract environment. The painter of the cup from Eleusis [34] skirted the issue almost entirely: he surrounded his battles with solid black glaze, not geometric ornament. On the New York krater [38] the issue is addressed but not completely resolved: the *prothesis* panel seems like a light hole rent in the abstract fabric, and the picture thus threatens the integrity of the surface. The vase painter had two choices now: either he could give the surface over to the pictorial once and for all and make mere borders of geometric designs or, more conservatively, he

34. Kerameikos 2159; see K. Kübler, *Kerameikos*, V.i (Berlin, 1954), pl. 111.

35. It must be pointed out that no figure in the battle scene is emphasized by size or action: it is fair for us to think only that the deceased aristocrat participated in combats *like* this one, not to try to identify him in the scene, or even the scene itself.

38. Middle Geometric II krater (Metropolitan Museum 34.11.2), around 770.
Photo courtesy of Metropolitan Museum of Art, Fletcher Fund, 1934.

could minimize the inherent (and unfair) competition between the pictorial
and the abstract by making the human figure into another geometric motif
and transforming the representation into half-abstract pattern. Ultimately,
Greek artists made the first choice. But the master potter and painter who
received that special aristocratic commission around 760–50 made the sec-
ond. With the great vase he constructed and decorated—Athens 804, as it
is known [37]—the Late Geometric style essentially began and Greek art
acquired its first recognizable personality: the Dipylon Master.

Leaving representation aside for the moment, the history of Geometric
vase painting had consisted of balancing rigid organization with the gradu-
al expansion of decorative zones. Athens 804 is the monumental culmina-
tion of the process: it is covered with ornament from its top nearly to its

(reconstructed) bottom. At first glance, the surface is a bewildering display of abstract motifs. In fact, the motifs are traditional and the surface is controlled by visual rhythms and formulae.[36] The simplest formula is a band of three (sometimes two) thin horizontal lines: it is so common (on the front of the vase it appears nearly fifty times, if the vertical strips between the handles are counted) that it binds together the larger building blocks of the surface like geometric mortar (or, to mix metaphors, stitching). The triple-line band is combined with other patterns to form more complex formulae: the formula triple-line band/dotted lozenge frieze/triple-line band, for instance, occurs eleven times. This formula in turn frames single meanders and double meanders twice each. Still other formulae can be discerned in this fabric, which increases in complexity as it nears the handle zone of the vase—the most important zone—and then contracts again. It is clear that the surface is ordered through the elaborate, rhythmic repetition of distinct parts—that it is, in short, tectonically and formulaically composed.

This is one of several ways in which the Dipylon style and the Homeric style appear to be parallel. In both, the formula—not the single word, not the single brush stroke—is the basic compositional unit. The poet, using verbal blocks that can be as short as two words or as long as thirty-five lines (compare, for instance, *Iliad*, IX.122–57 and IX.264–99) but are all pressed into the rhythmic frame of the hexameter, is as much a builder of narrative surfaces as the vase painter is of decorative surfaces (and *tektōn epeōn*, "builder of words," is just how the Greeks could conceive of their poets).[37] The formula, oral or geometric, is both the tool and the stuff of the construction, and it lends to both monumental epic and monumental vase the qualities of stability and unity. For Homer's audience the formula was an aid to recognition: one use of a formula predicts or recalls other uses of the formula. Any line of oral poetry must have *seemed* familiar and equal, even if it was mostly new (similarly, whole episodes or tales can seem familiar because they make use of certain narrative themes or patterns). Formulaic language is highly resonant language, alluding constantly to itself. And thus the narrative moment, which is in fact fleeting, takes on the sturdy character of the regular, the constant, and the predictable. In a sense, the very language of Homer is its own meaning: it is the embodiment and validation of order itself.[38] And just as oral formulae and thematic patterns

36. For an analysis of the vase, see B. Andreae, "Zum Dekorationssystem der geometrischen Amphora 804 im Nationalmuseum Athen," in *Studies in Classical Art and Archaeology* (Locust Valley, N.Y., 1979), 1–16.

37. See M. L. West, "Greek Poetry, 2000–700 B.C.," *CQ*, n.s. 23 (1973), 179, and Nagy, *Best*, 300.

38. See J. Russo, "How, and What, Does Homer Communicate? The Medium and Message of Homeric Verse," in *Communication Arts in the Ancient World* (n. 25), 39–52.

guided the ear through the intricate texture of epic song, so the visual formulae employed by the Dipylon Master guide the spectator's eye over the huge surface of the amphora: one use of a motif echoes another and the additive surface coheres. In the geometric medium lies a message of order.

Figures that are treated formulaically become archetypes, schemata. The deer that graze and the goats that kneel on the neck of Athens 804 [37]— they take part in the first two continuous animal friezes in Archaic art (thousands more will follow)—are so treated. The animals in each frieze are identical. They are there, in fact, less as animals than as pattern, and they do not function differently from the bands of abstract ornament above and below (the goats, for instance, turn their heads back upon themselves, seeming to mimic the design of the meander). There is some variation among the thirty-nine human figures who inhabit the handle zone of the amphora—eight in a panel on the back, six under each handle, nineteen in the commanding *prothesis* on the front—but there is not much. In the *prothesis* [39], the limp-wristed corpse—she is at the exact center of the entire vase—and the two reclining women beneath her apparently wear gowns. A figure on a stool gestures with her hand. A child is a miniature adult. Two figures at the far left wear swords (and so they are men) and raise one arm in mourning. But the distinctions are minute: the Dipylon

39. *Prothesis* scene on the amphora shown in fig. 37. Photo courtesy of Deutsches Archäologisches Institut, Athens.

The Art and Culture of Early Greece, 1100–480 B.C.

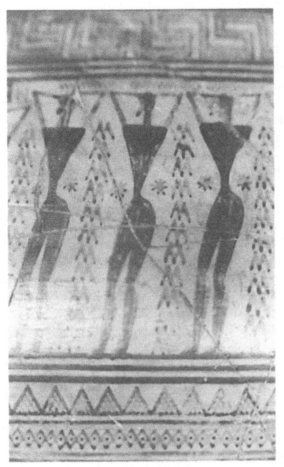

40. Detail of the amphora shown in fig. 37. Photo: Jeffrey M. Hurwit.

Master's mostly nude figures, male and female, on all seven of the vases attributed to him (nearly fifty more are assigned to other members of his shop) are essentially the same figure. The continuous, fleshy contours and irregular, relatively naturalistic proportions of earlier silhouettes [30, 34] have been rejected. Instead, the figure has been broken down into separate abstract shapes and, like the amphora itself, has been subjected to the ordering force of a proportional canon [40]. The head is a tiny circle with a large lump for a chin, but the height of the head and shaftlike neck together is one-half the height of the torso. The torso (shown frontally) is a tall and precise triangle precisely extrapolated by the muscleless sticks that serve for arms. The body is nearly cut in thirds at the waist (or at least at the spot where the waist should be) and at the knees: the distances between waist and knee and between knee and foot are virtually identical, and so are the curves of thigh and calf. All in all, the Dipylon silhouette, whose joints do not so much connect as exaggerate divisions, is the sum of distinct but mathematically related parts. It is structured according to a

1/2:1:1:1 ratio: the head (and neck) is one-seventh the height of the entire figure—a precociously Classical scheme. The unity of the figure is at any rate of a special sort: it is structural or tectonic, not organic, and the segment matters as much as the synthesis.

In this respect the Dipylon and Homeric conceptions of the human form may be cognate. Long ago, Bruno Snell argued that Homer has no one word for the body (or the mind or the soul) of a living person—one has a body (*sōma*) only when one is dead—and that Homer could thus have had no notion of the body (or the mind or the soul) as a whole.[39] Physically the Homeric human being is, Snell argued, as much a composite of head, chest, and limbs as a Dipylon silhouette: thus Akhilleus can say "my arms" have fought when he means "I" (*Iliad*, I.166). Emotionally and intellectually, too, Snell's Homeric human is an aggregate of distinct "organs": thus Odysseus can talk to his own *thymos*, that part of his soul concerned with temper and emotion, as if it were outside of him (*Iliad*, XI.403–10). Snell's thesis is not perfect: he does not say why a corpse can have (or be) a "body" but a living person cannot, and there are apparently a few exceptions to the rule in any case. It is also true that not all Late Geometric artists present so schematic and tectonic a view of the human form as the Dipylon Master: though their medium undoubtedly had something to do with it, the makers of bronze statuettes could create particularly rubbery and inarticulate figures [41] that have little to do with the Dipylon aesthetic. Nonetheless, the Dipylon Master and Homer—the greatest artist and the greatest poet of their age—both generally conceived of the human form in pieces and as pieces.

The Dipylon figure—a formulaic attachment of part to part—conveys information. It tells what makes up a human being. It tells what all human beings are like by eliminating (or ignoring) the peculiarities of individual members of the species. The Dipylon figure, in other words, expresses what is constant about the human form, not what is fleeting; what is essential, not what is idiosyncratic. Human beings are as changeable and as transient as the leaves Homer compares them to (*Iliad*, VI.146–49, XXI.464–66), but the *idea* of a human being—a creature with a blob for a head, a triangle for a chest, two legs, and two arms—is not. And it is a similar yearning for the essential, a similar impulse for the archetypal, that is expressed by the Homeric epithet—a descriptive word (or two) that helps fill out the hexameter line like an ornament but that also establishes

39. See Bruno Snell, *Die Entdeckung des Geistes* (Hamburg, 1948), published in English as *The Discovery of the Mind*, trans. T. G. Rosenmeyer (Cambridge, Mass., 1953), chap. 1. For criticisms, see Austin, *Archery*, 82–84, and R. Renehan, "The Meaning of ΣΩΜΑ in Homer," *California Studies in Classical Antiquity*, 12 (1981), 269–82. See also J. Russo and B. Simon, "Homeric Psychology and the Oral Epic Tradition," *Journal of the History of Ideas*, 29 (1968), 483–98.

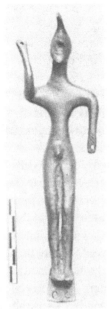

41. Bronze statuette (Olympia B 24), late eighth century.
Photo courtesy of Deutsches Archäologisches Institut, Athens.

what is constant and unchanging about a character or a thing. Dawn is early-born and rosy-fingered, ships are swift or black, women are white-armed, Hera is queenly and thus golden-throned even when she is lying down (*Iliad*, I.611), Akhilleus is swift-footed even when he is sitting still (XVI.5). Homer's characters, of course, differ from one another; the Dipylon Master's silhouettes differ hardly at all. Still, epithets regularly appended to names and objects help place them beyond the realm of change. The epithet-noun formula, like the formulae the Dipylon Master drew, seeks to exclude what is atypical and affirm what is permanent. Homeric diction and the Dipylon figured style share an abhorrence of the accidental and mutable.

A particular view of reality is shared besides. For the performing Homer, reality was whatever he was singing at the time, and his conception of reality—that is, his representation of it—was thus necessarily bound to his narrative medium and organizational methods. Two of his most important devices are symmetry and antithesis, devices that order because they arrange, enclose, and frame. The impulse for symmetry can be seen in a single line—for instance, the line that summarizes what it is to be a Homeric hero: *mythōn te rētēr' emenai prēktēra te ergōn* (*Iliad*, IX.443). The verse means "to be a speaker of words and a doer of deeds," but in the Greek "of words" (*mythōn*) at the beginning of the line is balanced by "of deeds" (*ergōn*) at the end, "speaker" (*rētēr'*) is balanced by "doer" (*prēktēra*), and "to be" (*emenai*) occupies dead center. This kind of symmetry, in which the order of words in parallel clauses is inverted, is known as *chiasmos*, and the

same antithetical (and mnemonic) principle governs whole passages as well. When in the underworld Odysseus asks the shade of his mother a series of questions about her death and the situation back home on Ithaka, she answers them in reverse order, last question first (*Odyssey*, XI.171–203). The *Iliad* itself, in fact, is framed by a vast *chiasmos*. Book I begins with a nine-day-long plague and mass burials and continues with Akhilleus' quarrel with Agamemnon, Thetis' visits to Akhilleus and Zeus, and finally an argument among the gods. Book XXIV begins with an argument among the gods and continues with Thetis' visits to Zeus and Akhilleus, the reconciliation between Akhilleus and Priam (antithetical to the quarrel with Agamemnon in Book I), and finally a nine-day-long truce for Hektor's burial. The principles of antithesis and symmetry have seemed so pervasive and authoritative to some scholars that they consider the *Iliad* the poetic equivalent of a Late Geometric amphora, designed with as much concern for abstract form as, say, the surface of Athens 804.[40] To say that every episode, every narrative part, is precisely balanced by another is to go too far: the "geometry" of the *Iliad* is not so pure. But there *are* plenty of symmetries and patterns to be found. This symmetry, together with the strong and gratifying sense that the epic finishes what it starts (its sense of closure),[41] is as much a manifestation of order as the formula itself, and it is as much a manifestation of order as the tightly organized works of the finest Late Geometric vase painter—or the Shield of Akhilleus. Homer may never have seen a vase of the quality of a Dipylon amphora. The Dipylon Master may never have heard Homer's *Iliad*. But there is nothing unreasonable about looking at, say, the Dipylon Master's *prothesis* (where mourners balance each other around the central bier and neatly fill their rectangular panel, holding their arms exactly parallel to the upper border) and detecting analogous impulses for symmetry and closure. Whether expressed in words or in images, these impulses are symptoms of a larger Late Geometric mentality that revered stability and finality—the values of order—and that perfected poetic and artistic structures to control the world and put its parts in their places.

The parts are generally set side by side. Perhaps even more fundamental to the Homeric and Late Geometric representations of reality than symmetry is parataxis, a style in which sentences, ideas, episodes, or figures are placed one after the other like beads on a string.[42] In paratactic narrative,

40. See above all Cedric Whitman, *Homer and the Heroic Tradition* (Cambridge, Mass., 1958), chap. 11. For a criticism of this approach, see Kirk (n. 23), 261–63.

41. There is no such satisfaction at the end of the *Odyssey*, which is abrupt and by comparison artificial: it simply stops. In a sense, the *Odyssey* is open-ended while the *Iliad* is closed: it could, we feel, continue on more easily. In this respect, the *Odyssey*, which makes use of symmetry and antithesis but is less dependent on them, may anticipate a breakdown of the Late Geometric mentality and the rise of the freer forms of seventh-century art; see Whitman (n. 40), chap. 12.

42. See J. A. Notopoulos, "Parataxis in Homer," *TAPA*, 80, (1949), 1–23.

every idea, every scene seems independent and equal to every other—equally important, equally emphasized—and thus all seem to exist on one uniform level or plane. The planar quality of the Homeric style is particularly evident in so-called digressions, long (but hardly irrelevant) passages that interrupt the narrative and occupy the listener so completely that the matter at hand is momentarily lost.[43] Digressions typically occur at times of tension or high drama—for instance, in the heat of battle, where a charge of chariots can be stopped by a long genealogy (*Iliad*, VI.145–211), or where a simile used to describe a bloody wound becomes a thing apart, and the wound is for a few lines forgotten (*Iliad*, IV.141–45). The most famous digression is the tale of Odysseus' scar in Book XIX of the *Odyssey*. Penelope has told the old nurse Eurykleia to wash Odysseus' feet (he is in disguise). She uncovers his leg, touches his scar, and at once recognizes her master. But her reaction is delayed for more than seventy lines while Homer tells how Odysseus got his name and how he got the scar in a boar hunt on Mount Parnassos (ll. 393–466). Only after the digression does Eurykleia finally drop her master's leg into the washbasin and exclaim, "You are Odysseus!"[44] As Erich Auerbach has argued, this and other digressions are not there to relieve tension but to elucidate. They are characteristic of the Homeric impulse to leave nothing obscure: if Odysseus has a scar, the reason for it must be explained.[45] Past events and experiences, even motivation and thought processes, are clearly expressed or externalized (cf. *Iliad*, XI.403–10). All phenomena are thrust forward to the narrative surface—to the foreground—where they receive even, objective illumination. No hidden depths exist; nothing is omitted, vague, or darkly imaginable. There is, we may say, no perspective in the style of narrative Auerbach has identified[46]—nothing that is subordinate, nothing that does not exist on the front plane of the epic. And this paratactic presentation of everything, everyone, and every thought was undoubtedly conditioned by the nature of oral performance, where there was only the sound of the words, where each hexameter, once heard, was gone and replaced by another of equal grammatical and semantic value. Homeric reality was in effect the narrative moment—a flat, continuous present.

Parataxis and the plane control Late Geometric artistic representations of reality as well. Like each excessively jointed Dipylon silhouette—Paratactic

43. See Norman Austin, "The Function of Digressions in the *Iliad*," *GRBS*, 7 (1966), 295–312.

44. The episode is also an excellent example of "ring composition," in which a speech, scene, or digression is framed at beginning and end by a repetition of formulaic words—in this case, "she recognized the scar." Ring composition, like symmetry and antithesis, is a common Homeric method of shaping and enclosing.

45. Erich Auerbach, *Mimesis: The Representation of Reality in Western Literature* (Princeton, 1952), 3–23.

46. Austin (n. 43) has discerned another, more elliptical or oblique style in Homer, but its existence does not seriously weaken the predominantly paratactic narrative.

Man if there ever was one—the entire *prothesis* on Athens 804 is a flat alignment of parts. It consists, first, of distinct groups of figures—those to the left of the bier, those to the right, and those below—but each figure is in fact independent, set off from its neighbor by vertical stacks of zigzags. This so-called filling ornament—something that was substantially missing in earlier scenes [38]—blends the picture with the abstract fabric beyond its borders: it is stitching, and it reduces the harshness of what would other-wise have been an airy, light patch suspended in a dense geometric tapes-try. But this is not all that the filler does: it also assigns each mourner a separate and equal place on the surface of the vase. Each figure is clearly framed: overlapping of figures is strictly prohibited because it would ob-scure the contours of the silhouettes and cause visual confusion. Even the dead noblewoman is completely visible: the checkered shroud that in real-ity covered her is apparently held above, and it is cut back so as not to muddle her outline—it is almost as if we are allowed to see through the cloth rather than peek beneath it. The Late Geometric representation of reality aims for clarity, comprehension, and objectivity above all. The corpse is exposed because it is known to be there: to cover it up would be, somehow, dishonest or deceptive. The other figures are objectively equal: therefore they must be equally intelligible and therefore they must exist on the same plane, in the foreground. The mourners who in the painting antithetically flank the funeral couch in reality probably circled it in ritual lamentation. The dance, which would have obscured the bier as it passed in front and been obscured by the bier as it passed behind, has been cut in two and its halves have been stretched across the surface to form, paratac-tically, two human colonnades. Similarly, mourners did not really sit be-neath the bier but in front of it, yet they are made to inhabit the same plane as the corpse and the standing mourners. Even when the Dipylon Master populated a much larger pictorial field with a much larger cast, we see the same flattening of space, the same projection of parts onto the regular, front plane. The row of mourners who sit, impossibly, atop the shroud of the deceased on a fragmentary krater in the Louvre [42] actually sat behind the bier, and the bier was really behind the tall mourners who stand com-fortably under it. The four smaller mourners who seem to stand pre-cariously on top of each other on either side of the bier are not really circus acrobats: the ones on top are to be thought of as standing behind those on the bottom. The rule that what is above was in fact behind is loose, but it is one of the very few in Late Geometric art,[47] and it was formulated because no distance or depth, no perspective, could be allowed to intrude into—and thus weaken—the Late Geometric conception of reality. Nothing (or

47. For other Geometric "laws" of representation, see S. Brunnsäker, "The Pithecusan Shipwreck," *Opuscula Romana*, 4 (1962), 165–242, and G. Ahlberg, *Prothesis and Ekphora in Greek Geometric Art* (Göteborg, 1971), 268–80.

42. Fragmentary Late Geometric I krater by the Dipylon Master (Louvre A 517). Photo: M. Chuzeville, by permission of the Musée du Louvre.

almost nothing) can be hidden or implicit. Geometric space, like the Homeric representation of reality, essentially consists of a uniformly illuminated foreground. The picture plane does not merely *contain* a representation of reality, it is the *equivalent* of reality.

A painted vase, no matter how fine, large, or intricately decorated, is not an epic poem. A sparse *prothesis* cannot compare with the rich, tragic complexity of the *Iliad*. A schematic silhouette cannot possess the mighty character and depth of an Akhilleus. The Dipylon Master did not attempt to compete with Homer or reproduce the *Iliad* in clay and glaze, and parallels between Homer and other Late Geometric artists do not hold so well.[48] Yet it is stranger to treat Homeric epic and the Dipylon style in total isolation than it is to see in them a rare spectacle of unity. In their delight in sheer size, in their tightly controlled use of formulae to construct monumental, highly patterned, and well-proportioned edifices, in their use of archetypes to counter the multiplicity and mutability of things, in their conception of the body as a summary of parts, in their dependence on symmetry and antithesis as means of arranging the world, in their power-

48. One Late Geometric Argive vase painter, for example, is remarkably successful in representing landscape and even recession into the distance, though all the elements of his picture are still evenly distributed over the surface of the vase; see J. Boardman, "Symbol and Story in Geometric Art," in Moon, figs. 2.4a and 2.4b and p. 19.

43. Seal impression on a vase found on Ischia (Pithekoussai), late eighth century. Drawing after J. N. Coldstream, *Geometric Greece* (New York, 1977), fig. 75d.

ful sense of closure, and in their paratactic projection (or refraction) of reality upon the flat plane of the foreground, the Dipylon style and Homeric narrative are related manifestations of the subliminal impulses, the ordered sensibility, of the culture of mid-eighth-century Greece—a culture that after the final dissipation of the Dark Age sought through both its art and its poetry to reinforce its beliefs and confirm its rigorous vision of the world.

Lions and Heroes: The Origins of Narrative

So much for the zeitgeist. Can anything more material, more palpable, be found to link Homeric epic and Late Geometric art? Specifically, did the circulation (however that is to be imagined) of the *Iliad* and *Odyssey* in the late eighth century affect the content of Greek art and transform the very nature and purposes of representation? Did epic—despite W. H. Auden's famous lament that "poetry makes nothing happen"[49]—make something revolutionary happen indeed?

What happened was the appearance, in the last third of the century, of one to two dozen vase paintings, engravings on fibulae and seals, and bronzes that can be interpreted as depictions of legendary events (e.g., Ajax carrying Akhilleus' corpse from the Trojan plain [43] and the struggle between Herakles and Apollo over the Delphic tripod [44]), portrayals of mythological characters (e.g., the Siamese-twin sons of Aktor [45, 48]), and even illustrations of Homer (e.g., *Odyssey*, XII.415–25 [46]). The representations that are open to such readings belong to a different category from

49. "In Memory of W. B. Yeats."

44. Fragmentary leg of a tripod (Olympia B 1730), late eighth century. Photo courtesy of Deutsches Archäologisches Institut, Athens.

the generic *ekphorai, prothesis* scenes, funeral games, and parades that portray the contemporary self-aggrandizing rituals of aristocratic society and that continue to dominate Geometric imagery to the end of the century. [49, 50].[50] They are, however, not always precisely identifiable themselves. The ability of the Late Geometric II vase painter (for instance) to depict unmistakably a particular mythological event with archetypal silhouettes was naturally limited. There are virtually no personal attributes to help us tell one hero or heroine from another—no visual equivalents of Homeric epithets, as it were.[51] And the vase painter has provided no scorecard: although some owners of Late Geometric jugs and cups could scratch

50. Occasionally there appears to be some broad correspondence between Late Geometric genre scenes and Homer: a parade of armed men and chariots beside a funeral couch, as on the Dipylon krater in the Louvre [42], is not unlike the *prothesis* of Patroklos described in the *Iliad*, when the Myrmidons drive their chariots around him three times, shedding tears upon their armor and the sands (XXIII.12–16). But the similarity here probably exists not because the vase painting is an illustration of epic but because both painting and poetry mirrored the same genuine contemporary practice.

51. Cf. Coldstream, *GG*, 355.

45. (Left) Late Geometric II oinochoe (Agora P 4885) with Nestor and the Aktorione(?). Photo courtesy of American School of Classical Studies at Athens: Agora Excavations.

46. Late Geometric II oinochoe (Munich 8696) with the shipwreck of Odysseus. Photo courtesy of Staatliche Antikensammlungen und Glyptothek, Munich.

poetic verses or their own names upon them, no vase painter had yet hit upon the idea of writing the names of his characters beside them in the field, so that figures that are schematic and essentially indistinguishable could nonetheless be immediately identified (few Late Geometric craftsmen could have known how to write anyway). Different, then, these works of art surely are: when a man fights a centaur [47], the world of the eighth (or any other) century has obviously been abandoned for the realm of the imagination, for the heroic past. But, as in the case of the solitary yet portentous centaur from Dark Age Lefkandi [26], ambiguity reigns: more than one Greek hero fought centaurs, and one of them, Herakles, fought centaurs more than once. Which hero is this? If it is Herakles (and it probably is), which centaur? To complicate matters still more, one or two iconographically desperate, second-rate (and non-Attic) artists of the seventh century showed other monsters (such as the gorgon Medousa) as

The Art and Culture of Early Greece, 1100–480 B.C.

47. Bronze group of a hero (probably Herakles) and a centaur (Metropolitan Museum 17.190.2072), around 750–735. Photo courtesy of Metropolitan Museum of Art, gift of J. Pierpont Morgan, 1917.

human-horse hybrids.[52] Such creatures should make us at least ask whether every single Geometric centaur really was meant to be a centaur and not some other monster in the first place (having at least asked the question, we can answer with some confidence, yes, every one was).[53] At all events, although Late Geometric artists presumably knew what stories they were telling in paint or bronze, we often do not. And so it is best to label their atypical, sometimes unparalleled, but nonetheless mistakable images protonarratives—images that are merely *susceptible* of mythological interpretation and often of more than one.

The deformed sons of Aktor—and with them Attic protonarrative—actually made their debut around 750 on a funerary krater from the Dip-

52. See Schefold, *ML*, pl. 15b.
53. For the centaur problem in general, see E. Buschor, "Kentauren," *AJA*, 38 (1934), 128–32; Fittschen, *Untersuchungen*, 88–128; Carter, 45–47; and Coldstream, *GG*, 354, who notes that Geometric representations of the man-horse hybrid are consistent with what later legend knew of centaurs, and there is no compelling reason to doubt that centaurs are what they are meant to be. It could, in fact, be that the iconography of the beast became unsettled only *after* 700, when artists who lacked models for other monsters and were not original enough to invent their own borrowed the man-horse to represent them.

The Idea of Order, 760–700 [109]

48. Fragmentary Late Geometric I krater from the Dipylon Workshop (Louvre A 519). Note the Siamese twins (the Aktorione?) just visible at bottom left. Photo: M. Chuzeville, by permission of Musée du Louvre.

ylon Master's workshop (though not from his own hand) [48].[54] They took part in a mass battle scene with an extraordinary cast of a hundred warriors or more. At least on their kraters, then, even members of the Dipylon and rival Late Geometric I workshops [49] could devote most of the vase surface to ambitious and densely populated scenes of silhouettes in action. There is no question about what counts on such vases, and the battlements, meanders, dotted lozenges, and triangles that had been the stuff of the Geometric tapestry assume a far lesser role. The abstract has ceased to be the point: it is there now merely to frame the pictures.

One of the remarkable things about the full Dipylon style was its brevity, and it was brief possibly because its brand of perfection was fragile. The Dipylon Master had successfully made the human figure as abstract as it could be, and he had done all that could be done with geometric design. There was nothing to do but undo it. The last of his closest associates stopped painting around 735 (only twenty-five years after the Dipylon Master's own career began) and the following Late Geometric II period (735–700) is a period of restlessness and reaction—and some boredom,

54. Boardman (n. 48), 25–26, is among those scholars who doubt that the double figure here and elsewhere in Late Geometric art really is the mythological Aktorione.

too. The surface tension of the Dipylon style quickly snaps; its taut discipline breaks down without much protest. Amphorae (much smaller now because of new burial customs or a more humble aristocracy or both) have their surfaces swept clear of abstract zones to make room for more numerous, proportionately larger, and usually quite banal figured zones whose size and placement have little to do with the underlying structure of the vase. Tectonics are passé, and even the angle where neck meets body— once the sharply articulated juncture of part to part—is commonly obfuscated by wiggly plastic snakes [50]. The snakes are probably chthonic (symbolic of earthly powers), but they muddle the profile of the vase. Filling ornament no longer neatly binds figures to their abstract milieu (what there is left of it) or puts them in their proper place: it is random, slapdash, loose, and sometimes it is not there at all. Things have come apart. And even the leading painters of the day—for instance, the Painter of Athens 894 [50], who could still draw a decent meander when he wished—often populated their friezes with stout, dumpy warriors who barely seem capable of lifting their massive legs (horses, on the other hand, often seem to strain at the bit or to be about to gallop off). Generally speaking, the Late Geometric II vase is not a pretty sight. But prettiness was not the object, and neither was a Dipylon-like sense of order, with its rigid, almost mechanical discipline. A century and a half of Geometric rigor and control was enough. And even

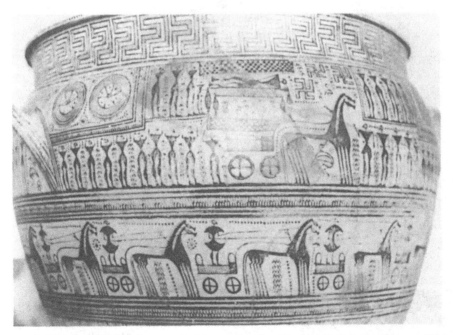

49. Detail of a Late Geometric I krater by the Hirschfeld Painter (Athens NM 990). Photo: Jeffrey M. Hurwit.

The Idea of Order, 760–700 [111]

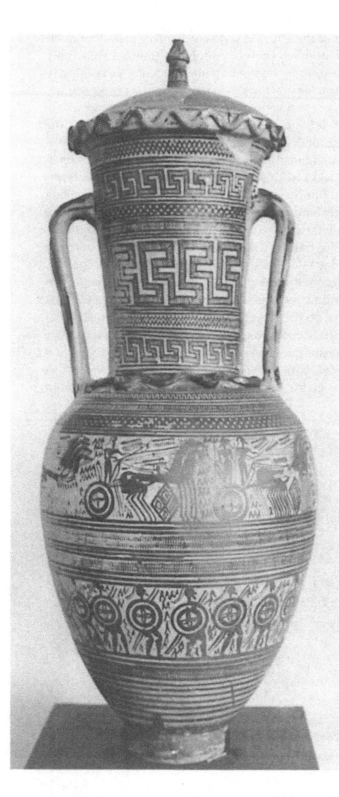

50. Late Geometric II amphora by the Painter of Athens 894 (name vase). Photo: Jeffrey M. Hurwit.

imprecision can have a few positive values of its own: erratic broad brush strokes express a certain energy, irregularity expresses a certain spontaneity.[55] It is easy to call Late Geometric II vase painting sloppy and degenerate because sometimes it is. But its stylistic "carelessness" can more charitably be considered a renunciation of the meticulous past, an unsubtle means of declaring a kind of artistic freedom. That might, admittedly, be too charitable a view were it not that the same period promoted iconographic freedom as well. For protonarrative is, with only an exception or two, a Late Geometric II phenomenon, and it is hardly coincidental that its rise occurs at the same time as the assault on the High Geometric aesthetic. Perhaps the breakdown of the Geometric style was a prerequisite for the rise of protonarrative. Perhaps the rise of protonarrative aided in the demolition of the Dipylon aesthetic. Whatever the case, the old syntax and the old content no longer served so well. Expectations were changing, and Greek art began to change course.

On one leg of a stand from the Athenian Kerameikos, dated to around 725, a massive but tiny-headed warrior does battle with a slightly shorter beast in an otherwise empty field [51 left]. Few eighth-century images illustrate better than this the difficulties of deciding just what is and is not narrative or just what the origins of narrative may have been. The beast is usually thought to be a lion, though few lions, I suspect, would be convinced of that. The creature has short bristles down its back instead of a shaggy mane and the legs it stands on have hoofs and fetlocks instead of claws. This all makes for an odd lion.[56] But of course it could be argued that the warrior is just as odd a man and the beast does have a ferociously gaping, toothy mouth—perhaps the quintessentially leonine feature [cf. 44]—so it is probably a lion after all. Who, then, is its fearless foe? It is natural to assume he is a hero, and only one Greek hero ever fought a lion single-handed: Herakles. This, in the opinion of many modern scholars, must be he. Thus the beast he stabs and spears must be the lion sent by Hera to ravage the people of Nemea (the lion Herakles in turn was sent to destroy as the first of his twelve labors).[57] Thus the vase painting must be a mythological narrative.

But natural assumptions are not always correct, and the trouble with identifying the scene as "Herakles and the Nemean Lion"—and thus with making it the eighth-century antecedent of the hundreds of later represen-

55. See C. Brokaw, "Concurrent Styles in Late Geometric and Early Protoattic Vase Painting," AM, 78 (1963), 63–73.

56. Kübler (n. 34), 177, suggests that the beast is a boar. For a full description of the stand, see Fittschen, Untersuchungen, 81 (L 28) and 87–88.

57. In the canonical version of the myth Herakles killed the lion with his club or bare hands, not with a sword or spear; but, given the early date of the Kerameikos stand, that discrepancy alone is not enough to preclude the mythological content of the scene. See Carter, 45n113.

51. Late Geometric II stand (Kerameikos 407). Photos courtesy of Deutsches Archäologisches Institut, Athens.

52. Bronze group of hunter, dog, and lion from Samos (now lost), around 720. Photo courtesy of Deutsches Archäologisches Institut, Athens.

The Art and Culture of Early Greece, 1100–480 B.C.

tations of the myth [12]—is that the Kerameikos stand has three more legs. On one of them another warrior fights another rearing lion. Conceivably this is a reprise of the alleged Herakles theme. But on the other two legs lions attack unarmed men who carry calves or lambs over their shoulders [51 right]. These men cannot be Herakles—they are shepherds, not heroes—and suddenly the mythological interpretation of the "Herakles" scenes is severely undercut. All four scenes on the stand illustrate not heroic legend but a harsh pastoral reality: mortal men defend their flocks from marauding beasts of prey. A similarly agrarian theme was the subject of a roughly contemporary (but now lost) bronze group from Samos [52], where a lion does battle with a helmeted man and his brave dog: Herakles did not have a pet.

If the images on the Kerameikos stand were not taken from myth, where did they come from? One possibility is everyday life (and we shall shortly get back to that). Another consists of other works of art. Heroes and kings kill lions all the time in Near Eastern art, and the motif of the lion fighter had in fact already appeared in the Aegean by the early eighth century, introduced by immigrant eastern craftsmen.[58] It has even been suggested that the whole story of Herakles and the Nemean lion was fabricated so that some sense could be made of such imported alien images, so that Greeks could find meaning in them.[59] Certainly it is easy to find good Near Eastern parallels for the warrior–lion combat on the Kerameikos stand [53]. But it is not hard to find a good Mycenaean Greek parallel or two, either [54], and if the Late Geometric II painting really did have as its source another work of art, it could have been one that emerged from Greece's own soil.

Art, however, may not *always* be born of art, and though animal bearers are common enough in Near Eastern art, it is difficult to find Near Eastern (or Bronze Age Greek) images of lions attacking shepherds who carry animals over their shoulders: two of the four paintings on the legs of the Kerameikos stand have no clear artistic antecedents. Then did such things actually happen in the Geometric period? Did lions really roam eighth-century Greece and attack eighth-century flocks? Did the painter of the stand paint, in some sense, from life? Now the physical evidence that lions existed throughout Greece (including the Peloponnesos, where Nemea is) during the Late Bronze Age is growing (there has always been a wealth of artistic evidence [16, 54]: lion teeth have been found on Keos (the Cycladic

58. For instance, on a bronze quiver from Fortetsa, on Crete; see J. K. Brock, *Fortetsa* (London, 1959), pls. 116, 169; also J. Boardman, *The Greeks Overseas* (London, 1980), 56–58 and fig. 24. The motif of two lions heraldically flanking a man, often kneeling and with his head in one of their mouths, is even older, though its meaning is unclear; see H. Sackett, "A New Figured Krater from Knossos," *BSA*, 71 (1976), 123–25.

59. Carter, 45.

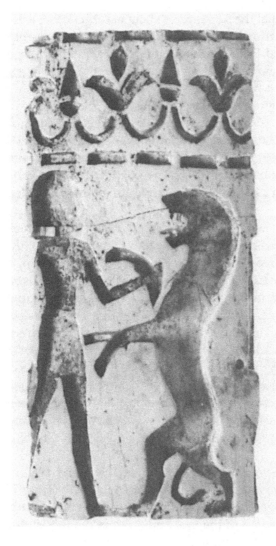

53. Small ivory plaque from Nimrud showing a hero or god and a rampant lion (BM 132940), before 700. Photo courtesy of the Trustees of the British Museum.

island that lies closest to Attica) and lion bones have been found in the excavations at Tiryns.[60] And the evidence that lions were still plentiful in (though limited to) northern Greece as late as the fifth century, while basically literary, is incontrovertible.[61] Whether there were any lions specifically in the wilds of *Attica* in the Late Geometric period, however, we simply do not know. To judge from the strange looks of Late Geometric II

60. See P. Warren, "The Miniature Fresco from the West House at Akrotiri, Thera, and Its Aegean Setting," *JHS*, 99 (1979), 123 and n. 29, and J. Boessneck and A. von den Driesch, "Ein Beleg für das Vorkommen des Löwen auf der Peloponnes in 'Herakleischer' Zeit," *AA*, 1981, 257–58.

61. See Herodotus, VII. 125–26, and Pausanias, VI.5.4–5. There is also the possibility that captured lions were brought to eighth-century Athens, as they were much later (see Isokrates, *Antidosis*, 213–14).

54. Gold flattened cylinder from Mycenae (Athens, National Museum), around 1500. Photo courtesy of Deutsches Archäologisches Institut, Athens.

lions, Attic vase painters were not intimately familiar with real ones (the same reasoning also suggests they were not familiar with the lions far more convincingly portrayed in Near Eastern or Mycenaean art, but never mind). It is wrong, however, to judge from looks alone: even a Late Geometric II painter who had actually seen lions in the flesh (or perhaps lion skins) could still have based his representations of them on animals he was more used to seeing or drawing (horses, boars, or dogs, for instance).[62] The mere fact that the lions on the Kerameikos stand do not look a lot like lions does not mean that the artist who drew them had never seen one. Art is not zoology.

At all events, there *was* a prominent part of the Geometric Greek world where information about lions was evidently easy to come by: Ionia. Lions were probably plentiful and widespread in Asia Minor in the eighth century (some were still there as late as the sixteenth century of our own era). They are certainly all over the Homeric epics. The poems (especially the *Iliad*) are full of similes, and Homeric similes are full of lions (interestingly, the one lion that is conspicuous by its absence is the lion of Nemea—for Homer, lions were not creatures of myth).[63] It is one function of similes to

62. This phenomenon has been documented in later art by E. H. Gombrich, *Art and Illusion* (Princeton, 1969), 78–83.

63. For Homeric lion similes (many of which seem to be late linguistically and thus not relics of Mycenaean poetry) see G. P. Shipp, *Studies in the Language of Homer* (Cambridge, 1953), 79–85. It is also true, however, that the *idea* of comparing warriors or kings with lions may be as old as the Mycenaean Age, and Bronze Age artists even seem to have created "similes in stone"; see W. C. Scott, *The Oral Nature of the Homeric Simile* (Leiden, 1974) 5–7, 174–76. There is some evidence that even the Late Geometric artist could think (and create) in terms of comparisons. On the tripodleg from Olympia [44] the image of Herakles and Apollo(?) struggling over another tripod is juxtaposed with an image of lions fighting on their hind legs. The point is surely that the god and the hero contend as fiercely as lions. It is Hesiod, incidentally, that first mentions the myth of Herakles and the Nemean Lion; see *Theogony*, 327–32. For him—a central mainland poet at the end of the eighth century—lions *were* creatures of myth.

make familiar what is unfamiliar, to make vivid the actions of distant heroes by comparing them with aspects of or events from the world of Homer's audience. There may be traditional or formulaic elements in Homeric similes. But a comparison of, say, Diomedes' furious attack on the Trojans with a lion's attack on sheep in a fold (*Iliad*, V.136–43) would not have made much of an impression on Homer's listeners unless they knew what lions were and feared them as a real and present danger to their own flocks.[64] In fact, some of the lion similes in the *Iliad* describe episodes very like those depicted on the legs of the Kerameikos stand and in the Samian bronze [51,52]:

> [Sarpedon charged] like a mountain-bred lion who has
> too long not tasted meat, and his proud heart drives him on
> to attack a strong fold and its sheep.
> Even though he finds herdsmen on the spot
> guarding their flocks with dogs and spears,
> he does not want to flee the fold without a try.
> Either he leaps and snatches a sheep away or he is
> cut down first, struck by a javelin from a quick hand.
>
> [*Iliad*, XII.299–306]

If there were lions in eighth-century Attica, then the images on the Kerameikos stand and the Homeric lion simile independently reflect the same perilous reality (in the same way that certain Late Geometric funerary scenes and Homer's description of the funeral of Patroklos in Book XXIII suggest each other).[65] But even if there were no lions in eighth-century Attica (and that, when it comes down to it, was probably the case), the Late Geometric II painter of the stand could still have depicted scenes from everyday life—not an everyday life he experienced for himself but one he had heard about in epic song, the everyday life of the Homeric simile. Whichever choice we make, there is no need to deny the role of artistic precursors in the creation of the Kerameikos stand: there was nothing to stop the vase painter from basing his lion killers on Near Eastern or Mycenaean compositions once he decided to draw them. But the images he drew were the result of something more complex than the simpleminded

64. T. J. Dunbabin has argued on the contrary that Homer's knowledge of lions must have been secondhand because the lions in his similes never roar; see *The Greeks and Their Eastern Neighbors* (London, 1957), 46. Certainly a lion's roar is one of the more impressive things about it, and one might expect a poet to capitalize on the terrible sound at every opportunity if he had ever heard it. Homer, it is true, does not do so. But one lion in the *Iliad* is heard to make a mighty sound: at XVIII.318–24, Akhilleus groans in lament for Patroklos the way an angry lion grieves for its stolen cubs. For the relationships between the Homeric simile and the imagery of Geometric art in general, see R. Hampe, *Die Gleichnisse Homers und die Bildkunst seiner Zeit* (Tübingen, 1952).

65. Cf. n. 50.

copying of imported (or rediscovered) models that he supposedly did not understand: he used them to aid in the depiction of something he understood well enough. The images he drew are (if, again, there were no lions in Attica) the products of the convergence of two powerful stimuli: the instruction of what was visually new, on the one hand, and vivid epic imagery of the natural (not the heroic) world, on the other. A line has come to be drawn between those who attribute the birth of mythological narrative solely to a Greek confrontation with cryptic foreign images that (at the same time that they encouraged duplication) demanded explanations taken from the corpus of Greek legend[66] and those who attribute it to the impact the Homeric epics had on the imagination as they spread throughout Greece.[67] The irony of the Kerameikos stand is that its painter was probably affected by both imports and epic but that what he painted was not mythological narrative at all.

The problem of mythological narrative's origins is not solved, of course, by the removal of one entry from the list of eighth-century examples. The other protonarratives are still there [e.g., 43, 45, 46, 47]: how are they to be explained? The answer, I think, is to be found in the general conditions of late-eighth-century society and its aristocracy.

We are just beginning to realize the extent to which the Greeks of the Late Geometric period perceived themselves in relation to their Mycenaean predecessors—and how increasingly positive was the perception. Sometimes, it is true, they suffered in the comparison: there are those passages in Homer that stress the physical gulf between the Akhaians and Trojans, who easily lift huge boulders, and "the men of today" (that is, the members of Homer's audience), who are not even half as strong (cf. *Iliad*, V.302–4, XII.447–49). But there are other Homeric passages in which heroes and heroines—Hektor and Helen, for instance—are prophetically conscious of the role they will play in poetry and even act so that "men to come" will know of them (*Iliad*, VI.354–58, XXII.304–5; cf. *Odyssey*, VIII.579–80). Such passages establish poetry as heroism's raison d'être and entrust "the men to come"—"the men of today"—with its guardianship. The eighth-century audience of epic was thus made to feel that it somehow was bound to or participated in the tales it listened to: Homer's characters are aware of Homer's audience, and without "the men of today," the heroes of old know that they would cease to exist, that their *kleos* would fade away. These passages make a kind of connection between two worlds.

As the eighth century progressed, the differences between those worlds were undoubtedly thought to have diminished. Geometric colonists settled

66. See Carter, 58. The "Herakles" scene on the Kerameikos stand is crucial to his argument, but he ignores the animal bearers on the other legs.

67. See Gombrich (n. 62), chap. 4, "Reflections on the Greek Revolution"; Coldstream, *GG*, 341–46.

western lands visited long before by Mycenaeans and Geometric merchants sailed eastern commercial routes previously traveled by Mycenaeans, too. If the massed battles depicted on kraters [48] and the story of the panhellenic Lelantine War are any indication, Late Geometric Greeks also fought wars on a scale that must have now seemed to approximate the heroic. Of course, Geometric Greeks did not colonize, trade, and fight in order to imitate their Mycenaean forebears, but as they did all these things they could not have avoided the conclusion that they were becoming a better match for the heroes they venerated, more worthy of comparison. And in the second half of the eighth century Geometric Greeks began to make the comparison themselves in everyday life: in several important ways (not counting the creation of kantharoi after Bronze Age models or even the manufacture of bronze armor at Argos, where the memory of "bronze-armed Akhaians" may have been especially strong) they consciously, compulsively decided to act like Mycenaeans (or to act as they thought the Mycenaeans acted) and even to recreate a Mycenaean environment.

At Thermon, in a rugged part of northwestern Greece, for example, a Late Geometric temple known as Megaron B was built next to an apsidal building (Megaron A) left over from the Mycenaean age. The tripartite plan of Megaron B, its alignment, and its curved walls (and possibly the hairpin-like arrangement of the supporting posts later placed around the building)[68] mimic elements of the Bronze Age structure, which in all likelihood was preserved to a considerable degree. Bronze Age ruins must have been more common sights in less remote parts of Geometric Greece. Some were even reused: at Koukounaries, on Paros, Mycenaean walls were incorporated in Late Geometric houses, and on the island of Keos a Bronze Age temple began to receive offerings again around 750 (a head from a fifteenth-century terra-cotta statue even became an icon for eighth-century suppliants).[69] In the Dark Age, the great gateways and impressive stretches of monumental masonry that still stood at such places as Tiryns, Mycenae [16], and Athens probably depressed and denigrated Greeks who did not know how (and could not afford) to build in that way. But in the technologically advancing and more prosperous Late Geometric period, these ruins on at least one or two occasions became a source of inspiration. Atop the citadel at Tiryns a long, rectangular temple of Hera—its plan is an abridgement of the true megaron form—was built within and even reused

68. Dinsmoor, 42 and fig. 14. See now B. Wesenberg, "Thermos B1," AA, 1982, 149–57, who argues that these posts did not buttress the building but instead served as reinforcements to the mud-brick walls of a free-standing apsidal house (B1) built (still within the eighth century) after the destruction of Megaron B.
69. D. U. Schilardi, "The Decline of the Geometric Settlement of Koukounaries at Paros," in Greek Renaissance, 177; Coldstream, GG, 329–30.

parts of the Bronze Age palatial hall. And at the Argive Heraion a massive terrace wall was built in the late eighth century in a style deliberately imitative of Mycenaean Cyclopean masonry.[70] In a sense, "the men of today" here demonstrated that they could lift stones as heavy as the ones their heroes lifted after all.

Late Geometric Greeks did more than occasionally build like Mycenaeans: they also began to worship them. Hero worship of a sort had been known in Greece before, at Dark Age Athens, Ithaka, and Lefkandi.[71] But after 750 hero cults suddenly proliferated across southern and central Greece: votive offerings (vases mostly) were now placed in accidentally discovered tombs from Volimedia in Messenia to Mycenae itself to Menidi in Attica.[72] At Eleusis a Late Geometric wall was reverently built around a group of graves already five to eight centuries old.[73] And with just a few exceptions (Eleusis is one of them) the graves that Late Geometric Greeks so piously honored were Late Bronze Age or Mycenaean graves; that is, they correctly identified them as the resting places of the people who populated their heroic legends. Sometimes Late Geometric Greeks could not name the heroes they worshiped in these tombs.[74] It did not matter. That they were, generically, "heroes" was enough: Late Geometric Greeks had found their past, and insisted that they had done so. Bronze Age tombs must, of course, have been accidentally discovered from time to time before the eighth century, and such discoveries may explain certain events in the early history of Greek representation. But it was only now, after 750, that they had a profound and pervasive influence on the Greek psyche: something had happened or was happening to make it far more receptive to the impact of the past. At all events, by 700 or so hero cults could be established away from tombs: Agamemnon acquired his own shrine not far from the citadel he supposedly ruled at Mycenae, and Menelaos and Helen began to be worshiped at Therapne, near Sparta. In short, the Late Geometric Greeks who deposited their vases in ancient tombs and

70. See J. C. Wright, "The Old Temple Terrace at the Argive Heraeum and the Early Cult of Hera in the Argolid," *JHS*, 102 (1982), 186–201; contra, H. Plommer, "The Old Platform in the Argive Heraeum," *JHS*, 104 (1984), 183–84. There is another Late Geometric "Cyclopean" wall at Eretria; P. G. Themelis, "An 8th-Century Goldsmith's Workshop at Eretria," in *Greek Renaissance*, 157.

71. The burials of the Lefkandi "hero" and "heroine" and the construction of their peripteral *heroon* seem to have occurred, however, in the same period. This hero was a Dark Age warrior who became a legend virtually in his own time: he was not a Mycenaean. There is, interestingly, a later parallel for almost instantaneous heroization at Eretria, a city that had probably been founded by Lefkandiots; see Coldstream, *GG*, 350.

72. For hero cults, see J. N. Coldstream, "Hero-Cults in the Age of Homer," *JHS*, 96 (1976), 8–17.

73. G. Mylonas, *Eleusis and the Eleusinian Mysteries* (Princeton, 1961), 62–63, and Pausanias, I.39.2.

74. See Coldstream (n. 72), 10.

new sanctuaries lived a part of their daily lives in direct relation to the heroes of their imagination, and even aspects of their death could become tinged with the heroic. There is some evidence, for instance, that both the discovery of Bronze Age graves and the sort of burials described in Homer had an occasional impact on late-eighth-century forms of burial.[75] The evidence is actually problematic, since as a rule the Mycenaeans inhumed their dead while Homeric heroes are regularly cremated (cf. *Iliad*, XXII.161– 257, XXIV.782–804; *Odyssey*, XXIV.63–84): did not Late Geometric Greeks notice and wonder at the contradiction? It is likely, in any case, that Homeric funerary practice is an amalgam, drawing upon (and, of course, enhancing) what Homer or his tradition knew of real burials. But there can be little doubt that the mood of nostalgia for past ages, ancestors, and heroes was thick in almost every sphere of Late Geometric society.[76]

The *Iliad* and the *Odyssey*—grandiose invocations of the Heroic Age— were beyond much argument the greatest products of the Late Geometric period, a period that with its colonial and mercantile expansion, its wars, its architectural and political achievements, its repeated discoveries of Bronze Age tombs, its establishment of hero cults and so on, had a distinctly neo-Mycenaean character, and we cannot be far wrong if we imagine that Late Geometric Greeks considered themselves "the new Mycenaeans" (or Akhaians, as they might have put it). But the culmination of the hexameter epic tradition in the poetry of Homer was a symptom, an effect, of this pervasive and powerful infatuation with the heroic past: it was not its cause.[77] Now Auden was not completely right about the impotence of poetry, and Homer did make some things happen. He probably influenced a few late-eighth-century artists, such as the one who painted Odysseus' shipwreck on the neck of a jug [46]. There are, it is true, differences between this scene and Homer's account of the wreck (in the *Odyssey* the hero rides a raft of mast and keel to safety, while here he straddles a capsized but intact ship).[78] But it is wrong to insist on a perfect match, as if the Greek vase painter wanted to be like an illustrator of Victorian books. Geometric methods of image making put certain limits on illustration, and an important artist of the eighth century (or, for that matter, of any century) should be expected to find a way of making the narrative his own in any case. Homer probably also inspired the author of the inscription on "Nestor's cup" from Ischia, and he certainly (and most important) provided the Greeks with a

75. See Coldstream, *GG*, 349–52.

76. See now R. Hägg, "Funerary Meals in the Geometric Necropolis at Asine?" in *Greek Renaissance*, 189–93.

77. Contra, Coldstream, *GG*, 351. See now S. Hiller, "Possible Historical Reasons for the Rediscovery of the Mycenaean Past in the Age of Homer," in *Greek Renaissance*, 9–14.

78. See R. Kannicht, "Poetry and Art: Homer and the Monuments Afresh," *Classical Antiquity*, 1 (1982), 74–75.

purer sense of their Greekness. Effects can in turn become causes. Nevertheless, Homer did not make Late Geometric Greeks reclaim and recover their past; he was part of the recovery, at the same time that he deepened and strengthened it. And it was not specifically the circulation of the *Iliad* and *Odyssey* that jarred Greek artists loose from their generic nonnarrative ways. The number of mythological narratives from the late eighth and early seventh centuries depends on who does the counting, but only a small fraction—something like 10 percent by one count[79]—is conceivably Homeric in content. If recitations of the *Iliad* and *Odyssey* really inspired Late Geometric artists to rush, stunned, from the performance to their workshops to translate what they had just heard into paint or bronze, we would expect the percentage to be much higher. As it is, when they decided to illustrate myth at all, late-eighth-century artists typically chose stories that would later be codified in the lesser poems of the "epic cycle" (post-Homeric epics dealing with the legendary events that took place before and after the ones Homer relates) or the stories told in Hesiod (who also mentioned the deformed sons of Aktor and who first mentioned the Nemean Lion) or, most of all, simple unversified folktales—the tall tales told to children on their grandparents' knees. The dearth of scenes taken from the *Iliad* and *Odyssey* in eighth-century art is persuasive: Homeric epic could not have been the singular, efficient cause of the narrative revolution.

But if Homer did not make that revolution happen, neither did Hesiod and neither, surely, did vernacular folktales. There had always been folktales, there had not always been narrative art, and if most of the subjects of early Greek narrative were taken from "ordinary myth," "ordinary myth" was not necessarily narrative's cause: a source and a cause are not always the same thing. The problem remains, but the rise of narrative must not be considered apart from the other phenomena of self-consciousness, self-confidence and nostalgia that characterized the Late Geometric period. The depiction of heroes in this neo-Mycenaean era was another way "the men of today"—but particularly the men of the aristocracy—established contact with the men of the age of bronze: it was another way of affirming and reinforcing the bond. And the bond was particularly useful in the new age of the polis, when the aristocracy's relation to the rest of society had changed: aristocrats were still in control, but they no longer ruled from their households (*oikoi*) alone. Narrative art, then, may have been used to claim heroic pedigrees for the nobility, and to insist on its right to remain nobility in a polis society. By commissioning illustrations of the exploits of their legendary predecessors—Herakles, for instance, the consummate workhorse of civilization and its defender against the monstrous [47], or

79. See A. M. Snodgrass, "Poet and Painter in Eighth-Century Greece," *PCPS*, 25 (1979), 118–30, who counts 68 mythological narratives, 7 to 9 of them "Homeric" (120). Also, *AG*, 71.

Odysseus, the prototypical traveler and survivor [46], or even Nestor, who once met the twin sons of Aktor in battle [45][80]—Late Geometric aristocrats fashioned their own reassurance. In narrative art they projected images of themselves, just as they had long projected images of their own importance in the nonmythological but elaborate burials and battles on Geometric grave markers. Like the climax of the epic tradition in the poetry of Homer, like the emergence of the polis itself, the use of mythological narrative was part of a complex process of definition. The definition took place against a broad, distant, and indistinctly seen Mycenaean backdrop, but heroes and legends now began to appear in art not only because Greek civilization was better able to endure comparisons with the Heroic Age, but also because Greek aristocrats recognized the social or political value in making those comparisons. Greeks could now create images of their legendary past because of both a new pride in the present and a need to validate it.

But there was probably one more factor in this Late Geometric invocation of the Heroic Age, in this renaissance: the intensification of contacts with the Near East. It may well be that the confrontation with the established, sophisticated civilizations of the East produced a kind of cultural anxiety among the Greeks, a need to seek their own cultural roots—and their own cultural models—in response. It is always comforting to look backward, and the Greeks of the late eighth century found both comfort and models in their legendary past. By creating narrative images, in other words, they asserted their own identity, and the neo-Mycenaean character of the Late Geometric renaissance was thus partly fueled by a conservative, even reactionary impulse.[81]

80. *Iliad*, XI.709–10. See Coldstream, *GG*, 352, who ingeniously suggests that the sons of Aktor became the "family crest" of the aristocratic Neleid clan of Athens, which traced its descent from Nestor himself. Also H. A. Shapiro, "Painting, Politics, and Genealogy: Peisistratos and the Neleids," in Moon, 87–96.
81. Cf. the comment of E. C. Kopff in *Greek Renaissance*, 210.

4

The Edge of Disorder:
The Seventh Century

Originality and the Orient

The poet of the *Iliad* has a kind word for eastern artisans: it is *polydaidaloi*, "of many skills," and it is used specifically of Sidonian (Phoenician) craftsmen who made a large silver krater, "the most beautiful on earth," that Akhilleus awards as first prize in one of the funeral games of Patroklos (XXIII.740–49). The poet of the *Odyssey*, however, is not so ready to praise either Phoenicians or their wares. Punning on the *Iliad's* epithet, he calls Phoenicians *polypaipaloi*, "of many tricks." They are here renowned for their craftiness instead of their craftsmanship.[1] They are *trōktai*, "cheaters," and they no longer make or trade in splendid silver bowls but flood the market with countless knickknacks, *athyrmata* (XV.415–19). Phoenicians made frequent appearances in the expanded Greek world of the eighth century, and it is as if, by the time the *Odyssey* took shape, familiarity had bred contempt. *Polypaipaloi* and *trōktai* are the sort of words a people that had only lately begun to establish its own identity and difference might use of another people that was not just foreign but also adventurous, competitive, and successful: condescension is the last refuge of the envious. The *Odyssey* reveals for the first time the enduring Greek sense of the Orient as cultural antagonist—and the enduring bias it produced.

The irony is enormous. If (as I believe) the *Odyssey* was composed toward the end of the eighth century, it was composed at the start of what is called the Orientalizing period of Greek art—a century or so in which Near Eastern styles, techniques, decorative motifs, and even subject matter so pervade Greek bronzework, vase painting, and sculpture that the dividing

1. Cf. R. Carpenter, "Phoenicians in the West," *AJA*, 62 (1958), 35–36.

line between Greek and Oriental seems at times to fade away. The ivory group of a skirted, pudgy god and his upright pet lion shown in figure 55 would not look out of place amidst the treasures of an Assyrian palace. But it was not found in the East: it was found at Delphi and the god was probably supposed to be Apollo when the piece was dedicated there early in the seventh century. The ivory could be an Oriental import. Or it could be the product of an easterner who had set up shop somewhere in Greece. Or it could be a truly Orientalizing work, the creation of a Greek laboring under the spell of the East. There is no way to tell, and it does not really matter. Whoever made it, the ivory was not really foreign to the material culture of early-seventh-century Greece. In such cases, Greece seems so receptive to the Orient that it almost seems an appendage to it, a cultural extension—the East, Aegean branch.

Oriental influence was nothing new, of course, and the Greeks had already learned a lot from the East by the time the Orientalizing period

55. Ivory group of Apollo(?) and lion (Delphi Museum), around 675. Photo courtesy of Ecole Française d'Archéologie, Athens.

The Art and Culture of Early Greece, 1100–480 B.C.

technically began (around 720 in some parts of Greece, around 700 in others.). The Dark Age and Geometric Greek iron and gold industries depended on the importation of eastern technologies. Athenians, Euboians, and others had begun to take Oriental bowls, faience, and trinkets of various sorts with them to their graves hundreds of years before 700. One or two Phoenician jewelers had settled in ninth-century Athens, and Oriental goldsmiths, bronzeworkers, and shield makers had established thriving businesses on late ninth- and eighth-century Crete. The raw material for such early Greek masterpieces as the ivory goddess from the Dipylon shown in figure 56 obviously came from the East, where elephants still roamed; but so did the way she stands and the way her eyes are carved and the kind of hat she wears (though not its meander band) and her nudity. Late Geometric vase painters and engravers were not above stealing an Eastern ornamental motif now and then to decorate their pots and fibulae, and even the grazing deer and recumbent goats painted by that quintessential Greek the Dipylon Master [37] probably owe something to Phoenician or Syrian ivories. We have examined both the possibility (and a possibility it must remain) that a confrontation with eastern artifacts played a role in the rebirth of representation in Dark Age Greece and the likelihood that a Late Geometric figured scene or two are modeled directly on eastern images [51, 53]. In other fields there is, of course, the alphabet, perhaps the most important borrowing of all. But it has also been argued recently that a few passages of the *Iliad* are dependent on Phoenician or Aramaic versions of Mesopotamian epics, that the Olympic Games, that quadrennial exercise in and expression of Greekness, were indebted to Phoenician athletics, that Greek prophets and diviners learned their trade from itinerant easterners, and even that the very idea of the polis, the one institution that is most often supposed to be distinctively and indelibly Greek, was yet another Phoenician import.[2]

One does not have to believe all of this to be convinced that the orientalizing impulse was going strong even in pre-Orientalizing Greece. The late eighth and seventh centuries simply saw an intensification of it, and they provide more data—literary and mythological as well as artistic and architectural—for those who consider the Near East the source of all blessings, and then some. The epic poet Hesiod (who was probably a rough

2. For Late Geometric but Orient-inspired patterns see, for instance, B. Borell-Seidel, "Spätgeometrische Kreisornamente," in *Tainia: Festschrift für Roland Hampe*, ed. Herbert A Cahn and Erika Simon (Mainz, 1980), 39–60; for the Dipylon Master's debt to oriental carvings, see Carter, 40–42; for eastern influence on the *Iliad* and on Greek prophecy, see W. Burkert, "Oriental Myth and Literature in the *Iliad*" and "Itinerant Diviners and Magicians," in *Greek Renaissance*, 51–56, 115–19; for Phoenician influence on the Olympic Games and the emergence of the polis, see L. Boutros, *Phoenician Sport: Its Influence on the Origin of the Olympic Games* (Uithoorn, 1981), and Snodgrass, *AG*, 30–31 (but see also C. Starr, *Economic and Social Growth of Early Greece* [New York, 1977] 31).

The Edge of Disorder: The Seventh Century

56. Ivory figurine of a goddess from the Dipylon cemetery (Athens NM 776), around 730. Photo courtesy of Deutsches Archäologisches Institut, Athens.

contemporary of the *Odyssey's* Homer and who should be dated around 700) has been considered an Orientalizing poet: his didactic epic *Works and Days* is squarely in the tradition of eastern wisdom literature, and the central myth of his *Theogony*—the gory succession of Ouranos, Kronos, and finally Zeus as rulers of the cosmos—is strikingly related to a Hurrian-Hittite tale (the myth of Kumarbi). Impressed by such parallels, one expert on Hesiod has gone so far as to conclude that "Greek literature is a Near Eastern literature."[3] Many of the heroes who are mentioned by Hesiod and who dominate seventh-century narrative art perform their heroics in eastern lands or destroy monsters apparently of eastern derivation. Bellerophon, for instance, time and again rides Pegasos against the Khimaira on Orientalizing vases [66]: both the elegant winged horse and the lion hybrid have Near Eastern pedigrees (though Pegasos' bloodline is purer) and even the poet of the *Iliad* knows that the Khimaira was killed in the Anatolian kingdom of Lykia, just east of the Aegean basin (VI.170–83). Perseus, who decapitated the Gorgon Medousa (Pegasos' inelegant mother) somewhere beyond Ocean in the farthest land toward night (*Theogony*, 274–75), is said to have been otherwise engaged in Anatolia and the Levant. The Kyklops Polyphemos, whose grisly blinding is a favorite subject of Orientalizing artists [73], has distant one-eyed Near Eastern cousins. Some of Herakles' labors (for instance, his battle against the Hydra, who happens to have been the Khimaira's mother) so closely parallel the struggles of Near Eastern monster-slayers that he has seemed, to some, a pastiche of eastern heroes (such as Gilgamesh) in Greek dress (and not even the dress need be Greek: Oriental heroes wore lion skins and carried bows and clubs thousands of years before Herakles began to do so, in the second half of the seventh century). The Greeks could borrow gods, too; Adonis is an import from the Levant (Hesiod called him "the son of Phoinix," that is, a Phoenician). Even Zeus himself had his own eastern exploit: part of his difficult combat against the huge, hundred-headed, fiery-eyed, and very loud Typhoeus, the last threat to his heavenly rule, took place in Cilicia and in northern Syria, atop Mount Kasios. The whole story seems dependent on another Hittite myth (the myth of Illuyankas), and it is not likely to be coincidental that, standing virtually in the shadow of Mount Kasios, was Al Mina, Greece's first trading post in the East. As the Greeks ex-

3. M. L. West, *Hesiod: Theogony* (Oxford, 1966), 31. Few doubt the priority of the Hurrian-Hittite myth of Kumarbi over Hesiod's story of Kronos (one who does is G. S. Kirk, *Myth: Its Meaning and Functions in Ancient and Other Cultures* [Berkeley, 1970], 219). Nonetheless, the date of the borrowing is uncertain: along with West (28–30) and others, I think it occurred in the late second millennium. But P. Walcot, in *Hesiod and the Near East* (Cardiff, 1966), argues for Babylonian influence in the eighth century, and in his *Hesiod: Works and Days* (Oxford, 1978), West leaves open the possibility of eastern influence over that epic at the later date (29–30).

57. Early Protocorinthian oinochoe from Kyme (Cumae) in Naples (National Museum 128199), around 710. After H. Payne, *Necrocorinthia* (reprint, College Park, Md., 1971), 9, fig. 4.

panded their commercial horizons, their divine and heroic landscapes evidently expanded, too.[4]

In the realm of ornament the Near East and Egypt supplied a wide variety of motifs, animal and vegetable. Tendrils or volutes that grow from nowhere swirl over some vases [57], repudiating the tectonics and right angles of Geometric with supple, sweeping curves. Other vases are generously, even haphazardly sprinkled with rosettes, cables, tongues, spirals, and curlicues. Formalized "trees of life," lotuses, palmettes, and bizarre plants that look like cacti sprout up like weeds or hang down like chandeliers; lotuses and palmettes are neatly chained together to fill continuous friezes. The Orientalizing menagerie contains real and fantastic animals

4. For Oriental models for Pegasos and the Khimaira, see E. Akurgal, *The Art of Greece: Its Origins in the Mediterranean and the Near East* (New York, 1968), 187–88; for Perseus in the East, see J. Fontenrose, *Python* (Berkeley, 1959), 276–81; for eastern Kyklopes, see M. Knox, "Polyphemos and his Near Eastern Relations," *JHS*, 99 (1979), 164–65; for Herakles' Oriental counterparts, see W. Burkert, *Structure and History in Greek Mythology and Ritual* (Berkeley, 1979), 80–83, and Akurgal, 188–89; and for the Typhoeus myth and its Near Eastern connection, see Hesiod, *Theogony*, 820–68; Apollodoros, I.6.3; Burkert, 7–9; and Akurgal, 166.

The Art and Culture of Early Greece, 1100–480 B.C.

alike. Boars, wild goats, dogs, roosters (the Greeks always called them "Persian birds"), lions (whether there were still any lions in Greece or not, seventh-century examples are most often based on Neo-Hittite and Assyrian prototypes), frontal-faced cats (conventionally called panthers), sphinxes, sirens, and griffins endlessly parade around countless seventh-century vases [63, 64, 70] but rarely pounce on one another: the Orientalizing "animal style" is an elegant diversion, rendering even the beasts of the imagination harmless through rhythm and repetition. Bronze sirens and lion and griffin protomes are also used to decorate the rims of large cauldrons [11], and that idea, like that of the hybrid griffin and the siren, is another borrowing from the East.

In sculpture, ivory continued to be imported in quantity, and so, evidently, were ebony (from Ethiopia, via Egypt) and cedar (from Lebanon), two woods that were used for eighth- and seventh-century *xoana* (carved images), some on a large scale, perhaps even life-size or more.[5] The making of *sphyrelata*, images made of hammered bronze plates riveted together like armor, was probably dependent on eastern technology, too: the earliest extant examples date to just before 700 and come from Crete, which, again, had long been home to eastern metalworkers.[6] Orientalizing Crete was also the birthplace of the so-called Daidalic style, which, created under the impact of Syrian terra-cottas, techniques, and attitudes, dominated seventh-century sculpture—free-standing and architectural, on Crete and off, on a large scale or small, in limestone, terra-cotta, ivory, or metal. The earliest *kouroi* and *korai*—the first representatives of Archaic sculpture's leading types—were Daidalic in style. But invented in marble, probably on Naxos and Samos in the middle of the century, the monumental *kouros* and *korē* owe even more to lessons learned in Egypt.

Egypt offered Greek visitors (and settlers) gigantic spectacles of stone architecture as well as sculpture, and the Egyptian experience must have reinforced (if it did not initiate) Greek attempts at monumental temple building. At the very least, Egypt supplied one or two kinds of decorative molding. At most, the Egyptian temple supplied the very idea that architecture could be both huge and stone and, with its rows of fluted columns that tapered from bottom to top and that were sometimes crowned with square slabs of stone (abacuses), contributed to the formulation of the Doric order of the Greek mainland. But whether Egyptian influence over the form of the Doric temple was great or small, Greek techniques of quarrying, lifting, clamping, and finishing heavy stone blocks were either

5. Cf. Pausanias, VIII.17.2. See R. Meiggs, *Trees and Timber in the Ancient Mediterranean World* (Oxford, 1982), 308–12.
6. See Boardman, *GS*, fig. 16. Pausanias indicates that "the oldest bronze statue of all" was a *sphyrelaton* of Zeus Hypatos at Sparta (III.17.6). Regrettably, he does not say how old it was.

58. Restored drawing of Aeolic column capital from Old Smyrna, late seventh century. After P. P. Betancourt, *The Aeolic Style in Architecture* (Princeton, 1977), p. 60, fig. 20.

learned or refined under Egyptian instruction. And Egypt was not the only part of the Near East to affect Archaic Greek architecture. North Syrian and Phoenician designs inspired late-seventh-century builders in the northeast Aegean (from the Hellespont down to Old Smyrna) to develop the so-called Aeolic order, characterized above all by its two-sided column capital of vertically rising paired volutes [58]. And though the different volute capital of the Ionic order (a nearly contemporary but independent and more important development of eastern Greece) owes rather less to Near Eastern architectural forms, the order as a whole, particularly in its rich floral and vegetable decoration, is distinctly Orientalizing in character.[7]

The litany of Oriental influences, both proven and possible, can be made much longer (and more numbing) than this (to name just one more, the Greeks probably learned the technique of eating and drinking while reclining on their sides from easterners). As it is, few ancient peoples might seem to have been less original than the Greeks of the seventh century. The impression is that they borrowed so much so eagerly from Egypt and the Near East that their very Greekness was in peril, that the culture of Orientalizing Greece was derivative, that the Greeks could think of nothing for themselves. The impression, of course, is absolutely false. Weak cultures imitate, strong cultures steal, and like most clichés, the old adage that the Greeks always transformed what they took holds true. The *Theogony*'s myth of the succession of Ouranos, Kronos, and Zeus, for in-

7. For Egyptian influences on Greek architecture, see Coulton, 32–35 and 45–50. For the Aeolic order (and its relationship to Ionic), see P. P. Betancourt, *The Aeolic Style in Architecture* (Princeton, 1977).

stance, has a balance or symmetry that is absent in its Hurrian-Hittite counterpart[8]—and that stamps Hesiod's account as characteristically Archaic and Greek. At all events, though the basic story pattern of the succession may have been borrowed from the East, it is possible that it was borrowed not in the eighth or seventh century at all, but in the second half of the second millennium (1400–1200), when Mycenaean Greeks were particularly active in the Levant. A tale that was assimilated five hundred years or more before Hesiod wrote his epic might just as well be called Greek. As for Herakles, he probably owes less to eastern heroes than all of them owe to common prehistoric sources—"narrative structures" that go, perhaps, all the way back to Palaeolithic and Neolithic times.[9] Herakles is not an imported hero but a cognate hero, and he is every bit as Greek as Gilgamesh is Mesopotamian.

Greek literature and myth are not eastern. Neither are Greek art and architecture. Orientalizing art is Oriental on the surface but still recognizably Greek below. As it turns out, very few works are as equivocal as the lord and lion from Delphi [55], and even the Dipylon ivory goddess of the preceding century [56], for all her eastern features, is in the clear articulation of her svelte bodily parts positively Geometric—the meander on her hat almost seems the artist's way of certifying her as such. In painting, too, the Near East had no real impact on the development of the Greek figured style: Greek painters generally rejected the short, squat, fleshy types they saw on imported works, even when their own pictorial tradition was new [30, 31]. Moreover, the Orientalizing figured style is most readily traced on painted vases, yet such vase painting was practically nonexistent in the contemporary Orient.[10] It is a fairly easy matter to tell a Greek siren or griffin protome from an eastern one: the Greek [11] has a clarity of form and an internal echoing of line and pattern that is missing in the import. The Daidalic style, as Orientalizing and widespread as it was, was ultimately a dead end: after 600 or so, Greek sculptors had little more to do with it. And even the marble *kouros* is not just a statement of (or paean to) Egyptian influence: in important ways it is an assertion of Greek independence and originality. Finally, whatever Greek builders owed to Egyptian and Levantine architecture, the way they combined columns, bases, capitals, and entablatures to form the Doric and Ionic orders [59] was new: the Doric and Ionic temples were Greek inventions, not eastern ones.

This brief survey is meant to correct the impression left (unintentionally perhaps) by many studies of Oriental influence that late eighth- and sev-

8. Kirk (n. 3), 218–19.
9. Burkert (n. 4), 88–98.
10. J. Boardman, *Pre-Classical* (New York, 1967), 75. Boardman sees more eastern influence on the human figure than I do. Cf. R. M. Cook, *Greek Painted Pottery*, 2d ed. (London, 1972), 43.

59. The Doric (*a*) and Ionic (*b*) orders. From J. J. Coulton, *Ancient Greek Architects at Work* (Ithaca, N.Y., 1977), 190, fig. 71, by permission of Cornell University Press.

enth-century Greece was like a dry sponge, passively, indiscriminately, and inevitably absorbing whatever Egypt and the Near East happened to drip upon it. The word "influence" itself is probably part of the problem: such statements as "Greek art was influenced by the Near East" make it seem as if Greek artists had no choice in the matter. They had a great deal of choice, and it is instructive to note a case in which they chose *not* to be influenced. Athens was most directly in contact with the East in the middle of the eighth century: it was then that Athenian artists *should* have turned Orientalizing if they were as impressionable as they are sometimes said to have been. Yet this is precisely when they did their "most consummate geometric work,"[11] ignoring—or perhaps reacting against—eastern forms

11. Brann, 18.

The Art and Culture of Early Greece, 1100–480 B.C.

and styles. Even the "Orientalizing" goats and deer in the Dipylon Master's animal friezes [37[have been brought completely under the control of the Late Geometric aesthetic: the Greek vision transformed the Oriental influence, not the other way around.

Influence, in short, is not a process of easy, mindless reception. It is a process of active selection, and it is sometimes laborious, as Greek students of Egyptian sculpture and building must have found out. The course of Greek art was not dictated by the East: Greek artists turned Orientalizing deliberately and selectively, because what they saw in the East or in imported eastern *athyrmata* served their own developing purposes. The decision to be influenced, in other words, is also a mark of originality and cultural strength, and it can be a kind of positive response.

Greek culture thus continued to establish its difference and to define itself in the seventh century. It was an extraordinary age of ferment, experiment, exuberance, diversity, individuality (in a special sense), and invention—qualities that are found in abundance in its lyric poetry, vase painting, and monuments of stone.

Lyric Poetry, Signatures, and Social Change

This is how Hesiod, near the beginning of his epic on origins, says he began his poetic career:

> Now once they [the Muses] taught Hesiod lovely song
> as he tended lambs on holy Helikon.
> And to me the goddesses spoke these words first,
> the Olympian Muses, daughters of aegis-bearing Zeus:
> "Shepherds of the field, evil wretches—bellies, no more—
> We know how to tell lies that are like the truth
> but we know how to tell the truth, too, when we wish."
> So they spoke, the word-perfect daughters of great Zeus,
> and breaking off a bough of luxuriant bay they gave it to me,
> a wondrous staff. They breathed divine
> voice in me, to tell of things to come and things that have been,
> and they told me to sing of the order of the blessed and eternal gods,
> but always to sing of them first and last.
>
> [*Theogony*, ll. 22–34]

This is how Archilochos was said to have become a poet (or at least to have discovered that he would grow up to be one):

> They say that Archilochos, when still a child,
> was sent by his father Telesikles
> to the country, to the district called Meadows,

to bring back a cow for sale, and that he rose
early in the night, while the moon shone,
to lead the cow to town. But when he reached
the place called Lissides, he seemed to see
a crowd of women. Thinking they had left
their work to go to town, he jeered them, but
they greeted him in sport and laughter and
asked if he was bringing the cow to sell. When he said he was,
they said they would give him a fair price.
They no sooner said those words than both they and the cow
vanished, but at his feet he saw a lyre.
He was wonder-struck. After some time he
came to his senses, and understood that the women he saw were the Muses,
and that they had given him the lyre. He picked
it up and went to town and showed
his father what had happened.

[Mnesiepes Inscription, ll. 22–40]

As we have it, the tale of Archilochos and his disappearing cow dates to
the third century, four centuries after the poet's lifetime (690–640?). But in
all probability there were earlier versions of the story,[12] and it is tempting
to use it, along with Hesiod's own account of his visionary confrontation
with the Muses, to symbolize fundamental differences between epic and
lyric, the dominant poetic genre of the seventh (and sixth) century. The
Muses do not just call Hesiod to poetry: they teach him what to sing,
literally inspiring ("breathing into") him. The epic poet, that is, is their
vehicle (Homer's invocations make the same point), and that seems to be a
way of saying that he is the recipient of a lengthy poetic tradition. He is not
separate from tradition; he is not completely responsible for what he sings.
In contrast, the Muses do not teach Archilochos a thing. They deposit a
lyre at his feet and so choose him as one of their own, but then vanish
without a trace or word of advice. Archilochos is abandoned the instant he
is called: without the Muses—Tradition—to breathe into him, he will be
forced to create entirely on his own. Taken together, the two stories seem
to suggest that with the apparent shift from epic to lyric in the seventh
century came a corresponding shift in the nature (or conception) of the
poet from traditional to traditionless.

The juxtaposition of the stories is less instructive, however, than it may
seem to be. There are indeed fundamental differences between epic and
lyric, and the dominance of lyric in the seventh century was at least partly
due to the extraordinary achievements and innovations of such poets as
Archilochos (there is no reason to suspect the general reputation for in-

12. See M. Lefkowitz, *The Lives of the Greek Poets* (Baltimore, 1981), 27–28.

The Art and Culture of Early Greece, 1100–480 B.C.

ventiveness he enjoyed even in antiquity). But lyric poetry was not the invention of the seventh century and it did not chronologically "succeed" epic. Archilochos had predecessors, just as Homer and Hesiod did: he was not entirely on his own after all. In fact, the lyric tradition goes back even farther than the epic one, and we can catch glimpses of it in, of all places, the *Iliad* and *Odyssey*. In the *Iliad* Homer mentions hymns and paeans to the gods (I.472–74), maiden songs (XVI.182–83), bridal songs (XVIII.493), laments or dirges (XXIV.720–21), and harvest songs (XVIII.569–72), and in the *Odyssey* he mentions work songs (X.221–22). We know that Eumelos (the late-eighth-century epic poet of Corinth) wrote a processional song for a chorus that performed on Delos probably around 730: we have two lines of it—the earliest extant Greek poetry that is not epic.[13] And we can safely guess that the prehistory and Dark Age of Greek poétry included drinking or party songs, fables, and "personal poetry" (love songs, for instance) as well.[14] Seventh-century lyric was not written on a clean slate.

Epic and lyric had thus coexisted for many centuries before 700 and they have some things in common. Like epic, lyric was always meant to be performed (though it was usually performed before a different kind of audience). Some lyric poems use traditional epic language and some borrow, address, or elaborate on themes and concerns announced in Homer. Occasionally lyric poets dealt with myths (Archilochos wrote a lost poem about Herakles, Deianeira, and the centaur Nessos [cf. 72]) and they could even compose heroic narratives as long as one or two thousand lines (Stesichoros, active from about 600 to 560, grandly narrated such stories as Herakles' battle with Geryon, the hunt of the Kalydonian Boar, the Orestes saga, and even the fall of Troy, "supporting on his lyre the weight of epic song," as one ancient commentator put it.)[15] But despite such points of contact, lyric and epic are very different classes of poetry. Still, it is difficult to pin lyric down. The simplest, narrowest definition is that lyric poetry is poetry meant to be sung or recited to the lyre. But that is also the worst definition, since it would make lyric poets out of such epic bards as Homer, who used a kind of lyre, and Demodokos (*Odyssey*, VIII.261– 65), and even Akhilleus (*Iliad*, IX.186–87), yet exclude such poets as Archilochos himself, who (despite the tale of the cow, the Muses, and the lyre) normally sang to

13. See Pausanias, IV.33.2, and G. L. Huxley, *Greek Epic Poetry from Eumelos to Panyassis* (Cambridge, Mass., 1969), 62.

14. Interestingly, many of the same kinds of poetry—hymns to gods, songs of harpers, fables, festival songs, love songs, songs of personal torment—are paralleled in Near Eastern and Egyptian literature; yet the parallels exist, it seems to me, because human beings and their situations, desires, and emotions are parallel, not because of any eastern influence on the rise of Greek lyric poetry. Moreover, Greek lyric poetry has something Oriental lyric poetry (as far as we can tell) does not: meter. Lyric poetry in strict metrical patterns is a wholly Greek phenomenon.

15. Quintilian, *Institutio oratoria*, 10.1.62.

the sound of a flute or to no instrument at all. Lyric can be classified according to metrics (in which case melic, elegiac, and iambic are the principal divisions) or according to the number of voices that did the singing (solo song, or monody, as opposed to choral song) or even according to occasion, context, or audience (some lyrics were intended to be sung before a small, convivial group of friends, others before the entire body politic or armies). But no one description or classification of lyric will do, and it is doubtful that Archaic lyric poets would even recognize, let alone agree with, the definitions and categories we try to impose so neatly upon them. And yet if lyric (like pornography) is hard to define, one still knows it when one sees it. So let us say broadly that Archaic lyric poetry was that body of Archaic poetry—now badly tattered and fragmentary—that was not epic, in the tradition of epic, or dramatic; let us add that a lyric poem is usually (though by no means necessarily) a short poem set to music (string or wind); let us stress that lyric is probably to be defined as much by mood, perspective, tone, and content as by meter and form;[16] and let us be done with it. For the really interesting question is not "What was Archaic lyric?" anyway, but "Why did lyric become the focus of the most vital Greek poetic energies when it did, in the seventh century?" Why did Archilochos and Tyrtaios and Alkman and Mimnermos and Sappho and Alkaios grow up to be lyric poets and not epic ones?

Major cultural phenomena seldom have single causes, and the apparent eclipse of epic by lyric soon after 700 seems to have resulted from the convergence of at least three factors. Ironically, one was the stupendous culmination of epic in the works of Homer and Hesiod. By the early seventh century their epics were surely recognized for the monuments they are—the "classic" statements of hexameter poetry, Homer's epics defining Greekness and the aristocratic ideal, Hesiod's ordering the generations of gods and heroes and the daily life of average men. Homer and Hesiod loomed large over the poets who followed, and the very existence of the *Iliad, Odyssey, Theogony,* and *Works and Days* deflected the best (and most anxious) poetic minds toward other genres. Lesser (if still competent) poets were content to compose hexameter hymns to the gods and epics in the Homeric and Hesiodic shadows. It was probably in the late seventh (or early sixth) century, for instance, that Stasinos (or Hegesias) wrote the *Kypria,* Arktinos the *Aithiopis* and *Iliou Persis* (the Sack of Troy), Lesches the *Little Iliad,* and Hegias the *Nostoi* (the Homecomings)—entries in the epic cycle that filled in (as far as we can tell, not very impressively) what Homer does not say about the origins, course, and aftermath of the Trojan War. But exceptional talents would have sensed that in the shadows lay mediocrity: to them the works of Homer and Hesiod proved obstacles to epic

16. See G. M. Kirkwood, *Early Greek Monody* (Ithaca, N.Y., 1974), 2.

production rather than encouragements. Eager to establish their own difference and originality, the most creative seventh-century poets turned toward the ancient, perhaps more primitive, but heretofore relatively neglected forms of lyric poetry.

The second contributing factor in the change of poetic focus was the spread and effects of literacy. In the *Phaedrus* (274–77) Plato's Sokrates claims that writing destroys memory, and in the sense that literacy subverted the central process of oral epic he was right. Now it is likely that even Homer knew how to write and did—at least a little. It is all but certain that Hesiod knew how to write and did—a lot. A strictly oral tradition is an impersonal tradition, and it would have prevented Hesiod's own identity from coming through at the opening of the *Theogony* and his (alleged) quarrel with his brother Perses and corrupt Boiotian *basileis* from figuring in the *Works and Days*. The best explanation for the fact that his name and personal history have stuck to his poems is that he wrote them down himself, thus separating them from their traditions, fixing them: the *Theogony* and *Works and Days* became his property, and any later rhapsode who recited the epics had to impersonate Hesiod.[17] But though they belonged to the first generation of literacy, Homer and Hesiod were still trained in the methods and language of oral epic: writing merely *aided* them. In contrast, writing largely *shaped* the lyric poets. They belonged to the second and third and fourth (and so on) generations of literacy: they were brought up in a literate culture, where memory was no longer vital, and that had important consequences for the poetic process. For one thing, the traditional formula receded in favor of the single, well-chosen, and long-pondered-over word. This is not to say that Homer and Hesiod were not aware of the power an individual word can have, or that lyric poets never used formulae: they did. But there is a shift in language and structure nonetheless: lyrics can be far more colloquial, for instance, and many derive their force from a single climactic verb or noun. In short, literacy gave the lyric poet a kind of compositional freedom (as well as a kind of responsibility) that the genuine oral poet did not know. Moreover, the technological limitations of seventh-century writing, which were still considerable, naturally promoted the production and "publication" of short poems: writing down lyrics simply took less ink, papyrus (if that was what was used), and labor than writing down lengthy epics.[18] Distributing them was easier, too. Lyrics were thus made to order for the modest technology

17. See West, *Theogony* (n. 3) 40–41.

18. Some lyrics (Stesichoros', for instance) could be hundreds of lines long, but most were far shorter, and some could have been as short as eight or even four lines. In any case, it is instructive that even the cyclic epics were far shorter than the *Iliad* or *Odyssey*—the *Kypria* was eleven books long, the *Iliou Persis* only two—and that even the literate Hesiod's *Works and Days* is only 828 lines long, his *Theogony* about 1,020.

at hand. Finally, writing creates a barrier between poetic creation and poetic performance: although lyrics were written to be sung in public, they were written in private, where there was opportunity for reflection (as well as revision). Unlike the truly oral epic, which theoretically was created in front of its audience, the written lyric was the product of a lonely, solipsistic act. The process of writing may thus have encouraged what seems to be one of the principal traits of Greek lyric: its apparent revelation of the poet's mental and emotional state, its introspection, its presentation of personality.[19] But this takes us to the third (and most complex) factor in the ascent of lyric: social change and the function of the poet.

The lyric age of Greece is also commonly referred to as "the age of the individual." The individual is variously supposed to have "emerged" or to have "risen" or to have been "discovered" after 700, and the most poetically gifted boys and girls are supposed to have grown up to be lyric poets instead of epic bards because lyric best served their individualism and need for personal expression. Now in one way the seventh century really does seem an age of individuals (at least in a way the ninth and eighth centuries do not): it is full of names. Names are conspicuous by their absence from the political, social, and economic history of Greece before 700;[20] the only names in the literary record of eighth-century Greece are Homer (and even that may not have been his real one) and, at the turn of the century, Eumelos and Hesiod; excluding legends, there are no names at all in the artistic record—just modern sobriquets such as "the Dipylon Master." But suddenly, after 700, there are names galore: Pheidon, Orthagoras, Kypselos, Periander, Prokles, Theagenes, Aristomenes, Kylon, Drakon, Megakles, Thrasyboulos, Pittakos, Kolaios, Menekrates, Battos, Telesikles, Archilochos, Terpander, Tyrtaios, Kallinos, Semonides, Alkman, Mimnermos, Sappho, Alkaios, Arktinos, Hegias, Stasinos, Lesches, Mantiklos, Pyrrhos, Kallikleas, Nikandre, and Deinodikes. This is just a partial list, and there are more names we only partly know: a cup found in the Athenian Agora (and dated to around 650–625) belonged to someone whose name ended in -ylos, and someone whose name could have been Antenor (some letters are guesswork) dedicated or owned (or just possibly made) a mid-seventh-century vase found on the Acropolis.[21] Around 650 the "sons of Brentes," whoever they were, set up a memorial to Glaukos, son of Leptines (and a friend of Archilochos), on Thasos. The sons of Brentes may or may not have been the creators of the monument as well as its dedi-

19. For general comments on the impact of writing on thought, see W. J. Ong, *Orality and Literacy* (New York, 1982), esp. chap. 4. Also, Humphreys, 218.
20. Thoukles and Archias, founders of Naxos and Syracuse, are two exceptions.
21. For the Agora cup, see Brann, 89, no. 511; for Antenor's signature, see Beazley, *Development*, 8 and n. 22.

cators. But it is the certain appearance of artists' names and signatures that is especially significant.

The spread of literacy, of course, made signatures possible, but it did not make them necessary or inevitable. Mycenaean artists did not sign their works, though they had access to Linear B. Artists in the literate Near East did not sign theirs, either. And only a handful of artists' names are known from all the millennia of Egyptian art. In the rest of the Mediterranean world, signing works of art simply was not a normal thing to do. Yet around the same time that Hesiod "signed" his name (or represented himself) at the beginning of the *Theogony*,[22] Greek artists rapidly, even eagerly, shed their anonymity. Around 700 a potter/painter on Ischia signed an otherwise undistinguished bowl, and the sherd that is left bears a piece of the signature: ". . . inos made me."[23] Meanwhile, the first great vase painter of post-Geometric Athens signed his name on a plaque (both plaque and signature are in ruins, so the artist is still known as the Analatos Painter).[24] Around the middle of the century, when a Greek émigré living in Italy decorated a large krater with a naval battle on one side and the blinding of Polyphemos on the other, he wrote above the Kyklops, "Aristonothos made me"—and Aristonothos is one of the first Greek vase painters whose full name we know. Istrokles, a potter who made and signed a vase found at Old Smyrna, is another. Around 650–620 a Naxian painter signed a vase with a chariot parade (though here the name is lost).[25] And another Naxian is the first stone sculptor we hear from: all that is left of a *kouros* set up on Delos around 625 or 600 are his feet, his base, and the inscription "Euthykartides of Naxos made and dedicated me" [60]. Writing, in short, enabled the seventh-century artist to announce his identity, and such artists as Aristonothos and Euthykartides helped establish an enduring Greek practice. But the new technology by itself was not enough: one had to have the impulse to sign—the desire to proclaim oneself and one's works—and something about Archaic Greek society (alone among the contemporary cultures of the ancient world) had to make that impulse acceptable. That something might as well be called the recognition of the individual.

But this is not what is normally meant by those who speak of the "discovery of the individual" in the seventh century. They mean that there was a change in the character of the Greek people, that the seventh century

22. If the career of the elegiac poet Theognis can be placed in the seventh century, his poetry contains another early instance of such a literary "signature." See M. L. West, *Studies in Greek Elegy and Iambus* (Berlin, 1974), 149–50.

23. Jeffery, *AG*, 64, fig. 1.

24. See L. H. Jeffery, *Local Scripts of Archaic Greece* (Oxford, 1961), 110, pl. 16, 1.

25. See *BCH*, 85 (1961), 850 and fig. 3.

60. Base of a *kouros* made and dedicated by Euthykartides of Naxos (Delos A 728), around 625–600. Photo courtesy of Ecole Française d'Archéologie, Athens.

witnessed a new phase in the evolution of the "Greek spirit," and that a brand-new Zeitgeist wafted over the Aegean. They mean that there was a general psychological crisis in which the individual Greek felt alienated from a polis society that was undergoing serious strain, and that the century was pervaded by the perception that the world was ephemeral and humankind helpless. And they mean that the epics of Homer no longer spoke so well to the Greeks of the era, that Hesiod, who tells his personal history and rails against the lords of Boiotia, represents a transition of spirit, and that lyric rose to poetic dominance because it was the proper means of expressing anxiety, fear, alienation, emotions, and new ideals, and because it set off the individual—the introspective self—from the turbulent external world.

It would be hard to prove that a Greek of around 650 was any more angst-ridden or neurotic than a Greek of 750 or 850, but there is no denying that the seventh century was a period of turmoil, fundamental social change, and even revolution. The threat or reality of war, for instance, either with other Greeks or with barbarians, was nearly continuous: in 669/68 the Spartans were defeated by the Argives at the battle of Hysiai; in

The Art and Culture of Early Greece, 1100–480 B.C.

664 Corinth and its colony of Corfu came to blows; in the middle of the century marauding Kimmerians swooped down on Ionia; and at century's end Old Smyrna was destroyed by the forces of Lydia (a kingdom that would have much more to do with the course of Archaic Greek history). Many of the names we know—Pheidon of Argos, Orthagoras of Sikyon, Kypselos of Corinth, for example—are the names of extraordinary individuals who became tyrants, unconstitutional and absolute rulers who overthrew entrenched aristocracies in many of the most prosperous and progressive Greek city-states. Tyrants (the word was not derogatory at first) either acquired or maintained power with the support of the hoplite class—the well-to-do nonaristocrats who could afford costly bronze body armor and round shields (*hopla*), who formed the state's first (and densely packed) line of defense [67], but who had under the aristocracies no real political power. Yet virtually every tyrant had been an aristocrat first, and the spread of tyranny—it almost seems to have been contagious—was the result not of popular discontent or of true class struggle but of strife between aristocratic factions, normally precipitated by some military or political crisis that the old regime could not handle or by the exclusive, arrogant behavior of the dominant aristocratic clan. At all events, in many seventh- (and then sixth-) century poleis the aristocrats lost their political and military monopolies to autocrats and hoplites (aristocrats and hoplites, in fact, fought side by side in the phalanx). And they lost their economic monopoly as well. In this era of extensive trade abroad and expanding productivity at home, profits earned in commerce and crafts could rival landed, hereditary wealth. Hoplites were men of some means. Euthykartides the sculptor could not have been poor. Kolaios was a Samian trader who set sail for Egypt in the 630s, got blown off course, wound up in the Atlantic, providentially landed in Tartessos (Cadiz), and brought back vast amounts of Spanish silver.[26] That sort of thing did not happen often, but there were more ways to acquire wealth—and lose it—than there had been before. Aristocrats fell into poverty as often as nonaristocrats were catapulted into riches, and it is no accident that the seventh century coined the proverb "Money makes the man"—money, not birth, not land, not good looks, not manly excellence or virtue (*aretē*). Aristocrats quoted the proverb bitterly, for it was their status and their values of *aretē* and *kalokagathia* (the ideal union of beauty and goodness) that were under attack. Colonization also continued apace: Telesikles, a Parian noble (and the father of Archilochos), founded a colony on Thasos around 680, Battos (or Aristoteles) founded the Theran colony of Cyrene around 630. And with colonization inevitably came displaced persons: the Greeks were on the move, but not all of them

26. Herodotos, IV.152.

The Edge of Disorder: The Seventh Century

moved voluntarily or happily. All in all, if a seventh-century Greek (aristocrat or commoner) happened to think life unstable or unpredictable, he had reason enough.

Lyric poems, again, are often used to document the individual's reaction to these developments, and one kind of reaction, it is often thought, was to express one's own individuality, to make oneself one's subject. So, by editorial convention, Archilochos' first words are *eimi d'ego*, "I am":

> I am the servant of lord Enyalios
> and I know the lovely gift of the Muses.
> [West, 1]

Enyalios is another name for the war god, Ares, and other fragments confirm that Archilochos was a military man:

> At the spear is my kneaded bread, at the spear
> my Ismarikan wine, and I drink it leaning on my spear.
> [West, 2]

And yet he was not so attached to his shield:

> My shield delights some Thracian now, a blameless shield
> I left behind beside a bush. I had to—
> I saved my life. What's that shield to me?
> To hell with it. I'll buy another just as good.
> [West, 5]

That, supposedly, is something a Homeric hero would never have done—Homeric heroes, after all, spend a great deal of their time fighting over armor, not tossing it away. And in another fragment Archilochos dismisses the aristocratic ideal of *kalokagathia* as well:

> I don't like a great big officer, a long-
> legged strutter who curls his hair and shaves his chin.
> I'll take a man who's short and knock-
> kneed, who takes a firm stand and is full of heart.
> [West, 114]

Archilochos is the first to use the word "tyranny" (it is, incidentally, an eastern word, not Greek):

> Golden Gyges' wealth is not for me,
> I don't envy him one bit. I don't blame

the works of gods, and I don't want a great tyranny.
Such a thing is far from my eyes.

[West, 19]

The reference is to a usurper who seized the throne of Lydia after a messy
palace intrigue, but there is no animosity here. At the end of the century,
however, the fallen but fierce aristocrat Alkaios repeatedly vilified Pittakos,
the Greek tyrant of Mytilene (and a former ally), hurling such insults as
"potbelly" and *kakopatridas* (lowborn, son of a base father) at him in verse.

Archilochos joined his father's colony on Thasos, though he hated the
island and did not care for his fellow colonists, either: "All the dregs of
Greece have come together on Thasos" (West, 102). And he turns to meta-
phor to express the perils of Thasos as it goes to war:

Glaukos, look! The deep sea is already churning
with waves, a cloud stands straight over the Gyrean Cape,
the sign of a storm, and fear comes unexpected.

[West, 105]

Given the turbulence of the era, it is perhaps not surprising that the
mutability of life, a sense of helplessness and impermanence summed up
by the Greek word *amēkhaniē*, forms a persistent lyric theme. An eclipse
(apparently that of April 6, 648/47) occasioned this Archilochean medita-
tion on the uncertainty of the world:

Nothing is unexpected now, nothing impossible,
nothing amazing, since Zeus, father of Olympians,
made night from day, hiding the brilliant light
of the sun, and limb-loosening fear came upon men.
From this day all things are to be believed,
expected by men. Let none of you be surprised,
not if beasts trade dolphins for pastures of the deep
and love more than land the resounding waves
of the sea, and they the wooded mountain . . .

[West, 122]

Existence is ephemeral:

For mortal men, Glaukos son of Leptines,
life is like the day Zeus sends.

[West, 131]

Such thoughts are found over and over again in the lyrics of the seventh
and sixth centuries. For Semonides, men possess no mind, but live *ephē-*

meroi (from day to day) like animals, knowing nothing of the end Zeus has planned. For Mimnermos, men are like leaves, and their fate is either hateful old age or, preferably, an early death in the bloom of youth. And for Alkaios, Helplessness is the sister of Poverty.[27]

Emotion is perhaps the major lyric subject. The poems of Archilochos and Alkaios and Hipponax are full of hate and blame, and even the lyrics of love can be joyless poems of suffering and vulnerability. Here is poor Archilochos:

> Wretched I lie, lifeless with
> desire, pierced through my bones by
> the harsh pains the gods have given me.
> [West, 193]

And for Sappho, love is virtually a fatal force:

> He seems to me like a god, that man
> who sits by you face to face
> and listens, close, to your sweet words
>
> And alluring laughter—that makes
> the heart pound within my breast.
> One brief look, and I cannot speak,
>
> My tongue cracks, and sheer fire
> races beneath my skin.
> My eyes see nothing, my ears ring,
>
> Cold sweat pours over me, I shake
> all over, and I am greener
> than grass: I think I am near death. . . .
> [Lobel and Page, 31]

Such lyric voices as those of Archilochos and Sappho are vigorous and strong, but it is nonetheless a mistake to hear in them either a revolution in the Greek spirit or the rise of the individual. For one thing, we have no earlier lyrics to compare them with. Love songs composed before 700, for instance, could have tried to be as intense as Sappho's: Geometric Greeks had feelings, too. For another, almost every seventh-century lyric we have is a verbal sherd. What we find upon looking into an edition of Archilochos or Sappho is page after page of fragments that often have as many holes in them as words, or isolated lines, or single words, or even senseless jumbles of letters. More than two hundred fragments of Sappho have sur-

27. West, Semonides 1, Mimnermos 2; Lobel and Page, Z41.

vived; we think we have one, maybe two complete poems. It is a dangerous business to reconstruct a Zeitgeist for the seventh century from "poems that are not there."[28]

Even so, it is clear that lyric poetry is not so anti-Homeric or so spiritually or psychologically radical as it may at first seem. It is true that the heroes of the *Iliad* could not have conceived of abandoning their shields the way Archilochos allegedly did, and even the cunning Odysseus dismisses the idea of inglorious retreat: "I know that cowards are those who run from battle" (*Iliad*, XI.408). But that is the Odysseus of the *Iliad*. The Odysseus of the *Odyssey* is the archetypal survivor and might not have censored Archilochos for living to fight another day. Archilochos' ideal officer is not so un-Homeric, either. It is true that Homer's heroes are handsome and that the ugliness of the common soldier Thersites is a visible symbol of his baseness (*Iliad*, II.211–20.). But Hephaistos is ugly, too (like Thersites, he is lame), and he is a god. Paris, who is one of the best-looking men at Troy, is one of the least heroic. And Odysseus, who was relatively short and (at least on one occasion) looked ignorant but who spoke with the forcefulness of winter storms (*Iliad*, III.216–24), would have suited Archilochos just fine (cf. *Odyssey*, VIII. 169–77). By rejecting *kalokagathia*, Archilochos rejects aristocrats, not Homer.[29]

Similarly, lyric's preoccupation with human helplessness and impermanence had also been a Homeric concern. Glaukos (the Trojan ally of the *Iliad*, not Archilochos' quite historical friend) had already proclaimed that human generations are as transient as leaves (VI.146–49). The "myth of the urns" that Akhilleus tells to Priam (XXIV. 527–33) is a précis of *amēkhaniē*. And even Odysseus, who is anything but helpless (and is called *poly-mēkhanos*, full of resources, besides), nonetheless expounds on the powerlessness of humankind and its ephemeral state (*Odyssey*, XVIII.130–37). In their ultimate presentation of heroic reconciliation and social restoration, the Homeric epics validate order and coherence.[30] But the words Homeric heroes speak are not far from the lyrics of mutability.

Finally, lyric is not autobiography, and the indomitable individualism that lyrics are supposed to document—the exploration of the self and the revelation of personal feelings and so forth—dissolves if the situations that are described or the people that are addressed or the reactions that are expressed are fictitious or conventional. Ancient critics believed that Archilochos and Archilochos' poetry were the same thing, and they used his

28. W. R. Johnson, *The Idea of Lyric* (Berkeley, 1982), 26.

29. Cf. H. Lloyd-Jones, *The Justice of Zeus* (Berkeley, 1971), 38–41.

30. It is worth noting, however, that although Archilochos uses formulaic epithets for things and gods, he rarely uses them for people. Epithets are verbal "tags" that bestow permanence. That Homer uses them for people and Archilochos does not may suggest a crucial difference in their attitudes; see Kirkwood (n. 16), 36.

own poems to reconstruct an unflattering portrait of him: he was the bastard son of Telesikles and a slave woman named Enipo, he was impoverished, he abused friends and foes alike, he was a sex maniac.[31] A series of poems has been used to trace a purported love affair with a girl named Neoboulē (the long Cologne papyrus suggests he seduced Neoboulē's young sister as well). Lykambes, Neoboulē's father, is said to have broken off the engagement, and Archilochos, attacking father and daughters in scathing verse, is supposed to have driven them to suicide. But not even that offense was as scandalous as throwing his shield away—for that Archilochos was censured throughout antiquity.

The problem is that little or none of this biography is likely to be true. Like Hesiod's Muses (and even Odysseus), Archilochos could tell many lies that only seem like the truth. If he ever said in a poem that he was "the child of Enipo," he was no doubt speaking allegorically (just as Odysseus is, incidentally, at *Odyssey* XXIV. 302–6): Enipo means Blame, and his ancient biographers missed the point. The unhappy love affair with Neoboulē is probably pure fabrication, the girl and her father drawn from a traditional lyric reservoir of stock characters or types: Neoboulē means roughly Girl Who Changes Her Mind, and the root of Lykambes is related to *iambos,* the genre of lyric that was the principal vehicle of invective.[32] And even the story of the shield is dubious: like other details in Archilochos' "life," it sounds suspiciously like a lie Odysseus tells in disguise on Ithaka.[33] No one doubts that Archilochos really was a soldier as well as a poet, but the worst thing we can do to Archilochos is to believe everything he says. A few of his poems are known to have been spoken by personae (imaginary, assumed identities, like Eliot's Prufrock and Melville's Ishmael): Charon the Carpenter—whoever he was—spoke "Golden Gyges" and a father (perhaps Lykambes, perhaps not) spoke "Nothing is unexpected" to his daughter. It is likely that personae spoke many of the rest of his poems as well. At least, given the tattered state of his lyrics, we simply cannot assume that when Archilochos wrote "Wretched I lie" he was talking about himself—and even if he were, we cannot be sure whether his love was real. Archaic lyrics do not necessarily reveal the poet's own personality or describe the feelings or perceptions the poet has. They are about personae or conventional poses the poet assumes, and they describe feelings and perceptions that the poet, being human, knows or imagines.

Lyrics are thus not really the soulful, private expressions of individuals; they are careful, public deliberations on individuality. They are not really

31. See Aelian, *Variae historiae,* 10.13 (= West 295).
32. Nagy, *Best,* 248; and M. L. West (n. 22), 25–28.
33. See XIV.191–284 and B. Seidensticker, "Archilochus and Odysseus," *GRBS,* 19 (1978), 5–22. If losing one's armor was not a conventional lyric theme by Archilochos' time, it seems to have been by Alkaios'; see Herodotos, V.95, and Lobel and Page, 428.

personal or egoistic; they are about personality and types. When and if the emotions described were rooted in the poet's own experience, it was the function of the lyric to generalize that experience, to make it broadly applicable, and so to instruct its audience.[34] Sappho's "He seems to me" did not, in fact, end with "I think I am near death": the poem apparently continued with words about the necessity of endurance, suggesting that a lesson was to be learned from the sufferings of love. The poem, in other words, was the dramatization or re-creation of character for the benefit of others. In a sense, lyric is a kind of wisdom literature.

Like epic, lyric was social poetry, but the society it addressed had changed. Heroic and theogonic epic was the poetry of the aristocratic household or *oikos,* the dominant social unit before the rise of the polis. The *oikos* lived on and epic continued to reinforce its ideals, but lyric is more or less polis poetry: it could address the polis at large in times of crisis (as in the martial elegies of Tyrtaios, Kallinos, and Solon) or it could address its various parts: men in military companies, commoners, aristocrats reclining and drinking in the symposium, groups of women apart from men, and so on. Greek society had been rearranged and the main foci of social intercourse had shifted. The rise of lyric undoubtedly had much to do with the shift[35]—at the very least, it could serve a wide range of audiences. And it also, in the end, had much to do with the nature of the seventh century after all. Almost as if to compensate for or to counteract the disorder and pressures of the era, lyric poets offered up models of behavior and patterns of personality in verse. In this period of rapid change and strife, lyric poetry was a way of making sense of the world of human experience, of extracting paradigms, of discerning unity. It is not poetry of alienation or of the self above all. It is poetry of social interaction. It had probably always been so, but social change after 700 made the function of lyric particularly appropriate, even indispensable, now.

Homeric epic is the embodiment of the idea of order. Hesiodic epic orders the history of the gods and human lives. Lyric, in its impulse to establish "paradigms of identity,"[36] in its perceptions of the world, and in its arrangement and universalization of experience and feeling, is just as much a poetry of order. Its basic task of generalizing from the particular is quintessentially Archaic, and it is best seen, perhaps, in this fragment of Archilochos:

> Heart, heart confused by helpless sorrows,
> Rise up, defend against the foe and set your breast
> Against them, standing fast amidst the hated spears[?].

34. See Johnson (n. 28), 29–38.
35. See Humphreys, 218–20.
36. Johnson (n. 28), 31.

Do not in triumph openly gloat,
Nor in defeat lie at home and grieve,
Do not rejoice in joyous things or mourn misfortune
Too much. Know this: such a *rhysmos* holds mankind.

[West, 128]

Even in life's unpredictability, even in its *amēkhaniē*, there is *rhysmos*—a rhythm, a pattern. The lyric poet's function was to find that pattern and reveal it to those who listened. Lyrics were written in private, but their meaning (as well as their performance) was always public. And when, as here, the poet seems to turn inward, he does so only to turn outward again.

Diversity and Narrative Experiment

If lyric poetry is not proof of the rise of individualism ("self-centered feeling") in the seventh century, it is evidence of the era's individuality— or rather its particularities, its diversity. There are diverse lyric voices: soldier, colonist, exile, patriot, aristocrat, commoner, lover (heterosexual or homosexual), male symposiast, female symposiast, misogynist, and so on. There are diverse lyric forms, meters, and contexts. And to a degree the genre can even be broken down regionally: solo singers (monodists) tended to be Aeolian and Ionian, while choral poets tended to be Dorian. Lyric poetry, in short, is heterogeneous—that is why it is so difficult to define—and heterogeneity is a hallmark of seventh-century (and early-sixth-century) culture as a whole. The lack of cultural uniformity is relative but it is nonetheless pronounced. It may be partly attributable to the great ethnic division of the Greek people into Ionians and Dorians, but the nature of the individual polis probably had much more to do with it: the city-state was an inherently fragmenting force. It emerged, as we have seen, at roughly the time that the Greeks learned how to write, and from the start Greeks in one polis wrote Greek a little differently from Greeks in most other poleis: they could tilt letters in different directions or give them different numbers of strokes. Some local alphabets even had more letters to choose from than others.

The local scripts of Archaic Greece were all used to write the same language, but it is their variety that is symptomatic. So, too, with seventh-century art: it is all Greek, but styles, techniques, spirit, and preferences varied from place to place. And even though most seventh-century poleis and islands produced most kinds of art, many had one or more specialities: Rhodes excelled in gold jewelry, Crete in decorated bronze armor, bronze plaques, and limestone sculpture, Tenos in large clay pithoi decorated with

figures in relief, Naxos and Samos in marble sculpture, Corinth in large-scale ("free") painting, Sparta in ivories, and so forth. Not all city-states specialized in painted pottery—in fact, one or two important poleis do not seem to have had local workshops at all—but so many of them did that vase painting remains the most convenient barometer of stylistic diversity in the period.

Now even in the Geometric period there had been local schools of vase painting,[37] and it is easy to tell an Attic Dipylon vase from, say, a contemporary Argive one (one is an abstract tapestry in paint, the other a crazy quilt). But there is still something coordinated or cognate about the pottery styles of Geometric Greece: nearly all seem to be variations on a common theme. Orientalizing pottery, on the other hand, is more an uncoordinated display of innovation, experiment, exuberance, brilliance, provincialism, and dullness: more styles had less to do with one another, and only the shallowest kind of unity is to be found in the widespread adoption of Orientalizing motifs. Although Protocorinthian pottery (as the Orientalizing pottery of Corinth is known) was by far the most commercially successful style of the time and was often imitated, major schools and individual craftsmen seem to have been freer to state and elaborate on their own themes in their own manner. Because they went their own way, there can be no one standard, no fair measure of seventh-century vase painting.

The pottery shops of the Cyclades in particular went many ways (it is hard, incidentally, to assign specific styles to specific islands) and their products are among the most idiosyncratic of the era. The amphorae of one mid-century shop, for instance, are noted for their austere linearity, precision, and restraint: they are almost anti-Orientalizing. A grazing stag fits perfectly within the trapezoidal panel on the shoulder of a vase in Stockholm [61]: it is at once a study in triangles—the lines of its sawhorse legs repeat the geometry of the triangle frieze near the rim—and in the interplay of light and dark, and no Orientalizing plants or curlicues distract the eye from the starkness of the pattern. Yet in other Cycladic styles Orientalizing fillers abound and agitate the eye. Complete human figures and mythological scenes do not interest Cycladic vase painters very much until the second half of the century, when seemingly out of nowhere the so-called Melian school appears. Melos was, in fact, probably not its home; Paros, Archilochos' birthplace, may well have been. Though the school also produced votive plates (and exported some to Thasos, Paros' colony),[38] the "typical" Melian vase is a tall amphora—loud, colorful, and typically eccentric, with *poikilia* in excess. The yard-tall amphora in Athens

37. J. N. Coldstream, "The Meaning of the Regional Styles in the Eighth Century B.C.," in *Greek Renaissance*, 17–25, finds the rise of the polis responsible for the regionalism of eighth-century pottery.

38. *Guide de Thasos* (Paris, 1968), 158.

61. Cycladic Linear Style amphora (Stockholm NM-A1), around 650. Photo courtesy of Nationalmuseum, Stockholm.

shown in figure 62, for example, is a decorative overdose that could not have less in common with the stag vase in Stockholm. Above rays and a meander on the foot, female protomes converse across a vent; above them are great volutes and a row of spirals; above them, Apollo—lyre in hand, Hyperborean maidens at his side—drives a team of winged horses home to sister Artemis, who holds a sheaf of arrows in one hand (her Homeric epithet is "pourer of arrows") and a dumbfounded stag in the other (it is as though the goddess had gone hunting on the Stockholm amphora and wrenched the stag from its panel); above, a file of geese; and on the neck two heroes fight over an empty suit of armor (they are probably Akhilleus and Memnon, and the women waiting and watching in the wings their divine mothers, Thetis and Eos). The pictorial zones are cluttered with palmettes, rosettes, diamonds, and tongues. The eye is given no rest.

The symmetrical composition of the heroic combat is roughly paralleled on a late-seventh-century polychrome plate from Rhodes, where Menelaos and Hektor (they are labeled) duel over the body and armor of Euphorbos (cf. *Iliad*, XVII.59–113).[39] But the Euphorbos plate is an East Greek anoma-

39. Schefold, *ML*, pl. 75.

The Art and Culture of Early Greece, 1100–480 B.C.

ly: human figures and heroic subjects were simply not to the taste of vase painters in that part of the seventh-century Aegean. For some reason they preferred wild goats—rows and rows of them, with deer, lions, dogs, bulls, birds, and griffins thrown in for variety [63]. From about 660 until well into the sixth century, vase painters in East Greek workshops from Chios to Rhodes joined in turning out Wild Goat style jugs and dishes: it is a regional style, and its remarkable uniformity sets it off from the other styles of Orientalizing Greece. There is a certain charm and gaiety about a Wild Goat style vase with its black and reddish-purple and partly outlined animals prancing over a nearly white background, and the filling ornaments, for once, seem just right. But gaiety is a hard mood to hold, and although the style goes on for generations, it goes, monotonously, nowhere.

Most Greeks of the seventh century liked animal friezes—they were fashionably "eastern" as well as visually soothing—and they liked Protocorinthian animal friezes best of all. Corinth's vase painters were the finest craftsmen of the period, and had to be, since they decorated the

62. "Melian" amphora (Athens NM 3961), around 650–25. Photo: Hirmer Fotoarchiv, Munich.

The Edge of Disorder: The Seventh Century

period's smallest vase: the ubiquitous two-to-three-inch-tall aryballos (a flask for the scented oils that "luxurious Corinth" imported, bottled, and distributed throughout the Greek world in vast quantities). Now even in the Geometric period, Corinthian vase painting was a display of meticulousness and precision—in a word, of *akribeia*. Despite its elegance, however, Corinthian Geometric was a slight and weakly rooted style (there was no figured tradition to speak of and no deep commitment to tectonics, either) and it was effortlessly swept away by Orientalizing flora and fauna in the last decades of the eighth century [57]. The full Orientalization of Greece began nowhere earlier or with greater enthusiasm than in mercantile Corinth: there was little to resist it. But the tradition of *akribeia* remained strong, and it was on the tiny, demanding surfaces of aryballoi that the Protocorinthian vase painter did some of his most accomplished work.

For the aryballos and other relatively small vases (the cup known as the kotyle, for instance), the Protocorinthian artist invented a new technique particularly suited to the precise rendering of minute detail: black figure, in which the artist painted a silhouette and then (still before the vase was

63. Wild Goat–style oino-
choe (BM 1867.5–8.928), late
seventh century. Photo cour-
tesy of the Trustees of the
British Museum.

The Art and Culture of Early Greece, 1100–480 B.C.

64. Middle Protocorinthian aryballoi (MFA 95.13, 95.12, 99.511), around 675. Photo courtesy of Museum of Fine Arts, Boston, H. L. Pierce Fund and Catharine Page Perkins Fund.

fired) used a sharp point to scrape away filaments of glaze, engraving fine anatomical or ornamental details within the form. Other features were soon picked out with touches of purplish-red or white paint laid over the black silhouette. But the great advantage of black figure over a pure silhouette or an outline technique was its combination of mass and line, its balance of weightiness with delicacy—just the qualities such a miniaturist style as Protocorinthian required.

Black figure remained the principal Protocorinthian technique and the continuous animal frieze remained the principal Protocorinthian theme [64 left and right]. Floral patterns fill subsidiary zones or are strewn about among the animals, but the animals are the stuff of the style. On countless vases dogs chase hares, sphinxes and griffins strike heraldic poses, lions strut toward wild goats or bulls or boars or other lions, and panthers stare back at the spectator. But once in a while animals and plants are moved to one side or are relegated to lesser friezes to make room for human figures and heroes. Oddly, many of the earliest Protocorinthian narratives are clumsy as well as ambiguous: the *akribeia* for which the Protocorinthian artist is justly famed is at first not apparent in his representations of myth. On an aryballos in Boston for example, in a frieze about one inch high, a grotesquely proportioned Herakles—he is all arms and legs, almost torsoless—aims a firebrand at a branch-wielding centaur; birds flutter about a cauldron shown partly in profile, partly from above; a swordsman churns wildly nearby—his identity and loyalties are unclear [64 center, 65].[40]

40. I prefer Fittschen's interpretation of this scene to the view that it shows Zeus, with his thunderbolt, attacking Typhoeus; see *Untersuchungen*, 113–14 (SB 5) and 119–24.

The Edge of Disorder: The Seventh Century [155]

Herakles is a favorite subject of Orientalizing narrative art in general. He is, after all, the monster-slayer par excellence, the prototypical defender against the inexplicable and abnormal. And the constant representation of his conquests in seventh-century art may have been, if only subliminally, an attempt to communicate the victory of the norm over the irrational and fantastic, of civilization over chaos. Perseus, who decapitates the bogey Medousa all over Orientalizing art, plays the same role. But Corinth had a monster-slayer all its own: Bellerophon, who though mentioned by both Homer and Hesiod was apparently expropriated for Corinthian legend in the late eighth century by the epic poet Eumelos. Bellerophon was said to have captured Pegasos at Corinth, and it was there that he had his only cult in Greece. It was natural that he became a darling of Protocorinthian artists, and on a fragmentary cup from Aigina [66] he fights his finest fight (on the other side Perseus was shown attacking Medousa, the two myths linked not only by the theme of monster-slaying but also by the fact that

65. Drawing of a narrative (probably Herakles and Centaur) on an aryballos (MFA 95.12; see fig. 64 center) by the Ajax Painter. Photo courtesy of Museum of Fine Arts, Boston.

The Art and Culture of Early Greece, 1100–480 B.C.

66. Fragmentary Middle Protocorinthian cup (kotyle) from Aigina (Aigina Museum 1376), around 670. Photo courtesy of Deutsches Archäologisches Institut, Athens.

Pegasos was born from Medousa's neck—a kind of narrative free association we will see again). The Bellerophon scene, at any rate, is not especially violent: the painter was concerned more with the exact depiction of form than with the representation of gruesome horror. The Khimaira is a masterpiece of swelling, crisp contours and precisely controlled lines, and there is no better example of black-figure *akribeia* than the curving incision at the monster's shoulder or the feathers of Pegasos' wing. There is a restraint and dignity in this confrontation of monster, hero, and winged steed that comes solely from the mastery of brush and point. And set in a virtually empty field with few ornamental distractions, the scene comes closer to the spirit of the monumental than any earlier Protocorinthian work. The style is still that of a consummate miniaturist—the figures are only a few inches tall—but there is the sense that the painter would have known what to do with a larger surface, and that something very large may loom behind this and other Protocorinthian scenes.

Ancient testimony suggests that "free painting" (that is, the practice of painting on large wooden panels, terra-cotta plaques, or the walls of buildings) was invented in the northeastern Peloponnesos, at Corinth or its neighbor Sikyon: Ekphantos of Corinth, for example, is credited with the invention of painting in color.[41] Ekphantos cannot be precisely dated, but monumental wall paintings existed in Corinth and its vicinity at least by the middle of the seventh century and may have inspired Protocorinthian experiments with polychromy.[42] Between 660 and 640, a few vase painters

41. Pliny, *Historia naturalis*, XXXV.15–16.
42. D. Amyx doubts that free painting had extensive influence on vase painting; see Moon, 37–52.

67. Late Protocorinthian olpe (the "Chigi vase") by the MacMillan Painter (Rome, Villa Giulia), around 640. Photos: Hirmer Fotoarchiv, Munich.

specialized in brushing figures in subtle shades of red, brown, and yellow, as well as black, directly on the vase surface (though they continued to incise details and outlines). They also painted far more complex and crowded scenes than those found in Protocorinthian black figure pottery, as if they tried not merely to imitate the techniques of free painting but also to stuff the larger and more populous compositions they saw on flat panels or walls into the narrow, sharply curving friezes of small bottles. On the face of it, they would not seem to have stood much chance of success. But *akribeia* allowed at least one artist to defeat the odds.

The finest practitioner of the polychrome style—and the leading vase painter in the Corinth of the tyrant Kypselos—is known as the MacMillan Painter. He gets his name from an aryballos in the British Museum,[43] but his masterpiece is a ten-inch-tall olpe (a sagging jug) that found its way to Italy: the Chigi vase [67], which for the most part displays the kinds of activity a Corinthian youth of about 640 could be expected to engage in and so show off his *aretē*. In the lowest of the three figured zones, boys crouch behind flamelike bushes while their dogs chase hares and a fox into their trap; this is essentially an animal frieze given content by the addition of human figures. The frieze above shows a less recreational kind of hunt: four long-haired youths spear a lion that has seized a fifth youth in his

43. K. Friis Johansen, *Les Vases sikyoniens* (Copenhagen, 1923), pl. XXXI.

jaws. Purplish blood pours from the wounds of both man and beast, yet the lion has not relaxed his grip and the crawling youth, being Archaic, seems unperturbed. Behind the lion hunt a double sphinx looks out at the spectator with a single inscrutable face. Approaching her is a cavalcade of youth: a boy leads a chariot and charioteer and behind the car four mounted squires lead four riderless horses; the boys and the horses strongly resemble Bellerophon and Pegasos on the somewhat earlier Aigina cup [66]. Behind the parade and beneath the handle is the only mythological narrative on the vase: the judgment of Paris (a.k.a. Alexandros). Its isolated and comparatively unimportant position epitomizes a broader Protocorinthian indifference toward the representation of myth: narratives exist, but they are outnumbered by anonymous genre scenes such as the parade of youth nearby, to say nothing of animal friezes. At any rate, nothing is left of the judgment but the judge, the tip of Hermes' caduceus, and parts of the beauty contestants (Hera, Athena, and Aphrodite). The figures are identified by inscriptions. This was a new feature in Protocorinthian, and the MacMillan Painter may have gotten the idea from free painting (if, indeed, he was not also a free painter himself).[44] Interestingly, the labels are not written in the local Corinthian alphabet, and that suggests that the MacMillan Painter, the greatest Protocorinthian artist of them all, was not a native of Corinth.[45]

The presence of a foreign craftsman in Kypselos' Corinth is hardly surprising. The tyrant (c. 657–27) was Greece's first great patron of the arts: he built a treasury at Delphi, and his architects (as we shall see) almost certainly contributed to the development of the Doric temple; his dedications (for instance, a gold statue offered to Zeus at Olympia) were renowned; and his son Periander (c. 627–585) followed in his footsteps, patronizing the literary arts as well (the poet Arion of Lesbos spent many years at his court and was said to have invented the choral form known as the dithyramb during his stay). Artists, however, were not as highly esteemed as poets, and the indifference, even disdain that Archaic Greeks displayed toward their craftsmen is perhaps reflected in the mythological discrimination that left the visual arts without any Muses of their own: apparently there was nothing inspired or inspiring about dirtying one's hands with clay and glaze or pouring hot bronze or noisily hacking away at stone. But in Corinth, we are told, men skilled with their hands were "despised less" than in any other Greek polis.[46] That relatively favorable attitude may have

44. Pliny not only places the invention of free painting in the northeastern Peloponnesos but also associates it with the decision to add identifying inscriptions; see *Historia naturalis*, XXXV.15–16.

45. See Jeffery (n. 24), 125n3 and 264, and H. Payne, *Necrocorinthia* (Oxford, 1931), 38–39.

46. Herodotos, II.167. It should be noted that even on Olympos, the divine craftsman Hephaistos is deformed and laughable.

been shaped as early as Kypselos' reign, and such master craftsmen as the MacMillan Painter helped to shape it. At all events, though Kypselos' patronage probably did not extend far into Corinth's potters' quarter, the prosperity and burst of artistic activity the city enjoyed during his rule would naturally have attracted craftsmen from various parts of the Greek world. It was the place to be.

Kypselos' power (like that of tyrants elsewhere) depended on his hoplites as well as on his good deeds, and it is thus fitting that a clash of hoplites is the subject of the highest band on the Chigi vase [67 right]. We cannot name the battle: the MacMillan Painter probably had no specific battle in mind. The scene is simply an ode to soldiers who fought in close-packed phalanxes, their round, emblazoned shields interlocked, their safety depending on the steadfastness of the next man in line, their individual prowess less important than the integrity of the whole. Though it is the moment when spears first touch, the army on the right has caught its foe by surprise: two hoplites at the far left are still arming and their quicker comrades run to join the line. The scene is asymmetrical and its spontaneity is enhanced by the presence, just off center, of an unarmed piper who stands by himself and fearlessly sounds the alarm or gives the measure of the march. The unheard notes he plays may not have been unlike the notes to which the contemporary elegist Tyrtaios rallied the warriors of Sparta:

> Those who endure and stay by each other's side
> and go to the front and fight hand to hand,
> Few of them die, and they save the ranks behind.
> But once men flee, all *aretē* is lost. . . .
> So let [each man] fight toe to toe, pressing shield against shield,
> crest against crest, helm against helm,
> and chest against chest, drawing near his man,
> gripping the hilt of his sword or the length of his spear. . . .
> [West, 11 ll. 11–14, 31–34]

The battle scene on the Chigi vase is thick with an atmosphere of Tyrtaian *aretē*. But there is another kind of atmosphere as well—a sense of space. There is no real perspective here: the hoplites are profile-frontal composites, they all stand on the same ground line, they do not diminish in size the farther back they go. But there *is* a front and back: distance and depth are strongly implied by the skillful layering of shield over shield, helmet over helmet, crest upon crest. And yet the sense of space is strongest around the isolated, purely profile (and optically correct) flute player: because, paradoxically, of all the overlapping around him (as well as the dark brown of his tunic, which sharply contrasts with the softer tones of

the hoplites' armor), the boy seems set apart in his own little capsule of space. At all events, the old Geometric equation of reality with a single flat and inviolable picture plane—an equation not even Protocorinthian black-figure artists had seriously challenged—is shattered here. The representation of reality is still planar; there are just more planes, parallel and superimposed. As a result, the figures are no longer uniformly illuminated, they do not all exist in the foreground, and some things are left unseen. Overlapping is the most rudimentary way of suggesting depth (and it will be virtually the only way of doing so for another hundred years). Still, in a period remarkable for its artistic experiments, the battle scene on the Chigi vase is one of the most successful experiments of all.

The experiment may or may not have been possible without the influence of free painting, but that may be the wrong way of looking at the matter. After all, is it likely that even as wealthy a city as Corinth could have supported artists who painted only walls? For all we know, muralists were at first chosen from the ranks of the best vase painters. That is, the MacMillan Painter could have painted walls and panels in addition to aryballoi and jugs. He was not bound to any one technique, his style would not have suffered from enlargement, and it is not very likely that any contemporary wall or panel painter surpassed him in *akribeia* or compositional skill anyway. It is difficult to say for sure because painted walls and panels are hard to come by. The stuccoed exterior walls of a mid-seventh-century temple of Poseidon at Isthmia (a sanctuary under Corinth's control) were covered with panels some six feet wide, and their artist's polychrome palette resembled the MacMillan Painter's. The surviving fragments are meager[47] but they include portions of a horse that may have been ridden in a parade like that on the Chigi vase [68]. There are also bits of floral and geometric patterns, including an oblique meander like that on the border of the Aigina Bellerophon cup [66]. Given the popularity of the Bellerophon myth on Protocorinthian vases, it is pleasant to imagine Bellerophon and Pegasos also charging the Khimaira somewhere on the walls of the Isthmia temple. The best-preserved examples of seventh-century large-scale painting, however, are themselves done on baked clay (like vase paintings) and they are from the provinces: metopes (square plaques two to three feet on a side) that were set into the entablature of the Doric temple of Apollo at Thermon, an Aitolian site well within Kypselid Corinth's sphere of influence. The Thermon metopes were painted a decade or two after the Chigi vase, and depicted such myths as Perseus, Medousa's head in a sack under his arm, fleeing the Gorgons (they probably chased him from a neighboring metope or two) [69]. The compositions on the Thermon metopes are not complex—at most there are three figures to a

47. See O. Broneer, *Isthmia I: The Temple of Poseidon* (Princeton, 1971), 33–36.

panel (incidentally, some are labeled)—and a two-foot-tall figure such as Perseus requires less meticulousness than a two-inch-tall hoplite. Still, the Corinthian-trained painter of the metopes (a moonlighting vase painter, perhaps?) was no match for the MacMillan Painter. Those who painted larger did not necessarily paint better.

But if Thermon had such paintings as these, Corinth and Sikyon undoubtedly had finer ones earlier, and it is those paintings—the work of an artist such as Ekphantos, perhaps—that the Chigi vase may reflect in its polychromy, spatiality, use of inscriptions, and perhaps even subject matter. The MacMillan Painter was not a derivative or minor artist even in the

OBLIQUE MEANDER BORDER. RESTORED

68. Drawing of fragmentary wall paintings from the Temple of Poseidon, Isthmia, around 650–40. After O. Broneer, *Isthmia*, vol. 1: *Temple of Poseidon* (Princeton, 1971), pl. A and fig. 53.

The Art and Culture of Early Greece, 1100–480 B.C.

69. Painted terra-cotta metope from the Temple of Apollo, Thermon, showing Perseus (Athens National Museum), around 630. Photo courtesy of Deutsches Archäologisches Institut, Athens.

unlikely event that he painted only vases. But in his time a major art had been reborn, and an impulse to respond to it arose as well.

The impulse did not last long. After the painting of the Chigi vase, the brief polychrome experiment abruptly ended, and so did the Protocorinthian style. The last years of Kypselos' reign saw a transition to the so-called Ripe Corinthian style (625–550), and the black-figure animal frieze, which was always the real subject of Corinthian vase painting, dominated once again. By abandoning polychrome, the vase painter may have conceded that he could not match the effects of free painting after all. But it is just as likely that he realized he did not have to match them in order to sell pots. The demand for Corinthian vases during the reigns of Kypselos and Periander was enormous, and that demand led to mass production. Chigi vases could not be easily churned out. Animal-style vases could. Yet its very popularity was the animal style's undoing. Friezes were filled with stereotyped, monotonous groups of inert beasts, and so that more of the surface could be decorated in less time, lions and panthers were stretched

70. Ripe Corinthian oi-
nochoe (BM 1864. 10-7.358),
around 625–600. Photo cour-
tesy of the Trustees of the Brit-
ish Museum.

out until they looked like dachshunds.[48] *Akribeia* was sacrificed to the profit
motive. And as if to distract the eye from the carelessly painted, hastily
incised animals, the surface around them was splashed with carelessly
painted, hastily incised rosettes [70]. This style is so ripe it is rotting. The
painters of such pots do not seem to have cared very much. They thought
their markets were assured and for a time they were right. But by the end
of the seventh century a worthy competitor began to emerge in Attica, and
in just a generation Athens would begin to wrest those markets away.

In a period noted for its diversity and individuality, no style of vase
painting was so idiosyncratic and unpredictable as Protoattic, the Orien-
talizing style of Athens. Athens in the seventh century was a provincial
place—it had lost the artistic leadership it had enjoyed for most of the
eighth—and Protoattic was a provincial style. It began two decades later
than Protocorinthian (that is, about 700); it got most of its Orientalizing
motifs at secondhand from Corinth (Athens was now a net importer of
painted pottery, and it imported more Corinthian vases than all other
styles combined); and it is rarely found beyond the borders of Attica itself

48. Payne (n. 45), 48.

The Art and Culture of Early Greece, 1100–480 B.C.

or the fairly nearby island of Aigina, where, it seems, there was an important branch workshop.[49] But the lack of any great demand for it meant that Protoattic avoided the mass-produced sameness that would afflict the animal style of Corinth, and so it could be many things. No seventh-century artist asserted his individuality more strongly than the Protoattic vase painter, and at its best the Protoattic style is nearly the opposite of Protocorinthian. It is monumental (and could decorate vases set over graves) where Protocorinthian is miniaturist (and decorated vases set on dressing tables); it is eccentric where Protocorinthian is predictable; it is full of energy and power—in a word, *dynamis*—where Protocorinthian is meticulous; and it prefers violent mythological narratives placed on one side of the vase to genre scenes and animal parades that continue all around it. It is exuberant, often indelicate, and sometimes not pleasant to look at. But whatever it is, Protoattic is not boring.

When it began, Protoattic was actually restrained enough. The founder of the style, the Analatos Painter [71], was heir to a figured tradition that extended as far back as the Dipylon Master, and so, despite his eager adoption of a wide range of Oriental flora and fauna and his preference for sinuous curves, his linked dancers (the men are still mostly silhouettes) and chariot parades—he did not illustrate myths—were kept under control. Something of Geometric antithesis and parataxis still remained: indeed, he was more disciplined than many Late Geometric II vase painters. But after him, in the second quarter of the century, Protoattic broke loose. There were technical experiments of all sorts, sometimes on the same vase. Restraint was no longer considered a virtue, and dynamic narratives burst through their boundaries, renouncing the closure that was so essential to the ordered Geometric temperament.[50] A bold work such as the so-called Nessos amphora in New York [72], where outline drawing, added color, and black figure are combined and where the kneeling centaur almost seems to dangle off the surface, probes the edge of disorder.

The New York Nessos amphora typifies Protoattic but it is not the best the style has to offer. The so-called Eleusis amphora is [73].[51] It is a huge, Dipylon-size vase over 4.5 feet (1.42 m) high—just a little shorter than Athens 804 [37]. And its belly is covered with the largest vase painting we have: 20 inches (0.52 m) high, 5.5 feet (1.75 m) long. This is on the scale of free painting—the Isthmia panels are just a little wider and a Thermon

49. Brann, 20, 24n109, 28. See now S. P. Morris, *The Black and White Style: Athens and Aigina in the Orientalizing Period* (New Haven, 1984). Aigina also imported large amounts of Protocorinthian pottery [cf. 66].

50. The denial of borders is, however, a widespread phenomenon in seventh-century art—even in Protocorinthian [65, 66]. See J. Hurwit, "Image and Frame in Greek Art," *AJA*, 81 (1977), 1–30.

51. See G. Mylonas, *O Prōtoattikos Amphoreus tēs Eleusinos* (Athens, 1957), and Morris (n. 49), 43–46.

metope is considerably smaller. There is no literary or archaeological evidence that seventh-century Athenian artists painted panels or walls, though they may have done so. But the Eleusis amphora is wall-like itself, and its maker—the Polyphemos Painter (who was Athenian-trained but evidently had his shop on his native island of Aigina)—conceded nothing to any other form of art.

In this monumental field an almost full cast of characters acts out the Perseus myth. At the far left the headless corpse of Medousa lies on its side amidst drooping tendrils, and one thinks of the soft meadow and spring flowers in which, according to Hesiod (*Theogony*, ll. 278–79), she once lay

71. Early Protoattic amphora by the Analatos Painter (Louvre CA 2985), around 700. Photo: M. Chuzeville, by permission of Musée du Louvre.

72. The Protoattic "New York Nessos amphora" (Metropolitan Museum 11.210.1), around 660. Photos courtesy of the Metropolitan Museum of Art, Rogers Fund, 1911.

with Poseidon. Pegasos and Khrysaor, the offspring of her bloodied stump, are missing. But her weird sisters Sthenno (Mighty One) and Euryalē (Wide One) strut their stuff and stretch their tiny arms vainly toward Perseus, who escapes round the damaged curve of the vase. In their way stands a stiff, thin (and *xoanon*-like?) Athena; a great bird (Zeus's eagle?) on the other side of Perseus may symbolize divine favor. The chorus line of Gorgons seems to have interested the vase painter most—like other Orientalizing artists, he dwelt on the fantastic and monstrous (or its annihilation)—and they are stylistically and iconographically startling. The strong contrast between solid black (their slit skirts) and white paint (added to

The Edge of Disorder: The Seventh Century [167]

73. Protoattic amphora by the Polyphemos Painter, name vase (Eleusis Museum), around 670–50. Photos courtesy of Deutsches Archäologisches Institut, Athens.

their outlined arms, legs, and chests) was nothing new to the Protoattic style, but the treatment of the legs (and one Gorgon's breasts) is exceptional: dark, cursive strokes apparently showed through the added white, giving the limbs unprecedented volume and corporeality. This is a kind of shading. It had never been tried before in Greek art, and the experiment, once conducted, was abandoned for another 150 years. When he came to the Gorgons' faces, the artist *had* to experiment: no one knew exactly what a Gorgon looked like—Hesiod had not said[52]—and Greek artists had not yet settled on a conventional rendering (a contemporary Cycladic artist, obviously at a loss, made Medousa a centaur).[53] So the Polyphemos Painter made them up: whimsically, surprisingly, he projected large, tilted eyes

52. A description (and a description of their chase) appears in *The Shield of Herakles* (ll. 216–37), but this poem is pseudo-Hesiodic and dates long after the Eleusis amphora.
 53. Schefold, *ML*, pl. 15b.

The Art and Culture of Early Greece, 1100–480 B.C.

and straight, toothy mouths on the sort of bronze protome cauldrons that were beginning to be seen in smithies and sanctuaries [cf. 11], keeping lion protomes for the "hair" of one Gorgon, changing the other's into snakes. And it was Medousa's face that supposedly turned men to stone!

Above this bizarre narrative, on the shoulder, is an unremarkable scene of a lion pawing a boar. But above that, in a panel almost as tall as the field on the body (the figures are about 15 inches high), there is the masterpiece that gives the artist his name: the blinding of Polyphemos [73 right]. Odysseus alone is described in the same painterly technique used for the Gorgons below (he, after all, is the hero); the other figures are combinations of silhouette and outline, with a few details (toes, fingers, beard) incised. With the aid of his men (who, incidentally, grab the triple-line band at the top of the panel, thus playfully converting the old geometric border into a weapon, into part of the narrative), Odysseus drives the stake into the Kyklops' eye. The hero's right leg is fully extended, his left knee is braced against Polyphemos' knee, and he throws all his weight behind the thrust. Protocorinthian myths are comparatively subdued: on the contemporary Bellerophon kotyle [66], the Khimaira has not been injured yet. But here there is all the violence and *dynamis* of the Homeric tale:

> A great divine force breathed courage into us.
> My men gripped the sharpened olive stake
> and drove it into his eye, while I leaning hard upon it,
> twisted it; just as a man bores ship's timber
> with a drill while men below spin it with a thong,
> holding it on both sides, and it runs on and on,
> just so we held the red-hot stake and drilled
> his eye. Hot blood poured all around.
> The blast singed lid and brow
> as the eyeball burned and the roots crackled with fire.
>
> [*Odyssey*, IX.381–90]

In the *Odyssey* Polyphemos, not surprisingly, howls in agony. On the vase, the Kyklops opens his mouth to scream. But that *is* surprising: it is the first Archaic display of emotion, and one of very few.

The Eleusis amphora is a work of intemperate individuality (and it is all the more Protoattic for that) but it raises issues of more general concern. First, the story of Polyphemos (including Odysseus' escape from the cave) is the only episode from the *Odyssey* to be represented in seventh-century art, and it is the only episode from either the *Iliad* or the *Odyssey* to be represented with any regularity—nine times. Of the nine other "Homeric" scenes that survive from the period, several are only debatably "Homeric," and two or three others are so conventional that without the inscriptions

that accompany the figures we would have no idea who they were.[54] Narrative artists had generally neglected or avoided Homer in the late eighth century, and the pattern evidently holds in the seventh. The stories to be codified in the other epics of the Trojan Cycle—the *Kypria*, the *Aithiopis*, and so on—are illustrated more than twice as often as the Homeric poems (but there were more than twice as many cyclic epics as Homeric ones, so the statistic should be used cautiously), and, to repeat, the Orientalizing psyche found the monster-slayer (which, of course, is practically what Odysseus is in the Polyphemos story anyway) the most satisfying theme of all. Second, even when we can match a scene to a Homeric passage, as we can in the case of the neck panel on the Eleusis amphora (or as we could in the case of the shipwreck of Odysseus [46]), the match is rarely if ever exact. Four companions, not two, helped Odysseus blind the Kyklops (IX.335), and Polyphemos was not awake, sitting straight up, when the deed was done: he was asleep, flat on his back, drunk (IX.371–73). The discrepancies do not mean that the Polyphemos Painter knew a different *Odyssey* from ours. They probably mean that he had to face certain exigencies of style or space. But they may also mean that the Archaic artist simply did not share the more modern notion of sticking to the text. Or changes may be the artist's assertion of independence. Illustration is, after all, a form of translation, and translation is such a notoriously inexact process because it inherently offers opportunities to add, omit, or revise—in other words, to exercise creativity. By making changes, the Polyphemos Painter staked a creative claim on the tale: he no more "got it wrong" than Classical tragedians, who often altered the stories they knew from epic.[55] Third, the Polyphemos Painter's very method of narrating the Homeric episode is non- or antiliterary. Reading or singing poetry, of course, takes time: time is the poet's province, and poets use it to describe successive events one after the other. In short, literature narrates progressively. The visual artist cannot use time in the same way (or could not until a very special form of narration was invented in the Hellenistic period).[56] The painter's fundamental task is to fill space, not time, and a fixed image must tell the tale at once. The Polyphemos Painter was one of the first artists we know to try to overcome this narrative disadvantage by depicting successive moments of an action as if they were happening si-

54. See Fittschen, *Untersuchungen*, 172–77(SB 74–82) and 192–94 (SB 111–16 and n. 915), and R. Kannicht, "Poetry and Art: Homer and the Monuments Afresh," *Classical Antiquity*, 1 (1982), 70–86.

55. See the opening remarks of S. L. Carr in "Verbal–Visual Relationships: Zoffany's and Fuseli's Illustrations of *MacBeth*," *Art History*, 3 (1980), 375–87. I owe the reference to Professor Kathleen Nicholson. Cf. Snodgrass, *AG*, 191–92.

56. This is continuous narration, in which the same characters appear over and over again in one *unbroken, uninterrupted* field; Roman reliefs such as the spiral frieze on the Column of Trajan are the most developed examples.

74. Pedimental sculptures from the Temple of Artemis, Corfu (Corfu Museum), around 580. Photo: Jeffrey M. Hurwit.

multaneously, collapsing separate stages of a narrative into one, violating the unity of time. Here Polyphemos, eye wide open (he should have passed out by now), still holds in his left hand a winecup. Now this cup destroyed him just as much as the stake he grabs with his right hand: if he is blinded, it is because Odysseus got him drunk a little while before, and the cup explains why the mutilation is now taking place. The Polyphemos Painter, in other words, makes coexistent what was in Homer consecutive (drinking, blinding, tearing out the stake). Simultaneous narration, as this method is known,[57] will be used with some frequency in the sixth century. In the center of the surviving pediment of the Temple of Artemis at Corfu (c. 580), for instance, a colossal Medousa, her head still on, was flanked by her children Pegasos and Khrysaor, despite the fact that they were born only after her decapitation: somehow the Gorgon is both alive and dead [74; cf. 127]. In one zone on the François vase (c. 560), Priam is being informed of the death of his young son Troilos even as Akhilleus is running the boy down [93 left]. On a Lakonian cup of about 550, Odysseus offers Polyphemos a cup of wine at the same time that he shoves the stake

57. See K. Weitzmann, *Illustrations in Roll and Codex* (Princeton, 1970), 13–14; Snodgrass, *AG*, 190–91; and B. Cohen, "From Action to Inscription: The Kleophrades Painter and Narrative Unity," *AJA*, 87 (1983), 229–30 (abstract).

The Edge of Disorder: The Seventh Century

into his eye (the Kyklops still holds pieces of a man he has just can-
nibalized).[58] On the Euphronios krater in New York [113], blood still pours
from Sarpedon's wounds, even though (as Homer expressly tells us (*Iliad*,
XVI.666–83]) the hero was dead and cleaned of blood (as well as clothed)
when he was carried from the Trojan plain by Sleep and Death.[59] And
various times (and even places) are similarly fused on a late-sixth-century
vase in Boston, where Akhilleus' chariot is at Troy and at Patroklos' tomb
at once [126].[60] In his attitude toward narrative, then, the Polyphemos
Painter seems less idiosyncratic or naive than precocious.

The seventh century actually saw many other kinds of narrative experi-
ment, both in Athens and elsewhere. The Protoattic Ram Jug Painter (a
rough contemporary of the Polyphemos Painter but more refined) deco-
rated a fragmentary amphora in Berlin with the story of Peleus delivering
his young son Akhilleus to the care of the good centaur Cheiron. Monu-
mental Protoattic vases were normally decorated with figured scenes on
only one side, and for most of the Archaic period it was unusual for the
two sides of an amphora to be directly related. But on this moderately sized
vase, the Ram Jug Painter placed father and son on the front and the
centaur on the back, unifying the vase with a single story. Such explicit
iconographic unity would not be common again until the end of the Archa-
ic period.[61] The Protocorinthian painter of the Bellerophon cup from
Aigina [66] engaged in narrative free association, as we have noted, and
the painter of the Thermon metopes [69], again, experimented by distribut-
ing the Perseus myth over two or three separate metopes. He seems to
have started a trend: in the sixth century the intervening triglyphs became
less and less of a barrier to storytelling. On the Artemis temple at Corfu,
Akhilleus and Memnon dueled with each other from separate panels (the
triglyph served as the axis of the composition).[62] On the so-called Sikyo-
nian Treasury at Delphi (c. 560), the stern of the good ship *Argo* was carved
on one metope and its prow was carved on the next, as if the ship, defying
the Doric order, continued behind the triglyph. And on the treasury of
Hera at Foce del Sele, near Paestum (c. 550), all of the metopes on one

58. Schefold, *GH*, fig. 353, and Weitzmann (n. 57), 13–14. Cf. the scene on a Caeretan
hydria of about 530, where, as on the Eleusis amphora, the Kyklops holds the cup as he is
being gored (G. M. A. Richter, *Handbook of Greek Art* [New York, 1969] fig. 432).

59. See D. von Bothmer, "The Death of Sarpedon," in *The Greek Vase*, ed. S. L. Hyatt
(Latham, N.Y., 1981), 68–69.

60. See E. Vermeule, "The Vengeance of Achilles: The Dragging of Hektor at Troy,"
Bulletin, Museum of Fine Arts, Boston, 63 (1965), 35–52.

61. Schefold, *ML*, pl. 29a. This vase seems to be an example of what Weitzmann (n. 57),
14–15, calls "monoscenic" narrative. He argues it is basically a Classical method, but again it
is the precociousness of Protoattic narrators that is noteworthy. See also Cohen (n. 57).

62. Cf. the treatment of the myth on the neck of the earlier Cycladic amphora from Melos
[62]: there Thetis and Eos stand in separate panels; on the Corfu temple, each mother stood in
the same metope as her son.

75. Relief pithos from Mykonos, with the Trojan horse and the sack of Troy (Mykonos Museum), around 675–50. Photos courtesy of Deutsches Archäologisches Institut, Athens.

facade were perhaps devoted to one myth (Herakles and the centaurs of Mount Pholoe). We might coin the term "serial narrative" for the method of telling a single myth on a series of contiguous yet self-contained panels, where the characters appear but once. It may be that this kind of narrative was at some point influenced by continuous sculptured friezes of the sort found on Ionic buildings, where the artist did not have to contend with the formal breaks created by triglyphs. At the end of the Archaic period, for instance, serial narrative was revived on the front and back of the Athenian Treasury at Delphi, probably under the impact of Ionic friezes nearby. And the technique would culminate on the Classical Parthenon, where all of the metopes on at least three sides of the building depicted the same myth (and where there was a continuous Ionic frieze within). Nonetheless, the discovery that one story could be distributed over a number of discrete pictorial fields was a seventh-century one, and it was made, in a different medium, even before the Thermon metopes.

The most extraordinary of all seventh-century narratives decorates a great relief pithos found on Mykonos in 1961, though it was almost certainly made on the nearby island of Tenos [75]. It is of roughly the same date as the Eleusis amphora, it is just three inches shorter, its shape is nearly the same, and it, too, bears representations only on its front—all of which argues for some kind of exchange between Protoattic and Cycladic artists in the second

quarter of the seventh century. But the maker of the Mykonos pithos was a more sophisticated (if even more violent) storyteller who employed several different narrative methods at once. Now when figured scenes appear on both the neck and body of an Orientalizing vase, they usually have nothing to do with one another. The theme of monster-slayer may loosely associate the Polyphemos and Gorgon scenes on the Eleusis amphora, and the panel on the neck of the New York Nessos amphora [72] may be a kind of visual simile, comparing Herakles' slaughter of the centaur on the body to a lion savaging a deer,[63] but if so, these works are exceptions. The Mykonos pithos, thematically unified from top to belly (where the images stop), certainly is. The story is the sack of Troy, and on the neck is the ruse that made the sack possible: the wooden horse. Seven Akhaians peek out from windows on the side and neck of the horse, and seven more Akhaians (they cannot be Trojans) are shown outside. But at what stage of the story are we? Has the horse been wheeled inside Troy, or is it still beyond the walls? What are the Akhaians outside the horse doing—why is one unhelmeted and another raising his spear? All of these questions come to mind because we are used to scenes that respect the unity of time, but they are the wrong questions. For this, it seems to me, is a simultaneous narrative:[64] some Akhaians are still boarding the horse, others are still inside (indeed, it looks filled to capacity), others are descending, and one has even begun the attack. One can almost intuit the entire operation from the nearly circular distribution of warriors outside the horse, from the figure at bottom left clockwise up and around to the attacker below the horse's belly. The Greeks, of course, could have boarded the horse only outside Troy and they could have emerged from it only inside. The horse is therefore to be thought of as being outside and inside the walls simultaneously: the neck panel does not depict one stage of the maneuver, but several at once.

The actual sack is shown in three tiers of separate panels on the body. Nineteen times we see Akhaians massacring Trojan innocents or threatening or capturing Trojan women. Few of the conquerors or conquered can be precisely identified—the artist simply wanted to load the vase with the kind of carnage that accompanied Troy's fall. But on one panel Menelaos, about to run Helen through, is stopped dead in his tracks by the sight of her naked breast, and near the center of the bottom row Neoptolemos (Akhilleus' son) prepares to hurl Astyanax (Hektor's son) by the ankle from the walls of Troy as Andromache looks on. Taken by themselves, the panels on the body form a serial narrative—the earliest known—that depicts the outcome of the simultaneous narrative shown on the neck. But it could be argued that neck and body are still independent iconographic

63. See chap. 3, n. 63, for a Late Geometric precedent [44].
64. So, too, Kannicht (n. 54), 82–83.

76. New fragment of the Mykonos pithos (fig. 75) with the death of Ekhion(?). From *AJA*, 80 (1976), pl. 5, fig. 19, by kind permission of Miriam E. Caskey.

units, that no matter how closely associated they are, the episode of the Trojan horse is still distinct from the sack itself. In 1974, however, a missing fragment of the vase came to light that directly unifies neck and body and reveals the maker of the pithos as the era's boldest and most original narrator. The fragment comes from the middle of the upper tier and contains a complete panel with a large dead or dying warrior [76]. He has fallen to his knees, blood pours from a wound on his neck, and his eyes are already closed. The special treatment given him—he fills a panel all by himself, he is placed directly below the horse, and he is the only warrior on the vase to die—indicates that his death was somehow critical in the taking of Troy.[65] He could be Deiphobos, the last great Trojan champion, whose death left Troy practically defenseless. But it is more likely that he is Ekhion, the first Greek to die after the emptying of the wooden horse (his armor, at least, is indistinguishable from the armor of the Greeks on the neck). If so, he seems to have descended from the horse on the neck of the vase only to fall and die on the body, and his death essentially signals the start of the final assault. Ekhion (if that is who he is) thus visually and thematically connects the two parts of the vase: the neck panel explicitly becomes the necessary prelude to the butchery on the body, and as our

65. See M. E. Caskey, "Notes on Relief Pithoi of the Tenian-Boiotian Group," *AJA*, 80 (1976) 19–41, esp. 36–37. I follow her arguments here.

The Edge of Disorder: The Seventh Century

eyes move from neck down to shoulder and belly, mythological or narrative time moves, too. There is iconographic unity and temporal progression at once, and the result is completely new. We might call it a kind of progressive narrative,[66] and it is an attempt on the part of the visual artist to reproduce in his medium the progressive flow of literary description: "this happened . . . then that . . . then that . . ."

Such Protoattic storytellers as the Polyphemos and Ram Jug painters were, then, just two participants in a widespread exploration of narrative technique in the middle of the seventh century. Some of the methods they and other artists developed continued to be used intermittently for the rest of the Archaic period. But others (such as the Mykonos Master's progressive narrative) were rarely if ever taken up again until the dawn of Classical art. And in the third quarter of the century, the brilliant flare of narrative experiment subsided (though it was never quite extinguished) and Greek artists settled down into a few set narrative patterns.

The Protoattic style settled down, too, and Protoattic vase painters began to exchange raw freedom and spontaneity for discipline. *Dynamis* was not dead, nor was the Protoattic impulse for monumentality. But by around 625 or so, Protoattic was so settled that it was in fact something else: Attic Black Figure (capital B, capital F, to distinguish the style from the technique that Corinthian vase painters had used continuously—and even Protoattic vase painters occasionally—for seventy-five years or more). The first masterpiece of the new style is a four-foot tall (1.22-m) amphora that once stood over a grave in the Dipylon cemetery (where the tradition of monumental grave markers began): the Athens Nettos amphora [4, 77]. In Protoattic fashion only the front of the vase bears figured scenes (the back is washed in black glaze) and in Protoattic fashion the theme (if there is one) is the violent dispatch of monsters. On the neck Herakles battles the centaur once again: the names are written in the field, as if otherwise we would not know who they were (in the Attic dialect Nessos was pronounced Nettos, and in the local script one *t* stood for two—hence "Netos"). Our hero jams his heel into the small of the centaur's back, grabs a handful of hair and pulls, and cocks his arm for the fatal sword thrust. Nettos' knees buckle as he is forced to look away from his destroyer, his beard ripples, and his mouth opens in terror— a second rare Archaic display of emotion [cf. 73, right]. This is a scene of efficient, controlled violence, and it is controlled even in the way the triangular composition overlaps the square frame precisely at each angle. The violation of the border makes the image seem more dynamic, but it is also as if Herakles had leaped out of the frame in order to pull Nettos back in.

66. Cf. Weitzmann (n. 57), 12, and E. B. Harrison, "Direction and Time in Monumental Narrative Art of the Fifth Century B.C.," *AJA*, 78 (1983), 237–38 (abstract), who discusses the existence of progressive narration in Classical art.

77. Detail of fig. 4: Herakles and Nettos. Photo: Jeffrey M. Hurwit.

There are powerful contrasts as well: at the center, beside Herakles' stern, unmoved (and neatly mustachioed) face, are the desperate, shaggy beast's open, imploring hands. Touching the chin is a conventional gesture of entreaty in Archaic art, yet here it seems particularly futile, even moving: the contest does not seem fair. On the New York Nessos amphora [72] Deianeira is there to remind the spectator of Nettos' crime of rape. But she is not here, and without her the justice of the avenging hero's cause recedes and the doomed centaur becomes almost sympathetic.

The Nettos Painter (as the artist is known) was an economical narrator— "economical" is perhaps the last word we might choose to describe Protoattic—and he also reduces the cast of the Perseus myth in the scene on the body of the vase [cf. 73 left]. Perseus himself is gone; so is Athena. There are only a headless Medousa, an eagle that flies inquisitively over her neck, her hideous siblings, and a frieze of leaping dolphins that indicate the marine setting of the chase (and whose movement to the left accentuates the Gorgons' movement to the right). The Gorgons are winged now, their heads are no longer cauldrons, and with their masklike faces,

tusks, and protruding tongues they have become canonical: from now on, every Gorgon in Archaic art will look more or less like this. Moreover, they sharply bend their knees and arms in a swastika-like pose that is symbolic of rapid movement: on another vase the Nettos Painter showed Perseus flying in the same way. The Athenian artist, in other words, has acquired a new set of visual formulae with which to build his scenes—formulae that facilitate both narration and recognition. There are now, in the last quarter of the seventh century, limited, fixed ways of doing things—of depicting Gorgons, of indicating flight, of showing supplication, and so forth. After a period of idiosyncrasy, experiment, and whim, Athenian image making is once more subjected to the rigors of the schema and type. The idea of order has come again.[67]

But it did not come by itself. The ordering of Athenian iconography, as well as the decision fully to adopt the black-figure technique, took place under the impact of Corinthian art. The standardized Gorgon's head was standard in Corinthian art first, and figures in the bent-knee posture appeared much earlier on Protocorinthian aryballoi, not to mention the Thermon Perseus metope [65, 69]. Even the geese, owls, and swans on the rim and handles of the Nettos amphora, the fine lotus and palmette chain on its shoulder, and the dot rosettes sprinkled all over the place are borrowings from Corinthian vase painting. Now late-seventh-century Athens imported Corinthian vases like every place else, but at least some of this influence can be explained by the arrival of Corinthian artists in the flesh: there is reason to believe that around 620—roughly the date of the Nettos amphora—a member of an important Corinthian workshop emigrated to Athens, joined an Attic shop, and began to decorate Attic shapes in a Corinthian style.[68] Relations between Athens and Corinth during the reign of Periander (c. 627–585) were good, and more Corinthians may have followed. It is not necessary to argue that the Nettos Painter was himself a Corinthian (indeed, his handwriting argues against that conclusion), but it is nonetheless remarkable that he introduced to Athenian art a subject that was unknown in Protoattic but that was typically Protocorinthian: Bellerophon aboard Pegasos charging the Khimaira.[69] Above all, the Nettos Painter exhibits a precision of line and composition that the Protoattic artist had not cared to master. And it is really the fusion of linear control and dignified form with the native Attic predilection for the monumental and for the powerful narrative that determined the qualities of the new style. The Nettos Painter painted meticulously *and* big, and in his treatment of

67. Cf. Beazley, *Development*, 13.
68. See T. J. Dunbabin, "An Attic Bowl," *BSA*, 45 (1950), 193–202.
69. Beazley, *Paralipomena*, 3 (no. 9), and Schefold, *ML*, pl. 40b. On another vase, he twice painted the Khimaira without Bellerophon; see *Paralipomena*, 1 (no. 1); and a contemporary— the Bellerophon Painter—depicted the myth on two vases from Vari; see Beazley, *ABV*, 2.

the Bellerophon myth the hero on his horse and the Khimaira do not sedately square off [cf. 66] but violently collide. Attic Black Figure is the synthesis of Protocorinthian *akribeia* and Protoattic *dynamis*.

At least one customer outside Attica and its immediate vicinity seems to have quickly realized the importance of the union: it is no coincidence that an amphora by the Nettos Painter (apparently decorated with Gorgons like those on his name vase—only a fragment survives) is the first Attic vase known to have been exported to Etruria, long a Corinthian market (the Chigi vase, for instance, was found near Veii).[70] That isolated find heralds the end of Attic provincialism[71] and the beginning of a competition between the Athenian and Corinthian ceramic industries that would last half a century. But Athens was as yet not much of a threat; and the complacent Ripe Corinthian vase painter, satisfied with his monotonous animal parades [70] because his markets were still satisfied with them, could not have guessed that he would lose.

Attic Black Figure had a great future, but monumental vases for tombs did not: they went out of style in the course of the Nettos Painter's career. These were troubled times in Athens (as we shall see), and social disruptions may have had something to do with their disappearance from the graves of aristocrats. At all events, when the practice of setting up expensive grave markers shortly resumed around 600, the most magnificent ones were of marble and they were shaped like youths.

Egypt, the Temple, and the *Kouros*

For a few years early in the second quarter of the seventh century, Lower Egypt (that is, the region of the Nile delta) was divided up among a dozen vassals of the Assyrian Empire. Around 664 one of them, an Egyptian prince named Psamtik (Psammetikhos, as he was known to the Greeks), was banished to the marshes by the other eleven. As he plotted his return to power, he is said to have received an oracle that "vengeance would come when bronze men appeared from the sea,"[72] and the oracle was duly fulfilled when bronze-armored adventurers from Ionia and Caria (in southwest Asia Minor), driven off course by a storm, fortuitously landed in the

70. The fragment is from Cerveteri. See Beazley, *Paralipomena*, 2 (no. 5), and J. M. Cook, "Protoattic Pottery," *BSA*, 35 (1934–35), 204. About the same time (at least before 600), the first Athenian vases were exported to Naukratis, in Egypt, but they may have been taken there by Aiginetans; see Boardman, *GO*, 125.

71. Athens happens to have shed its provincialism in nonartistic spheres at precisely the same time: around 620–10, Athenians planted the controversial colony of Sigeion in the Troad—the first time Athenians had settled abroad since the Ionian Migrations; see Jeffery, *AG*, 89.

72. Herodotos, II.152.

delta. They were spears for hire, and probably in return for promises of land they helped Psamtik defeat his rivals, break with Assyria, and unify all of Egypt. Ancient Egypt's last great period of independence thus began. Skeptics who do not believe in oracles or luck are free to assume that the exiled Psamtik had sent for the Ionians and Carians in the first place and concocted the oracle to justify the presence of foreign mercenaries in that most xenophobic of ancient lands.

Whether the Ionians arrived by chance or by invitation, Egypt was now officially opened to the Greeks. They had imported Egyptian goods before, and although most seem to have reached Greece through Levantine middlemen, it is likely that Greek traders had occasionally visited Egypt for themselves even in the eighth century.[73] But no post–Bronze Age Greek is definitely *known* to have set foot on Egyptian soil before Psamtik's reign (664–10) and certainly no Greek had been granted the privilege of settling there. Psamtik, however, kept his promise and gave his mercenaries two tracts of land along the easternmost branch of the Nile (where they would be especially handy in case of Assyrian or Babylonian attack—it was not for nothing that these Greek settlements were called "the Camps"). In the meantime he encouraged Greek merchants to visit Egypt and, soon, to live at Naukratis, in the western delta, not far from his own capital city. He did these things not for Greece's benefit, of course, but for his own and for Egypt's: his power continued to come from the points of Greek spears and he saw foreign trade as one way of rebuilding his country's economy. At any rate, by 638 or so it was nothing special for Kolaios of Samos to set sail for Egypt (what was special about his voyage was that he never made it and ended up in Spain), and eastern Greeks (led, perhaps, by Milesians) seem to have taken up residence at Naukratis by 620, if not a decade or two earlier. Psamtik needed the military and commercial skills of the Greeks and so did his successors, who also did much to remain on good terms with them—such kings as Amasis (570–26) sent dedications to many Greek sanctuaries. And Egypt was from now on open to tourists as well as to businessmen and soldiers: the poet Alkaios, we hear, at some point traveled to Egypt; Sappho's brother (a wine merchant named Kharaxos) fell in love with a beautiful but expensive courtesan at Naukratis; and Greek wise men and lawgivers came to see the sights and to learn as well as trade. The Greek fascination with Egypt was immediate and strong enough to inspire some Greeks to give their children Egyptian names before the end of the seventh century. The last tyrant of Corinth—Periander's nephew and short-lived successor—was named Psammetikhos.[74] And so was one of

73. Cf. Boardman, *GO*, 111–13; W. S. Smith, *The Art and Architecture of Ancient Egypt*, rev. W. K. Simpson (New York, 1981), 404; and G. Hölbl, *Beziehungen der ägyptischen Kultur zu Altitalien* (Leiden, 1979), 373–75.

74. The name may have appeared in Greece even earlier, on an inscribed cup from Athens; see J. M. Cook, review of Brann in *Gnomon*, 34 (1962), 823.

the Greek mercenaries who, sent on campaign far up the Nile in 591, came upon the vast rock-cut temple and colossal (68-foot-high) statues at Abu Simbel. These were the mighty works of Ramesses II, the thirteenth-century pharaoh known to the Greeks as Ozymandias. But instead of looking on his works and despairing, the Greeks irreverently carved their names—Psammetikhos son of Theokles, Arkhon, Telephos, and so on—into two of the statues' massive legs.

Egypt's spectacular monuments of stone inspired Greek awe as well as Greek graffiti, and awe led to more tangible things. At the beginning of this chapter we briefly noted some possible Egyptian influences on Greek stone architecture. Even though we do not yet know enough to be able to gauge the extent of Egyptian influence precisely, it is time to elaborate a little. Here are some of the things we know (or at least have good reason to believe):

1. The basic Greek building materials before 700 were mud brick, wood, and thatch, and buildings were not particularly durable [cf. 20, 32].
2. The Greek impulse for monumental architecture—that is, for buildings meant to impress as well as to serve—began to be felt in the Late Geometric period at such places as Samos [33]. But for a time Greek architectural ambitions outran Greek architectural skills, and the techniques needed to channel the monumental impulse into a truly stone (and thus much more durable and impressive) architecture were developed in the course of the seventh and early sixth centuries.
3. The first large-scale stone temples in Greece were built in the first half of the seventh century. A temple with walls of fitted and dressed soft limestone (poros) blocks was built at Corinth sometime after 700 but before 660.[75] Shortly after that (650?) the peripteral temple of Poseidon was built at Isthmia. Its walls (covered with those polychrome murals mentioned earlier [68]) were also of careful ashlar masonry. Evidence has been found, however, to indicate that Corinthians had begun to work poros limestone (and had even put it to architectural use) by the last quarter of the eighth century.[76] If these dates hold, then either the Corinthians got the idea of stone architecture on their own or Egypt, despite the literary evidence, had been sufficiently opened up to the Greeks before 664 to give them the idea.
4. The early temples at Corinth and Isthmia had roofs of fired terra-cotta

75. H. Robinson, "Excavations at Corinth: Temple Hill, 1968–1972," *Hesperia*, 45 (1976), 216–17, dates the Corinthian temple to about 700; but see C. K. Williams II, review of Coulton in *Art Bulletin*, 62 (1980), 151. For the Isthmia temple, see Broneer (above, n. 47).

76. A. C. Brookes, "Stoneworking in the Geometric Period at Corinth," *Hesperia*, 50 (1981), 285–90, notes the discovery in a Late Geometric well of two fragmentary poros half columns. There is evidence for the use of the drove on these pieces, though this tool is usually thought to have been borrowed from Egypt; see, for instance, Ridgway, *AS*, 31.

tiles. The tiled roof was a Greek invention—there are no foreign precedents—and other seventh-century developments (such as low-pitched roofs and heavy supporting entablatures and perhaps even the increased use of stone in walls) were dependent on this indigenous technical innovation.

5. The sight of Egyptian stone temples and pyramids—Giza is only some seventy-five miles from Naukratis—may have stunned and inspired the earliest Greek arrivals, but the Greeks would not have learned very much simply by looking at them. For Egyptian monumental architecture to have had much more than a superficial stimulative effect on Greek monumental architecture, Greeks had to have had opportunities to watch and study Egyptian builders at work. And soon they did: Psamtik embarked on a grandiose and extensive (if badly preserved) building program probably early in his reign[77]—building great buildings (and thus employing great numbers of people) was a time-honored means of legitimizing authority even then. Greeks apparently learned much by closely observing Psamtik's workers quarrying, transporting, positioning, clamping, and dressing stones much harder than the poros limestone used at Corinth and Isthmia. At any rate, Greek architectural techniques are most like Egyptian ones in the decades just before and after 600, and two basic kinds of Greek decorative moldings—the half round and the cavetto—were almost certainly borrowed from Egypt.[78]

6. There is no evidence for the existence of the Doric order before the Greek experience in Egypt fully began in 664 (the temples at Corinth and Isthmia are not known to have had anything resembling an order, though it is not impossible that they did). Not long after the opening of Egypt, however, evidence of the existence of the order abounds. The earliest representation of a Doric capital appears on a Protocorinthian sherd of about 650.[79] The temple to which the Thermon metopes [69] belonged was Doric by definition (even though we do not know what its columns looked like); it is the oldest Doric temple known (c. 630) but it is hardly likely to have been the first one. The Doric order appeared again (and on a much larger scale) in the so-called Temple of Hera (it was also dedicated to Zeus) built at Olympia around 600, but its columns and entablature were originally of wood, and above the height of 3.5 feet its cella walls were of mud brick [78].

77. Cf. Herodotos, II.153.

78. Coulton, 42–43, and L. J. Shoe, *The Profiles of Greek Mouldings* (Cambridge, Mass., 1936), 5, 130, 145.

79. T. J. Dunbabin *et al.*, *Perachora*, vol. 2 (Oxford, 1962), 61–62 and pl. 22 (no. 420). The earliest Attic representation of Doric columns appears on the base of an early Black Figure vase from Vari by the Nettos Painter (Beazley, *Paralipomena*, 3 [no. 13]).

78. Temple of Hera, Olympia, around 600. Photo: Jeffrey M. Hurwit.

The sparing use of stone in the Temple of Hera reflects not on the architect's abilities (which, as the stone portions of the walls attest, were considerable) but on his budget (which was apparently limited). The earliest known temple that was both Doric and completely of stone (columns, walls, entablature, and all) was the even larger Temple of Artemis at Corfu, probably built around 580, after the death of Periander and perhaps in monumental celebration of the island's renewed independence from Corinth [74]. At all events, it is notable that unless the Isthmia temple was also Doric, the first stone temples seem to have been built a century or so before the first fully stone Doric one.

7. The Doric column and capital may owe something to Egyptian columns, but they surely owe as much or more to Bronze Age Greek models:[80] decorative columns that adorned the facades of late-fourteenth- or thirteenth-century tombs at Mycenae may still have been visible in the seventh century; the column at the center of the great

80. Coulton, 39.

The Edge of Disorder: The Seventh Century

relief above the Lion Gate at Mycenae almost certainly was [16]; and for what it is worth, Pausanias, in the second century of our era, reports he saw a wooden column that supposedly had stood in the Bronze Age palace of King Oinomaos at Olympia (V.20.6–7).[81] And although the origins of the distinctively Doric triglyph-metope frieze [59] remain controversial—some scholars believe the parts of the frieze were translated directly into stone from originally *functional* wooden elements (the triglyphs, for instance, are thought to reproduce the grooved ends of wooden beams), others believe that the frieze does not directly reproduce anything structural but was invented to be ornamental[82]—the frieze can owe virtually nothing to Egypt.

8. Finally, it is worth noting that most of the Greeks who visited or settled in Egypt in the seventh century seem to have been Ionians and eastern Greeks, but that the Ionic order formally owes even less to Egypt than the Doric order does. The sight of Egyptian buildings evidently did not have a great impact on Ionian architects, at least not until the second quarter of the sixth century, when the order first appears fully developed in colossal stone temples with two surrounding peristyles. The grandiose multiplication of columns seen, for instance, in the Temple of Artemis at Ephesos [87] or the third Heraion of Samos (c. 570) was undoubtedly inspired by Egypt's vast columnar halls (the major architect of the Samian temple, incidentally, was Rhoikos, and a Rhoikos is known to have dedicated a cup in a sanctuary at Naukratis between 575 and 550; I would like to believe they were the same man).[83] Nonetheless, it is apparent that Ionians did not rush home from Egypt in the middle of the seventh century with very many borrowed architectural ideas. Influence, again, is a process of selection: despite their stronger presence in Egypt, the Ionians chose to select less from its architecture than the Greeks of the mainland, and to do their borrowing later. As the ornamentation of their own order indicates, the Ionians preferred the forms of the Near East.

The Archaic period being what it is, the conclusions to be drawn from all this must be tentative. But the evidence as we have it suggests that the Greek impulse to build temples in stone preceded (if only by a decade or

81. Incidentally, that Protocorinthian sherd with the first representation of a Doric column (above, n. 79) seems to show it tapering from top to bottom, in Bronze Age Greek fashion, not from the normal bottom to top.

82. See, for instance, Dinsmoor, 56–57 and Coulton, 37–39. The "ornamental" explanation of the triglyph-metope frieze does not preclude the possibility that it represents an aesthetic reorganization of elements originally made of wood.

83. See Boardman, *GO*, 131–32 and fig. 153.

two) the first broad Greek exposure to Egyptian monuments during the reign of Psamtik, that this impulse was not necessarily concurrent with the impulse to "build Doric," and that the earliest techniques for working stone—the techniques used at Corinth and Isthmia—could have been largely self-taught. It is clear that the lessons that were certainly learned in Egypt in the second half of the seventh century were essentially technical in nature and had relatively little to do with aesthetics, form, or plan. The Greeks had already decided for themselves that their temples would be long halls, surrounded by rectangular colonnades, with low-pitched, tiled roofs, and their experience in Egypt did not change their minds. But it is also clear that Egyptian techniques enabled the Greeks to build much better and much larger in stone than they had been able to do, and that the Greeks had learned their lessons by the time the temples at Olympia and Corfu were built. Those scholars who believe that the Doric order was not the natural result of a lengthy evolutionary process but was invented almost at a stroke around 650 seem to me to be right. And it is likely that Corinthian architects working during the tyranny of Kypselos invented it:[84] in fact, the order may have been invented specifically for use in the Kypselid building program, the result of a conscious decision to build monumentally and claim Greek architectural superiority for Corinth (the claim might have been made early at panhellenic Delphi, where Kypselos built his treasury and where Greeks from other poleis would quickly have learned of the invention).[85]

The Doric order, at any rate, is just that: a means of ordering and patterning, a *rhysmos*, a way to ensure that every Doric temple would be like every other Doric temple. Moreover, the Doric frieze, by positioning a vertically grooved triglyph directly above each vertically fluted column and another triglyph in between, is a way of echoing the rhythm of the peristyle below: it is a variation on a pattern. The triglyph-metope frieze and the Doric colonnade thus participate in a harmony of measurement—the columns measure, the triglyphs remeasure—that is another sign of the renewed strength of the ordered temperament in the late seventh century. The Doric order—the very idea of *an* order, Doric or Ionic—is thus a supremely Archaic achievement.[86] It would probably have been invented even if the Greeks had never been allowed into Egypt, but they were, and so its invention was probably hastened. For if the Doric order was in no real sense invented in imitation of Egyptian architecture, it was invented in emulation of it. That is, its formulation was a means of rivaling and re-

84. That is what some ancient literary evidence had implied all along; cf. Pindar, *Olympian Odes*, XIII.20–21.

85. If the Isthmia temple was both Kypselid in date and Doric, the claim would probably have been made there first.

86. Cf. Coulton, 50.

sponding to what the Greeks saw along the Nile, a means of asserting Greek differences in Greek terms, even as the Greeks borrowed from the Egyptians some of the very techniques that allowed them to respond better and on a monumental scale. The Egyptian experience, in other words, stimulated an architectural declaration of originality.

So, too, Egyptian influence made Greek sculpture not less original but more so, and whatever parallels in technique or form can be drawn between Archaic monumental stone statues and Egyptian ones, the Greek statue is in both style and meaning a statement of cultural identity and independence, not an acknowledgement of artistic debt. For the strong artist—and for the strong culture—influence is not only a process of selection but also a struggle for artistic difference, and the successful struggle will clear or generate the artistic space necessary for new creations.[87]

We could draw up a whole new list of facts and probabilities that pertain to the beginnings of monumental stone sculpture in seventh-century Greece.[88] But one of the most instructive "facts" is the *korē* (or draped female statue) shown in figure 79, still generally considered the earliest large-scale stone statue left from Archaic Greece.[89] She is 5'9" tall and thus at least life-size, and she was set up in or near the sanctuary of Artemis on the sacred island of Delos around 650. A three-line inscription etched along the left side of her sheathlike dress (*peplos*) gives a few details:

> Nikandrē dedicated me to the far-shooter, pourer of arrows,
> the excellent daughter of Deinodikes of Naxos, the sister of Deinomenes,
> and now(?) the wife of Phraxos.

The details are only enough to show that this mid-seventh-century woman of Naxos, no matter how excellent she was, felt compelled to identify herself in terms of the men in her life (father, brother, husband). Nikandrē is often thought to have been a priestess, and the last line of the inscription suggests that the statue was dedicated on the occasion of her wedding and release from service. But it is unclear whether the *korē* represents the virgin goddess Artemis or Nikandrē, or indeed any specific woman at all. Small holes are drilled into her hands, and whatever was originally inserted into them might have clinched her identity: arrows would make her Artemis, pourer of arrows (cf. Artemis on the contemporary painted amphora from Melos [62], and so would the leashes of lions, since Artemis is often shown

87. Cf. Harold Bloom's introductory remarks concerning poetic influence in *The Anxiety of Influence* (Oxford, 1973), 5–8.

88. See, for instance, Ridgway, *AS*, 37–38.

89. B. Freyer-Schauenburg, *Bildwerke der archaischen Zeit und des strengen Stils, Samos*, vol. 11 (Bonn, 1974), 13–14, dates a fragmentary *korē* from Samos to the second quarter of the seventh century, which would make her at least as early as "Nikandrē," but the Samian *korē* is simply too fragmentary to date precisely.

79. The Nikandrē *korē*, from Delos (Athens NM 1), around 650. Photo courtesy of Deutsches Archäologisches Institut, Athens.

as Mistress of the Animals in early Archaic art.[90] But the holes could simply have been filled with the stems of metal flowers, in which case the *korē* could have been either Nikandrē herself or a generic offering bearer—an excellent woman, to be sure, but no woman in particular. Whoever she is, the years have not been kind to her: she is broken in several places, her face has been eroded away, just slight traces of the cape she wore over her shoulders remain, and the painted (and perhaps lightly incised) patterns that originally decorated her gown have long since disappeared. Yet the multiple origins or roots of the Nikandrē *korē* are clear enough.

First, the statue is remarkably flat: at no point is it more than about seven inches thick. The *korē* thus has all the corporeality of a wooden plank, and in fact statues hewn from wooden beams were probably her prototypes. The Greeks had carved large statues of wood long before the opening up of Egypt in 664. A life-size (or more) wooden image of Hera, for instance, stood on a base within the Geometric *hekatompedon* on Samos [33],[91] and it should not be surprising that the age that gave the Greeks hundred-foot temples and man-size tripods and vases [35, 37]—the age that first committed the Greeks to monumentality—also produced statues on such a large scale. Wooden statues (many of them cult statues) continued to be made throughout the seventh century—our ancient literary sources abound with references to them—and although all the big ones have disintegrated, a few wooden figurines survive to suggest what some may have looked like [80]. The Greeks even developed a fairly elaborate if imprecise terminology for their wooden statues: a wooden image could be a *xoanon* or a *bretas* or a *kolossos*—a term that originally had nothing to do with size but evidently denoted a kind of image that was shaped like a pillar or column (tree trunk?) and that may have been only barely human in form. But it is not just the Nikandrē *korē's* boardlike shape that suggests wooden precursors: a tenon projecting from under her feet and plinth fastened her to her base, and such a device (which, incidentally, is also found on a roughly contemporary *korē* from Samos)[92] is more natural to wood carving than to stone sculpture [cf. 80]. In short, a long and probably indigenous tradition of large-scale sculpture in wood stands behind the stone Nikandrē *korē*.[93]

Second, the *korē* is Daidalic in style. The style is called Daidalic only because it has to be called something, and the name of the legendary but

90. Cf. Richter (n. 58), fig. 373; but see Ridgway, *AS*, 86.

91. Ridgway, *AS*, 25; H. Walter, *Das Heraion von Samos*, 40.

92. Freyer-Schauenburg (n. 89), pl. 1.

93. See H.-V. Herrmann, "Zum Problem der Entstehung der griechische Grossplastik," in *Wandlungen Studien zur Antiken und neueren Kunst*, ed. E. Homann-Wedeking (Walsassen, 1975), 35–48; K. Lehmann-Hartleben, "Drei Entwicklungsphasen griechischer Erzplastik," *Boreas*, 4 (1981), 7–14.

80. Wooden figurine of a goddess (Samos H 41), around 640–30. Photo courtesy of Deutsches Archäologisches Institut, Athens.

81. The "Auxerre Goddess," probably Cretan (Louvre 3098), around 630. Photo: M. Chuzeville, by permission of the Musée du Louvre.

The Edge of Disorder: The Seventh Century [189]

nebulous Skillful One (for that is what Daidalos means) happens to be convenient.[94] It is, as we have briefly noted, an Orientalizing style (like the styles of vase painting contemporary with it): it was invented on Crete before the middle of the seventh century;[95] it was probably inspired by molded terra-cotta plaques imported from the Levant; and, though Crete remained the style's real home—hundreds of Daidalic terra-cottas and limestone statues have been found on the island—it soon spread throughout Greece [cf. 10]. Since the Nikandrē *korē* is so worn, the principal characteristics of the style are seen better in the much smaller, slightly later, and probably Cretan limestone statuette still known as the Auxerre Goddess (though she has not been in Auxerre for many years and is probably not a goddess) [81]. Most early Daidalic figures have their feet set close together and are severely frontal, small, and female. But it is the head that gives the style away: the face is triangular or U-shaped, the forehead is low, the top of the head is flat (giving it a brainless look), and the hair, heavily braided and sectioned in the manner of eastern wigs, falls over the shoulders in massive wedges that invert and balance the shape of the face. It seems inappropriate somehow to imagine the Auxerre Goddess' heavy features on the face of the more graceful Nikandrē *korē*, but the style was nonetheless the same.

Third, the Nikandrē *korē* is not just made of stone: she is made of marble, a material that had not been used for sculpture in Greece for about 1,400 years, even though the Aegean is loaded with it. Greek limestone is not much harder to carve than wood, but marble is a different story, and it is often suggested that the Greeks must have learned to work marble in Egypt, where sculptors had long carved statues in such very hard stones as granite, basalt, and, once in a while, even marble itself. Whatever the degree of Egyptian influence on Greek techniques, the *idea* of carving large-scale statues in marble probably occurred to the Greeks only after their first full exposure to the colossal stone sculptures of Egypt. And at least before the actual modeling began, Greek sculptors proceeded in much the same way as Egyptian ones, quarrying the stone block and then sketching the four principal views of the intended statue on its sides. Moreover, it now seems likely that the Nikandrē *korē* was created under even more intense Egyptian influence than that. During Psamtik's reign, Egyptian sculptors developed a new method for identically fixing the proportions of all their

94. The name Daidalos was apparently applied by later Greeks to any impressive work that seemed of remote and unidentifiable antiquity. Fairly typical is Pausanias' remark that "all the works Daidalos made strike the eye as very odd, but something inspired is nonetheless manifest in them" (II.4.5). Cf. Pollitt, *Ancient View*, 225.

95. G. Rizza and V. Santa Maria Scrinari, *Il Sanctuario sull' Acropoli di Gortina* (Rome 1968) date the beginning of the style to around 700–690, but this date is probably too early.

figures (in the round or in relief): grids were drawn on the sides of the block, standing figures were made precisely twenty-one units or squares high from the soles of the feet to the level of the eyes, and the lines of the grids always intersected the body of one figure at exactly the same points as the body of another (the canon allowed slight differences for men and women—the female waist, for instance, was located a little higher up the grid than the male). A recent computer study suggests that later Archaic sculptors did not use the Egyptian canon very often or consistently, but that the Nikandrē *korē*—again, it is the first Greek monumental stone statue—conforms to it in too many ways to be the result of coincidence. (The statue conforms to the Egyptian *male* canon, but given Nikandrē's identification of herself as the daughter, sister, and wife of men and the general Greek obsession with male beauty, this is not surprising).[96]

Thus the origins of the Nikandrē *korē* are complex: she owes her shape to a native tradition of large-scale sculpture in wood, her style to a popular Orientalizing fashion, and her proportions to Egypt, and it was probably also the Greek experience in Egypt that gave her sculptor the inspiration and confidence to transpose a large-scale wooden image into marble.

Naxos was Nikandrē's home, Naxos was the source of the marble used for her *korē* (and for most of the earliest marble sculptures of Archaic Greece), and so it is a good bet that Naxian sculptors invented the *korē* type itself (soon followed, perhaps independently, by sculptors on Samos, though they may at first have used Naxian marble, too). Naxian sculptors also seem to have invented (c. 650) the other principal Archaic sculptural type: the male youth, or *kouros*, a type that was from the beginning conceived in marble on a colossal scale and whose invention spelled the beginning of the end of the Daidalic style [82, 84].[97]

The Greek tendency to personify almost all early sculptural styles, innovations, and techniques in the figure of Daidalos explains why he is given credit in our ancient sources for repudiating the very style that is today named after him:

> In the production of statues he so excelled all other men that later generations preserved a story to the effect that the statues which he created were exactly like living beings; for they say that they could see, and walk, and preserved so completely the disposition of the entire body that the statue which was produced by art seemed to be a living being. Having been the first to render the eyes open and the legs separated as they are in walking, and also to render the arms and hands as if stretched out, he was marvelled at, quite naturally, by

96. E. Guralnick, "Proportions of Korai," *AJA*, 85 (1981), 269–80.
97. Ridgway, *AS*, 27–29. As Ridgway notes (38), the walking *kouros* led to the creation of walking *korai*, and that led to the abandonment of the confining Daidalic dress.

82. Parts of a colossal *kouros* (Apollo?) set up on Delos by the Naxians, around 600. Photo: Jeffrey M. Hurwit.

other men. For the artists who preceded him used to make their statues with the eyes closed, and with the arms hanging straight down and attached to the ribs.

[Diodoros, IV.76; trans. J. J. Pollitt]

It is not clear what to make of all these remarks (the reference to early statues with closed eyes is particularly puzzling). But the first striding *kouroi* must have seemed marvelously dynamic to eyes that had seen nothing but inert *xoana, kolossi,* and planklike Daidalic works before, and their apparent capacity for movement—ironically the most anti-Daidalic thing about them—earned Daidalos the reputation for making statues that would run away if they were not tied down.[98] For what it is worth, we are told that the first sculptors to win fame by carving marble statues were

98. Plato, *Euthyphro,* 11B, and *Meno,* 97D.

83. Diorite statue of Ir-khonsu-aat (MFA 07.494), Dynasty XXV (early seventh century). Photos courtesy of Museum of Fine Arts, Boston.

Daidalos' pupils (or sons) Dipoinos and Skyllis. But it is probably more to the point that Daidalos himself is said to have worked in Egypt and to have made statues with the same *rhysmos* (pattern) as Egyptian ones.[99] For it is in Egyptian images of clench-fisted, straight-armed, striding pharaohs and

99. Pliny, *Historia naturalis*, XXXVI.9 (cf. Pausanias, II.15.1), and Diodoros, I.97.1–6.

The Edge of Disorder: The Seventh Century [193]

noblemen [83] that the major inspiration for the Greek *kouros* is surely to be found.

There are grounds on which to object to the theory of Egyptian influence.[100] Images of nude males advancing one leg before the other, for instance, were not really new to Greek eyes: Late Geometric bronze figurines (as small as they are) already adopted the pose.[101] And early Greek *kouroi*, whatever the similarities in stance, simply do not look like their supposed Egyptian models: the Egyptian statue is far more naturalistic, its anatomy far more rounded and accurate, than the Greek statue, whose anatomy is a highly articulated assemblage of equally sharp ridges and equally shallow grooves [cf. 7, 8, 84]. This is anatomy as ornamental pattern, and no Greek could have been taught to carve that way in Egypt.[102] But those who would deny Egyptian inspiration for the *kouros* on that basis mistake the nature of influence. Greek sculptors wanted to imitate Egyptian statues no more than Greek builders wanted to imitate Egyptian temples: they wanted to compete, not to copy, to establish their own difference, not to admit debt. Egypt did not dictate to the Greeks what their sculpture should be, but presented them with colossal works to respond to and change and intentionally misread: the highly patterned anatomy of early *kouroi* is very probably a critique of Egyptian naturalism. And the differences between a Greek *kouros* and an Egyptian statue are not limited to anatomical style. The standard Egyptian stone male [83] wears a kilt and unevenly distributes his weight between the right leg, which is stiff and aligned vertically with the torso, and the left, which is placed far and often unnaturally forward. Despite the position of the left leg, the Egyptian figure is not going anywhere: he is static, off balance, almost ready to tilt backward. But a stone backboard props him up, and stone screens stretch between the legs and between the arms and body. The figure has not fully emerged from the original block of stone: the statue is, in fact, a relief—an extremely high relief, but a relief nonetheless. The Greek *kouros* [7, 84] keeps his hands at his sides and puts his left leg forward, too, But, having adopted the basic

100. See, for instance, R. M. Cook, "Origins of Greek Sculpture," *JHS*, 87 (1967), 24–32; R. Anthes, "Affinity and Differences between Egyptian and Greek Sculpture and Thought in the Seventh and Sixth Centuries B.C.," *ProPhilSoc*, 107 (1963), 60–81; and P. Kranz, "Frühe griechische Sitzfiguren—Zum Problem der Typenbildung und des orientalischen Einflusses in der frühen griechischen Rundplastik," *AM*, 87 (1972), 1–55.

101. See Schweitzer, *GGA*, pls. 151–58.

102. It has been suggested that the anatomical patterns found on Greek bronze armor as early as the Late Geometric period may have influenced the details of some marble *kouroi* over a long period of time; see J. F. Kenfield III, "The Sculptural Significance of Early Greek Armour," *Opuscula Romana*, 9 (1973), 149–56. I find this suggestion plausible, and wonder whether some of the earliest Greek travelers in Egypt may have been armorers. Psamtik sent for bronze-armored Ionians, and they would have been wise to bring their own armorers with them.

84. *Kouros* from Sounion (Athens NM 2720), around 600–590; Naxian marble, about 3 meters tall. Photo: Jeffrey M. Hurwit.

The Edge of Disorder: The Seventh Century

schema of the Egyptian statue, the *kouros* proceeds to reject it in almost every other way. He is naked and unaccommodated (occasionally he wears a belt or choker). The left leg is not placed nearly so far forward and the right leg is placed slightly behind, so that the weight is distributed evenly and the figure, like the statues credited to Daidalos, seems to walk. Finally, the *kouros* is free-standing: he has no backboard to lean against, no screens to secure his limbs. Like the Greek temple, he is self-contained, independent, isolated in space. The schematic *kouros*, then, is as much an assertion of originality under cultural pressure as the Doric order; and, faced with a textbook comparison like that between, say, the statues shown in figures 83 and 84, any Archaic Greek would surely have been struck not by the similarities but by the differences. Still, the fact that the type seems to have forgone any kind of formal evolution and appears suddenly, fully formed, huge, and in marble around 650 cannot in my view be explained without invoking Greek experience in Psamtik's Egypt. It helps that computers have again determined that a few Archaic *kouroi*, including the turn-of-the-century statue in New York [7], were made more or less according to the same Egyptian canon of proportions as the considerably earlier Nikandrē *korē*.[103] But that is what one ancient literary source has suggested all along. The passage concerns the mid-sixth-century sculptors Theodoros and Telekles—possibly the sons of that Rhoikos who left his cup at Naukratis around 575—who once lived among the Egyptians and made a statue of Apollo for the Samians:

> Of this image it is related that half of it was made by Telekles in Samos, while, at Ephesus, the other half was finished by his brother Theodoros, and that when the parts were fitted together with one another, they corresponded so well that they appeared to have been made by one person. This type of workmanship is not practiced at all among the Greeks [that is, not in the first century B.C., when the passage was written], but among the Egyptians it is especially common. . . . Dividing up the layout of the body into twenty-one parts, plus an additional one-quarter, they produce all the proportions of the living figure. . . . They say that this statue is, for the most part, quite like those of the Egyptians, because it has the hands suspended at its sides, and the legs parted as if in walking. . . .
>
> [Diodoros Siculus, I.98.5–9; trans. J. J. Pollitt]

The story that the Samian Apollo was made in halves is a garbled reference to a *kouros'* bilateral symmetry, but the quoted proportions are exactly right.

Certainly not many Archaic sculptors adopted the Egyptian canon, and if Theodoros and Telekles were really Egyptian-trained, they were un-

103. E. Guralnick, "Proportions of *Kouroi*," *AJA*, 82 (1978), 461–72.

doubtedly the exceptions rather than the rule. Still, it is necessary to emphasize that the Archaic sculptor, no matter what proportions he chose for his *kouros*, proceeded in a manner first learned in Egypt: he plotted grids on a blank stone pier, sketched front, back, and profile views on its four vertical planes, and gradually peeled off layers of stone until the *kouros* was finally freed from the block. It would not have taken very much to learn the technique—perhaps only observation—and it was learned quickly: the first sculptors of *kouroi* were just as good at it as the last. The *kouros*, at any rate, makes no effort to conceal its origins in a stone block or to soften the impression that its four principal views were independently conceived as two-dimensional drawings. To walk around a *kouros* is to turn four corners. And although the *kouros* will change in style, its severe block-consciousness will not. In fact, it cannot. For when the *kouros* ceases to be four-square, it ceases to be a *kouros*, and Archaic sculpture is over.

This, then, is what a *kouros* is: a naked, frontal, blocklike youth, left leg advanced, arms down by the sides, that seems to generalize and pattern the male form. It is the rendering not of a particular man but of the idea of a man—an archetype that can stand for all. But how did it serve, and what, beyond its generalization, did it mean?

Precisely because the *kouros* is archetypal, it is nonspecific, and thus could be put to a variety of uses. Like the *korē*, the *kouros* basically served either as a marker over a grave or as a dedication in a sanctuary (the sex of the *kouros*, incidentally, did not ban it from the sanctuaries of goddesses, and we hear of at least one *korē* that stood over the grave of a man, as we shall see). Some regions of Greece preferred one use or the other: except for an early group of colossal *kouroi* from the sanctuary at Sounion [8, 84] and one or two controversial figures from the Acropolis,[104] the Athenians used the *kouros* solely as a tombstone [7, 109, 110] while the Boiotians employed it in huge numbers as a votive offering. Some areas (Samos, for instance) used it both ways. But many areas had almost no use for it at all: there are fewer than a dozen *kouroi* from all of the Peloponnesos, and not one example—not even so much as a fragment—has turned up at Olympia, showplace of athletic Greek youth.

In other words, the *kouros* was a versatile image but, despite its great popularity in some places, it was not a compulsory one: no Archaic city-state *had* to have *kouroi* in its cemeteries or sanctuaries. Moreover, it looks very much as if the *kouros* were a kind of all-purpose iconographic blank, as if it had no real identity or meaning until or unless context, inscriptions, or added attributes supplied one.[105] For most of the last century, *kouroi* were

104. See Brouskari, 61 (no. 665) and fig. 109, and Ridgway, *AS*, 49.

105. This point is forcefully made by A. Stewart in his article "When Is a *Kouros* Not an Apollo? The Tenea 'Apollo' Revisited," to appear in a festschrift for D. Amyx. My discussion is greatly indebted to this article.

considered representations of Apollo, the god of ideal youth (among other things), and Brunilde Ridgway has recently revived the theory, arguing that the *kouros* was introduced as a portrait of the god and only later became a generic image.[106] Now early poetry does say Apollo strides powerfully through the heavens and over the earth and takes the form of a vigorous, strong, long-haired youth in his prime,[107] and the similarities with the early *kouros* are clear. It is also true that the majority of extant *kouroi* have been found in areas sacred to Apollo (though 120 of them come from one place, the Ptoion sanctuary in Boiotia) and that the colossal size of many early *kouroi* seems to lift them from the purely mortal realm. And it is true that at least one of these early giants was almost certainly meant to be Apollo: namely, the ten-meter-tall colossos that was dedicated by the Naxians on Apollo's sacred island of Delos around 600 [82] and that boasts through an inscription, "I am of the same stone, statue [*andrias*] and base." But the Naxian Apollo was carved half a century after the invention of the type, and it represented Apollo not because it was a huge *kouros* set up in Apollo's precinct but because (so it seems) it held a bow in its left hand. That is, an attribute, a prop, converted an image of a youth into an image of the archer god, and the very etymology of the inscription's word for statue—*andrias*, "man image"—suggests that the invention of the generic, multipurpose *kouros* was independent of and prior to any direct identification with the god. A *kouros* may be Apolline (that is, youthful, strong, handsome), but it is not an Apollo unless something makes it one.

The Naxians seem to have dedicated their statue collectively, as a community. But most *kouroi* and *korai* were dedicated by aristocrats or by people who were wealthy and pushy enough to act like aristocrats [cf. 60]. Marble statues were expensive—and enormous marble statues (such as those favored on Samos) were enormously expensive.[108] The clientele for such works was obviously self-limiting, and so the *kouros* and *korē* were essentially the preserve of a privileged class, not of the polis as a whole. But aristocrats did not commission such works simply for the sake of conspicuous consumption. They did so to promote their ideals of *aretē* and *kalokagathia*[109]—ideals that had begun to come under attack from certain quarters (Archilochos and such tyrants as the potbellied Pittakos, to name two) in the seventh century. The *kouros* and *korē* were perpetuating symbols of the physical prowess, moral authority, goodness, and beauty that

106. Ridgway, *AS*, 26–27, 49–59; contra W. Burkert, *Griechische Religion* (Stuttgart, 1977), 225–26.

107. *Iliad*, I.43–53; *Hymn to Apollo*, 133–35, 449–50.

108. See Freyer-Schauenburg (n. 89) and, for the recent discovery of an originally five-meter-tall *kouros*, *AR*, 1980–81, 41 and fig. 78.

109. See Stewart (n. 105) and V. Zinserling, "Zum Bedeutungsgehalt des archaischen Kuros," *Eirene*, 13 (1975), 19–33. Cf. Snodgrass, *AG*, 185, who comments on the conservatism of the *kouros*.

aristocrats (naturally) considered innately aristocratic: they were quite literally the emblems and embodiments of Archaic Greece's beautiful people. The fundamental meaning of the *kouros* and *korē* is thus indistinguishable from their appearance, their beauty (and thus their nobility). And in the case of the four-cornered *kouros*, it is at least suggestive that the sixth-century philosopher Pythagoras of Samos (or his followers) could identify *aretē* with foursquareness: in the mathematical Pythagorean view of the world, excellence was quadratic, blocklike.[110]

For much of the Archaic period notions of beauty varied from place to place. The Naxians liked their *kouroi* slender, relatively flat, and elegantly contoured, with sharply patterned anatomy. The Samians liked theirs massive and muscular, with soft anatomical transitions and spherical heads (they liked their *korai* cylindrical). The Parians liked their *kouroi* thick-waisted and barrel-chested. The Boiotians liked theirs sharp-edged and angular. But whatever the local taste, *kouroi* and *korai* were everywhere stone mirrors in which the aristocracy could approvingly see itself. And with *kouroi* and *korai* aristocrats projected beautiful, youthful images of themselves out upon the larger community. It follows that the history of the *kouros*—the central repository of the aristocracy's perception of itself—should be intimately bound to the fortunes of the aristocracy. As Andrew Stewart has recently argued, where in Archaic Greece aristocracies flourished, the *kouros* tended to flourish, and where aristocracies declined or fell (to tyrants, for example), the production of *kouroi* tended to fall off, too.[111] The *kouros*, in short, is a monument of social as well as artistic conservatism—the way it unswervingly holds its schematic pose over 150 years despite advances in other forms of sculpture is nearly reactionary—and so its use and history are as much social or political as aesthetic. And when at the end of the Archaic period Athenian sculptors do not simply cease to produce *kouroi* but transform the type into something else, something no longer "foursquare" [cf. 150], the implications are social and political, too, as we shall see.

Whatever prestige aristocrats hoped for by setting them up, *kouroi* and *korai* dedicated in sacred precincts were also *agalmata*: statues meant to please and serve the gods.[112] It is possible that *kouroi* and *korai* placed over the graves of the dead—such works as the New York *kouros* [7], which originally marked a tomb in rural Attica—were meant to please the dead as well. But this is not to say that the funerary *kouros* promised a literal life after death or guaranteed the immortality of the soul the way an Egyptian funerary statue did. The investments the Greeks made in the afterlife were not remotely so heavy as those made by the Egyptians. And although it is

110. Fränkel, *EGPP*, 277 and 308n11.
111. Stewart (n. 105).
112. Cf. Euripides, *Phoinissai*, 220–21.

not easy to summarize the often contradictory Greek attitudes toward death,[113] in general the afterlife was nothing to look forward to: when we catch glimpses of the shades of heroes in the *Odyssey* (bks. XI and XXIV), for instance, all they do is look mournfully back on the end of life, and Akhilleus, whose power is great among the dead, would gladly trade places with the poorest peasant on earth. What the funerary *kouros* promised was not a happy life beyond the grave but eternal heroization among the living. Though it does not realistically portray the aristocratic dead, it embodies and memorializes him at the height of his beauty and *aretē*. It is a monument to *kalokagathia*, but it is also, in essence, a negation of time and change, an immutable repudiation of lyric *amēkhaniē*.

Two seven-foot-tall clues to this reading of the *kouros* came to light at Delphi in 1893 and 1894 [85]. They are the nearly identical, not quite canonical (they wear boots) marble youths known as Kleobis and Biton.[114] As it happens, their story is preserved by Herodotos:

> When the festival of Hera among the Argives took place, their mother had to be taken to the temple in a cart. But the oxen did not return from the fields in time, and the youths, pressed for time, put themselves under the yoke and drew the wagon while their mother rode. They drew it forty-five stades [about five miles] and arrived at the temple. Their deed was witnessed by those assembled, and their life ended in the best way of all, and in this god showed how much better it is for men to die than live. For the Argive men, standing round the youths, praised their mother, who had such sons as these. And their mother, beside herself with joy at the deed and its fame, stood before the image and prayed to the goddess to give Kleobis and Biton, the sons who so greatly honored her, the thing that is best for man to have. After this prayer they sacrificed and feasted, and the youths, having slept in the temple, did not rise again but died. The Argives made statues of them and dedicated them at Delphi, since they were the best of men. [I.31]

The story is a lyric meditation in prose, and its point is that it is best for ephemeral human beings not to exist at all, since alive they are helpless and subject to forces beyond their comprehension. Yet these commemorative post-Daidalic *kouroi*, who seem bovine and eminently capable of pulling an oxcart for miles, hardly evoke despair or a sense of human frailty. They are instead unselfconscious, detached, transcendent projections out upon a world that can no longer threaten. Kleobis and Biton and more canonical *kouroi* present the remembered dead as plucked from the

113. See E. Vermeule, *Aspects of Death in Early Greek Art and Poetry* (Berkeley, 1979).

114. See also Pollitt, *Art and Experience*, 6–9. C. Vatin's recent argument that the statues are not really Kleobis and Biton but the Dioskouroi (Kastor and Polydeukes) is, in my opinion, not yet proved; see "Couroi argiens à Delphes," *Etudes Delphiques* (*BCH*, suppl. 4, 1977), 13–22, and "Monuments votifs de Delphes," *BCH*, 106 (1982), 509–25.

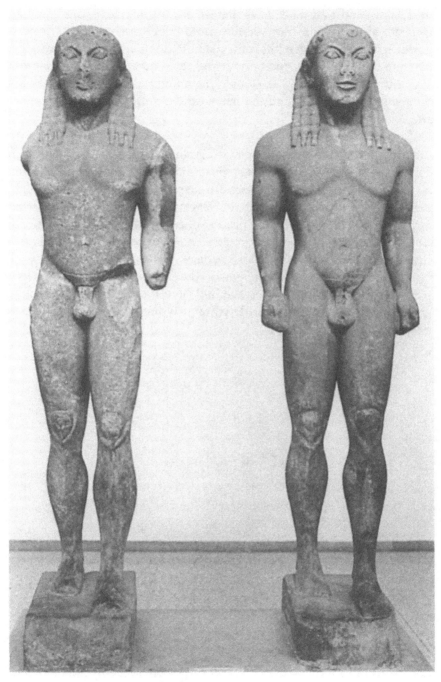

85. Kleobis and Biton (Delphi Museum 467 and 1524), around 580. Photo: Jeffrey M. Hurwit.

uncertainty and transience of existence, and in their schematic pose and generalized, patterned features they find refuge from mutability. And so, however much it served the purposes of the aristocracy and whatever pleasure it afforded the gods, the *kouros*, the embodiment of heroic *aretē*, also affirms a belief as old as Homer: that immortal *kleos* (fame) is the only compensation for death and that fame can be conferred only by poetry or art.

By the end of the seventh century, Archaic Greece had essentially re-defined itself. A new kind of poet spoke to it, and its artists and architects had renewed the old idea of order with such inventions as the Black Figure schema, the Doric temple, and the *kouros* and *korē*. The Near East and Egypt had much to do with the process of redefinition. Egypt in particular stimulated some of the period's greatest innovations simply by offering the Greeks something to rival—stone spectacles that practically compelled the culturally anxious Greeks to invent. In the early sixth century the Orient would act as a stimulus once more, but here too the response would be typically inventive, typically ordered, and typically Greek: this time, the response was philosophy.

5

Golden Ages: Ionia and Athens in the Sixth Century

Anaximander's Map

When the moon blotted out the light of the sun on April 6, 648, the darkness generated one of Archilochos' great meditations on *amēkhaniē* and the utter incomprehensibility of the world. When on May 28, 585, the moon eclipsed the sun again, the event abruptly brought a battle between the Lydians and the Medes to a standstill and convinced their kings that peace was preferable to heavenly wrath. It also happened to make the reputation of Thales of Miletos, who had predicted to his fellow Ionians (some of whom may have fought on the Lydian side) that an eclipse would take place somewhere, sometime, that year. For the lyric poet an eclipse was a thing of terror sent by an inscrutable Zeus. For the warring kings of the East it was an omen of disaster. But for Thales it was, above all, something that could be foretold. We do not know if Thales ventured an explanation for the event: he certainly did not know enough astronomy to have ventured the right one. Still, Thales realized that eclipses were not supernatural causes for alarm or lyric despair. They were not divine warnings and they were bound to occur from time to time whether armies fought or not. Eclipses were natural phenomena and the world was comprehensible after all. Things made sense.

Thales' prediction of 585 apparently earned him the title *sophos*, wise man, soon after.[1] It also conventionally marks the birth of Western philosophy (and science, too, but science and philosophy were then the same thing). That a Milesian gave birth to it and that it was a Milesian monopoly for the

1. According to Diogenes Laertius (I.22), Thales was certified *sophos* (along with the other seven sages of ancient Greece) in 582/81. But see A. Mosshammer, "Thales' Eclipse," *TAPA*, 111 (1981), 145–55, who argues that the story of the prediction is complete fiction.

first half century of its existence (that is, during the careers of Thales and his fellow Milesians Anaximander and Anaximenes) had a lot to do with the nature of Miletos itself. East Greece as a whole could boast a mighty intellectual heritage that already included Homer and numerous lyric poets, and Miletos could claim a general share in that. It was a prosperous place, too: by the end of the seventh century Miletos had outstripped the rest of Ionia in wealth and importance (the fact was not lost on the aggressive kings of Lydia, who spent twelve futile years trying to conquer it). Moreover, Milesian horizons embraced most of the known world: the city was the center of a vast commercial and colonial network that stretched west to Corinth and even farther west to Sybaris, north to the Black Sea (its shores were dotted by so many Milesian trading posts that it must have seemed their private lake), probably east to Al Mina, and definitely south to the joint Ionian settlement at Naukratis, in Egypt. And this particularly broad exposure to the diversity and strangeness of the world undoubtedly encouraged (and possibly enabled) a few Milesians to come to terms with the world on their own and to reduce its variety to a single unity.

But if a powerful cultural tradition, prosperity, and far-flung foreign contacts were preconditions necessary for the birth of philosophy, they cannot have been the only ones. Miletos was not the only Greek city to have poetry, wealth, and foreign trade. The city-states of Phoenicia, moreover, were also prosperous and the Phoenicians were even more extensively exposed to the world than the Milesians, yet Phoenicia did not produce philosophy. Something set Miletos apart, not only from the civilizations of the East but also from the rest of Ionia and Greece. Something made it particularly fertile ground for speculations concerning the nature of the world. That something is elusive. It has been suggested, for instance, that the crucial factor in the origin of philosophy—the precondition that was not merely necessary but sufficient—was the rise of participatory forms of government or the rise of law, written law codes, and political equality; these phenomena, it is argued, encouraged logical argument and objective reasoning.[2] They may well have done so, but they do not explain why the Milesians chose to reason logically about what they did: nature, not society, not politics, not human rights. And, as we shall soon see, participatory government and the rule of law were egregiously irrelevant to the Milesian political condition of the early sixth century anyway. A more provocative theory suggests that at its inception philosophy played a radical political role in the polis. Thales invented philosophy, it is argued,

2. See G. E. R. Lloyd, *Magic, Reason, and Experience* (Cambridge, 1979), 226–67, who also lists several more preconditions than I do here. See also E. Hussey, *The Presocratics* (New York, 1972), 14–15. Lloyd's views are effectively criticized by B. Frischer, *The Sculpted Word* (Berkeley, 1982), 11–16. Frischer notes, for instance, the oddity that philosophy often flourished in cities that lacked participatory forms of government (15).

in order to subvert the religious and ideological systems enshrined in epic poetry, systems that were the foundation of the aristocracy, its traditional claims to hereditary, heroic *aretē* (excellence), and thus its claims to political power. Philosophy, by undercutting the gods, heroes, and values of the aristocracy, established a legitimate foundation for tyranny.[3] Now around 600, when it was threatened by Lydian aggression, Miletos was indeed ruled by a tyrant, Thrasyboulos, and there are good grounds for believing that Thales could involve himself in politics. But the evidence that Thales actually supported Thrasyboulos is extremely weak (it is inferred from a very obscure source)[4] and we know next to nothing about the chronology of Milesian events in the early and middle sixth century anyway: Thrasyboulos may have been long gone by the time of Thales' famous prediction.[5]

At all events, Thrasyboulos was a ruthless tyrant, and ruthless tyrants succeeded him (briefly, it seems). Then followed two generations of vicious class war and massacres of innocents. The paradox of Milesian philosophy and the intellectual achievements of Thales, Anaximander, and Anaximenes is that they were produced before a backdrop of brutality and political chaos. When, as we are told, the poor trampled to death the children of the rich and the rich set fire to the children of the poor, it must have been hard to be philosophical—unless philosophy itself was a form of refuge from atrocity, a reiteration of order amidst disorder, an intellectual withdrawal from social disruption.[6] Other cities in Greece and the Near East shared some if not all of the same preconditions for philosophy as Miletos, but none seems to have been so ravaged. The decisive factor in the birth of philosophy was not the need to legitimize tyranny but the need to escape it and the bloody strife left in its wake.

The escape was physical as well as intellectual. Anaximander is said to have led a colonial expedition to the Black Sea and to have visited Sparta (which, incidentally, was fanatically opposed to tyranny). Thales himself visited Egypt (probably on business, since sages in those days were practical men), where he is said to have measured the height of the pyramids by the length of their shadows. It is not impossible that Thales traveled to Babylon as well (he would not have been the only Greek to do so: a brother of the poet Alkaios, for example, fought as a Babylonian mercenary around 600). But whether Thales visited Babylon or not, some sort of Milesian contact with it is beyond much dispute. For what emboldened Thales to make his prediction of 585 was his consultation or acquisition of Babylo-

3. Frischer (n. 2), 16–20.
4. Minyes, quoted in Diogenes Laertius, I.27.
5. Jeffery (*AG*, 214), however, is willing to see Thrasyboulos disappear only by the middle of the century.
6. Athenaios, XII.524a; cf. Humphreys, 221–22.

nian records: whatever mix of necessary and sufficient preconditions one chooses, the birth of philosophy was attended by an Oriental midwife (and that may be behind the tradition that Thales himself was of eastern, specifically Phoenician, descent).[7] Babylonian priests had long observed and chronicled celestial events of all kinds, though they did so for astrological rather than scientific purposes: priests watched for heavenly portents so that their kings might know in advance of divine favor or wrath. Their accuracy in any case amounted to no more than a rough ability to tell, on the basis of long-accumulated data, whether an eclipse was *possible* in a given year or not. Thales knew no more than they did. Wherever he gained access to their records, he could not have calculated that an eclipse would definitely occur in 585, much less that it would be seen from a particular battlefield in Asia Minor. His prediction was no more than an audacious, crudely educated guess. But audacity was a Milesian trait, and so, apparently, was luck.

Greek geometry owed something to Egyptian land measurement, Greek astronomy to Babylonian chronicles. But neither Egypt nor Babylon—each a highly theocratic and conservative culture—produced an abstract theorem or postulate, and neither produced philosophy, any more than Phoenicia did. But, in fact, a Milesian deserves to be called the first *physikos* (philosopher of *physis* or nature) not because he could measure the pyramids or predict an eclipse, but because he is supposed to have asked what the origin and lasting basis of things was and is supposed to have answered, "Water." Compared to that, the prediction of 585 was a parlor trick.

Now Thales was not the first Greek ever to wonder about the origins of the world. Over a century before, Hesiod had given a detailed account of its evolution from the "coming to be" of *Chaos* on (*Theogony*, 116–38). Earlier Homer had noted in passing that "Okeanos is the *genesis* [begetter] of all" (*Iliad*, XIV.246). Like the poets, Thales assumed that the world developed when something engendered something else: this genealogical approach to origins, this premise that the world as it is was not always as it is, is a mythopoeic way of looking at things, and patterns of mythopoeic thought would continue to influence the Milesians. But mythological explanations of nature would not, and Thales' interpretation of the world was new. He dispensed with personifications and myths of procreation and substituted material cause. Water, not a water god, was for him the ultimate source of things, and this rejection of mythological terms marks the true revolution in the history of thought. Explaining the world was a matter no longer of arranging myths—of making the world narratable—but of rational inquiry into the nature of what Aristotle (and possibly the

7. Herodotos, I.170.

Milesians themselves) called the *archē:* here not simply "beginning" but "the first and sustaining principle," that which is both primordial and permanent, both the initial state of being and the source of the contents of the phenomenal world, something that contains within itself the dynamics of change yet remains the enduring ground of existence.

Water, then, was Thales' *archē*. The world came from it and the earth floated on it like a log (as it does, incidentally, in Egyptian and Babylonian myths). It is unclear whether Thales believed that water was immanent in all things—that rocks and people and trees were really various forms of water—because he never wrote anything down, and even our best authority, Aristotle, concedes that what he knows of Thales is hearsay. Thales' younger contemporary Anaximander, however, did write a book. Significantly, it was one of the first known examples of prose, and his very choice of this new form may have been an attempt to free the language of philosophy from undesirable connotations or preconceptions: poetry had long been a traditional vehicle of myth, and its rhythms and diction might have biased speculative thought. In short, the new medium conveyed a new message. Only one sentence of Anaximander's book remains in something like its original form, but it is clear from later authors who had the whole thing that his response to the questions of origin and existence was startlingly abstract, and because it was abstract it separated Greek from eastern thought once and for all. Anaximander's *archē* was the *apeiron*, the Infinite or Indefinite, an imperceptible undifferentiated substance from which opposite qualities (hot and cold, wet and dry) "separated out" to form the perceptible world, and into which the world would pass again. For Anaximander's younger contemporary Anaximenes the *archē* was air: the earth rested on it and through rarefaction and condensation air became fire (its least dense state), wind, cloud, water, earth, and stone (its most dense state). Anaximenes, the last of the Milesians, was the first to outline a consistent picture of the world as mechanism. The differences in matter, he argued, were not qualitative but quantitative, and it is through familiar, natural processes (evaporation, for instance) that the *archē* is transformed into the diverse constituents of the phenomenal world.

The significance of the Milesians, however, lies less in their particular cosmologies (which were occasionally brilliant, occasionally bizarre) than in their very impulse for free and rational speculation. They were hypothesis makers: they guessed and generalized about nature. They did not gather data and deduce an *archē*, but grandly established one and then made the world fit it. The orderliness and consistency of their imaginative constructs mattered more than testing their validity through experiment: order was truth. And there is no finer emblem of Milesian attitudes than the map of the world Anaximander is supposed to have drawn. The earth is shaped like a column, Anaximander believed, and we stand on its upper

86. Reconstruction of Anax-
imander's map, mid-sixth
century. After J. M. Robin-
son, *An Introduction to Early
Greek Philosophy* (Boston,
1968), 32.

surface (interestingly, on a contemporary Lakonian cup Prometheus and
Atlas, shown holding up the heavens, are supported by a column—a
Spartan artist's literal rendering of Anaximander's earth, made, perhaps,
during the philosopher's visit to Sparta).[8] His map of the surface we walk
on was perfectly circular, and symmetrical besides [86]. Its rim was Ocean
(which, incidentally, also encircles the poetic shields of Akhilleus and Her-
akles), its center was marked by the sacred Aegean island of Delos, and the
land between was divided into three equal parts—Europe, Asia, and Lib-
ya—by the Mediterranean, the Nile, and the river Phasis. It was perhaps
the far-flung maritime experience of his city that encouraged Anaximander
to produce the first Greek map of the world, but it could not stop the
philosopher from regularizing the irregularities of continents, rivers, and
seas. Anaximander's map was as quintessentially Archaic as the Dipylon
silhouette [40], the Attic Black Figure schema [4], and the *kouros* [84]. Just
as they are symptoms of the Archaic need to reshape the transient experi-
ence of the senses into the generic and immutable, so Anaximander's
map—and Milesian philosophy as a whole—manifests the relentless Ar-
chaic search for the constant, its insistence on *kosmos*.[9]

The idea of order had been implicit in Homer's language, Akhilleus'
shield, and Geometric form. It had been threatened, perhaps, by lyric

8. See N. Yalouris, "Astral Representations in the Archaic and Classical Periods and their
Connection to Literary Sources," *AJA*, 84 (1980), 313–18, and G. P. Schaus, "Two Notes on
Lakonian Vases," *AJA*, 87 (1983), 85–89.

9. It was only after the impact of the Milesians that the meaning of the word expanded
from simply "order" to "world order" and "universe."

The Art and Culture of Early Greece, 1100–480 B.C.

expressions of *amēkhaniē* and the intoxicated styles of Orientalizing vase painting. But it reemerges to be the very essence of Milesian thought. *Kosmos*, in fact, is one of two Milesian postulates. The other, as we have noted, is that the anthropomorphic gods of conventional Greek religion had nothing to do with the world order. The object of Milesian inquiry was nature, not the supernatural, and the gods of Homer and Hesiod were banned. Like the eclipse of 585, the *kosmos* was subject to natural law, not divine caprice. This is not to say that the Milesian philosophers were godless. Thales is said to have believed that "all things are full of gods" and Anaximander thought the Infinite was divine (in fact, his prose could not shed poetic language completely, since he described the Infinite as "deathless and ageless," which is just what Homer called the Olympian gods). Divinity, then, somehow existed, but it was not what it had been. For Anaximenes, at least, if there were gods at all, they were derived from air like everything else. The Milesians, at any rate, started a trend. A slightly later Ionian, Xenophanes of Kolophon, blasted the Homeric and Hesiodic gods for their immoral ways, ridiculed their anthropomorphism (if cows, horses, and lions could draw, he said, they would draw gods that looked like cows, horses, and lions), and replaced them with a single god unlike mortals in body or mind. And for Herakleitos of Ephesos, idolatry—praying to anthropomorphic *agalmata*—made as much sense as talking to houses.

But most Greeks were not philosophers, and the notion that there was an impersonal *kosmos* underlying existence must have been of little comfort to the vast majority of people, who still had to contend first and foremost with existence's messy surface. One can imagine the look on a sixth-century farmer's face upon being told by, say, a follower of Anaximenes that the boulders he pulled from his fields were really made of air. Reality simply did not correspond with the orderly picture the Milesians drew of it. But natural philosophy had a greater problem: it left human beings alone with their reason, and that can be very lonely indeed. Myth, if it placed human beings at the mercy of unfathomable, whimsical gods, at least assumed that the gods paid some attention to them.[10] Thus the birth of philosophy did not mean the death of traditional religion. The *Iliad, Odyssey,* and *Theogony,* not Anaximander's prose treatise, remained the textbooks of Archaic Greece. Sixth-century poetry, such as the choral lyrics of the great Stesichoros (a rough contemporary of the Milesians from the other side of the Greek world, Sicily), still dealt with the heroes and deities of myth. And temples continued to be built to the old gods that water, infinity, and air could not displace.

10. W. K. C. Guthrie, *A History of Greek Philosophy,* vol. 1, *The Earlier Presocratics and the Pythagoreans* (Cambridge, 1962), 27–28.

The era of the Milesians was, in fact, the great era of Ionian temple building (as well as sculpture), and the leading cities of Ionia undertook projects so gradiose that they almost seem to be conscious repudiations of the rational and radical views of the first philosophers. Around 570 at the Heraion on Samos—Miletos' island rival and the only comparable power in Ionia—Rhoikos and his son Theodoros began a colossal limestone temple on the site previously occupied by eighth- and seventh-century *hekatompeda*. And these two architects (perhaps just back from an inspiring trip to Egypt) continued the Samian tradition for innovation. The Geometric Heraion [33] had been the first Greek temple to be surrounded by a complete peristyle. This third Heraion was the first temple to be surrounded by two of them—more than a hundred columns in all.[11] It must have been an awesome sight, unlike any ever seen before in Greece, with its dense maze of columns, and in fact it came to be known as the Labyrinth. Rhoikos and Theodoros wrote a book about their limestone behemoth—another example of early prose and one probably far more prosaic than Anaximander's book on nature. Perhaps a decade or so later, Theodoros was hired away by the city of Ephesos to engineer the foundations of an even larger *dipteros* (as a temple with two peristyles is called) dedicated to Artemis—the first monumental structure largely of marble [87].[12] The principal architects, Chersiphron of Knossos and his son Metagenes, wrote a book about their temple, too. Not to be outdone, Miletos soon entered the furious architectural competition with still another *dipteros* dedicated to Apollo at Didyma, some dozen miles south of the city (no book this time). Clearly, these colossal works were more than the houses of traditional gods: they were the proud, expensive boasts of cities vying for the leadership of Ionia.

Not much remains of any of them, but they nonetheless represent at one and the same time the first monumental expression of the Ionic order and its Archaic climax. The Ionic order not only was a later development than the Doric of the mainland, but also was far more elaborate. The multiplication of peristyles, for instance, blurs the clear relationship between colonnade and cella established in Doric (or, for that matter, in the orderless *hekatompeda* of early Samos): instead of a single row of columns mediating between free and enclosed space, there is a deep and enigmatic petrified forest. The profusion of columns is nearly matched by a profusion of intri-

11. Since a confrontation with the gigantic columnar halls of Egypt may have inspired the invention of the dipteral temple, it may not be mere coincidence that the architect Theodoros was evidently the same fellow who with his brother Telekles used the Egyptian canon of proportions for his statue of Apollo; see chap. 4.

12. See now A. Bammer, *Das Heiligtum der Artemis von Ephesos* (Graz, 1984).

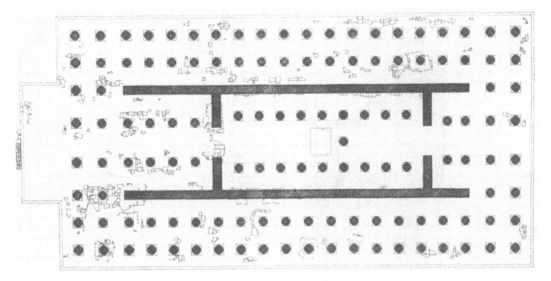

87. Plan of Temple of Artemis at Ephesos, around 560. Photo courtesy of the Trustees of the British Museum.

cately carved and lush ornament. But perhaps the difference between Doric and Ionic is best seen in a comparison of their column capitals [59]. While the Doric capital's principal parts are two plain geometric forms, a round cone and a square slab that are round and square from any side, the Ionic capital, with its curling volutes, limp palmettes, and eggs and darts, is essentially flat. All sides of the Doric capital are equal. The sides of the Ionic capital are not. The Ionic order, for all its sumptuous stone vegetation, goes best in only one direction—laterally—and has problems turning corners (perhaps it was originally developed for use in colonnades that did not have to do so—those of stoas, for instance). Despite its use in enormous buildings that are mostly stone groves, the Ionic order is the architectural embodiment of *poikilia*. It is an order of brilliantly variegated surfaces, planes, and cylinders. So, incidentally, is Ionian sculpture, such as the intricately streaked and partly smooth cylinder that is the *korē* dedicated by Cheramyes [88] at the Samian Heraion around 560. Doric, in contrast, is an order of abstract, unelaborated volumes. No contemporary mainland Doric temple approaches the scale of the colossi at Samos, Ephesos, and Didyma, but perhaps none had to: in Doric's inherent clarity and simplicity lies a kind of power, a sense of substance, that sheer size alone cannot really match.

The construction of the Ionian *dipteroi*, as well as the dedication of the statues that populated the sanctuaries or lined the sacred ways to them, Egyptian style,[13] documents the extraordinary wealth and sophistication of

13. Cf. Boardman, *GS*, figs. 94, 95.

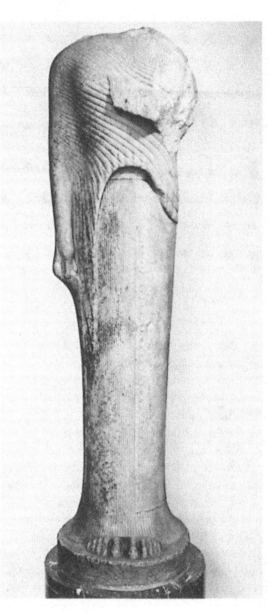

88. *Korē* dedicated by Che-
ramyes at the Heraion of
Samos (Louvre 686), around
560. Photo: M. Chuzeville, by
permission of the Musée du
Louvre.

Ionia during its golden age. But a lot of the gold came from the neighboring
kingdom of Lydia, and Ionian history took a turn for the worse because of
the ambitions of a Lydian king. Around 560 Kroisos mounted the Lydian
throne and almost at once resumed the expansionist policies of his prede-
cessors. He began with Ephesos and did not stop until virtually every city
of East Greece was under his sway. "Before that," Herodotos notes, "all
Greeks had been free" (I.6). Some Ionians still were: Miletos nominally
retained its independence, and such islands as Samos were left alone. But

life was not hard for the Greeks under Kroisos' control—in one poem Xenophanes of Kolophon rebukes his fellow citizens for the ostentatious and decadent ways they learned from the Lydians. And Kroisos was a generous master. He helped Ephesos (his first victim) finance the construction of its dipteral Artemision [87] by paying for most of the columns. Some bore sculptured reliefs on the lowest drum (in the manner of eastern architectural reliefs) and at least three of them bore inscriptions identifying Kroisos as the dedicator. We are told that Kroisos delivered golden calves to Artemis besides: clearly, Ephesos could have done worse. The Artemision strongly influenced the temple of Apollo at Didyma (it also had columns carved with reliefs) and it is not unimaginable that Kroisos had a hand in that project as well; at the very least Apollo received magnificent gifts of gold, silver, and electrum from him. Apollo was, in fact, Kroisos' favorite Greek god, and several sanctuaries on the Greek mainland profited from his generosity as well. But Kroisos' favorite sanctuary was Delphi, and he loaded the place with spectacular offerings of gold and silver.[14] Alas, he was repaid with ambiguity. In 550 Cyrus II of Persia overthrew and swallowed up Media, spreading his new and powerful empire to the banks of the Halys River (the eastern boundary of Lydia, apparently established after the eclipse-ending battle of 585). The Ionians were too comfortable to accept Cyrus' bribe to join him against Kroisos, but Kroisos was justifiably concerned and asked the oracle of Apollo whether he should launch a preemptive strike against Persia. The notorious reply was that "if Kroisos attacked Persia he would destroy a mighty empire." To Kroisos this seemed a straight enough answer (and he had reason to expect one from the god he had so much enriched). Sometime between 546 and 540, he crossed the Halys—Thales is supposed to have turned engineer and divided the river into two fordable streams—but the empire he destroyed was his own.

The philhellenic buffer between the Greeks and the East thus perished. The last thing we hear about Thales is that he urged the Ionian cities to unite against the Persian threat. But the advice of the wise man was ignored and Ionia rapidly fell within the expanding shadow of an Oriental empire far larger and more alien than Lydia. Ionian creativity began to stifle under Persian rule—the Ionic order, for instance, failed to develop in its birthplace, and Ionian sculpture declined in quantity if not in quality— and the Ionian golden age essentially came to an end. The gold did not turn completely to dross: Ionia continued to produce great minds (such as Herakleitos) and fine artists (some of whom were even hired by Persian kings to decorate their palaces). But the extension of the Persian Empire to the shores of the Aegean effectively pushed the center of Archaic civiliza-

14. Herodotos, I.50–51, 54.

tion west. Many Ionians went with it. The entire populations of some cities simply abandoned their homes and sailed away. Artists, poets, and thinkers joined the exodus. The poet Anakreon of Teos emigrated with his fellow citizens to Thrace before he was lured to the court of Polykrates, tyrant of a still independent and flourishing Samos. And although he could stand to live in a city infested with Lydian fashions and tastes, Xenophanes found the prospect of Persian rule unbearable and fled Kolophon for Magna Graecia. In the sixth century Magna Graecia enjoyed a golden age of its own, but despite its receptiveness to such immigrants as Xenophanes and Pythagoras (a refugee not from Persia's Ionia but from Polykrates' Samos) and despite its own weighty contributions to art, architecture, poetry, and thought, the true focus of Archaic culture did not move quite that far. It shifted back to where it had been two centuries before, to the less cosmopolitan city across the Aegean that had been the center of Geometric Greece and before that the fount of the Dark Age migrations: Athens, the Ionians' ancestral home.

Solonian Athens

When Athens makes its first genuine appearance in the annals of Archaic history—that is, when it enters a period that was actually written about in some detail by ancient authors and that does not have to be reconstructed totally from potsherds and stones—it is in deep trouble. The first Athenians who are, unlike Theseus or Erechtheus, something more than legends are failures. Around 632 a former Olympic champion named Kylon attempted a coup d'état with the aid of his father-in-law, the tyrant of Megara. Kylon was soon forced to flee Athens, and his followers were impiously massacred by order of Megakles, the archon (chief official) of Athens and head of the Alkmeonidai, a family that, it was said, thus became cursed. Yet whatever precipitated the Kylon affair did not go away, and Drakon's publication of the first Athenian law code about a decade later (c. 621) was probably a response to a persistent social and economic crisis—broadly speaking, the strife between the common people and the *Eupatridai*, the nobles, those conspicuously consuming aristocrats who displayed their wealth in, among other things, the monumental vases that stood in their cemeteries [4] and the marble statues that before long would begin to take their places beside them [7], stone expressions of the aristocratic ideal of *kalokagathia*. But Drakon was probably in the pocket of the rich and may have been more of a stenographer than a lawgiver, merely writing down (not rewriting) the laws as the Eupatrids wanted them written. An inequitable status quo seems even more inequitable when it is sanctioned by a text put on public display. And although Drakon

was given the job because the lower classes wanted to know just what the laws were, matters went from bad to worse when they found out.

But class conflict was not Athens' only problem around the turn of the century. The morale of the polis seems to have been dealt a blow by the loss of the island of Salamis to the hated Megara, the power behind the earlier Kylonian conspiracy. Drakon's law code is supposed to have punished almost every crime, from theft to homicide, with death, and after the loss of Salamis, the Athenians passed another law in the same vein: to advocate in either speech or writing that the war for Salamis should be renewed was a capital offense. The law did not mention poetry, however, and a Eupatrid whose family may have come from Salamis composed an elegy (the traditional form of crisis poem at least since Tyrtaios), took the additional precautions of feigning madness and posing as someone else, and sang his lyrics from memory to a crowd assembled between the Areopagos and the Acropolis, the site of Athens' first agora. Eight lines out of a hundred survive:

> I am a herald come from lovely Salamis
> with a song, words adorned, not a speech. . . .
> I would rather change my country, and be
> a man of Pholegandros or Sikinos, not Athens.
> For soon this would be the talk among men:
> 'There goes an Athenian, a Salamis-Loser.' . . .
> So let us go to Salamis to fight for the lovely
> isle and put aside our hard disgrace.
>
> [West, 1–3]

The performance evidently worked and Salamis was retaken. Hostilities with Megara would flare up again, but in the meantime Athens had acquired not only its first poet[15] but also its first great statesman: Solon.

The polis was still troubled by a civil crisis that had already threatened a tyranny and produced a law code said to have been written in blood. And Solon soon turned to poetry again, this time to chastise the wicked and defend the oppressed. In his longest extant elegies Solon sounds both Hesiodic in his unwavering faith in the justice of Zeus and Archilochean in his assertion of the instability and helplessness of the human condition. But his main topic is wealth. All men, even poets like himself, strive for it, he says, and it can be had justly. But wealth was now tearing the polis apart:

15. The Homeric Hymn to Demeter, which deals with the far-western Attic site of Eleusis, is thought to have been composed in the seventh century but before Eleusis became part of the Athenian polis.

> For those of us who have the greatest wealth
> Try for twice as much. Who could satisfy them all?
> [West, 13, 72–73]

> The citizens themselves in their folly wish to destroy their great
> city, compelled by wealth,
> And the mind of the leaders of the people is unjust; surely
> suffering will befall them, because of their violence.
> For they do not know how to check their greed. . . .
>
> [West, 4, 5–9]

There is, Solon suggests, plenty of blame to go round, but his principal targets are the Eupatrids: it is their rush for wealth that has sent many of the poor into slavery and evil into every house. The attack was poetic but withering. And whatever their faults, the Eupatrids had enough sense to realize that matters could not continue as they were much longer. Faced with the prospect of violent revolution—and of more scathing verse—they gave Solon the chance to establish the "good government" (*eunomia*) his poems demanded. In 594 he became archon and was granted extraordinary though temporary powers to cure what ailed the Attic state.[16]

What ailed it is not precisely known, but diagnoses have focused on a kind of debt in which the borrower put up his freedom (and the freedom of his family) as collateral and on the *hektemoroi*, the class of "sixth-parters" whose ancestors evidently struck a bargain with the ancestors of the Eupatrids and, in return for an annual share of their crops, settled the Attic countryside at the end of the Dark Age. The categories of debtors and indentured peasants no doubt overlapped. But the best evidence for what the problems were is what Solon says he did about them:

> My witness in the court of time
> is mother of Olympian gods,
> best, most great, black Earth.
> I took away the *horoi* stuck everywhere
> in her, once enslaved, now set free.
> Back to Athens, godly land, I brought
> many who had been sold abroad, legally
> and not, some who by necessity had fled
> their debts, and some who had forgot
> their Attic tongue, wandering everywhere,

16. The dates of Solon's Salamis harangue, his archonship, and his reforms are controversial, but those who place the reforms in the 570s remain a minority; see, for example, M. Miller, "Solon's Timetable," *Arethusa*, 1 (1968), 62–81, and "The Accepted Date for Solon: Precise, but Wrong?" *Arethusa*, 2 (1969), 62–86; and R. Sealey, *A History of the Greek City States, 700–338 B.C.* (Berkeley, 1976) 121–23. The traditional date is supported by N. G. L. Hammond, *Studies in Greek History* (Oxford, 1973), 164–66.

and those who here bore shameful slavery,
trembling before their masters, I set free. . . .
[West, 36, 3–15]

Solon never uses the word *hektemoroi*, but the *horoi* that wounded the black earth were probably stone markers that declared the mortgaged status of the fields of the *hektemoroi* and their hereditary obligations to the Eupatrids. What seemed a fair deal in the Dark Age was at the beginning of the sixth century obsolete and oppressive. The protection and patronage of the Eupatrids were no longer needed, but they still insisted on their sixth part from farmers who not only could not afford it but also, after generations of tilling the rocky Attic soil, must have considered it fully their own. By lifting the *horoi* from the earth, Solon broke the ancestral contracts: the *hektemoroi* simply ceased to exist. And by canceling all existing debts and forbidding loans from being secured on the bodies of the borrowers, Solon liberated large numbers of the poor.

This *seisachtheia*, or "shaking off of burdens," was the reform of which Solon was most proud; at least he glosses over everything else he did in a mere two lines:

Laws for the bad and good alike
I wrote, and fixed straight justice for each.
[West, 36, 19–21]

But we know more than what he briefly tells us here. He almost completely dismantled Drakon's law code. He created a new constitution based on qualifications not of birth but of property, dividing the citizenry into four classes graded by wealth and guaranteeing each certain rights and offices. The archonship, for instance, was reserved for the two highest classes, but even members of the lowest class (the class of most former *hektemoroi*) were entitled to vote in the assembly and (possibly) to sit in the court known as the Heliaia. From this assured political status even the humblest Athenian could aspire to something higher: all it took was money. Now Solon expressly states that the masses were entitled to just so much and no more. He did not know what democracy was, let alone decide to institute it in Athens. But his legal and political reforms gave the idea of democracy a place to be born. By the end of the century, it (or something close to it) was.

Solon had broken the absolute power of his own class and for the time being Athens avoided civil war and tyranny, the fates of other Archaic poleis. But that was not enough to satisfy everyone. In fact, it satisfied hardly anyone. The poor had certain burdens shaken off, but they were still poor. The Eupatrids no longer received their steady sixths and were forced to share power with the nouveaux riches besides. "In great mat-

ters," Solon says, poetically shrugging his shoulders, "it is hard to please all" (West, 7), and he was right. But his replies to his critics (written, perhaps, long after his archonship) could be sharper than that. In one poem Solon pictures himself holding a shield over both the rich and the poor, preventing either side from gaining an unjust victory. In another he compares himself to a wolf surrounded by a pack of dogs; the simile is nearly Homeric. He is both above and attacked by the people whose lives he changed—these are images of isolation on a heroic scale. And it may not be coincidence that some of his poetry of self-defense is in iambic trimeter, the meter used for the dialogue of a later Athenian poetic creation: tragedy.

Solonian Athens actually did without Solon for its first decade. To avoid the hounding of his critics and to give the new constitution a chance to succeed or fail on its own, he left town. Like Thales, his contemporary, he visited Egypt. Herodotos also puts him in Lydia, where like a good lyric poet he lectured an uncomprehending and flustered Kroisos on the mutability of human fortune.[17] Wherever he went, Athens did not lack political crises in his absence. Twice no archon was elected. Later an archon refused to leave office after his year was up and had to be thrown out. The Solonian constitution did not eliminate political conflict or personal ambition. But the new order essentially held and the land stayed free. When Solon finally returned, he resumed his career as poet and political commentator and watched the city he had saved from civil war enter a period of economic and cultural revival.

The revival, too, was partly Solon's doing. We are told that he took a number of actions to strengthen the Athenian economy. Some of what we are told may not be true,[18] but there is no reason to doubt that he stimulated native olive-oil production by banning all other agricultural exports, or that he encouraged skilled foreign artisans to settle in Athens, or that he made it mandatory for fathers to teach their sons a craft (the record of Attic vase painting in the sixth century includes a number of father-and-son teams, but it would have done so even without Solon's edict). Pottery, Solonian Athens' leading economic indicator, in fact records something of

17. I.30. If the lower dating of Solon's reforms is accepted (see above, n. 16), the meeting of Solon and Kroisos is not so anachronistic as it seems.

18. It is, for example, the consensus today that Solon could not have reformed Athens' coinage, as Aristotle says he did (*Constitution of Athens*, 10), because Athens had no coinage to reform before the middle of the sixth century; see C. Kraay, *Archaic and Classical Greek Coins* (Berkeley, 1976), 56–60, 331. D. Kagan, "The Date of the Earliest Coins," *AJA*, 86 (1982), 343–60, is among the minority who believe the modern consensus wrong and Aristotle right. J. H. Kroll and N. M. Waggoner, "Dating the Earliest Coins of Athens, Corinth, and Aegina," *AJA*, 88 (1984), 325–40, are to be counted among the majority, but suggest that Solon could have reformed a protomonetary system based not on coins but on weights of bulk silver.

a boom. There is no need to imagine great captains of industry running vast smoke-spewing factories in the Kerameikos: a potter's workshop was a modest place, and if a hundred potters and painters were working at any one time in Solonian Athens, it would have been a lot. But the Attic vase, which in the seventh century had been made almost entirely for local consumption, soon found its way to every corner of the Mediterranean, even to Corinth. By the middle of the century, the Attic vase thoroughly outclassed its Corinthian rival and drove it from the market. Ironically, a few Corinthians helped. As we have seen, even before Solon's archonship at least one Corinthian vase painter had moved to Athens. Other Corinthians almost certainly accepted Solon's invitation to emigrate and brought Corinthian traditions, motifs, and shapes with them. For the first time in Athenian history it is possible to detect the impact of public policy and not merely aristocratic tastes on the arts.[19]

A Corinthianizing parenthesis in the history of Attic vase painting begins in the 590s, when the native Attic impulse for monumentality is temporarily lost beneath a wave of miniaturism and animal friezes. Corinthian influences had been felt before—at the very beginning of the Black Figure style, for instance—but an artist such as the Nettos Painter [4, 77] knew perfectly well what distinguished Attic from Corinthian. The Nettos Painter's first important successor, the Gorgon Painter, did not. We cannot conclude that he was an immigrant, but if he was not a Corinthian, he wanted to paint like one. His name vase [89], even set atop its candlestick support, falls far short of the Nettos Amphora (in height as in other things), but it is about as large as Attic vases get in the early sixth century. Nonetheless it is treated as if it were an olpe or aryballos: no large panels here, just stacks of mechanically arranged hybrids, boars, and stretched-out lions and panthers—all transplants from the Corinthian menagerie. The widest diameter of the vase is reserved for an elaborate lotus-palmette chain. The highest register presents one, possibly two, mythological scenes, and they are the standard fare. On one side anonymous heroes duel stiffly and symmetrically while, in Homeric fashion, their chariots await. On the other side the Gorgons still have not caught Perseus. But they are not trying very hard, and in fact the bent-limbed monsters and hero are there merely for the exercise in convention and schema. The only danger Perseus is in is of flying into the chariot of the unrelated combat on the other side of the vase. Any open-ended frieze, but particularly one as episodic and airy as this, by nature diffuses what had

19. In the art of sculpture Solon's impact may not have been so beneficial. I favor the view that a Solonian law banning luxurious displays at funerals—another blow to the Eupatrids—depressed the market for *kouroi*, which were expensive and in Attica were almost always funerary in function. This may explain why Attic *kouroi* are so hard to come by between 590 and 570.

89. Dinos and stand by the Gorgon Painter (Louvre E874), around 590. Photos: M. Chuzeville, by permission of the Musée du Louvre.

been seventh-century Attic vase painting's chief strength: narrative power. It will be some time before there is an Attic painter capable of concentrating it again.

Although there is no *dynamis* here, there is *akribeia*: the Gorgon Painter may have been a dull storyteller but he was a good draftsman. So were a few of his Corinthianizing successors in the Solonian Kerameikos—the KX Painter, for example, the leader of a group of painters who were fond of covering cups of Corinthian shape with pudgy gesticulating revelers (komasts) of Corinthian descent.[20] But there were bad vase painters, too, and one of the worst, the Polos Painter, was one of the most prolific [90]. His pots, sloppily covered with rows of slapdash beasts, were shipped to many parts of the Mediterranean and are counted in the hundreds. There is no explaining taste, but perhaps the stylistic stamp "Made in Athens" now lent even his work a certain cachet. The Polos Painter relied on uneducated consumers, and there were plainly enough of them.

Possibly such mass-produced, slipshod work had something to do with it, but the Attic fascination with things Corinthian began to taper off

20. See Boardman, *ABFV*, figs. 21–23.

around 570. Black Figure artists did not (and never would) stop painting animal friezes or cultivating miniaturist skills, and for a while pictures remained small. But if monumental dimensions were lacking, there was a revival of the monumental spirit and the interest in myth that nourished it. It is this revival that ultimately closed the Corinthianizing parenthesis in Attic painting. As it happens, the revival started with the first Attic artist whose name we do not have to make up.

Sophilos was not the first Attic painter to sign a vase (the Protoattic Analatos Painter [71] had done so over a century before) but he was the first whose signature survives intact. The Gorgon Painter may have been his teacher (his father?) and at first glance Sophilos seems just as much of a Corinthian sympathizer: most of his vases are pure animal style and on the few that are not only one frieze is reserved for human figures, in the fashion of the Gorgon Painter's dinos. Sophilos was not a gifted draftsman. But when he painted just animals he was particularly lackadaisical and, as if admitting it, left his work anonymous. It was only when he turned to myth that he came to life—and signed his name. He wanted to be remembered for the gods and heroes he drew, not for the lions and sphinxes, and

90. Amphora by the Polos Painter (BM B 18), around 570. Photo courtesy of the Trustees of the British Museum.

91. Dinos and stand by Sophilos (BM 1971 11-1.1), around 570. Photo courtesy of the Trustees of the British Museum.

simply by signing his mythological scenes he put distance between Attic and Corinthian attitudes.[21]

Sophilos' favorite myth was the celebration of the marriage of Peleus and Thetis, the parents of Akhilleus. He painted it at least twice [91]. Each time he encircled the entire vase with a single grandiose procession of wedding guests and thus brought unity of theme to the Black Figure frieze. And each time he not only labeled the participants but also wrote (none too inconspicuously in the porch of·Peleus' house): *Sophilos egraphsen*, "Sophilos painted [me]." On a fragment of a vase found in Akhilleus' homeland, Thessaly, he painted the great Homeric hero himself in his role as sponsor and judge of the funeral games held for Patroklos [92]. This is the first certain

21. The first Corinthian painter to sign a vase—Timonidas (c. 590–80)—was also the last of any importance. Sophilos, in contrast, was the first in a long Attic line.

The Art and Culture of Early Greece, 1100–480 B.C.

92. Fragments of a dinos by Sophilos (Athens NM 15499), around 570. Photo: Hirmer Fotoarchiv, Munich.

Attic representation of an event also described in the *Iliad* (XXIII.257–533), though that fact does not prove that Sophilos was here illustrating Homer, as we shall see. The figure of Akhilleus himself is actually missing, but the word *Akhiles* scrawled to the right of a grandstand packed with tiny Akhaians shows that he is not missing by much. To the left the winning chariot team heads for the finish line: if Sophilos followed the Homeric account, Diomedes would have held the reins. Above the horses are the first letters of a signature—probably *Sophilos mepoiesen*, "Sophilos made me" (that is, he was the potter), since he signed as painter between the horses and bleachers. Two more words—a title—are squeezed in there: *Patroklus atla*, "The Games for Patroklos," and it is all but certain that the chariot race was not the only game shown (half the spectators turn their backs on it and look at some other event).

There was nothing new about Athenians writing on their vases (though none had ever titled a picture before).[22] Others could print better than

22. Titles and captions remain very rare on vases, though they may have been more common on large-scale paintings done on walls or panels. Perhaps that is where Sophilos got the idea; see M. Robertson, *Greek Painting* (Geneva, 1959), 57.

Golden Ages [223]

Sophilos and spell better, too (*Akhiles, Patroklus,* and *atla* are all wrong). But what was new was Sophilos' enthusiasm for the written word; from now on writing could be an integral part of the Archaic image, with its own formal and aesthetic values. He loved the look of letters, and his words no less than his long, populous friezes prepared the way for the finest mythographer of the Solonian Kerameikos: Kleitias.

It could not have been very long after these works by Sophilos (two or three years? less?) that a potter named Ergotimos made a volute krater (it is more than two feet tall) and turned it over to Kleitias, his partner, for decoration. Kleitias had absorbed the narrative innovations of Sophilos practically in no time and he painted both the wedding of Peleus and Thetis and the chariot race held in honor of Patroklos on the krater—the François vase [93]. But Kleitias did not stop there: the vase is covered from lip to foot with eight different narratives populated by more than two hundred figures—the most since Late Geometric battle kraters [48]—and other mythological subjects appear on the handles. There is only one animal frieze and it is a fine one, but the old Corinthianizing ratio of animals to people has finally been reversed. So, significantly, have Corinthianizing attitudes toward the animals themselves: Kleitias' beasts do not parade sluggishly and pointlessly around the vase but are locked in life-and-death combat. Lions and panthers maul bulls, a boar, and a stag in images that recall the elemental violence and *dynamis* of Protoattic—one thinks of the helplessly trapped deer on the neck of the Nessos amphora in New York, made a century earlier [72]. Even Kleitias' seated, heraldic sphinxes and griffins seem eager to exercise their claws.

The François vase, the greatest extant narrative experiment since the Mykonos pithos [75], is often called an encyclopedia or dictionary of myth. It is more of an anthology. The difference is that Kleitias selected his myths to illustrate several distinct (if related) themes. The principal one is the heroic ancestry, life, and death of Akhilleus. The major scene, and the only one that rings the entire vase, is the wedding of his mortal father and immortal mother: the wedding seems to have been the subject of a lost poem by the contemporary Stesichoros, which Kleitias (and Sophilos) surely knew.[23] Peleus, the father, is also one of the two chief hunters of the Kalydonian boar on the neck of the vase—Stesichoros also wrote a *Boar Hunters,* but if Kleitias knew this poem, he made a wholesale change in the cast of characters—and Peleus may have fought with Theseus and the Lapiths against the centaurs on the other side; in other words, Akhilleus is given a heroic pedigree. Akhilleus himself appears at the finish line of the chariot race run in honor of Patroklos. He ambushes the boy Troilos at the fountain house in another zone—a brutal but from the Akhaian point of

23. See A. F. Stewart, "Stesichoros and the François Vase," in Moon, 53–74.

93. Volute krater by Kleitias and Ergotimos (the François vase) (Florence, Museo Archeologico 4209), around 570–60. Photos courtesy of Soprintendenza Archeologica della Toscana, Florence.

view a necessary act. Yet the murder of Troilos enraged Apollo (the god gestures in protest to the left of the fountain) and Apollo's anger ensured Akhilleus' own death. And so Akhilleus is twice carried dead from the field by Ajax on the handles of the vase—a subject treated by Late Geometric seal engravers long before [43]. But Akhilleus is not the vase's only hero. Theseus, the local Attic favorite, appears twice in friezes placed atop each other on the back of the neck: the centauromachy and the dance performed

with Ariadne and the youths and maids of Athens after their escape from the Labyrinth. Other scenes, it is true, are less obviously related to either Akhilleus or Theseus, but may be there because of some kind of free association of myths. Artemis, as Mistress of the Animals, appears, for instance, on the handles above Ajax and Akhilleus: she seems out of place until it is remembered that it was Artemis that sent the great boar to ravage Kalydon. The drunken Hephaistos, led by Dionysos and accompanied by a band of ithyphallic satyrs, returns to Olympos, where he will release his mother, Hera, from a throne he made that would not let her rise (the story was told in a hymn by Alkaios). But while away from Olympos Hephaistos enjoyed the hospitality of Thetis, and both Hephaistos and Dionysos also figure prominently in the wedding frieze, so there may be some link to the Akhilleus cycle. The battle of pygmies and cranes on the foot of the vase seems to have little to do with anything else, but Theseus and Ariadne and their band danced "the crane dance" upon their liberation, and the tiny combat may simply and lightheartedly serve to mock the sober and weighty myths that cover the rest of the vase. Only the two Gorgons on the inside of the handles, who literally flew over a wine-dark sea when the krater was full, seem odd monsters out: they are there to ward off the evils of intoxication.

Still, one great theme cuts across most of the friezes on the vase: marriage.[24] The wedding of Peleus and Thetis states the theme, of course; other friezes present variations on it. The centauromachy took place at the wedding of the Lapith king Peirithoos; Hephaistos was promised the hand of Aphrodite if he agreed to free his mother from her well-deserved seat (Aphrodite and her lover, Ares, do not seem pleased by his return); and Theseus and Ariadne were romantically involved. All this suggests that the François vase was commissioned as a wedding present (so, undoubtedly, were Sophilos' vases with Peleus and Thetis). But Kleitias' view of matrimony was not a happy one: Theseus jilted Ariadne; Hephaistos was cuckolded (though he got even, as Demodokos sings in the *Odyssey*); the Lapith wedding was an unmitigated disaster; and Thetis, an unwilling bride in the first place, left Peleus in a huff after he protested her burning Akhilleus' mortality away in a fire. Moreover, Akhilleus was not the only issue of their marriage: a quarrel at the wedding led to the judgment of Paris, which led to the Trojan War, which led to Akhilleus' death. Akhilleus' doom was sealed the night his parents wed, and that is the point of the great amphora that Dionysos—the central figure in the wedding procession and the central figure (formally speaking) on the vase—carries as his gift to Thetis: it is the golden amphora, made by Hephaistos, that according to both Homer and Stesichoros would be used to hold the cre-

24. See Robertson, *HGA*, 126.

mated remains of Akhilleus (and Patroklos, too).[25] Implicit in the principal zone of the François vase, then, is the whole story of Akhilleus, from his half-divine, half-heroic conception to his inevitable destruction (pictured for us on the handles) and burial. The bride and groom who were given the vase could hardly have been cheered by the images it bore.

They would have had no difficulty identifying the various myths, and if they could read they would have been able to identify almost all of the individual figures. Kleitias' pictorial anthology is supplied with a text: painted inscriptions that label gods and heroes, youths and centaurs. But Kleitias also labeled hunting dogs, a water jug, and even the fountain house. Perhaps he just got carried away. He was a much better writer (and a much better speller) than Sophilos, and he sensed even more clearly the decorative value of the carefully written word. That Kleitias could write so freely on his paintings also tells us something of the nature of the Archaic, of *archaios*, in general. Letters painted on the vase affirm the reality of the surface—its hardness, its flatness, its impenetrability. Inscriptions are handwriting on a wall, and areas packed with words are not conceived of as light or atmosphere or sky but simply as areas. Like any post-Geometric painter, Kleitias could suggest depth by the elementary device of overlapping forms. But he had no idea of a coherent, enveloping picture space. Archaic art is an art of surfaces, and letters have as much right to the surface as images. Kleitias makes us beholders and readers at once, and the sense is that writing and drawing are not, somehow, such radically different graphic exercises.

The François vase was not the only mythological anthology produced during the second quarter of the sixth century, and Athenian artists were not the only ones consumed by the intense new interest in myth. In the sanctuary of Hera at Foce del Sele, in South Italy, sculptors adorned a small treasury-like building with a set of thirty-eight metopes. Herakles plays the leading role, but the death of heroes—Agamemnon, Patroklos, Troilos, Hektor, and Ajax [94]—is also a major theme. Contemporary Lakonian vase paintings [95] may reproduce elements of another great mythological program at Sparta, anticipating the encyclopedic Amyklaian Throne at the end of the century.[26] And at Olympia, inside the Temple of Hera, Pau-

25. See Stewart (n. 23), 55–56.
26. At Amyklai, near Sparta, the Ionian artist Bathykles of Magnesia decorated the throne of Apollo Hyakinthos with more than forty mythological scenes; see Pausanias, III.18.9–16. The date is generally taken to be around 500; see Schefold, *GH*, 25, and R. Martin, "Bathyklès de Magnésie et le 'Trône' d'Apollon à Amyklae," *RA*, 1976, 205–18. But Bathykles may have fled Magnesia when it lost territory to Ephesos in the middle of the sixth century, and a date of between 550 and 525 for the Amyklaian Throne—a date much nearer the work of the Spartan Hunt Painter (570–30)—is not out of the question. The notion that some Lakonian cups (particularly those that offer the eye a mere glimpse at a much longer narrative scene through a circular "window," the frame of the tondo) were dependent on the Amyklaian Throne's extensive narrative program should not be dismissed out of hand.

94. Metope showing the suicide of Ajax, from Foce del Sele (Paestum Museum), around 575–50. Photos: Jeffrey M. Hurwit.

The Art and Culture of Early Greece, 1100–480 B.C.

95. Lakonian cup by the Hunt Painter (Louvre E670), around 550. Photo: M. Chuzeville, by permission of the Musée du Louvre.

sanias saw the Corinthian edition of the Archaic visual dictionary of myth: an elaborate chest of cedar, gold, and ivory that, he was told, had been the hiding place of the infant Kypselos, the future tyrant of Corinth (V.17.5–19.10). If Pausanias' guide was correct, the chest was made early in the seventh century. But the guide was undoubtedly wrong: there are no parallels for such encyclopedias that early and, again, the Protocorinthian interest in myth was limited. Parallels for the individual subjects Pausanias describes—the combat between Akhilleus and Memnon or Hektor and

Ajax, Herakles fighting the centaurs or the hydra, the departure of Amphiaraus, and so on—are, however, fairly common in Corinthian vase paintings of around 580–60. Another subject Pausanias mentions—Boreads and Harpies—is also found on a fragmentary ivory dedicated at Delphi around 580 or 570,[27] and that is the best guess for the date of the chest of Kypselos. Perhaps it was a dedication of his son Periander—a brute but a patron of the arts nonetheless. Perhaps it was dedicated by a Kypselid refugee after the overthrow of the tyranny around 582.[28] But whoever gave it to Olympia, the chest expressed the same fascination with myth that held the Foce del Sele sculptors, Spartan cup painters, and Kleitias.

Pausanias notes that most of the figures depicted on the chest were identified by inscriptions, and there were captions far more elaborate than Sophilos' simple "Games for Patroklos": for example, "This is Hermes who shows Alexander [Paris] Hera, Athena, and Aphrodite, so he can judge their beauty." The chest also included allegories and personifications: Night as the nurse of both Death and Sleep, Justice beating down Injustice. Personifications are not common in Archaic art, but they had already appeared in literary works of art—the *Iliad*'s fantastic shield of Akhilleus and the much less fantastic shield of Agamemnon (XI.37)[29]— and they abound on the imitation shield of Herakles, described in a poem that went unfairly under the name of Hesiod. The poem describes the shield not in the making, as Homer describes Akhilleus' shield, but as a finished work (that is the technique of a literate poet, one who fixes things on paper, not an oral poet, who creates as he performs). And it includes specific (if not particularly surprising) myths—Perseus and the Gorgons, the battle of Lapiths and Centaurs—as well as universal images lifted from Homer's great *ekphrasis*. The shield of Herakles is for different reasons a work of dulled imagination. Yet in its depiction of personifications (Fear, Slaughter, Strife, and so forth) and myth it is as characteristic a product of the second quarter of the sixth century as the shield of Akhilleus was of the middle of the eighth. And it is unlikely to be accidental that some of the Lapiths and centaurs mentioned in the poem have the same names as some of those painted on the contemporary François vase [93].

If the François vase is just one manifestation of a boom in mythological narrative that pervaded Greek art as a whole around 570, it remains the first great expression of the reawakening Attic impulse for monumentality—not because it is a large vase (the individual friezes are still the work of

27. See Schefold, *ML*, pls. 54c, 62, 67a, 64b.

28. We are told that Olympia did not show the same hostility toward the Kypselid tyranny that Delphi did after its downfall and so the chest may have been offered in appreciation; see A. Andrewes, *The Greek Tyrants* (London, 1974), 48.

29. Fear, one of the two personifications on Agamemnon's shield in the *Iliad*, also appeared on Agamemnon's shield on the chest of Kypselos (Pausanias, V.19.4–5).

a miniaturist) but because of the dignity and sophistication of Kleitias' conception of Akhilleus' saga and because of his narrative techniques of evocatively linking myths that are scattered over the surface and exhausting the possibilities of a given theme (marriage); in short, because of his epic sensibility. Kleitias even relieved the gravity of his fateful processions and conflicts with incidents of humor: the mock-epic of the pygmies and cranes, or the return of the lame Hephaistos (who is used here in much the same way Homer uses him in the *Iliad*, I.595–600). Kleitias' epic sense was surely shaped by both Homer and Stesichoros (the choral poet who wrote, it was said, epics in lyric meters), and he strikingly acknowledges his double debt in the wedding procession. The muse of choral lyric, normally Terpsichorē, has been renamed Stesichorē.[30] And only one muse is (like Dionysos a few inches away) singled out by being turned to face the spectator: she is Kalliope, the muse of epic poetry.

Nearchos, *Megethos*, and Homer

Still, it was a contemporary of Kleitias that first captured the epic spirit in individual images, not simply in the compilation and interplay of myths: the potter and painter Nearchos. His principal work, a large kantharos dedicated on the Acropolis (and on display there until the end of the Archaic period), survives only in fragments, but they are very impressive potsherds [96]. In a field several times the height of Sophilos' "Games for Patroklos" and taller than any frieze on the François vase, Akhilleus harnesses his team. A white-haired old man brings up the last horse. Other fragments indicate that Akhilleus' charioteer was already mounting the car, while behind Akhilleus one of several nymphs (including, probably, Thetis) held his helmet, shield, and weapons. In the midst of all this bustle, Akhilleus stands still and, though expressionless, bows his head slightly toward the horse he holds; the horse nods too, seemingly in response. It is a highly charged moment before departure, and although the fragments as they are accidentally focus attention on the sympathetic relationship between hero and animal, it is hard to believe this was not the point of the entire scene. Earlier artists had elicited sympathy for one character or another [77], but none had created so contemplative, even moody, a scene, so subdued a study of heroic isolation. Despite an uncomfortable detail or two (the profiled Akhilleus wears his corselet sideways), Nearchos has painted a scene not of action but of grave implications. He presents a moment of melancholy, of fatal choice, suggesting something that has not yet happened. The scene is not huge, but by any standard it is monumental in

30. Stewart (n. 23), 56.

96. Fragmentary kantharos by Nearchos (Acropolis 611, in National Museum), around 560–50. Photo: Hirmer Fotoarchiv, Munich.

character and is pervaded by something new in Attic vase painting: somber grandeur or largeness of spirit, a quality that might be called *megethos*.[31]

The interpretation of the painting has often been colored by a famous moment at the end of Book XIX of the *Iliad:* Akhilleus' immortal horse Xanthos, given voice by Hera, prophesies the hero's death, and Akhilleus, already aware of his fate, angrily drives out to destroy Hektor and thus himself. But this is not that moment, at least not as Homer describes it.[32] Homer's Akhilleus arms himself; Thetis and the nymphs are nowhere around. The names of Akhilleus' horses on the vase differ from those in the *Iliad*. And the charioteer, whoever he is, is not Automedon, who chauffeurs Akhilleus about in the epic. We have noted such discrepancies between Homer and Homeric narratives before, and by now we should not expect Nearchos to follow Homer in every detail. He was a painter, not a rhapsode (a professional reciter of epic). Even rhapsodes could change things, and if there was such a thing as a text of Homer in Athens around 560, it is not likely to have been found in a potter's shop. Nearchos could not easily check his facts, even if he wanted to. Nonetheless, if Nearchos intended to depict that episode from the tale of Troy, either he was remarkably, even willfully unfaithful or the *Iliad* he was illustrating was not the same as ours.

31. See Pollitt, *Ancient View*, 198–201.
32. See K. Friis Johansen, *The Iliad and Early Greek Art* (Copenhagen, 1967), 117–19, and Robertson, *HGA*, 129, for different views.

The Art and Culture of Early Greece, 1100–480 B.C.

It is, in fact, curious how uninspiring the Homeric epics seem to have been for Attic vase painters before the last third of the sixth century.[33] Sophilos' "Games for Patroklos" [92] is, again, the earliest Attic scene that can be tied to the *Iliad*, though there is not enough of it to be certain how closely he followed Homer's account. But Kleitias did not follow it closely at all; the competitors (like everything else) are named on the François vase [93], and they are not the names Homer gives. Only Diomedes races both on the vase and in Book XXIII of the *Iliad*. But according to Homer, he wins; according to Kleitias, he comes in third, and Odysseus (who is not even entered in the *Iliad*) is victorious. Evidently Kleitias knew or cared to know his Homer no better than Nearchos.

Solon, to be sure, knew his: in the dispute with Megara over Salamis he cited a line of the *Iliad* to support the Athenian claim (the Megarians, incidentally, cited a version of their own: textual criticism settled nothing). But perhaps rhapsodic performances of Homer were not yet regular features of Athenian life—a deficiency that, along with one rhapsode's tendency to deliver a poem a little differently from the next, would be corrected later in the century but that for the moment would have contributed to the Athenian artist's unfamiliarity with details. Perhaps the scarcity of identifiably Homeric scenes in early Black Figure vase painting (as in Late Geometric and Protoattic art) had something to do with the nature of the Homeric poems themselves. Attic and non-Attic artists alike may have instinctively looked for inspiration to the more episodic poems of the Trojan cycle (the *Kypria*, for instance, where the wedding of Peleus and Thetis was described) or to the epics in lyric meters composed by Stesichoros (his *Boar Hunters*, for instance, or his *Geryoneis*, which dealt with an exploit of Herakles that was increasingly illustrated after around 550)[34]—poems that offered richer pictorial possibilities than the *Iliad*, whose stated theme is not an action at all but a frame of mind (Akhilleus' wrath).[35] Still, we do the Archaic artist an injustice if we expect him to follow literally the instructions of a Homer or even a Stesichoros: his function was not, after all, to illustrate a text, and he had his own purposes for the myths he chose to depict and recast.

Whatever the reasons, Homeric content is hard to detect in the art of

33. Friis Johansen (n. 32), 82–84 notes that the artists of the northeastern Peloponnesus made more use of the *Iliad* than the Attic artists did, and he cites one Late Corinthian vase where Akhilleus' immortal horses are correctly named (Xanthos and Balios). We do hear that Homeric recitations were regularly given at Sikyon (near Corinth) until the tyrant Kleisthenes put a stop to them about 590.

34. See P. Brize, *Die Geryoneis des Stesichoros und die frühe griechische Kunst*, Beiträge fur Archäologie, vol. 12 (Würzburg, 1980).

35. Aristotle's comment (*Poetics*, 1459b.1–7) that Classical tragedians found more material for their plays in the *Kypria* and *Little Iliad* than in the *Iliad* and *Odyssey* may shed some light on the predicament of the Archaic artist.

Solonian Athens. Nonetheless, although his representation of Akhilleus and his team does not match the Homeric account, Nearchos has captured the mood of epic, its sense of heroic self-absorption, its *megethos*. Solon himself conveys a similar mood in his poems of lonely self-justification, where he is beset by critics like a wolf by a pack of dogs. But with Nearchos, Attic vase painting has almost imperceptibly entered a new era: we are, in fact, no longer in the Athens of Solon but in the Athens of Peisistratos.

Peisistratos and Athens

Solon was near the end of his life when, in 561 or 560, Athens was once again threatened from within. Recognizing a clear and present danger to the state he had reshaped over three decades before, he again took up the weapon of elegy to scourge the Athenians:

> Everyone of you walks with the steps of a fox,
> yet all together your mind is dull.
> You heed the tongue and words of a crafty man,
> and see not the deed that is being done.
> [Diehl, 18]

The crafty man Solon alluded to was his own younger cousin Peisistratos, and what he was doing was laying the foundation for tyranny.

Solon grew old in a city dominated by two factions that came into existence as a result of (or in reaction to) his constitutional reforms: the party of the Plain, led by Lykourgos, and the party of the Coast, led by the Alkmeonid Megakles (the grandson of that Megakles who had ordered the sacrilegious execution of Kylon's supporters). The geographical distinction between the two parties was loose; their ideological differences were apparently more real. The men of the Plain are supposed to have been reactionary Eupatrid landowners, while the men of the Coast were progressive aristocrats, merchants, and nouveaux-riches landowners. For years the political history of Athens seems to have consisted of maneuvers between them. But at some point (probably in the mid-560s), the party of the Coast split apart and a third party, the men beyond the Hills, appeared. The new faction was the creation of Peisistratos, who came from the district of Brauron, beyond the mountains that ring the central Attic plain, and who had first distinguished himself when Athens and Megara came to blows once more over Salamis (c. 570–65). Peisistratos led an amphibious assault against Megara's port of Nisaia, captured it, and rode the crest of his popularity as a military hero onto the political stage. As leader of the men

beyond the Hills, Peisistratos championed the cause of the common people, both the rural and the urban poor. Their lot had perhaps improved somewhat during the Solonian economic revival. If so, political expectations may have risen as well, yet they would surely have been frustrated by bickering factions that either yearned for the old days of the *hektemoroi* and the Eupatrid monopoly or tried to maintain the Solonian status quo. The common people needed a leader and found him in Peisistratos—if he did not find them first.

Solon has often been blamed for Peisistratos yet it is difficult to see how he could have prevented his rise. In fact, the discontent of the lower classes may have been as much the result of Solon's general success as of any particular failure of his constitution.[36] Economic expansion created problems and rivalries even a wise man could not have foreseen, and Solon himself had guaranteed the people a basic political tool: the right to sit in the Assembly. That right was severely limited, but one day in 561 or 560 it was enough. Peisistratos theatrically drove his chariot into the agora, displayed wounds he said he received from his enemies (ancient authors unanimously claim they were self-inflicted), and asked for a personal bodyguard. A crony made the motion. And, apparently over Solon's strenuous elegiac objections, the Assembly voted Peisistratos a guard of club bearers. Defeated and resigned to the fact that what he had postponed for thirty-four years was now at hand, Solon went home and piled his armor outside his door—a declaration that he would do no more for his city. But Peisistratos did not go home. Instead, he gathered his club bearers and took the Acropolis.

He did not stay very long. He had underestimated Lykourgos and Megakles and for once they united to drive the man who would be tyrant back to Brauron. A year or two later, however, Peisistratos struck a deal with Megakles and the two of them devised a preposterous—and successful—plan. They found a beautiful and extremely tall country girl named Phyē, dressed her in armor, and taught her how to act like Athena. Peisistratos, who could keep a straight face, stood beside her in a chariot and together they drove to the city. The goddess, everyone knew, had led Herakles (her favorite hero) to godhead on Mount Olympos, and the idea was that the Athenians might be gullible enough to believe she was now coming to install another favorite, a new Herakles, on her own citadel. They were; at least, they willingly suspended disbelief.[37] For the second time in two or three years, a melodrama had produced a tyranny.

Peisistratos secured his position by wedding Megakles' daughter, but in

36. W. G. Forrest, *The Emergence of Greek Democracy* (New York, 1966) 175–77.

37. A more charitable view of the Athenian intelligence quotient holds that Peisistratos and Phyē intended merely to reenact the legendary event, not to fool anyone. I owe this suggestion to A. Podlecki.

that performance he failed. The bride told her father that Peisistratos had sex with her in an unnatural way (he already had grown sons, and to have more would not have been politically astute), and the enraged Megakles ousted him from power once again. This time Peisistratos' exile lasted a decade, but he put it to good use by amassing a fortune in silver and an army of mercenaries. Around 546—perhaps the same year that also saw the fall of Kroisos and the loss of Ionia to Persia—Peisistratos was ready to try again, and this time there were no theatrics. He landed at Marathon, linked up with political supporters, and surprised a lax Athenian force at Pallene, about seven miles from the Acropolis (some of the defenders were playing dice when Peisistratos attacked). His opponents, including the Alkmeonidai, fled the city (though only temporarily), and so for the third time Peisistratos became master of Athens. This time he stayed for good, and when he died peacefully in 528/27, the tyranny passed smoothly to his elder son, Hippias.

The Archaic Acropolis

What the Acropolis looked like on the day Peisistratos first seized it in 561/60 and what he and his sons did to it before the tyranny came to an end in 510 are the most troublesome questions in the archaeology of Archaic Athens. Some people believe that throughout the sixth century only one major temple stood atop the citadel. Others believe there were two. Some argue that Peisistratos himself had practically nothing to do with the architectural embellishment of the Acropolis. Others believe he initiated an extensive building program both on and off the citadel. Most scholars believe that Hippias and his brother Hipparchos, not long after their father's death, built a peripteral Doric temple—the Archaios Naos or Old Temple of Athena—on the foundations still to be seen on the north side of the Acropolis, partly beneath the classical Erechtheion [97, 146]. But not even that much is certain, and the Archaios Naos (to judge from the style of its surviving sculptures [99]) may not in fact have been built or finished until after the tyranny fell (say, around 505).[38] The surviving stone rectangles, at any rate, are known as the Dörpfeld foundations, after the great German archaeologist who discovered them in 1885. The real problem is that the late-sixth-century Archaios Naos may not have been the first temple to stand upon them.

The foundations occupy the area of the old Mycenaean palace, now completely obliterated. By the Geometric period the palatial site had been

38. See K. Stähler, "Zur Rekonstruktion und Datierung des Gigantomachiegiebels von der Akropolis," in *Festschrift Hans Erich Stier*, ed. R. Stiehl and G. A. Lehmann (Münster, 1972), 101–12.

97. The Dörpfeld foundations from the northwest, Athenian Acropolis, around 560(?). Photo: Jeffrey M. Hurwit.

transformed into a sacred precinct. Homer seems to associate the "strong house" of King Erechtheus with the "rich temple" of Athena (*Iliad*, II.546–51; *Odyssey*, 7.80–81), but his references to the topography of the Acropolis stand a good chance of being later interpolations and are thus questionable evidence. Still, a Geometric temple of some kind must have stood in the vicinity of the Dörpfeld foundations, and near the east side of the inner rectangle are two crude limestone column bases that may have belonged to it (or to an early-seventh-century successor).[39] This humble early Archaic temple stood until it was razed to make room for the Dörpfeld foundations and the temple they bore. Scholars part company when it comes to deciding when the demolition took place, and they part today into three main groups:[40] those who believe the Dörpfeld foundations did not exist before

39. See C. Nylander, "Die sog. mykenischen Säulenbasen auf der Akropolis in Athen," *Opuscula Atheniensia*, 4 (1962), 31–77. E. Touloupa, "Une Gorgone en bronze de l'Acropole," *BCH*, 93 (1969), 862–84, published a bronze gorgon disk that may have been an akroterion for the early Archaic temple.

40. For the old but now generally discounted theory that the inner rectangle of the Dörpfeld foundations is earlier than the outer rectangle—in other words, that an originally peristyleless temple was later given a colonnade—see Th. Wiegand, *Die archaische Poros-Architektur der Acropolis zu Athen* (Cassell-Leipzig, 1904).

about 525, when they were laid to carry the (Peisistratid) Archaios Naos (they are the majority); those who believe the foundations were originally built for an early-sixth-century temple and were reused (and reworked) in the last quarter of the century (they are an influential minority); and those who believe the foundations were built even earlier, in the second half of the seventh century (they are not many at all).[41] But whenever the Dörpfeld foundations were first laid, there is no disputing that they constitute the principal archaeological fact of the sixth-century Acropolis.

The principal fact, but not the only one. Others are strewn over the bare surface of the Acropolis rock, or are built into the citadel walls, or are on display in the Acropolis Museum. These remains—column capitals of various sizes, profiles, and dates, triglyphs and metopes, architraves and cornices, and above all numerous architectural sculptures, large and small, limestone and marble—complicate things. Some pieces are relatively uncontroversial. Many poros limestone capitals lying about the Acropolis [98], for instance, surmounted the columns of the Archaios Naos, and a large marble Athena routed large marble giants in one of its pediments [99]. Much smaller architectural blocks and sculptures, such as the so-called Olive Tree Pediment [100], belonged to a handful of small treasury-like buildings (oikemata) whose foundations no longer exist. It is not clear where they were on the Acropolis, what they were, who built them, or why.

But the most difficult problem of all is where to put a series of large limestone sculptures, originally covered with stucco and brilliantly painted, that were found more or less together in the earth south and southeast of the Parthenon. The principal pieces are (1) an enormous maned lioness (there seems to be some zoological confusion here) who crumples a diminutive bull beneath her (a male lion, known only from fragments, accompanied her heraldically on the left); (2) two great, coiled snakes that slithered menacingly from the left and right corners of the same pediment as the lioness; (3) another pair of lions savaging a bellowing bull—blood pours from his wound [101]; (4) Herakles wrestling the sea god Triton; and (5) a strange but affable monster with three human heads, three human torsos, three intertwined snaky tails, and wings [102]. This last creature is called Bluebeard because blue is the color of its hair and no one is sure what it is; Typhoeus is a common but not entirely satisfactory guess. A small figure apparently approached Bluebeard from the left, but too little of it is left to be of any help. In any case, everyone agrees that the monster filled the right side of the

41. For the Peisistratid dating see W. B. Dinsmoor, "The Hekatompedon on the Athenian Acropolis," *AJA*, 51 (1947), 109–40. For the early-sixth-century dating, see H. Plommer, "The Archaic Acropolis: Some Problems," *JHS*, 35 (1960), 127–59. For the seventh-century dating, see I. Beyer, "Die Datierung der Grossen Reliefgiebel des alten Athenatempels der Akropolis," *AA*, 1977, 44–74.

98. Column capitals from the Archaios Naos, Athenian Acropolis, last quarter of the sixth century. Photo: Jeffrey M. Hurwit.

99. Marble Athena and giant from the east pediment of the Archaios Naos, Athenian Acropolis (Acropolis 631), last quarter of sixth century. Photo: Jeffrey M. Hurwit, by kind permission of Maria Brouskari and Acropolis Museum.

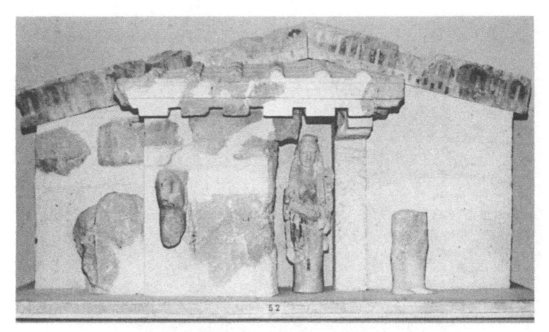

100. The so-called Olive Tree Pediment, from an *oikematon* on the Athenian Acropolis (Acropolis 52), mid-sixth century. Photo: Jeffrey M. Hurwit.

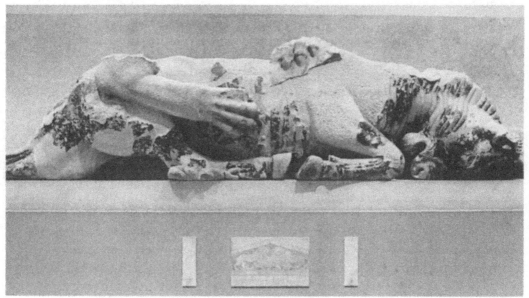

101. Limestone lion and lioness attacking a bull, from a pediment of a mid-sixth-century temple on the Acropolis (Acropolis 3). Photo: Jeffrey M. Hurwit.

The Art and Culture of Early Greece, 1100–480 B.C.

102. Limestone sculptures of Herakles and Triton and a three-bodied monster ("Bluebeard"), from the same pediment as fig. 101 (Acropolis 36 and 35). Photo: Jeffrey M. Hurwit.

same pediment that carried Herakles and Triton on the left, and that the brutal group of lions and bull [101] occupied its center, commanding awe and terror before the house of the divinity.

These sculptures are most often dated to the 560s, though they have recently been dated as late as the 540s and as early as the late seventh century—a range of nearly a hundred years.[42] Nothing, however, definitely connects any of them to any spot on the ground: they are pedimental statues in search of a temple, and where they end up depends on the date of the Dörpfeld foundations. Those who believe the foundations (and the first temple they supported) belong to the early sixth century put the sculptures there, and, they argue, the sculptures stayed there until the temple was rebuilt and the marble gigantomachy [99] inserted in the late sixth century. Those who are convinced that the foundations were not laid before 525 or so have to put these stylistically earlier sculptures somewhere else. And so they postulate *another* large temple in the only area of the Acropolis big enough to hold one: the south side. This conjectural temple—a temple whose foundations are totally lost or else remain hidden

42. For the late date, see Boardman, *GS*, 154 and figs. 190–93. The seventh-century date is Beyer's (n. 41).

beneath (or within) the foundations of the classical Parthenon—is called the Hekatompedon.

The word appears on a late Archaic inscription carved on two marble metopes that were taken from a dismantled Acropolis temple and reused. Among other things the inscription mentions the *naos* and something called the *hekatompedon*. The *naos* almost certainly refers to the Archaios Naos, built some years before. And it is clear from the context that the *hekatompedon*, whatever it was, was something else. Now the official name of the classical Parthenon (or a part of it) happens to have been Hekatompedos Naos, the hundred-foot temple, even though none of its dimensions equals a hundred feet. Neither did any known dimension of the Parthenon's late Archaic predecessor on the same site, the so-called Older Parthenon, begun after 490 but never finished [cf. 146]. The inscription is commonly thought to date to 485/84. If it does, the *hekatompedon* it mentions is the Older Parthenon, then under construction. In 1947 William Bell Dinsmoor concluded that the title "hundred-footer" went with the site, that it was passed down from architectural generation to generation, and that *hekatompedon* originally described a sixth-century temple on the Parthenon site—the grandfather of the Parthenon, as Dinsmoor called it— which really was one hundred feet long. To his Hekatompedon Dinsmoor assigned column capitals [103], metopes (including those that bear the inscription), and other architectural pieces that had previously been thought part of the early-sixth-century temple supposedly built on the Dörpfeld foundations. He denied that such a temple ever existed and argued that the only temple on the north side of the Acropolis before the building of the Archaios Naos was the primitive Geometric shrine or a seventh-century successor. Dinsmoor placed all of the great limestone sculptures in the pediments of the Hekatompedon—on the west the lioness, her fragmentary mate, and the snakes, on the east the other lion group, Herakles and Triton, and Bluebeard—and dated the whole thing to precisely 566.[43]

Dinsmoor's Hekatompedon is an ingenious hypothesis but it is a paper temple. If the Dörpfeld foundations did in fact exist in the first half of the sixth century, there would not be enough architecture and sculpture to go around, and the Hekatompedon collapses. Moreover, Dinsmoor's argument that the temple lacked a peristyle and had three columns in its porches would make the building impossibly crude for the date he gave it, which was a time of Athenian economic and artistic resurgence. Such a building is indeed shown in the Troilos scene of the contemporary François vase [93], but that is a fountain house, not a temple, and today even scholars who honorably defend the Hekatompedon concede (faced with the large

43. Dinsmoor (n. 41); see also Travlos, *PDA*, 258.

103. Column capitals from an early- or mid-sixth-century temple on the Athenian Acropolis. Photo: Jeffrey M. Hurwit.

number of early-sixth-century column capitals still to be found here and there on the Acropolis) that it must have been peripteral. Finally, the accepted date and interpretation of the Hekatompedon inscription have lately been questioned: the hundred-footer it refers to, for instance, may not have been a temple at all—the text does *not* say *hekatompedos naos*—but an open precinct in which the *oikemata* [cf. 100] stood and which bequeathed its name to structures built later on the site.[44] The Hekatompedon is literally a temple without visible foundations, and that, in the end, is the most troublesome thing about it. The existence of the Hekatompedon simply cannot be substantiated, and the most plausible conclusion is that the controversial pedimental sculptures belonged to a temple begun on the Dörpfeld foundation in the 560s, that they remained there until that temple was dismantled, rebuilt, and fitted with the marble gigantomachy in the last quarter of the sixth century, and that no temple was ever planned for the south side of the Acropolis until the early fifth century.

Those who believe in the Hekatompedon and those who do not can at any rate agree that the Acropolis became a busy place just before the middle of the sixth century. Somewhere or other a large limestone temple

44. F. Preisshofen, "Zur Topographie der Akropolis," *AA*, 1977, 74–84. The date of 485/84 depends on a restoration of heavily damaged lines, and Preisshofen maintains that a sixth century date is not impossible. For a recent defense of the Hekatompedon, see W. B. Dinsmoor, Jr., *The Propylaia to the Athenian Akropolis*, vol. 1, *The Predecessors* (Princeton, 1980), 28–29.

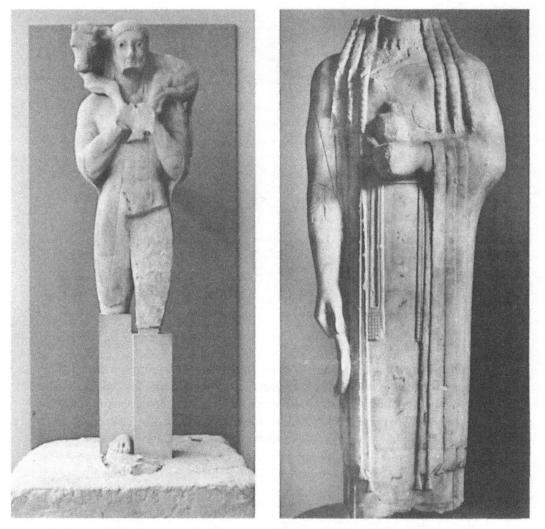

104. (Left) The Calf-Bearer (Moschophoros), dedicated by ⟨Rh⟩ombos (Acropolis 624), around 560. Photo: Jeffrey M. Hurwit.

105. The Pomegranate *Korē* (Acropolis 593), around 560–50. Photo courtesy of Deutsches Archäologisches Institut, Athens.

to Athena was begun, and so were the first *oikemata*. It was only toward 560 or so that the first free-standing marble statues—private dedications, not public monuments—began to populate the citadel: the Calf-Bearer, for instance, dedicated by (and conceivably meant to stand for) someone named something like Rhombos [104], and two elegant *korai* evidently imported from Naxos (Acropolis 677 and 619), and the planklike Pomegranate *Korē*, the earliest in the long series of native Attic maidens offered either as pleasing gifts (*agalmata*) or as eternal stone servants to the virgin

goddess of the rock [105]. Athenians who climbed the Acropolis and approached the temple (or, if Dinsmoor is right, the temples) of Athena had before them not only awesome spectacles of lions, heroes, and monsters crowded high up in architectural triangles, but also increasingly numerous images of men and women not unlike themselves. By the 550s the Acropolis was in the process of being transformed from a relatively modest place into a grandiose repository of Attic art, a lofty showcase of the Attic spirit. The question is whether this transformation had anything to do with Peisistratos.

The decade of the 560s was, again, a momentous one for both Peisistratos and Athens. It began with another war over Salamis and Peisistratos' capture of Nisaia, it saw his creation of a new political party, and it ended with his first, aborted tyranny. No ancient source says anything about the construction of a new temple on the Acropolis at this time (though it would not have been beyond Peisistratos to finance one as a way of ingratiating himself with the Athenian people, and it is easy to imagine a liberal, magnanimous prelude to his tyranny). One tradition, however, does credit Peisistratos with the founding or reorganization of the Greater Panathenaia, an elaborate popular festival that honored Athena—and, of all things, the unity of her city—on her midsummer's birthday. There had long been an annual Panathenaia (allegedly founded by Theseus), and the Greater Panathenaia, held every four years, was a magnified version, culminating in a procession through the streets, sacrifices (it is tempting to think of the Calf-Bearer [104] as the proud dedication of a participant in the first Greater Panathenaia), and finally, the presentation of a newly woven robe (peplos) to the ancient olive-wood image of Athena—a *xoanon* that was always kept in the temple on the north side of the Acropolis and that was, according to an early Christian author, "a rough stake, a shapeless piece of wood"[45] (the badly damaged and much-restored Olive Tree Pediment [100] may have depicted the festival's recurring climax). Athletic contests were added to the festival after the model of the ancient Olympic Games and the more recently established games at Delphi (582), Isthmia (582), and Nemea (573). Another source states that this Greater Panathenaia was established during the archonship of Hippokleides, who belonged to an important family from Brauron (Peisistratos' home town) and thus possibly to Peisistratos' inner circle. The traditional date, in any case, is 566/65—five years before Peisistratos seized the Acropolis by force (and the year Dinsmoor chose for the dedication of his Hekatompedon). The year 566 is not absolutely certain, but a date in the vicinity is more or less supported by an inscription recording the construction of a *dromos* (roadway or racecourse) in the Agora

45. Tertullian, *Apologia*, 16.3.8. But see now J. H. Kroll, "The Ancient Image of Athena Polias," in *Hesperia*, suppl. 20 (Princeton, 1982), 65–76.

106. Panathenaic amphora, name vase of the Burgon Group (BM B130), around 560. Photos courtesy of the Trustees of the British Museum.

and by the appearance of the first Panathenaic amphorae—large Black Figure vases commissioned by the state, produced in the leading workshops of the Kerameikos, and awarded, full of precious olive oil, to the victorious athletes. These prize amphorae carried pictures of the relevant event on one side and a striding armed Athena, with the inscription *ton athenethen athlon [emi]*, "from the games at Athens [I am]," on the other [106]. The Panathenaic Athena probably represents a statue set up somewhere on the Acropolis, possibly near a new altar of Athena Nikē on the bastion flanking the entrance to the citadel. Athena Nikē is Athena of Victory. And although the cult was an ancient one, there may have been an event in the 560s important enough to merit the dedication of a new altar and the creation of a new warlike, confident image of Athena: Peisistratos' victory at Nisaia.

All of this activity clearly reflects Athens' growing sense of itself, formed despite the party politics of Lykourgos, Megakles, and Peisistratos. With the Greater Panathenaia above all, Athens acquired a grandiose festival that transcended all the local cults of Attica, momentarily blurred the boundary between commoner and aristocrat, and emphasized Athens' unique character. Just as the panhellenic festivals at Olympia, Delphi,

[246] The Art and Culture of Early Greece, 1100–480 B.C.

Isthmia, and Nemea confirmed the distinction between the Greeks and everyone else, so the Panathenaia distinguished the Athenians from all other Greeks. Legend gave Theseus the credit for unifying Athens physically. But if Peisistratos really was behind the establishment of the Greater Panathenaia (as well as the transformation of the Acropolis into an architectural and sculptural showplace worthy of the new festival), he deserved the credit for unifying Attica in the minds of the Athenians and for making the citadel the spiritual as well as the geographical center of the polis.

Again, no hard evidence ties Peisistratos (or, for that matter, anyone else) to the large temple that stood (in my opinion) on the Dörpfeld foundations and that carried the lions, Herakles and Triton, and Bluebeard in its pediments—it is another, disputed matter whether those and other Acropolis sculptures were elements of an elaborate Peisistratid propaganda campaign.[46] But Peisistratos was beyond doubt a great builder, and we know that when he became tyrant once and for all he undertook a series of important projects. Artemis of Brauron probably acquired her first cult place on the Acropolis during his rule. On the west side of the Agora he built shrines to Apollo and Zeus as well as the Royal Stoa, where the administrator of most state cults and law courts had his office and where Solon's constitution (which Peisistratos evidently upheld) was displayed. Toward the southwest corner of the Agora he built a sprawling structure (Building F) which may have been his residence; if so, Athens' civic center was his front yard. At Eleusis he constructed a new Hall of Mysteries (Telesterion), and back at Athens, on the gentle slope between the Agora and the Acropolis, he built or rebuilt the Eleusinion. Farther afield he purified Apollo's sacred island of Delos by removing all graves within sight of the sanctuary and built a temple there besides, thus effectively laying claim to the leadership of Ionian Greece just after the fall of Kroisos and the ominous rise of Persia. It would be strange if Peisistratos did all those things and did nothing truly monumental on his own Acropolis, nothing that would visibly justify his (and before him Solon's) claim that Athens

46. J. Boardman has led a wave of attempts to extract political content from Archaic Athenian sculptures and vase paintings. Thus Herakles' introduction to Olympos, painted on vases from the middle of the sixth century and the subject of an Acropolis *oikematon* pediment, is considered an allusion to the charade that led to Peisistratos' second tyranny—supporting evidence, as it were. Similarly, when Herakles wrestles the sea god, Triton, as he does on more than one Acropolis pediment [102] and on many vases, the reference is to Peisistratos' successful attack by sea against Nisaia. Peisistratos, in other words, was presented through art as the new Herakles and Herakles was presented as the old Peisistratos; see "Herakles, Peisistratos, and Sons," *RA*, 1972, 57–72; "Herakles, Peisistratos, and Eleusis," *JHS*, 95 (1975), 1–12; and R. Glynn, "Herakles, Nereus, and Triton: A Study of Iconography in Sixth Century Athens," *AJA*, 85 (1981), 121–32. As seductive as this kind of argument may be, there are problems, brought out well by W. Moon, "The Priam Painter: Some Iconographic and Stylistic Considerations," in Moon, 97–118, and D. Williams, "Ajax, Odysseus, and the Arms of Achilles," *AntK*, 23 (1980), 137–45 (esp. 144n55).

was the oldest and foremost land of Ionia, nothing that would display Athens' new greatness to the Athenians themselves.

What we are left with, then, are the Dörpfeld foundations, an assortment of large and small pedimental sculptures (many of which deal with Herakles, the hero Peisistratos identified with on at least one occasion), an elaborate festival, and a colossal personality who reshaped Athenian political life in the mid-sixth century—a tyrant who was not tyrannical. On balance the last of these phenomena probably had something to do with the rest. And, given the nature of Dinsmoor's Hekatompedon (a hypothetical temple on a spot that cannot be examined), it seems best, once again, to consider the Dörpfeld foundations a product of the 560s—a decade that was still "Solonian" but that also witnessed Peisistratos' political ascension. The temple may have been planned as a thank offering to Athena, who, as Solon says in one of his elegies, held her hand over the Athenian people in its time of trial. But temples took time to build, and the work may have proceeded slowly between 560 and 546, a time of political uncertainty when Peisistratos was more out of power than in. The temple may have been finished, its last pedimental sculpture hoisted into place, only after Peisistratos' final return to power. In that case, whether the great new temple on the Acropolis was truly Peisistratos' idea to begin with or not, it almost certainly was his building in the end.

The Golden Age

Later Greeks, according to Aristotle, compared the peaceful, moderate, and popular tyranny of Peisistratos to the mythical reign of Kronos—the Golden Age, when mortals delighted in festivals, knew no hardship or pain, and had all good things.[47] They did not extend the same compliment to the tyranny of his sons, but from the point of view of art and literature they should have. It is not always easy to say which achievements of Peisistratid Athens were the work of Peisistratos himself and which the work of Hippias and Hipparchos. But the sons shared and extended the father's vision of Athens as the cultural leader of Ionia, and by the end of the thirty-five years of uninterrupted tyranny the city looked the part. Atop the Acropolis, Hippias and Hipparchos, perhaps vying with the achievement of their father, may have begun their own temple to Athena, the Archaios Naos, with its pedimental marble battle between the gods and the giants [99]—the same battle, incidentally, was woven into the peplos presented to Athena's image during the Panathenaia. It is also possible that they commissioned the sculptor Endoios to refit the ancient xoanon of

47. *The Constitution of Athens*, 16.7; cf. Hesiod, *Works and Days*, 109–20.

Athena with gold ornaments and attributes (e.g., an owl) around 525 or so.[48] On a low ridge southeast of the citadel Hippias and Hipparchos (if not Peisistratos himself) began but never finished a huge dipteral temple dedicated to Athena's only parent, Olympian Zeus [117]. The Olympieion was the largest temple yet attempted on the Greek mainland, and though it was Doric and late, it was the Attic entry in the colossal Ionian architectural competition held at Didyma, Ephesos, and Samos (where, a decade earlier, the tyrant Polykrates—the only real threat to the Peisistratid claim to the heritage of Ionia—had rebuilt the Heraion). To the civic and sacred structures lining the Agora Hippias' son Peisistratos added the Altar of the Twelve Gods. Distances within Attica were measured from this spot, and it is evidence as much for the tyrants' policy of centralization as for their piety. And at the southeast corner of the Agora, at the end of a long pipeline that brought water from the hills east of the city, the Peisistratids built an impressive fountain house (the Enneakrounos, or Nine Spouts) to serve the expanding urban populace.[49] Hippias may not have been popular at the end of his reign, but numerous late-sixth-century vase paintings indicate that his fountain house was [125].[50] What worse than Hippias, what better than Hippias' fountain?

Under the Peisistratids Archaic Athens became a city of fine public monuments and conspicuous wealth. The economy of its golden age was partly founded on silver from the mines at Laurion, and it was with this silver that Peisistratos or aristocrats at his invitation minted the earliest Athenian coins, beginning, perhaps, in the 540s. They are a heterogeneous lot and bear an assortment of emblems—amphorae, horses, gorgon heads—though each emblem may represent the issue of only one year. It is now generally thought that Hippias and Hipparchos replaced this "heraldic" currency with the "owls"—coins with Athena's sacred bird, an olive branch, and the abbreviation ATHE on the back and the goddess' helmeted profile on the front. But the date of the introduction of the owls is really no more certain than the date of the Archaios Naos—the last quarter of the sixth century is the best we can do—and it is possible that the first owls were not minted until after the tyranny fell and a new "democratic" form of government, in need of its own badges and symbols, was established in 508/7.[51] Coins and temples aside, however, there is no doubt about the strength of the Peisistratid economy: if nothing else, the wide distribution of Attic Black Figure and (after around 530) Red Figure pottery testifies to

48. See Kroll (n. 45).

49. The *Enneakrounos*, like the Olympieion, may have been partly the result of Peisistratid jealousy of the works of Polykrates, who hired the engineer Eupalinos of Megara to drive a kilometer-long aqueduct through a Samian mountain before 522.

50. See, however, Moon (n. 46), 109–10.

51. See Kraay (n. 18), 60–63; M. Price and N. Waggoner, *Archaic Greek Coinage: The Asyut Hoard* (London, 1975) 64–66; and Kroll and Waggoner (n. 18), 327–29.

it. Unlike the inhabitants of the mythical Golden Age, the people of
Peisistratid Athens may not have had all good things, but they had more
than they had ever had before.

Art flourishes where there are the funds to pay for it, and in Peisistratid
Athens (as in Kypselid Corinth a hundred years before) the funds were
there, both public and private. The state employed builders and masons
almost continuously and sculptors only a little less often. Its patronage
extended even into the Kerameikos: in a later century well over a thousand
Panathenaic amphorae were awarded by the city every four years,[52] and a
workshop lucky enough to win the Panathenaic commission must have
been a busy place even in the sixth century. The effects of private patron-
age could be seen in the aristocratic cemeteries of rural Attica, where most
Attic *kouroi* and a few *korai* were set over graves. But the Acropolis con-
tinued to be Attica's most important art gallery, and in the Peisistratid era
there was a population explosion in stone. *Korai* formed the single most
numerous group, but there were also *Nikai* and sphinxes with the faces of
korai, horsemen [6], a statue or two of Athena, relief sculptures, and per-
haps a *kouros* or two.[53] Craftsmen, then, did well for themselves under the
tyranny. And, although artists were never exalted, they could get rich and
set their own costly offerings beside the marbles dedicated by the well-
born. It was a sign of the times that around 520 the potter Nearchos (possi-
bly but not probably the author of the much earlier Akhilleus kantharos
[96]) hired the sculptor Antenor, son of Eumares, to carve a *korē* as a thank
offering to Athena. That information is given on an inscribed and now
unoccupied base. But if, as many scholars believe, Acropolis 681 [107] once
stood upon it (and in turn atop a pillar that lifted her high off the ground),
then the potter had a lot to be thankful for: he could afford the largest *korē*
there is.

Nearchos and Antenor were Athenians. A large percentage of the artists
of Peisistratid Athens—perhaps the finest group of artists ever assembled
anywhere in the Archaic period—were not. Sculptors seem to have been
especially mobile, and they naturally went where the commissions were: in
the last part of the sixth century, that was Athens. While some carved
monuments for the Acropolis, the finest foreigner of them all, Aristion of
Paros, specialized in funerary statues for the aristocratic cemeteries of rural
Attica.[54] Potters and painters, once established, were a more sedentary lot,
yet signatures on Attic vases of the Peisistratid era tell much the same tale
of immigration. Two of the three greatest names of mature Attic Black
Figure are Lydos (that is, the Lydian) and Amasis (a Greek version of
the Egyptian Ahmosis), and the third, Exekias, alluded to the African

52. See D. A. Amyx, "The Attic Stelai," *Hesperia*, 27 (1958), esp. 178–86.
53. Contra Ridgway, *AS*, 49.
54. See Boardman, *GS*, fig. 108a.

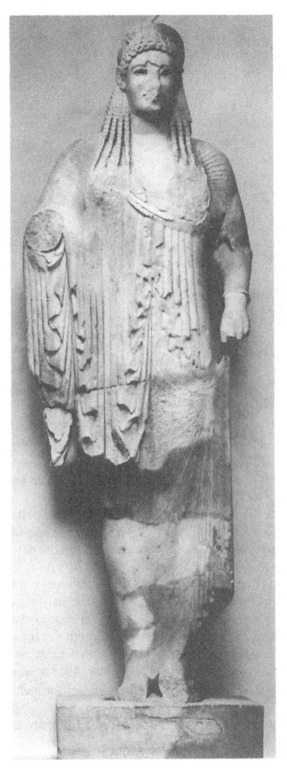

107. *Korē* dedicated by Nearchos the potter and carved by Antenor (Acropolis 681), around 520. Photo courtesy of Deutsches Archäologisches Institut, Athens.

108. Belly amphora by the Amasis Painter (Basel Kä. 420), around 540. Photo courtesy of the Antikenmuseum, Basel.

(Naukratite?) origin of his rival down the street by labeling black youths Amasis and Amasos. (Whether he intended a jest or a slur is hard to say, but there is a hint of malice on one vase where an Amasos is speared by Menelaos.)

These immigrants (or sons of immigrants) had a measurable effect on the character of Peisistratid art. East Greek influence is particularly strong in the elaborate fashions most Acropolis *korai* wear after the 540s [9]: the date coincides with the Persian conquest of Ionia, and it would be surprising if some Ionian sculptors did not flee to Athens. Non-Attic influence is not confined to the types of garments worn, however: some scholars detect East Greek, Chian, and Parian ways of carving the drapery of *korai* or the muscles of *kouroi*. Still, by 530 or so there developed throughout Greece a sculptural *koinē*, or "international style,"[55] in which regional traits are harder to detect and influences interpenetrate. Peisistratid Athens was surely one place where the international style was forged—an artistic melting pot.

The story is different in vase painting. There is some Ionian influence in

55. Ridgway, *AS*, 64.

the ornament and perhaps even in the syntax of Attic vases after 550,[56] but no immigrant could teach an Athenian a thing about how to draw a human figure or compose a narrative scene. Wherever they came from, such foreign painters as the Lydian and Amasis (the name actually belongs to a potter, but Amasis was undoubtedly his own painter) worked solely within the Attic figured tradition. If they learned how to pot or paint elsewhere, they had to have forgotten what they knew and begun again in the Kerameikos: there is nothing in their heroic narratives or Dionysiac revels [108] that is not purely Attic. The picture we get of Peisistratid Athens, then, is of an artistic cosmopolis, a center of the Archaic sculptural *koinē*, and the home of the dominant school of Archaic vase painting. Attic art is not the same as Archaic art, but the sculptures and vases of Peisistratid Athens are the classic expressions of Archaic style.

Archaios

Perhaps just a year or two before Peisistratos' death, a *kouros* was placed above the grave of an aristocratic youth named Kroisos (after the ill-fated king of Lydia) in a cemetery at Anavysos [109].[57] The base of the statue is inscribed with a call to mourning:

> Stop and grieve beside the tomb
> of Kroisos, dead, whom once
> in battle's front ranks
> raging Ares destroyed.

The statue and the epitaph, the image and the words, seem (to our eyes) incongruous. The inscription commands grief, but the *kouros* forbids mourning. Kroisos' marble sign, his eternal embodiment, is not melancholy or pitiable but an affirmation of power and substance. His swelling musculature protests the deterioration of the flesh and his fixed gaze and inscrutable smile deflect the spectator's attempt to probe for emotion, which is fleeting and inessential. Impassive and unselfconscious, he transcends the lyric fear of mutability and expresses that other pervasive Archaic attitude: in art and remembrance is the only refuge from the mortal states of becoming and having been. Thus the Anavysos *kouros* recalls (and its inscription echoes) lines by Tyrtaios, composed a century before:

56. See D. A. Jackson, *East Greek Influence on Attic Vases* (London, 1976).

57. Some believe Kroisos was an Alkmeonid who met his death fighting Peisistratos at Pallene in 546. If so, his funerary *kouros* was not carved until some time after his death, perhaps during a period of temporary accommodation between the Alkmeonids and the Peisistratids; see C. W. J. Eliot, "Where did the Alkmaionidai Live?" *Historia*, 16 (1967), 279–86.

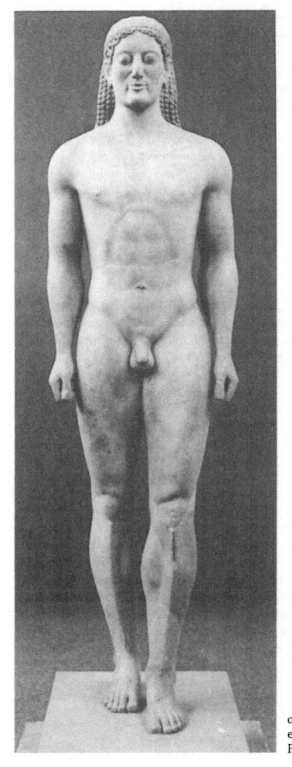

109. *Kouros* from the grave of Kroisos at Anavysos (Athens NM 3851), around 530. Photo: Jeffrey M. Hurwit.

The Art and Culture of Early Greece, 1100–480 B.C.

His tomb and children are notable among men,
and his children's children, and his race thereafter;
His noble memory is not destroyed nor his name,
but he is immortal, though he lies beneath the earth,
Whomever, excelling in valor, standing fast, and
fighting for his land and children, raging Ares destroys.
[West, 12, 29–34]

Monuments last, *kouroi* preserve, and the remembered dead enter a state of timelessness and timeless *aretē*.

The meaning of the funerary *kouros* had not changed since the New York *kouros* [7] was carved. The schema had not changed either. Kroisos still stands stiffly with the left foot slightly advanced and both arms at the sides, he is still frontal and foursquare, and he still occupies a pillar of space. What had changed was the sculptor's apparent ability (or desire) to render forms naturally. The sculptor of the Anavysos *kouros* certainly continued to interpret anatomy in terms of pattern and line: the shins, stomach and back muscles, eyes, and eyebrows are still defined by sharp ridges, shallow grooves, or incisions, and the neat array of spiral curls over the forehead attests to the enduring strength of the Archaic drive to transform nature into abstract pattern. The fact remains that his consummately Archaic statue looks more natural, more "human," than the consummately Archaic statue in New York. In the six or seven decades that separate these two *kouroi* Archaic sculptors had adjusted proportions, changed anatomical details, and begun to soften the flesh instead of merely dividing it up. The process would continue (especially in Attica) after Kroisos until, around the turn of the century, one of the most naturalistic of all Archaic youths who are still *kouroi* was set atop the grave of one Aristodikos in the district of Anavysos, perhaps not far from the tomb of Kroisos himself [110].

If all the *kouroi* in the world could be gathered together into one large room, it would be a fairly simple matter for anyone with a rudimentary knowledge of tear ducts, kneecaps, earlobes, collarbones, abdomens, and so on to arrange them in order, from the least naturalistic to the most. If the assumption were also made that what is "less natural" is earlier than what is "more natural"—that, in short, anatomy is chronology—the evolution of the Archaic *kouros* would seem irrevocable, even predestined. It was not. The development of naturalism—"the Greek miracle," as it used to be called—was not as neat, consistent, or universal as all that. No Archaic sculptor asked himself what should come next in the development of the *kouros*, and in art there is no such thing as destiny. Yet Archaic art *is* more naturalistic at its end than it was at its beginning, and the reasons are complex. Romantic explanations that simply invoke the remarkable spirit

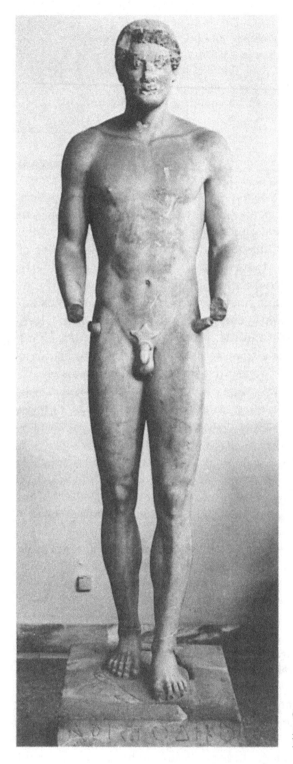

110. *Kouros* of Aristodikos
(Athens NM 3938), around
510–500. Photo: Jeffrey M.
Hurwit.

The Art and Culture of Early Greece, 1100–480 B.C.

or character of the Greeks will no longer do, and neither will the view that naturalism or realism was the initial, explicit, and conscious intent of Archaic artists, that the sixth-century sculptor really wanted to carve a fifth- or fourth-century nude but was not technically up to the task. This view makes failures of all *kouroi*. There is no doubt that Archaic sculptors gradually modified or "corrected" details and that these individual corrections led to a more convincing rendering of the whole. To convince was an Archaic goal, but naturalism could not have been one because naturalism as such, naturalism as an ideal, would have made little sense to the Archaic mind. The overriding and enduring impulse of Archaic art (as of Milesian philosophy) was to formalize, to pattern, to remake nature in order to make it intelligible. Sometimes that impulse clashes with the increasing naturalism of forms, as it does in the Aristodikos, where the relatively accurate anatomy is starkly at odds with the rigid archetypal pose. And one or two late *kouroi* even seem to protest the new trend: a *kouros* in the British Museum (the Strangford Apollo), usually dated within a few years of the Aristodikos, reasserts the primacy of line and plane as if the Aristodikos had not happened or never would [111].[58] No simple lineup of all the *kouroi* in the world could easily explain the chronological proximity of these two works. Regionalism or provincialism may be a factor here (the Strangford Apollo probably comes from the island of Anaphe). But Greek sculptors regularly traveled from place to place, and the sculptor of the Strangford Apollo was surely aware of developments in Athens and elsewhere. The naturalistic movement of the Archaic *kouros* almost seems to have been movement against itself, something that almost undermined the type's social, aristocratic function. The *kouros*, in its way, is an emblem of conservatism; as such, it is not likely to have admitted rapid change.

If naturalism was a consequence of rather than the motivation behind the development of Archaic sculpture, there may still have come a time when the development of naturalism began to affect the artist's conception of his own task and led to a fundamental change in the function of his art. Typically, the Archaic artist was a creator, a maker, and his creations were considered somehow "alive," magical substitutes. Hephaistos—Homer's archetypal craftsman—has gold statues "like living girls" to attend him (*Iliad*, XVIII.418) and wheeled tripods that come and go of their own accord (XVIII.376); the shield he makes for Akhilleus teems with life. The archetypal human artist, Daidalos, made statues that, according to legend, could see and walk or run away if not tied down. Soon after real artists learned to write, vases began to speak in the first person: "I am Nestor's cup," "So-

58. Robertson, *HGA*, 175. One should note also the fantastic, antinaturalistic tendencies of late *korai*; see Ridgway, *AS*, 106.

111. Strangford Apollo, probably from the island of Anaphe (BM B 475), around 500. Photo courtesy of the Trustees of the British Museum.

and-so made me." And through inscriptions such sculptures as the *korē* Phrasikleia[59] speak too:

> Tomb of Phrasikleia:
> Maiden shall I be called
> Forever, given this name,
> not marriage,
> by the gods.
> Aristion of Paros made me.

59. Boardman, *GS*, 73 and fig. 108a.

112. Belly amphora by Exekias (Vatican 344), around 530. Photo: Hirmer Fotoarchiv, Munich.

Phrasikleia speaks through her epitaph. A third party seems to speak for Kroisos. But the inscription on the base of Aristodikos does not really speak at all: it reads simply *Aristodiko*, "of Aristodikos." A word is missing but understood. Perhaps it was *sēma* (marker, tomb) or *mnēma* (memorial). But, just possibly, it was something like *eikon:* "image" or "likeness." If so, the sculptor (and his letterer) realized that the statue was no longer a substitute for or an embodiment of the dead but an imitation of him and that he, the sculptor, was no longer a "maker" but a "matcher" of human beings. Paradoxically perhaps, the more naturalistic Archaic sculpture became, the more it was acknowledged as false, as imitation (*mimesis*), as not the thing itself but only its likeness.[60]

Around the same time that Kroisos was set up at Anavysos, Exekias potted and painted an amphora now in the Vatican [112]. No Black Figure

60. See T. B. L. Webster, "Greek Theories of Art and Literature down to 400 B.C.," *CQ*, 33 (1939), 166–79; Chr. Karusos, *Aristodikos* (Stuttgart, 1961), 37–38. The lack of solid evidence that the words *eikon* and *mimesis* existed before 500 does not mean that the ideas behind the words did not exist; possibly it took language some time to catch up.

vase is better than this and none exemplifies the essential qualities of *archaios* quite so well. In a panel framed by lustrous black glaze Exekias drew a symmetrical and deceptively tranquil scene of Homeric heroes at play. Akhilleus and Ajax, muscled as massively as Kroisos, bend over a table, call out the roll of the dice (the scores are written by their lips—*tesara*, four, for Akhilleus, *tria*, three, for Ajax), and move their pieces on the board. The silhouettes are like cutouts pasted over the undisguised red wall of the vase. And although the spears of Akhilleus disappear behind the table and those of Ajax cross in front, the scene is flat and seemingly backlit. The light ground is not read as air or space but as a neutral void pushing the figures forward to the surface: luminous, it shows through the incisions within the forms. It is as if the red ground were not considered a part of the image. Moreover, the eye naturally equates the black pictorial forms with the glaze outside the panel, and so they seem as tightly surface-bound as the vase's ornamental black skin. The planarity of the image is complemented by clarity of contour and precision of line, and anyone who doubts the incising tool's capacity for lavish meticulousness need only study the heroes' hair, cloaks (the patterns are doily-like), and armor.

There is no sense of space in the scene, but there is an atmosphere of a different sort, and Exekias' subject was not merely an innocuous dice game. Both Akhilleus and Ajax are heavily armed; Akhilleus still wears his helmet. They hold their spears as if they may suddenly have to use them, and their great shields lean against the sides of the panel (as if they were the walls of a tent). No poem we know describes such an episode, but later Attic vase paintings (and apparently a marble group dedicated on the Acropolis) present fuller versions of the same scene. What seems to have happened is that the two mightiest Akhaians neglected their duties and irresponsibly threw dice while the Trojans entered the surprised Greek camp—a critical lapse of heroic vigilance that, as John Boardman has argued, may have brought to mind the lackadaisical performance of Peisistratos' opponents at Pallene.[61] The scene may be politically allusive, but it is not too much to suggest that the game of chance—the focus of the scene, on which all compositional lines (the spears, which themselves pick up the diagonal thrust of the handles, the fixed gaze of the eyes, even the oblique words *tesara* and *tria*) converge—is also a metaphor for fate. No Greek could have failed to observe that both heroes would die at Troy, that Akhilleus, the victim of Paris' arrow, would be carried from the field by Ajax himself (Exekias painted this subject several times), and that Ajax

61. "Exekias," *AJA*, 82 (1978), 18–24. Boardman interprets the scene as anti-Peisistratid, as a rebuke of the Athenian aristocracy for letting Peisistratos come to power a third time. But Exekias also painted Athena introducing Herakles to Olympos, a motif Boardman elsewhere considers an allusion to Peisistratos' second attempt at tyranny, so it may not be fair to list Exekias among the tyranny's opposition; cf. n. 46, above.

would fall on his own sword [115]. Beyond the formal perfection of the image, then, there are, exceptionally, implications. Archaic art is normally the art of the overt. Here something is sensed—a gravity, a concentrated mood that had not been conveyed so well since Nearchos (possibly Exekias' teacher) drew his own Akhilleus some thirty years before [96]. Still, it is the observer, not the heroes, that senses it. They do not brood, they simply stare. It is a contemplative scene, but Akhilleus and Ajax do not contemplate. The scene is a masterpiece of *megethos* but there is no emotion, no introspection, no response. Unlike Kroisos, Akhilleus and Ajax do not smile, but they are just as impassive, just as opaque.

Tesara and *tria* are not the only words in the panel. Over Akhilleus' back is a signature: *Exekias epoiesen*, "Exekias made [me or it]." Those words, at least, are pertinent. But written vertically between Ajax and his armor is an irrelevant inscription praising the looks of an aristocrat of Peisistratid Athens: *Onetorides kalos*, "Onetorides is beautiful." Exekias either was fond of the man or wanted something from him: he praises him on five vases in all. (*Kalos* inscriptions become very common in the late sixth century: there were plenty of handsome youths to be admired in such places as the Agora and the symposium). The curious thing is that the Athenian in the market for a nice amphora was called upon to think about epic heroes and read about a contemporary dandy at the same time—curious unless Exekias made the vase for Onetorides himself. Finally, Akhilleus and Ajax are labeled. But like the mason who would carve the letters on Aristodikos' base two or three decades later, Exekias wrote their names in the genitive case: *Akhileos*, "of Akhilleus," *Aiantos*, "of Ajax [Aias]." And here something like "image" must have been understood. Around 530 the finest Black Figure vase painter Athens ever produced conceded that he painted likenesses, that he was an imitator. Within the inherently antirealistic medium of Black Figure there is nothing like the naturalistic movement of sixth-century sculpture. But something happened in Athens at the height of Exekias' career that not only eludicates the *megethos* and moods he was capable of creating but may also have called his attention to the mimetic role art could play. That was the development, if not the invention, of the most mimetic art of all: drama.

The Peisistratids and the Poets

Solon, we are told, wrote more than five thousand verses. Fewer than three hundred survive, and that is all the Athenian literature there is before the end of the sixth century.[62] Either no other Attic poet was worth pre-

62. I am not counting metrical inscriptions or signatures (such as the iambic trimeter *Exekias egrapse kapoiese me*). See also n. 15, above.

serving—not even worth mentioning—or none existed. In either case early Athens' poetic barrenness was a major problem for tyrants who aimed to make their city the intellectual as well as the artistic capital of Greece. But Peisistratos and his sons were resourceful, and they hit upon two different solutions: they imported poetry and poets from other parts of Greece, and they encouraged the development of the only peculiarly Attic literary form: tragedy.

Solon's was by no means the only poetry heard in pre-Peisistratid Athens. The lyrics of Archilochos, Tyrtaios, Sappho, Mimnermos (whom Solon addresses in one poem), and others were known. Itinerant rhapsodes must have stopped to perform their memorized editions of Homer and Hesiod—Solon's elegies echo Homeric-Hesiodic language and, again, he appealed to the authority of the *Iliad* in the dispute over Salamis. But rhapsodes may not have visited often, and Peisistratos or his son Hipparchos or both realized that if Athens could somehow gain fuller possession of Homer, it could lay yet another powerful claim to the cultural leadership of Ionia and all of Greece. At some point during the tyranny, in some way, one of them expropriated Homer for Athens and institutionalized his epics at the Greater Panathenaia. Thus a religious, political, and athletic festival became literary as well, and it may not be irrelevant that in many Black Figure scenes after around 530 Herakles, the Peisistratid hero par excellence, plays the *kithara* like a bard.[63]

Precisely what Peisistratos or Hipparchos did to the Homeric poems other than make them a prominent feature of the Panathenaia was uncertain even in antiquity. There are essentially two different traditions. The earlier states that Hipparchos first brought the Homeric epics to Athens (an impossible claim unless it means that Hipparchos imported Athens' first manuscripts of the *Iliad* and *Odyssey*) and that he instructed the Panathenaic rhapsodes to recite the epics fully and in order, one picking up where the other left off, omitting nothing. The later tradition claims that Peisistratos first arranged the poetry of Homer, which had been in disarray before, into the epics "as we now have them."[64] This second tradition is the basis of the old analyst theory of the "Peisistratid recension," which states that Peisistratos or editors working for him gathered numerous short poems that went under Homer's name and assembled them into the monumental epics called the *Iliad* and *Odyssey*. If he really did so, the implication is that the *Iliad* and *Odyssey* as we know them did not exist before the second half of the sixth century and that the creator of the Homeric epics was not Homer at all but an Athenian editorial board. The theory has been demolished more than once, though it dies hard. But the idea that Pei-

63. Beazley, *Development*, 76. See Boardman, *ABFV*, fig. 165.
64. See pseudo-Plato, *Hipparchos*, 228B; Cicero, *De Oratore*, IV.137.

sistratos or Hipparchos tried to stabilize the poems of Homer by regulating rhapsodic performances of them has merit. And the chance to tamper with the epics, inserting some verses here and there for self-serving purposes, may have been too tempting for a Peisistratid to resist. It *is* remarkable that Nestor's son and Telemachos' companion in the *Odyssey* happens to be named Peisistratos,[65] that when Athena travels to the Acropolis in the *Odyssey* (VII.80–81) she goes by way of Marathon—the same route Peisistratos took on the way to his third tyranny—and that the *Iliad* seems to refer to something like the Panathenaia (II.547–51). Any tampering that occurred did not, however, seriously affect the structure or quality of the epics. Homer did not have his poems composed for him. Rather, they were given an elaborate institutional setting and protection from the whims of rhapsodes.

It is another matter to say which Peisistratid, the father or the son, should get the credit. The same source that says Hipparchos established the Panathenaic regulations also says he was Peisistratos' oldest son. That is not so, and the error casts a little doubt on the whole story. But the evidence of vase painting indicates that Hipparchos was responsible after all. A few Homeric scenes were painted during Peisistratos' reign, just as a few had been painted before. Exekias, for instance, depicted the battle for the body of Patroklos, although the fragmentary state of the vase makes it unclear how familiar he was with Book XVII of the *Iliad*. It is clear, however, that Attic vase painters—both Black Figure and Red—became very familiar with the epic after around 520 and began to represent episodes they had never represented before in addition to ones they had. Oltos (c. 525–500), who painted Diomedes wounding Aphrodite, Akhilleus and Briseis, the fight over Patroklos, and Priam's ransoming of Hektor, seems to have been the Kerameikos' first great Homeric scholar. His contemporaries were increasingly inspired by epic, too, though even greater artists could be less strict Homerists. On his kalyx krater in New York, for example [113], Euphronios (c. 520–505) illustrated (in simultaneous narrative) a passage from the *Iliad* (XVI.676–83): the twin personifications Hypnos (Sleep) and Thanatos (Death) carry the dead Sarpedon from the Trojan plain, but Euphronios either forgot that Sarpedon was clothed and that it was Apollo, not Hermes, that directed the operation or consciously decided to make the changes and so to lay claim to originality. As we have noted before, the Archaic artist did not consider himself bound by poetic texts, and changes in the received account had the positive value of making the myth his own, of establishing both his contribution and independence,[66]

65. Cf. H. A. Shapiro, "Painting, Politics, and Genealogy: Peisistratos and the Neleids," in Moon, 87–96.

66. See D. von Bothmer, "The Death of Sarpedon," in *The Greek Vase*, ed. S. Hyatt (Latham, N.Y., 1981), 63–80.

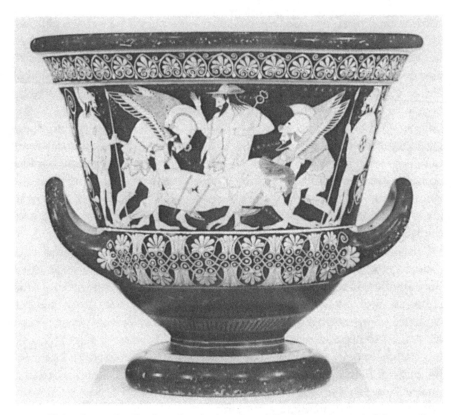

113. Kalyx krater by Euphronios (painter) and Euxitheos (potter) (Metropolitan Museum 1972.11.10), around 520–10. Photo courtesy of Metropolitan Museum of Art, bequest of Joseph H. Durkee, gift of D. Ogden Mills, and gift of C. Ruxton Love, by exchange, 1972.

and of allowing him to tell the tale effectively in his own medium. We must always avoid the temptation of making the artist subordinate to the poetry that may have inspired him. Still, the strong Homeric content of Attic vase painting after 520 suggests it was Hipparchos that inserted the *Iliad* and *Odyssey* into the Greater Panathenaia (the festivals of 526 and 522 are likely candidates) and demonstrates the impact words can have on images.

Homer, like the Greater Panathenaia itself, was culture for the Attic masses. His poems were imported to edify and unify the Athenian people and to assure them of their city's intellectual superiority. He was not, however, the only poetic import to Peisistratid Athens, and just as the Kerameikos and Attic sculpture workshops were full of foreigners, so was the Peisistratid court. Hipparchos did not share the more serious responsibilities of his older brother, Hippias, and so was free to pursue his tastes in music and lyric poetry (as well as in love affairs). He was even something of a versifier himself: halfway between the Altar of the Twelve Gods and the various Attic districts (demes) Hipparchos set up road markers inscribed with such immortal lines as "A reminder of Hipparchos, this:

walk thinking just things" and "A reminder of Hipparchos, this: do not deceive a friend." Only the brother of a tyrant could publish such platitudes along all the major roads in Attica and get away with it. Happily, Hipparchos did not write much poetry and instead used his position to attract to Athens the greatest lyric poets of the late sixth century: Lasos of Hermione (a town in the Argolid), Simonides of Keos, and Anakreon of Teos (whom Hipparchos rescued after his former patron, the tyrant Polykrates of Samos, was murdered by the Persians in 522). We know little about Lasos and less of his work. He did something to the form of the dithyramb, he instituted a dithyrambic contest at Athens, and he did not like the letter sigma (he wrote whole poems without it). We know a good deal more about Simonides. He, too, composed dithyrambs, and in fact did a better job than Lasos—he defeated him in at least one competition. Simonides is said to have been the first poet to write for wages and was hired by patrons in many parts of the Greek world. No extant poem, however, was definitely written during his stay in Peisistratid Athens. Simonides wrote hymns, dirges, epigrams, and the first epinician odes (choral songs honoring the champions of the various Panhellenic games). But perhaps his finest work is a fragmentary narrative about the distraught Danae, mother of Perseus:

> when in the well-wrought chest
> the wind raged blowing
> and the rising sea cast her down
> in terror, her cheeks wet,
> she put her arm around Perseus
> and said: 'O child, the woe I bear!
> But you sleep, with tender thoughts
> you sleep upon
> joyless bronze-pinned wood
> shining in the night
> in the black-blue night.
> The wave's thick salt spray above
> your head, the wind's roar,
> you do not heed, wrapped
> in your purple cloak, your pretty face.
> If danger were danger to you
> your tiny ear would catch my words.
> But sleep, I say, sleep, my babe,
> Let the sea sleep, let boundless misery
> sleep. O father Zeus, let some change
> from you appear.
> Whatever bold words I speak,
> whatever unjust prayers,
> forgive.
>
> [PMG, 543]

The Danae fragment is a picture in words, a dark, pagan Madonna[67] pierced by light, strong color, and detail, by verbal *poikilia*. Its pictorial effects, its appeal to the mind's eye, are the sorts of thing one might expect from the poet who supposedly said that "painting is silent poetry, and poetry painting that speaks."

Even though they worked for a private patron in the Peisistratid court, Lasos and Simonides wrote primarily public poetry—choral songs performed before the community. The future of lyric belonged to such poets. But the third great member of Hipparchos' literary stable, Anakreon, was heir to the more private tradition of solo song. Personal poetry had suffered a decline in the mid-sixth century, and Anakreon was virtually the only late Archaic successor to Archilochos, Sappho, and Alkaios. Like them he wrote mainly for the entertainment of his immediate circle, and his circle usually gathered at convivial drinking bouts called symposia, where the participants were attended by pretty flute girls and pretty boys. His poetry sometimes read like texts for Red Figure representations of such goings-on [114]:

> Come, boy, and bring a jar
> so I may drink long and deep.
> Pour ten parts water
> to five of wine,
> for I shall be a Bacchant—
> but only in moderation.
>
> [PMG, 356]

A moderate Bacchant is a contradiction in terms, a playful paradox. And if Anakreon's poetry is anything, it is superbly crafted play, quintessentially Archaic in its mastery of meter, image, and the well-chosen word.

We do not know for sure which words he wrote for the pleasure of Hipparchos, but the extant poems of this sophisticated Ionian generally convey much of the luxurious tastes and temper of Peisistratid Athens. (Contemporary vase painters, at least, seem to have recognized Anakreon's role as the court's arbiter of elegance: Oltos, for one, put him on a vase.) The poetry is colorful, witty, and urbane. It is also ironic: no subject, not even himself, is taken too seriously. Anakreon was famous for his love poetry, but compared to the verses of, say, Sappho, it is poetry without passion:

> Again golden-haired Eros
> hits me with his purple ball
> and challenges me to sport
> with a girl of many-colored sandals.

67. Fränkel, *EGPP*, 315.

114. Detail of a stamnos by Smikros (Brussels, Musée Royaux A 717), around 510–500. Copyright A. C. L.–Buxelles.

But no, she's from well-built
Lesbos, my white hair
she scorns, and at another girl
she stares with mouth agape.
[PMG, 358]

No Sapphic anguish here, just some fun at his own expense, a profusion of color that decorates the poem like paint, and a final barb. In another fragment Anakreon is stunned by love and longing:

Eros struck me again, like a smith
with a great axe, and plunged me into a wintry stream.
[PMG, 413]

But even here the passion is submerged beneath the brilliance of the metaphor and the poet's ability to look at himself from a detached point of view, from outside himself. Anakreon carefully crafted his own literary identity, and the craft, the *tekhnē*, mattered more than the substance. And if paral-

lels for his formal precision and ostentatious exhibitions of *tekhnē* for its own sake need be found in contemporary art, then they are the *korai* dedicated on the Acropolis in the last years of the sixth century [9]— colorful statutes dressed in Ionian garb with free-hanging folds that display the sculptor's mastery of his tools, virtuoso performances that are at once meticulous, alluring, fanciful, full of *poikilia*, and unprofound.

Homer was Ionian, Hesiod Boiotian, but their epics became the textbooks of Greeks everywhere. Lyric poets were born all over Greece, from Ionia to Sicily, and many, like the rootless Simonides and Anakreon, went wherever they could find a patron: lyric, too, was panhellenic. But there was only one place in the Archaic Greek world where tragedy, the third great genre of Archaic poetry, was certainly performed. That was Athens. There are, it is true, a few ancient references to "tragic modes" and "tragic choruses" supposedly performed earlier elsewhere, but they are overshadowed by the weighty testimony of the third-century chronological inscription known as the Parian Marble. As its entry for a year around 534 the inscription records that Thespis the poet first acted, produced a play in Athens, and won a goat (*tragos*) as a prize. Thespis is a shadowy figure at best and it does not help much that his name means "Divine." But all sources agree that he did not have to be imported to Athens like the poets of the Peisistratid court: he was a native Athenian. *Tragoidia* is, in fact, an Attic word.[68] It is logical to think it was coined to describe an Athenian invention.

The matter of the birth of tragedy is, unhappily, not so simple as the story suggests, for almost all theories of its origins—both ancient and modern—proceed from the assumption that tragedy had to be created out of something else, that whatever Thespis did around 534 he must have done it to an existing literary form—that, in short, tragedy was not invented at a stroke but evolved. Accordingly, the ultimate source of tragedy has been sought in such choral performances as the dithyramb or something called the *satyrikon* (satyr drama). That is where Aristotle sought it, for instance, and since he had much more early poetry on his shelves than we do, numerous scholars have assumed he knew what he was talking about.[69] If there has ever been an orthodox opinion, this is it: The precursor of tragedy (*tragoidia*, goat song) was the dithyramb, sung and danced in honor of Dionysos by a chorus dressed up as the god's goatlike companions, the satyrs. But satyrs in art have the tails and ears of horses, not those of goats [108], and not every scholar has been happy with the idea that so solemn a genre as tragedy began as a grotesque chorus of men wearing tails and funny ears. So some have theorized that tragedy evolved from

68. See Gerald F. Else, *The Origin and Early Form of Greek Tragedy* (Cambridge, Mass., 1967), 25. My discussion of tragedy's origins relies heavily on this radical little book.
69. *Poetics*, 1449a9–15.

more serious rituals concerned with Dionysos or the seasonal death and rebirth of some universal year spirit (*eniautos daimon*) or from cultic lamentations sung beside the tombs of heroes. But in all these theories Thespis' role is pretty much the same: he tinkered with an organically evolving choral form that was already approaching drama and (as Aristotle said in a lost but quoted work) added a prologue and a set speech. He thereby turned a narrative song and dance into a performance with a spoken part and someone new to speak it: the first actor.

If tragedy evolved out of something else—specifically, out of some kind of choral lyric—it is hard to see why its evolution should have taken place in Athens. Athens had no strong tradition of choral lyric and we hear nothing of dithyrambs or satyr plays there until Hipparchos imported Lasos and, possibly, Pratinas of Phlius,[70] some years *after* Thespis is supposed to have presented the first *tragoidia*. Yet it was in Athens, and in Athens alone, that the critical transition from something to *tragoidia* supposedly occurred.

Perhaps, as Gerald F. Else has argued,[71] the very idea of a transition should be discarded: it is possible that *tragoidia* was not the end product of a lengthy evolution at all but was invented almost ex nihilo, that it was the conscious creation of an Athenian genius. Else suggests that Thespis invented the tragic chorus and the first actor at the same time. And although he probably modeled the choral portions of his *tragoidia* on older lyric forms, his model for the spoken element, the part of the actor, was itself Athenian: the iambic trimeter verse of Solon, whose own dilemma and impulse for self-justification were nearly "tragic" and whose ethics sometimes anticipate the tragic concerns of Aeschylus. If Else is right, Thespis' *tragoidia* was the beginning of an evolution, not the end of one. Moreover, Thespis' source material was not religious, cultic, or Dionysian, but derived from heroic myth and epic. Aeschylus called his own tragedies "slices from Homer's great feasts." For Plato, Homer was the most tragic of poets. Even Aristotle concedes that tragedy was heir to the Homeric vision, that it was the spiritual descendant of the *Iliad*.[72] It may not be accidental, then, that *thespis* happens to be a Homeric epithet for epic song and epic bards.

Thespis' crucial achievement probably was to present an actor (himself) speaking in iambic verse and impersonating a hero caught in some fateful situation, in some moment of despair or suffering. The actor spoke to the chorus, which performed the dual role of dramatic character and narrator:

70. Pratinas is said to have invented the satyr play, and the proliferation of satyrs on Attic vases after around 520 suggests he introduced the form to Athens about that time. Phlius is a town in the Peloponnesos.

71. Above, n. 68.

72. *Poetics,* 1448b34–1449a6.

it could respond to the hero, comment on his fate, or simply observe and listen. The chorus thus mediated between the fictive hero and the actual Athenian audience, which had gathered (perhaps at first in the Agora) to watch the hero's self-presentation and often his self-destruction.

If the origins and content of *tragoidia* had nothing necessarily to do with Dionysos, there was something undeniably Dionysian about it after all: its occasion. Thespis won the goat prize for his goat song at the spring festival known as the City Dionysia, and that festival brings us back to Peisistratos. The tyrant fostered the popular cult of Dionysos of Eleutherai (an Attic border town) and probably transferred it, wooden cult statue and all, to Athens. The move seems to have been another instance of the tyrant's policy of centralization as well as an attempt to cultivate the masses: Dionysos was their god. In any case, Peisistratos' establishment or elaboration of the City Dionysia may lie behind the numerous Dionysian revelries painted by Amasis and others around 540 [108]. It almost certainly lies behind the construction of a modest temple of Dionysos Eleuthereus on the south slope of the Acropolis, where the old *xoanon* was kept. The organization of the festival and building of the temple cannot be precisely dated, but it is tempting to tie them to the one date we do have, 534, and to believe that Peisistratos at once recognized the importance of the new form, made it a part of his broader cultural program, and institutionalized tragic competitions at the first (or one of the first) City Dionysia. If so, *tragoidia* was intentionally projected as a distinctly Attic achievement, almost as if it were compensation for a native literary heritage that before Thespis had boasted only Solon, almost as proof of the intellectual vitality and supremacy of Peisistratid Athens. Whatever the origins of *tragoidia*, whatever Thespis did, the tragic competition of 534 cannot be completely separated from the political ends of a tyrant.

There is a story that when Solon was a very old man he heard about the new dramatic form and went to see Thespis act. After the *tragoidia* he asked Thespis if he were not ashamed to tell so many lies before so many people. Thespis replied that he saw nothing wrong with it—that was the nature of the drama. Solon then struck the ground with his staff and exclaimed: "If we are so very pleased with this kind of performance, we shall soon find it in our public affairs."[73] The tale is surely apocryphal: it smacks of Platonism, and even if Solon and Thespis could have met, the poet who had faked madness and posed as a herald from Salamis was hardly the man to criticize Thespis for play-acting. And yet the tale gives some sense of how the first audiences may have reacted to the first dramas—not with anger, as Solon did, but with astonishment. Athenians had witnessed histrionics before: besides Solon's impersonation of a lunatic there were the award-winning performances of Phyē as Athena and Peisistratos as Herakles

73. Plutarch, *Life of Solon*, 29.

(indeed, the story of Solon's meeting with Thespis may have been con-
cocted so that the Athenian wise man could seem to have predicted
Peisistratos' theatrics), and there were the recitations of rhapsodes who as
they spoke the speeches of Homeric epic momentarily assumed the identi-
ty of the speaking hero or, as they recited the *Works and Days*, became
Hesiod scolding his brother. But there had never been anything quite like
this. Greek tragedy was not naturalistic or illusionistic theater. Like Archa-
ic art, it was conventional and depended for its effects on schemata—
schematic gestures, movements, masks. Yet conventional theater makes
special demands on its audience. While the rhapsode's audience knew that
the fellow reciting Akhilleus' great speeches was still a rhapsode and
would soon cease to speak Akhilleus' words and begin to speak, say,
Agamemnon's, the audience of the first *tragoidia* was called upon to make
an imaginative leap, to believe that the actor standing before it was in fact
someone else, a hero of myth. If Greek tragedy was not realistic in our
sense of the word, it may have seemed startlingly real to those who had
never experienced anything truly imitative before.[74] The "lies" the in-
ventor of *tragoidia* told thus forced his audience to confront in the theater
something it would in time have to confront in visual art as well: *mimesis.*

We do not know what role Thespis played in 534. We do not know a
single role he ever played. Not one word of his poetry survives, and only
four titles (none positively genuine) have come down to us.[75] We can be
fairly certain that there was not much, if any, action in his plays, and we
can imagine that Thespian *tragoidia* concentrated on the dilemma, moti-
vation, and suffering of a hero as representative of the broader human
condition. Tragedy, like Archaic art, abstracted and generalized.

Not far from 534 Exekias depicted such a hero preparing to die [115]:
Ajax, who had been dishonored when Akhilleus' armor was awarded to
Odysseus and had fallen victim to a murderous madness, squats to plant
his sword into a mound of Trojan earth. Ajax's suicide had been treated
before in Archaic art, but earlier scenes show him already impaled on the
point: the explicitness is, again, typically Archaic [94]. Exekias, however,
chose the quiet, charged moment before the suicide: Ajax, his thin feet
barely able to support his massive physique, firms the mound with his
long fingers and stares at the blade. As in the case of Nearchos' Akhilleus
[96] or Exekias' own scene of Akhilleus and Ajax at dice [112], the true
subject of the painting is not what is shown but what is sensed: the im-

74. It is instructive that the audiences of early motion pictures of waves breaking upon the
shore emptied the front rows of the theater for fear of getting wet; see G. C. Pratt, *Spellbound
in Darkness* (Greenwich, Conn., 1973), 16. I owe this reference to Lawrence Engel.

75. One title is the *Pentheus,* after the king of Thebes who opposed Dionysos and was torn
apart for doing so. It is interesting that around 515 or so Euphronios painted the first known
representation of Pentheus in Greek art; see Boardman, *ARFV,* fig. 28. It is not impossible that
the vase painter was impressed by a *tragoidia.*

115. Belly amphora by Exekias (Boulogne-sur-Mer 558), around 530. Photo H. and B. Devos, by permission of Musée des Beaux-Arts et d'Archéologie, Boulogne-sur-Mer.

plications and responsibilities of heroism and its terrible, tragic isolation. Ajax is surrounded by empty space; the stage is bare except for armor, a helmet that seems a witness to the act, and a palm tree that wilts in sympathy.[76] There is something else, something extremely rare in Archaic art: Ajax's cheek and brow are furrowed. With three crisp incisions Exekias has conveyed the hero's troubled state of mind, his self-absorption, his utter weariness. Unlike Nearchos' Akhilleus or Exekias' other Ajax or the Anavysos *kouros* [109], Ajax responds emotionally to his fate, to the necessity of death. The response is minimal, but this Archaic figure is not quite impenetrable, not quite impassive.

The chances that Exekias saw an early tragedy are excellent. Whether Thespis ever made Ajax the subject of a play is unknown. All we can say is that the hero would have been an appropriate choice for an Archaic Athenian playwright (as he was for the classical tragedian Sophokles): Ajax came from Salamis, he fought alongside the Athenian contingent at Troy, and an important Athenian family traced its descent from him. But it is unlikely that we shall ever know much more about the content and form of Thespis' dramas than we do today, and the *megethos* of Exekias' vase paintings may be as close to the spirit of early tragedy as we shall ever come.

76. See J. M. Hurwit, "Palm Trees and the Pathetic Fallacy in Archaic Greek Poetry and Art," *CJ*, 77 (1982), 193–99.

6

Revolution: Red Figure and Relief Sculpture in the Late Sixth Century

The Origins of Democracy

By the morning of Hekatombaion 28, 514, all the preparations had been made for the celebration of the Greater Panathenaia, the fourteenth to be held since the organization of the festival in 566. A team of highborn girls had finished weaving a fresh peplos for the old wooden *xoanon* of Athena housed upon the Acropolis. Horsemen, charioteers, hoplites, elders, musicians, youths leading sacrificial beasts, and maidens carrying baskets full of offerings were gathering in the Kerameikos, where the tyrant Hippias was acting as grand marshal. Just within the entrance to the Agora his brother Hipparchos was attending to some last-minute details as spectators awaited the procession's start when suddenly two aristocrats, Harmodios and Aristogeiton, drew their swords, bolted from the crowd, and hacked him to death.

The assassination of Hipparchos was the outcome of a homosexual lovers' quarrel that had grown into a larger, ill-conceived plot to overthrow the tyranny. Hipparchos, who had tried to steal the young Harmodios from Aristogeiton, was the original target of their revenge—they had nothing against Hippias. But if the brother of the tyrant was to be killed, it was prudent to kill the tyrant, too, and Harmodios and Aristogeiton may well have become the dupes of unnamed co-conspirators. At all events, they botched the job. Hippias was saved because they lost their nerve. The Athenian people did not spontaneously rise up in revolt when Hipparchos fell, as the conspirators had hoped. Harmodios was killed on the spot and Aristogeiton captured and tortured to death. They succeeded only in eliminating an arrogant dilettante and in turning Hippias' former benevolence into murderous cruelty and paranoia. Athens was not well served.

[273]

As it happens, Hippias had other good reasons for being nervous. Abroad Athens had been losing ground to Persia for some time: specifically it had lost its important colony at Sigeion (at the mouth of the Hellespont) to barbarian control. At home Hippias had less impetuous and more dangerous enemies than Harmodios and Aristogeiton: Kleisthenes, the head of the supposedly cursed Alkmeonid family, led those out to get him.[1] Just as Megakles, his father, had briefly been an ally of Peisistratos, so Kleisthenes had previously collaborated with Hippias: he served as archon in 525/24. But like his father before him, Kleisthenes had been forced into exile, probably even before the murder of Hipparchos and the beginning of Hippias' reign of terror. However they came to be outside of Attica in 514, in the next year the Alkmeonidai (and other exiles) tried to come back. They fortified a position at the foot of Mount Parnes (Leipsydrion), but, reign of terror or no, the Athenian people gave them no more support than they had given Harmodios and Aristogeiton, and severe losses forced Kleisthenes to withdraw. He took refuge at Delphi and there won over two powerful allies: Apollo and Sparta. Apollo was easily recruited because his priests were easily bribed. Kleisthenes assumed the contract for rebuilding the god's temple and personally financed the construction of the east facade in marble. From the look of the maidens who stood in the pediment [116], Antenor, who had previously carved that huge *korē* for Nearchos [107], was probably the sculptor in charge. Kleisthenes wanted one thing in return: whenever a Spartan came to consult the oracle, Apollo had to answer, "First, free Athens." An army of foreign mercenaries had helped Peisistratos seize power in 546. An army of foreigners could be expected to drive the tyrants out. The Spartans did not need much coaxing. They did not like tyrants (they preferred oligarchs like themselves) and were busy expanding their influence besides. And so in 510 Kleisthenes and the Alkmeonidai cheered from the sidelines as the Spartan king Kleomenes invaded Attica and penned Hippias up on the Acropolis. The Athenian people still were in no hurry to rise up against the dynasty that had so enriched the polis and Kleomenes was about to abandon the siege when the Peisistratid children were caught trying to escape. There was a negotiated surrender and Hippias was given his life, his family, his possessions, and five days to leave town—very lenient terms for a tyrant with so bad a press.

The Peisistratid Golden Age thus ended and Athens entered a critical period of transition. Hippias fled to Sigeion: the fates of Athens, the mother city of Ionia, and Persia, the empire that had swallowed Ionia up, thus became more ominously intertwined. Work on the colossal temple of

1. Aristotle (*Constitution of Athens*, 20) mentions one Kedon who had somehow, at some time, attacked the Peisistratid tyranny.

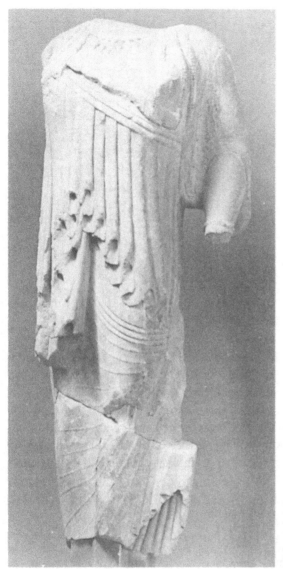

116. *Korē* from the east pediment of the Temple of Apollo, Delphi (Delphi Museum), around 510. Photo courtesy of Ecole Française d'Archéologie, Athens.

Olympian Zeus [117], the architectural symbol of the Peisistratids' drive for preeminence, came to a halt as enthusiasm waned—not for Zeus but for the costly monuments of tyranny (another wealthy *tyrannos*, the Roman emperor Hadrian, finally completed the building six and a half centuries later). The tragedy competitions begun under the tyranny at the City Dionysia apparently went on without interruption (Phrynichos, said to have been the pupil of Thespis, won his first victory between 511 and 508). But Anakreon and Simonides, the imported poet laureates of the Peisistratid court, apparently feared guilt by association. If they did not leave Athens after the murder of Hipparchos in 514, they discreetly found other em-

Revolution

117. Unfinished (and reused) column drums from the projected Peisistratid temple of Olympian Zeus, before 510. Photo: Jeffrey M. Hurwit.

ployment in Thessaly after the expulsion of Hippias. Yet the Athenians, to their credit, did not blame the poets for their patrons and both soon returned. Anakreon became the friend of the father of Perikles (Perikles was an Alkmeonid on his mother's side) and a statue of him was set up on the Acropolis sometime after his death. Simonides spent a good deal of his old age in Athens and, if he really was the author of an epigram attributed to him, showed how easily a poet who sang for his supper could switch sides:

> In truth a great light shone on the Athenians when
> Aristogeiton and Harmodios slew Hipparchos.
>
> [Diehl, 76]

The assassination was commemorated in other ways almost as soon as Hippias quit Attica. A concerted effort, in fact, was made to elevate the bungling lovers to the ranks of heroic martyrs and thus to deflect credit for the overthrow of the tyranny from Sparta, where it belonged, to the Athenians themselves, who did not deserve it. The Alkmeonidai probably had something to do with the publication of the new national myth.[2] And Antenor, the sculptor who had worked for Kleisthenes at Delphi, was hired at public expense to cast bronze statues of the tyrannicides—with the possible exception of Kleobis and Biton [85], the first statues commissioned by a Greek state to honor, without allegory or mythological disguise, the

2. See M. Ostwald, *Nomos and the Beginnings of Athenian Democracy* (Oxford, 1969), 130–36.

deeds of historical figures. The group (possibly no more than two metal *kouroi* standing side by side—Pausanias calls them *archaious* [I.8.5]) was set up around 509 or 507 near the spot where Hipparchos fell. The myth soon acquired a text to go with the image, a *skolion* (drinking song) that made the rounds of aristocratic symposia:

> I shall bear my sword in a myrtle branch
> like Harmodios and Aristogeiton,
> when at the festival of Athena
> they killed the tyrant Hipparchos.
>
> Always shall their fame live on earth,
> Harmodios and Aristogeiton most dear,
> since they slew the tyrant
> and made Athens a city of equal laws.
> [*PMG*, 895, 896]

Any Athenian who thought a moment knew better: Hipparchos was not the tyrant and the tyranny survived his death. No matter. The song was what many Athenians wanted to hear.

The man who in fact made Athens a city of equal laws (*isonomous*) was Kleisthenes, though it is unlikely he did so entirely out of principle. The expulsion of Hippias set Athens back forty or fifty years and its politics rapidly degenerated into the kind of cutthroat aristocratic power plays that had led to tyranny in the first place. Kleisthenes led one faction, the reactionary Isagoras the other, and after Isagoras was elected archon in 508 Kleisthenes boldly countered by taking the Athenian people into partnership (in the words of Herodotos) or by promising to turn the state over to them (in the words of Aristotle).[3] To survive politically he may have had little choice, but his course had to some degree been laid out for him first by the *eunomia* of Solon, whose invalidation of the Eupatrid birthright almost ninety years before broadened access to political power, and second by the Peisistratids themselves, who not only courted the common people and encouraged the formation of an Athenian national consciousness but also, by their very existence, made everyone else equal by comparison. Kleisthenes transformed this emerging spirit of equality into a political platform that called for the reorganization of the structure of the polis. His program carried in the Assembly (the same body that granted Peisistratos his club bearers in 561), perhaps during Isagoras' own archonship. Ten tribes were artificially created, each one consisting of three geographically distinct *trittyes* (thirds)—one from the city, one from the Attic interior, one from the coast. Each *trittys* was in turn composed of a varying number of

3. Herodotos, V.66; Aristotle, *Constitution of Athens*, 20.

demes. The deme ("township" is a rough translation) now became the basis, the smallest unit, of Athenian political life. It was, in fact, a kind of miniature polis with its own cults, elected officials, and council. Every citizen of Athens was also a citizen of a deme: he owed his allegiance to his deme, he owed his rights to his deme, he even owed a part of his name to his deme. Every citizen continued to sit in the Assembly, but each of the ten tribes sent fifty demesmen to the new Council of 500, which was the effective governing body of the state. The contingents of fifty men sent by the tribes—the so-called *prytaneis*—took turns managing the daily affairs of Athens and each *prytany* sat for a tenth of the Attic year. Finally, Kleisthenes instituted a procedure by which the people could exile for ten years any one man it did not like or thought dangerous: names were scratched on potsherds (*ostraka*), the sherds were counted, and the man who won the most votes lost.[4]

Ostracism, or the threat of it, guarded against severe internal strife. The new tribes and *trittyes* brought men of different economic classes and regions into the same political units and thus into common interest. The demes broke the influence and authority of local aristocratic families and gave each citizen the opportunity to act in a well-tempered microcosm of the larger polis. Theoretically, every citizen had the same political rights as every other citizen: to act as an individual in the Assembly, as a member of a deme, and potentially as a member of the Council. This was *isonomia*, and in 507 Isagoras called in Spartan troops to put a stop to it.

In a sense Kleisthenes had only himself to blame: after all, he himself had set the precedent by inviting Sparta, through the Delphic oracle, to intervene in Athenian internal affairs in 510. But if Sparta did not care for tyranny then, it liked what Kleisthenes was doing now even less. So once again King Kleomenes marched into Attica and once again Kleisthenes went into exile (evidently the curse of the Alkmeonidai was that they could never stay put for very long). But this time the Athenian people, who for so long had let their future be decided for them by aristocratic feuds, attempted coups, successful coups, tyrants, and Spartans, had had enough. They banded together to drive the Spartans and their pet oligarch Isagoras out of Attica and recalled the man who offered them partnership and *isonomia*. The Spartans did not quit, and in the next few years several more attempts were made to thwart the Athenian political revolution. But they failed each time, and Herodotos was sure he knew why:

> It is clear, not from this case alone but everywhere, that freedom is an excellent
> thing, since while the Athenians had a tyrant they were no better in war than

4. Aristotle, *Constitution of Athens,* 22.1, credits Kleisthenes with the law of ostracism. Many scholars (citing Aristotle's own statement that the first ostracism did not occur until 487, twenty years later) do not believe him. I do.

their neighbors, but when they had gotten rid of the tyrants they were best by far. It is clear from this that, when oppressed, they acted like cowards, since they toiled for a master, but once they were free, each man was eager to act for himself.

[V.78]

Not much more is heard about Kleisthenes, but by the last years of the sixth century his constitution was in place and by the beginning of the fifth *isonomia* began to be architecturally expressed. Across from the Acropolis the gentle slope of the hill known as Pnyx was prepared for a new meeting place of the citizen assembly: the hillside became a theater of politics and, as the citizen listened to the speaker standing below him, his eyes and thoughts could wander over the polis whose future he now helped shape. The Agora, the city's principal civic space, was now formally marked off with boundary stones. At its southwest corner a large, unroofed enclosure was built for the Heliaia, the court that Solon had probably opened up to the people. The Heliaia turned slightly toward the west side of the Agora and it was there that Kleisthenes' Council of 500 was given a home: the Bouleuterion, a square roofed hall with rows of wooden seats. Just to the north of the Bouleuterion a small shrine for the cult of the Mother of the Gods was built. Its simplicity sharply contrasts with the grand, costly temples of the Peisistratid building program: Kleisthenic Athens seems to have spent most of its energies and funds on civic buildings used by men, not on the houses of gods, though the possibility remains that the Archaios Naos [97–99], usually considered a Peisistratid project, was built or completed in the last years of the sixth century, presumably under Kleisthenes.[5] At the northwest corner of the Agora, the Royal Stoa may have been rebuilt around or shortly after 500, and a new altar was built nearby. And just south of the Bouleuterion, Building F, possibly the court of the Peisistratids, became the lodgings of the *prytaneis*. The house of tyrants became the house of ordinary demesmen chosen by lot to administer the polis in their turn—the architectural conversion could not be more eloquent.

This burst of architectural activity around 500 reflects the vigor of Athens shortly after the implementation of Kleisthenes' reforms and their successful defense. *Isonomia*, equality before the law, and its correlate, *isegoria*, equality in the assembly, were not quite *demokratia*, rule of the people: the

5. If the Archaios Naos was begun (and not merely finished) under Kleisthenes, then the temple with the so-called Hekatompedon sculptures—Herakles and Triton, Bluebeard, and so on [101, 102]—would have been removed from the Dörpfeld foundations either because of its associations with the Peisistratid tyranny or because the new Attic state wished to honor its patron goddess anew, or both. And if it was Kleisthenes' Athens that first put Athena in the pediment of her own temple, then it is not implausible that it also first placed her image on Athenian coins—the owls—as another visible symbol of the new order.

archon, for instance, still had to be a rich man. But Kleisthenes made the Athenian constitution more democratic than any Greece had ever known, and the new mood may explain why there was a notable decrease in the production of that aristocratic emblem, the *kouros*, in Athens after 508/7. At all events, Herodotos may have been right about the effects of freedom: the Athenian citizen now had something to fight for. Before the end of the Archaic period, with *isonomia* still in its infancy, he would have to fight again, and then again, and his enemy would be far more terrifying than Sparta.

The Red and the Black

The last decade of the sixth century was almost as exciting in the shops of the Kerameikos as it was in the political arena, and Attic vase painters knew it. On one side of an amphora in Munich [118] the Red Figure artist Euthymides painted three naked, tipsy partygoers (such scenes from

118. Belly amphora by Euthymides (Munich 2307), around 510. Photo: Hirmer Fotoarchiv, Munich.

119. Kalyx krater by Euphronios (Berlin Staatliche Museen 2180), around 510. Photo: Hirmer Fotoarchiv, Munich.

everyday life—or at least from the everyday life of the upper class—now took up a larger share of the artistic repertoire). Next to the chief reveler Euthymides wrote the comment *hos oudepote Euphronios,* "as never Euphronios [could do]." This sally was probably intended to tease Euphronios rather than to taunt him, though it may also have been a serious attempt to steal Euphronios' customers. But the remark is nonetheless the earliest extant case of Greek art criticism. To judge from his uninhibited, twisting dancers, what he claimed he could do better than Euphronios was to foreshorten the human figure—that is, to draw it (or parts of it—the heads, for instance, remain in profile) in three-quarter view. Because its anatomical lines are no longer visible in their fullest extension, the foreshortened figure seems set at an oblique angle to the picture plane. It thus frees itself from the total domination of the surface, to which the figure composed purely of profile and frontal parts (or even the fully profile figure) rigidly adheres [cf. 112]. Incidentally, Euthymides was right: he could foreshorten better than Euphronios. On a krater in Berlin [119], Euphronios partly hides the back of an athlete with a cloak, as if he were hesitant about drawing a twisting spine. But more important, his boast suggests that both he and his competitors knew they were beginning to

Revolution [281]

dispense with the schemata of conceptual art (even if they did not know those terms) and transform the nature of representation. These still Archaic artists were well aware that they had entered one of the most revolutionary eras in the history of art—an era that subverted the principles of *archaios*.[6]

The Red Figure technique was probably an instrument of the revolution rather than either a cause or a consequence. It appeared some twenty years before Euthymides painted his revelers, in the closing years of Peisistratos' reign, when Amasis and Exekias were still working. We think we know who invented it: the Andokides Painter (Andokides was the potter the painter worked for). But we do not know why. Commercially there was no need for it. Black Figure's popularity had not diminished, and in fact most of the Black Figure vases we have belong to the first generation of Red Figure (530–500). Perhaps it was simply a strong experimental urge that led the Andokides Painter to leave red what he had been taught to paint black and to paint black what he had been taught to leave red. But the invention of Red Figure was probably not casual or impulsive. The Andokides Painter seems to have learned his craft from the best Black Figure vase painter there was, Exekias, and the teacher's stylistic perfection may have been the mother of the pupil's invention [cf. 112, 120]. Conceivably the Andokides Painter taught himself Red Figure in reaction to the consummate achievements of his teacher, achievements that, he realized, could not be matched in the same medium. But not even that kind of artistic anxiety can be the whole explanation. The roots of Red Figure went deeper, and they were probably nourished by a growing sense of the intrinsic limitations of Black Figure.

Signs of discontent appear even in the work of Exekias' main rival, the Amasis Painter, who rejected an important Black Figure convention. Instead of painting female faces and limbs white, he often drew them in outline, "reserving" them in the color of the clay [108]. Outline drawing was not new: it is common in Protoattic [72], and the practice was kept alive (if just barely) in the sixth century.[7] But no Black Figure artist used the technique more than the Amasis Painter. It is not impossible that his outline drawing was a conscious revival of the old fashion[8]—an archaism. From a chronological standpoint it is also not quite impossible that he was influenced by the first Red Figure vases displayed in the Kerameikos. But it is more likely that he looked forward rather than back and that his use of outline anticipated Red Figure rather than reacted to it. At any rate, the

6. On a later stele from Boiotia, an old man leans on his staff and places his left leg over his sharply foreshortened right; the inscription reads: "Alxenor of Naxos made this, just look!"—presumably at the foreshortened limb. See Boardman, *GS*, fig. 244.

7. Beazley, *Development*, 57.

8. Cf. Boardman, *Pre-Classical* (New York, 1967), 114.

120. Amphora by the Andokides Painter (MFA 01.8037), around 525–20. Photos courtesy of Museum of Fine Arts, Boston, H. L. Pierce Residuary Fund.

Amasis Painter only tampered with Black Figure. The Andokides Painter, by proceeding from an outline and then glazing in the area around it, turned Black Figure inside out. After a century of refining a technique ultimately learned from Corinth, Athenian vase painting found a technique all its own.

Dissatisfaction with Black Figure could have been sharpened by observation of contemporary developments in two other media: sculpture (both in the round and in relief) and monumental painting. The increasingly subtle depiction of anatomy and drapery on statues possibly pressured the vase painter into finding a better way to render muscles and cloth than the incision of silhouettes allowed. And the flourishing art of relief, in which white or lightly tinted figures generally appeared against a deep-blue or red background, may have suggested the new light-on-dark color scheme.[9]

9. Boardman, *ARFV*, 14–15.

The possibility that Attic wall painting had some impact on the invention of Red Figure is harder to judge: there is no Attic wall painting left. But in the last few decades of the sixth century Athens seems to have finally taken the lead in free painting from such older centers as Corinth. We hear of a certain Eumaros of Athens (perhaps the same man as Eumares, the father of the sculptor Antenor) and of a Kimon of Kleonai (a town near Corinth), who carried on Eumaros' inventions, possibly as his pupil—times had changed if a muralist from the vicinity of Corinth developed an Athenian's style. It had been a century since the Attic vase painter had stopped trying to act like a wall painter: the full adoption of Black Figure around 625 can be taken as his concession that he decorated bulging pots, not flat walls. But the rise of Athenian monumental painting under Eumaros may have re-kindled the vase painter's desire to compete, and the shiny black sil-houettes he had been painting must have seemed to be to his disadvan-tage. Now Red Figure is no less a vase painter's technique than Black. But its light, matte forms must have approximated the figures painted on Athe-nian walls better than the lustrous shadows of the old style. Part of the reason for Red Figure, then, may have been the need to respond to free painting, to narrow the gap.

That this gap was at least on the minds of vase painters after 530 is suggested by the development of yet another technique that altogether eliminated the stark contrast between red and black by drawing figures over a white or pale background—a muralist's background. The An-dokides Painter himself experimented with an unsuccessful variety of white ground. But one of the technique's early exponents was none other than Euthymides, though he used it not on vases but on large terra-cotta plaques dedicated on the Acropolis. On the best preserved [121], a mostly chocolate-brown but partly outlined warrior—a strange combination of profile, back, and three-quarter rear views—runs across the panel as a satyr prances out of sight around the curve of his foreshortened shield. Interestingly, the warrior's sash is black and incised, as it would be on a Black Figure vase. But vase painter had rather effortlessly turned panel painter nonetheless.

By the last years of the sixth century, Attic painters of walls and vases (and sculptors, too) were—and evidently considered themselves to be—equally capable and pioneering members of a single artistic community. When Pliny says that Kimon invented *katagrapha*, possibly meaning three-quarter views, and that he "shaped faces in different ways, looking back, up, or down; he distinguished the parts of the body with articulate divi-sions; he brought out veins and, moreover, depicted the wrinkles and folds of drapery,"[10] he is attributing to one man the spatial and naturalistic

10. Pliny, *Historia naturalis*, XXXV.56. Pliny gives a very early date for Eumaros and Kimon, but most scholars agree they should be placed late in the Archaic period.

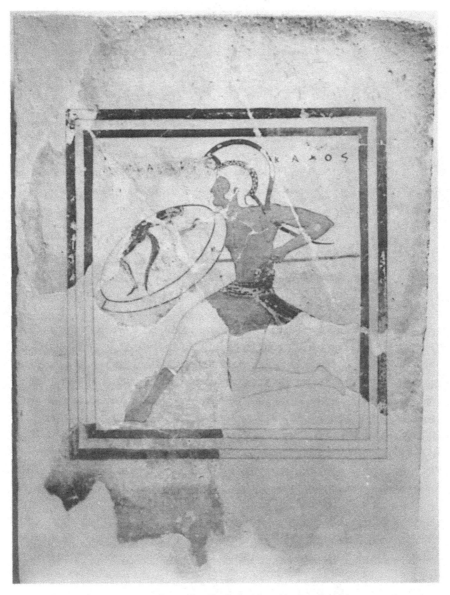

121. Painted terra-cotta plaque by Euthymides (Acropolis 67), around 510–500. Photo courtesy of Deutsches Archäologisches Institut, Athens.

concerns of a generation of late Archaic artists. There is every chance that the vase painter was the wall painter's or sculptor's competitor in the depiction of foreshortening and the articulation of musculature and not merely a follower. The rivalries among the visual arts had, in fact, never been so intense, their interrelationships never so close.

Whatever made him invent Red Figure, the Andokides Painter spent a lot of his time testing the relative values of black and red, often on the same

Revolution [285]

122. Detail of a cup by the Andokides Painter (Palermo V 650), around 525. From *Jahrbuch des Deutschen Archäologischen Instituts*, 4 (1889), pl. 4.

vase and sometimes even within the same scene: on the exterior of a cup in Palermo he switched from one technique to the other in the middle of a fight [122]. These technical experiments are called bilingual vases, and that is an especially good term for a few amphorae whose Black and Red Figure sides are more or less translations of each other—almost like the negative and positive of a photograph [120].[11] Other artists painted bilinguals, and what is remarkable about most of them is their apparent reluctance to show any real bias toward one technique or the other (despite the fact that on the Palermo cup the red warriors defeat the black!). At first Red Figure seems to be presented objectively as an alternative to Black Figure rather than as its inevitable replacement (and some fine artists in the last years of the sixth century shunned Red Figure altogether—not everyone was dissatisfied with the old technique). The earliest Red Figure scenes do not, in fact, differ very much from Black Figure in subject, style, or ornamental spirit: they are just as flat, linear, and patterned, and accessory colors and even incision—hallmarks of Black Figure—are common. The Andokides Painter in particular wielded his brush as he had been taught to handle his incising tool. He showed some interest in anatomical detail, he revealed the shape of a leg through the folds of some drapery, and he foreshortened a collar-bone or two. But he did not fully exploit the inherent qualities and benefits

11. That the Andokides Painter painted Black Figure as well as Red is certain, that he painted the Black Figure scenes on all his bilingual vases is not. The most recent defense of the position that a distinct personality, the Lysippides Painter, should be credited with the Black Figure scenes is Beth Cohen's *Attic Bilingual Vases and Their Painters* (New York, 1978), esp. 1–8, 105–10.

of the technique he invented. He may not have fully realized what they were. Others—Euthymides and Euphronios, for instance—soon did.

The drawn line is Red Figure's first natural advantage. The brush is a more supple, deft tool than the engraver, and the painted line is more fluent and swift than the hard incision. That does not mean the brush is less disciplined: if Exekias had shown how precise and intricate incision could be [112], Euphronios set out to match him on the wings and cuirass of Thanatos on his krater in New York [113]. But Euphronios' magnificent obsession was anatomy, and the brush let him pursue the same study that occupied contemporary sculptors of *kouroi* and such wall painters as Kimon: the articulation of body parts. Anatomy was not the transcendent concern of Archaic art as a whole, but it was Euphronios'. And unlike the Black Figure vase painter (who could only slice a thin line of uniform intensity through his silhouettes), Euphronios had at his disposal two kinds of line: a thick and noticeably raised "relief" line (applied by a specially tipped brush or syringe) and a dilute line, which, depending on the concentration of the glaze, took on various shades of brown. Both kinds appear on the Sarpedon krater—relief for the principal lines, dilute for the minor ones (and for a wash over Hermes' shirt and Sarpedon's hair). The relative values of relief line and dilute are perhaps even clearer on Euthymides' revelers [118]. Thus, while Red Figure is in principle just as linear a technique as Black Figure, its lines can be softened and modulated. That is an important difference, for the varying intensities of line, by stressing some contours and depreciating others, increases the apparent volume, the corporeality, of muscle. The effect is in its way sculptural and, as in contemporary sculpture [110, 132], the keen observation has been made that not all features of the human body, not all bulges and hollows, are equally prominent or need be equally displayed.

Euphronios flaunts his anatomical knowledge in the dying Sarpedon. The hero's eyes are almost shut, his teeth are gritted in pain (this is the *herkos odontōn*, or "wall of teeth," Homer speaks of as the last barrier of life's last breath [*Iliad*, IX.409]), but his divine morticians, as they lift him from the ground, tilt his torso toward us so we can appreciate his belly. And a fine belly it is, accurate yet (since it is an Archaic belly) still subordinated to the clarity of pattern. When it came to anatomy Euphronios was something of a pedant, and he gave another lesson in the figures of Herakles and the giant Antaios on a large kalyx krater in the Louvre [123]. Antaios could be killed only after he was lifted from Earth, his strength-giving mother. But here he is on the ground and still he does not have a chance. As two diminutive women gesture theatrically behind them like members of a tragic chorus, Herakles catches the villain in a half nelson. Antaios struggles for leverage with his left arm and leg, but the strength has gone out of his right arm and his right leg is bent back under him—only the foot

123. Kalyx krater by Euphronios (Louvre G 103), around 515–10. Photo: Hirmer Fotoarchiv, Munich.

reappears behind the thigh. Antaios is an incredibly contorted hulk, mostly frontal, partly profile, partly foreshortened. Herakles, on the other hand, is a pure, compact profile. The different postures of the hero and his foe, the different ways they are related to the surface of the vase, express the invincibility of one and the desperation of the other: Herakles seems to draw power from the plane he stretches along—it is a field of force—while Antaios, partly twisted from the strength-giving plane, is doomed to agony and death. The contrast is also made by Antaios' unkempt hair (drawn in dilute), beetled brow, rolling eye, and painfully bared teeth—yet another Archaic grimace—and by Herakles' rich black hair (done up neatly in relief curls), trimmed beard, and emotionlessness. One thinks back to the contrast between the well-groomed Herakles and the open-mouthed, shaggy-haired centaur on the Athens Nettos amphora, painted just over a century before [77], but what is new is the concentration on Antaios' suffering or *pathos*. The scene is one of the most expressive in Archaic art—expressive

124. Neck amphora by the Antimenes Painter (BM B 226), around 515. Photo courtesy of the Trustees of the British Museum.

enough to anticipate some of the concerns of the Early Classical style.[12] But Euphronios the anatomist did something else new, and Herakles seems to stare right at it: he inspects Antaios' belly, and there, in the hollows dividing the stomach muscles, Euphronios spread dilute. It is faint, but it may be (with the exception of the Protoattic Polyphemos Painter's remarkable but isolated treatment of flesh on the Eleusis amphora [73]) the earliest acknowledgement that light plays differently over rising and sunken surfaces, that corporeality can be described not only by line but also by the unarchaic (and very rare) device of shading.

Red Figure's second decisive advantage is the very nature of the relationship between light form and dark ground. It is an ambiguous relationship, for although the red figure seems to stand in front of the black

12. The way Antaios' right hand has gone limp foreshadows the powerless left hand of the dying warrior from the Early Classical east pediment of the Temple of Aphaia on Aegina; see Pollitt, *Art and Experience*, fig. 7. On the other hand, the way Antaios crosses one leg over the other is paralleled by the dying warrior on the Archaic west pediment; see Pollitt, fig. 6.

glaze as if before a curtain, somehow it also seems to exist *within* blackness. A Black Figure scene, again, appears backlit, like an image silhouetted upon a screen by a source of light projected from behind. Whatever sense of space there is in a painting such as Exekias' Achilles and Ajax [112] or even the Antimenes Painter's Olive Harvest [124], where fruit falls through the air, it begins on the surface and stays there, or extends only a little way back. A Red Figure scene, on the other hand, seems spotlit: forms are individually illuminated, as if on a darkened stage pierced by lights projected from the front. The sense of space extends from the black glaze forward, enveloping the light forms within it. And when figures like Euphronios' Antaios or Euthymides' revelers twist and turn, they aggressively appropriate the surrounding blackness as their field of existence. That is, Red Figure allows the human form to generate its own space. Now the habit both Black and Red Figure vase painters had of printing words across the background (red or black) suggests that their attitude toward it may not have been the same as ours: they could have regarded the areas around and between their figures not as space but as neutral gaps or margins for names and notes. But no background can, in the end, be absolutely neutral: human perception will not allow it. And the change from Black Figure (a style that favors patterned *groups* of figures) to

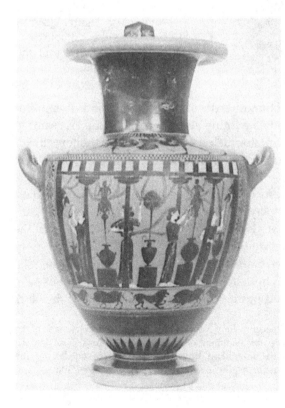

125. Hydria by the Priam Painter (BM B 329), around 510. Photo courtesy of the Trustees of the British Museum.

The Art and Culture of Early Greece, 1100–480 B.C.

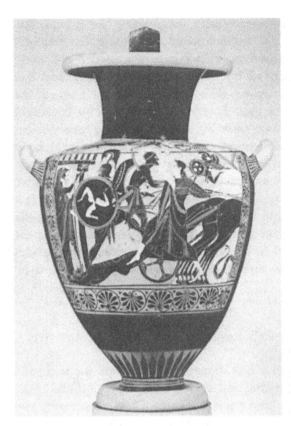

126. Hydria of the Leagros Group (MFA 63.473), around 515. Photo courtesy of the Museum of Fine Arts, Boston, William Frances Warden Fund.

Red Figure (a style that favors the *individual* figure) genuinely altered the potential for intimating the space in which figures independently move. This change in turn encouraged the development of foreshortening.

It is not true that Black Figure is completely spaceless or that the Black Figure artist could not foreshorten: he could, at least from the middle of the sixth century on. But he generally chose to foreshorten horses or things (shields, chariot wheels), and the few foreshortened human figures he drew are unquestionably late responses to the success of Euphronios, Euthymides, and their circle. Black Figure was being forced from the mainstream of Greek art, but it did not go willingly, and Black Figure rivals of Euphronios and Euthymides often refined the device they knew best—the layering of parallel planes—to create ambitious, if not completely successful, representations of figures in space. On a vase by the Priam Painter, women wind in and out of the columns of a fountain house as their jugs catch water pouring from lion-head and horse-and-rider spouts on the walls [125]. There are spatial curiosities: women standing in front of the colonnade (and thus outside the fountain) effortlessly hang wreaths on spouts inside the building. But this is still an imaginative view inside a *place*, and contemporary Red Figure, preoccupied as it is with the anatomy

and torsion of the individual human figure, has nothing like it. Other late Black Figure artists are less subtle in their use of overlapping. The members of the Leagros Group, for instance, were partial to crowded and lively scenes: charging chariot teams all but obscure warriors behind them and the horses themselves are often cut off at mid-belly by the frame of the panel [126].[13] The sense is that the action continues beyond the borders of the picture in a space we know is there but cannot see. The spatial effect is more dramatic than, say, the foreshortening of a spotlit dancer [118], but it is cruder, too. The Leagros Group artist's principal reaction to the challenge posed by Red Figure was formal violence. He produced an active, dense surface, but everything, or almost everything, takes place on that surface or on planes parallel to it. Black Figure could not easily or finally break the authority of the plane and the schemata it demanded. After the Leagros Group, Black Figure lived on, but its existence on anything besides Panathenaic amphorae (which would always be decorated in the old style) was insignificant.

Late Archaic Relief and the Community of the Arts

Relief is an art of two and a half dimensions. It covers the wide and shifting ground between painting and sculpture in the round and is the synthesis of those other arts (and not just because Greek reliefs were vividly painted). The synthesis is protean: the higher the relief, the more it is like sculpture in the round; the lower the relief, the more it is like painting. But relief is never quite one or the other. The relief artist uses the methods and tools of the sculptor. He must concern himself with the projecting volumes of the forms he carves and the way they are related to the real space around or in front of them. But he begins his work by sketching on the face of a stone and so must plan and think like a draftsman as well. A relief actually has depth: in that sense it is like a statue and unlike a painting. But a relief exists on a background and in that sense it is like a painting and unlike a statue. Stone chips fly about as the relief sculptor goes about his task, but a two-dimensional design lies embedded in the product. His problems are pictorial as well as sculptural. And because of the pictorial quality of relief, certain attitudes of the relief artist and of the vase painter coincide. In fact, late-sixth-century reliefs and Red Figure scenes are sometimes so close in style and conception that it is easy to imagine sculptors and painters exchanging chisels and brushes. One expla-

13. The Leagros Group takes its name from the youth whose beauty is frequently praised on its vases. Euphronios, Euthymides, and other artists thought he was *kalos*, too, and said so on their Red Figure vases as well [for example, 113].

nation for the community of the arts in the late Archaic period may be the versatility of late-sixth-century artists. Another may be an especially high degree of collaboration between them.

The pictorial, linear origins of relief are nowhere clearer than in the Foce del Sele metopes—one of those mythological dictionaries Archaic artists were fond of compiling in the second quarter of the sixth century. Some metopes look unfinished, but what is not carved may have been left for the painter to complete. In any case they display the relief system that was dominant in the early Archaic period. On one metope Ajax kills himself and like a good Archaic figure gestures broadly as he stiffens upon his sword—no Exekian subtleties here [94]. Even if the sculptor meant to carve more than he did, judging from other finished metopes, he would not have carved much more. The edges would have remained sharp and the inner details would have been shallow, almost incised. The procedure was simply to draw an outline and cut straight back along it. Ajax is what was left after the excavation of the original surface of the block—a stone cutout, a silhouette with vertical walls for sides. The background of the relief is really an irregular trench dug into the stone, and here as elsewhere in early Archaic relief it is deeper in one spot than in another. The background does not, in fact, matter much. The figure of Ajax does not so much push out from the background as lie upon and behind a flat surface—the front plane. The activity of the sculptor has not really damaged that plane. Its existence is tangible and its force dictates the two-dimensional character of the relief. Not all early Archaic reliefs are as planar as the Foce del Sele metopes: the metopes from Temple C at Selinus, for instance, are stone boxes with high relief figures within them [127]. But all submit to the authority of the front plane. They are surface-bound and space-shy. They are like Black Figure vase paintings turned to stone.

The background began to matter more around the middle of the sixth century. It acquired substance and strength and turned into a continuous, stable support for relief. The relief figure now seems to project from the background, to exist in front of it or against it. The original surface of the stone is still often strongly sensed, and many reliefs occupy a shallow uniform space like that between parallel panes of glass. But the front plane becomes less palpable, less authoritative than it had been, and occasionally it is even ignored. The change in the Archaic conception of relief—a change that in many ways corresponds to the change from Black to Red Figure—seems to have started not in Athens but at Delphi, where it would have been particularly noticed and from which it would have spread to other parts of the Greek world with some speed. The shift in formal authority from the front to the back plane is first detected in a handful of metopes usually thought to have adorned a treasury erected by Sikyon

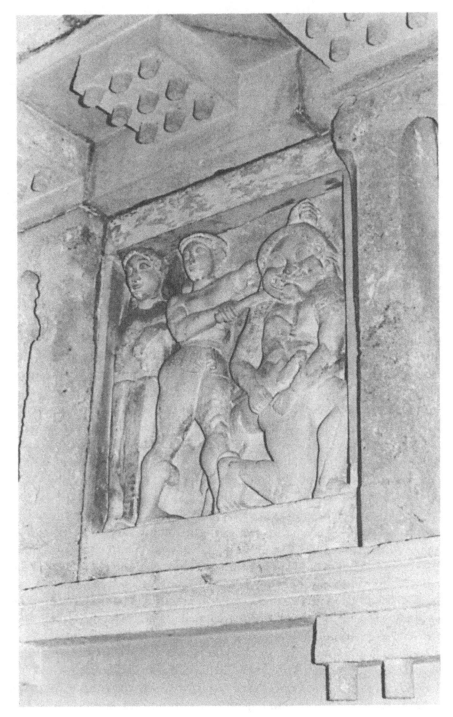

127. Metope from Temple C at Selinus (Palermo Museum), around 550. Photo: Jeffrey M. Hurwit.

The Art and Culture of Early Greece, 1100–480 B.C.

shortly before the fire that devastated the sanctuary of Apollo in 548.[14] But none of these reliefs is whole, and the change can be seen better on the Ionic frieze that ran for more than 29 meters around the top of the Treasury of the Siphnians. Herodotos (III.57–58) indicates that the Siphnians built this elegant marble jewel box just before their prosperous island was plundered by Samian exiles, around 525. This is usually said to be one of the few dates in the history of Archaic art that we can count on, and a lot depends upon it—the date of the Andokides Painter, for instance, and thus the date of the invention of Red Figure.[15]

The Siphnians hired two principal sculptors to design the frieze and supervise its execution. Neither was necessarily a Siphnian. One—Master B—almost certainly was not. In any case, they worked independently and made no obvious attempt to homogenize their very different styles: either they never looked over each other's shoulder or they did and did not like what they saw. The sculptor responsible for the west and south friezes—Master A—was probably Ionian; and although Ionian aesthetics may explain his style, he still seems the more old-fashioned of the two. His compositions—the judgment of Paris on the west, possibly the rape of the Leukippidai on the south—are sandwiched between two sturdy planes: a solid, very visible background and a strongly implied front plane [128]. The few surviving human figures are the usual combinations of profile and frontal parts. The horses, magnificent beasts though they are, are strictly profile and flat, like raised silhouettes. Master A was on all counts a better sculptor than the one responsible for the Foce del Sele metopes, but his conception of relief, his strict adherence to the surface, was not much different.

The west side was originally the front of the treasury—it faced the Archaic entrance to the sanctuary at its southwest corner—and it is therefore no surprise that the Siphnians assigned its sculptures (there were also two Karyatids and a pediment) to a (conservative) Ionian. The irony is that the major entrance to the sanctuary was shifted to the southeast corner in the early fifth century, and with that move, pride of place belonged to the east and north friezes of Master B. For they were the first sides seen by anyone making his way up the slope of the Sacred Way.

The east frieze is divided in two. On the left [129 top] the gods sit in pro-

14. Ridgway, AS, 231–34, argues that the "Sikyonian" metopes are of Magna Graecian origin. See also Boardman, GS, fig. 208.

15. In "Signa priscae artis: Eretria and Siphnos," JHS, 103 (1983), 49–67, E. D. Francis and M. Vickers argue that the date of 525 for the Siphnian Treasury really is insecure, but are not likely to win over many converts to their radical redating of Archaic art by putting the Treasury and its sculptures in the 470s. For an effective critique of their argument, see J. Boardman, "Signa tabulae priscae artis," JHS, 104 (1984), 161–63.

128. Detail of the west frieze of the Siphnian Treasury (Delphi Museum), around 525. Photo courtesy of Ecole Française d'Archéologie, Athens.

Trojan and pro-Akhaian camps around the central figure of Zeus and apparently argue about what is happening (or has happened) on the right [129 bottom]. There Aeneas and Hektor and Menelaos and Patroklos fight over the corpse and armor of a fallen hero—Sarpedon, probably—while Glaukos and Automedon keep their taxi-chariots close by. The east frieze, then, presents two different locations: Mount Olympos and the Trojan plain. It may also, in simultaneous narrative, present two different moments: though in the *Iliad* Hera has to convince Zeus of the necessity of Sarpedon's death, no Olympian debate is held over the fate of his body. In other words, what may be hotly discussed in one half of the frieze is already a fait accompli in the other. But the unities of place and time did not concern Master B (any more than the unity of time concerned the Polyphemos Painter [73], the sculptor of the Corfu pediments [74], or Euphronios, who shows Sarpedon, supposedly dead, cleaned, and bathed, still bleeding [113]). And his juxtaposition of divine and mortal realms foreshadows the presence of the gods on the east frieze of the Periklean Parthenon, where they chat amidst the activities of the Panathenaic procession but are to be imagined as observing them from Olympos.

Though they are thematically related and deal with two kinds of conflict, the divine debate and the Homeric battle are symmetrical and self-contained compositions. There is no formal transition between the halves of

129. Details of the east frieze, Siphnian Treasury. Photos courtesy of Ecole Française d'Archéologie, Athens.

the east frieze—it is a case of Archaic parataxis in stone—just as the Homeric account switches abruptly from the realm of the gods to the Trojan plain (*Iliad*, XVI.457–61). But Master B also did the north frieze (the most conspicuous of them all, since it overlooked the Sacred Way and matched the pilgrim's progress for more than eight meters), and there he chose a different and innovative approach [130]. The subject is the battle of gods and giants, a challenging myth that Attic vase painters had tackled, that was embroidered on the Panathenaic peplos, that would soon fill the pediment of the Archaios Naos on the Acropolis [99]—the Athenian connection

130. Detail of north frieze, Siphnian Treasury. Photo courtesy of Ecole Française d'Archéologie, Athens.

may be significant[16]—but that would not be tried on a continuous frieze again for 350 years. Master B's solution was to carve a restless stream of overlapping encounters, not a series of discrete episodes. There are, of course, individual duels within the vast battle: the wine god Dionysos (with a panther skin knotted around his neck) aims his spear long-distance at a fleeing giant appropriately named Winecup (Kantharos)—Master B punned by carving the base of the giant's crest in the form of such a vase. But between the god and his quarry (and behind his line of fire) another giant aims his spear at someone else. In front of Dionysos Kybele drives her chariot against yet another giant: the lions that pull her are her weapons, and one ferociously sinks its teeth into the foe. And still before we reach Winecup, Apollo and Artemis take twin aim against a phalanx of giants advancing (as the giants usually do) from the right. The relief is only a few inches deep but Master B has skillfully layered several planes of action. The layering makes the relief seem deeper than it is and the action relentless. Moreover, some figures are carved in low relief while others are carved nearly in the round: they are not the equally raised, equally flat silhouettes of earlier reliefs (or even of Master A's south and west friezes) and the front plane is no longer a thing to contend with. As a result the eye moves easily and rhythmically in and out of the relief, from one plane to another and back again, as it is carried steadily along. There are no gaps or pauses, there is no metrically dull succession of isolated incidents. There is something about this intricate interweaving of duel upon duel—its irreversible, ceaseless flow—that is unusual for Archaic art, which generally

16. For a skillful political interpretation of the Siphnian sculptures, see L. V. Watrous, "The Sculptural Program of the Siphnian Treasury at Delphi," *AJA*, 86 (1982), 159–72.

prefers images built up of distinct parts and stark juxtapositions.[17] One thinks back upon the wedding procession on the François vase with its many overlapping figures [93], but they are all placed in separate groups. One thinks forward to certain vase paintings of the Leagros Group,[18] but they might themselves have been influenced by the Siphnian Treasury frieze. For a truer parallel in stone one has to look beyond the Archaic period—once again to the frieze of the classical Parthenon.

The north and east friezes are different but, again, Master B designed them both. He says so in an inscription carved along the rim of a giant's shield: ". . . made these and those on the back" (that is, the east). Of course, the signature is defaced precisely where Master B chiseled his name, so if we know what he did—he probably also designed the east pediment of the treasury—we still do not know who he was.[19] But there is a good chance that he was an Athenian or at least that he spent some time working in Athens before being called to Delphi, and there is more than a good chance that he was a painter as well as a sculptor.[20] Again, every relief sculptor must to some extent think like a draftsman or painter, but Master B acted more like one than most. Like a painter he identified his heroes, gods, and giants by writing inscriptions beside them in the field (Master A did not). Like a painter he conspicuously signed his work. But most of all he used paint to supplement his sculpture, not merely to color it. The chariots in the east frieze, for instance, are no longer all there [129 bottom]: the cars and wheels and even parts of the horses were painted on the background of the relief, not carved, and have faded away. Without them the Homeric combat is incomplete. At various points along the frieze, then, one art form turned into another, and Master B, who began his task by sketching on the blank surface of the stone, ended it by taking up the brush. No other Archaic relief was so literally between two and three dimensions, and few Archaic artists were so agile in different media as Master B.

Whether he was Athenian or not, Master B's work reflects—or perhaps anticipates—developments in Attic painting, particularly the use of fore-shortening. The chariot wheels he painted on the east frieze were not round but almond-shaped. The front legs, chests, and heads of the horses in each team are carved in subtly varying three-quarter views. So are some shields on both the east and north friezes. Chariots, horses, shields—these

17. An earlier gigantomachy painted on a fragmentary dinos by Lydos has something of the same character as the north frieze; see M. B. Moore, "Lydos and the Gigantomachy," *AJA*, 83 (1979), 79–99. But the kind of flow represented on the north frieze still seems atypical of Archaic ways of thinking and expression in general. Poetic examples are equally rare; see Fränkel, *EGPP*, 226–27.

18. See Boardman, *ABFV*, fig. 206.

19. L. H. Jeffery's guess is Aristion of Paros; see *AG*, 185.

20. Robertson, *HGA*, 157.

are the things Attic Black Figure vase painters had been foreshortening for about a quarter century. Human figures on Black Figure vases had not yet been foreshortened, and most of Master B's people are, like them, strict profiles or profile-frontal composites (Winecup is caught in a pose that is remarkably neck- and stomach-wrenching even for Archaic art). But Master B also conducted some important experiments. In the divine assembly of the east frieze Apollo turns his back to the spectator as he consults with his sister Artemis [129 top]. On the north frieze Hermes is shown in a slightly three-quarter back view and seems to stride obliquely into the relief. And at the west end of the gigantomachy a foreshortened giant carrying a foreshortened shield crumples to the ground. In relief as in painting, the foreshortened figure resists the flattening force of the plane. By breaking the hold of the schema it seems to exist in a space that is open and free instead of shallow and layered.

The three-quarter view, then, extends the sense of space. And Master B extended it in yet another new way. For most of its length the background on the east and north friezes is as stable and solid as the background on the west and south (even though it is not so visible on the north). It is, on the whole, a wall behind the figures. But here and there the background turns soft and the concave shields of warriors, gods, and giants sink into it, as if it were not marble but air. This kind of immersion of forms in the background had not happened before and it will not happen very often again in the Archaic period. Nonetheless, the value of Master B's background—it was originally painted blue—has something of the same value as the black glaze of a Red Figure vase painting: it is primarily the ground of the image but it is also, somehow, atmospheric.

Master B and the Andokides Painter were contemporaries, possibly both Athenians, perhaps even associates, and it is not clear which came first: the carving of the Siphnian Treasury or the invention of Red Figure. But the Andokides Painter's figures often seem two-dimensional versions of figures on the Treasury, and it is not impossible that he worked on the frieze as a colorist before the idea of Red Figure came to him—or that he was working on it *when* the idea of Red Figure came to him.[21] It may be, then, that Red Figure owed more to the Siphnian Treasury friezes than Master B owed to Red Figure. But the extension of space that Master B achieved with foreshortening and the intimation of space that Red Figure inherently allowed (even if the Andokides Painter did not intimate it as much as Euthymides or Euphronios did later) were probably not independent developments. If every relief sculptor has to think like a painter, the important

21. See Cohen (n. 11), 117, and D. von Bothmer, "Andokides the Potter and the Andokides Painter," *Bulletin of the Metropolitan Museum of Art*, 24 (1966), 201–12. The closest parallels for the Andokides Painter's early style are found, however, on the south and west friezes, and since the Andokides Painter, like Master A, avoids foreshortening, Master B's accomplishments seem to have had less effect on him.

131. "Ball Players' Base," from the Themistoklean wall (Athens NM 3476), around 510. Photo courtesy of Deutsches Archäologisches Institut, Athens.

point is that Master B began to think like a Red Figure vase painter—or else Red Figure vase painters shortly began to think like him.

Relief and Red Figure drew even closer together in the last decade of the sixth century. Around 510 a funerary *kouros* was set up in a family plot in the Athenian Kerameikos. The statue is lost but its base, carved on three sides with scenes from a day in the life of a young aristocrat, survives. One side shows two teams playing catch [131]: the youth at the far left prepares to toss a ball and the boys on the right prepare to receive it. Given our experience with modern stop-action photography, it is perhaps too easy to imagine that these are not six different youths at all but the same one in six different stages of a single exercise—tilting to throw, beginning to run, turning around, backing up, standing still again. But there is in any case a regular progression from a nearly frontal view to a three-quarter to a profile to two kinds of three-quarter and finally to a back view. The relief is a manual for the rendering of the body in action, a visual handbook of possible poses. Like contemporary Red Figure vase paintings [118]—but unlike the fountain-house scenes of contemporary Black Figure [125]—the relief does not concern itself with setting or environment. There is no clue as to where the boys play ball. Instead, the artist presented each figure *in* space, not space itself, and like their Red Figure counterparts, the twisting and turning youths do not so much inhabit a coherent, enveloping space as individually generate their own. The sculptor who carved the *kouros* that stood atop the base may also have sketched the reliefs for assistants to execute. If he did, he would have made a fine painter.[22] But the reliefs,

22. The sculptor may have been Endoios, whose works were on display in the Kerameikos and on the Acropolis, and who may also have painted; see Ridgway, *AS*, 294–95, and Boardman, *GS*, fig. 242.

Revolution [301]

with their light figures raised only slightly above the originally dark-red background, are so pictorial in nature, so much like Red Figure vase paintings turned to marble, that their creator could just as well have been someone like Euthymides or Phintias moonlighting from his regular job in a potter's shop. Again, it may not have been unusual for a late Archaic vase painter to sculpt—or, for that matter, for a sculptor of *kouroi* to paint.

But what of the late Archaic *kouros*? It could not share in the spatial enthusiasm of contemporary reliefs and Red Figure and remain a *kouros*. And such juxtapositions as that between the space-generating youths on the ball players' base and the statue that stood foresquare upon it, the way *kouroi* had always stood, may have begun to seem odd. *Kouroi* such as Aristodikos [110] and Ptoon 20 [132] seem stylistically related to the youths of contemporary reliefs and vases. But they do not—they cannot—move, twist, or relax. The late Archaic *kouros* must increasingly have seemed creakingly old-fashioned, but the hold of the schema on the free-standing nude male statue was still tight, perhaps because the *kouros* was still closely bound up with the aristocracy and its ideals. Adjustments in the type would imply adjustments in the aristocracy's conception of itself and its values. And yet a few figures on late-sixth-century reliefs and vases suggest how the hold of the schema would finally be broken. The youth on the far right of the ball game stands with his back to us and with one leg straight, the other bent—his left heel even lifts off the ground. On another side of the base a youth testing a javelin stands in a similarly relaxed (though frontal) pose. In relief (and, for that matter, in Red Figure), nude youths can shift their weight from one leg to the other. That may seem a modest discovery. But when sculptors decided to duplicate that pose in free-standing youths some twenty or thirty years later [150], the *kouros*—and with it Archaic sculpture—ceased to exist.

Once the Siphnian Treasury's gigantomachy frieze had finished escorting him along, the visitor to Delphi had to negotiate a steep hairpin turn in the Sacred Way. As he turned he saw above him a high, stepless cube of Parian marble: the Treasury of the Athenians [133]. It was built thirty to forty years after the Siphnian Treasury, and it is Doric and by nature not so ornate as the Siphnian Treasury was. But the richness of the Siphnian Treasury down below apparently impressed those who designed and decorated the Athenian structure some time later, and its sculptures, too, were numerous. Amazons rode horses on the corners of the roof. A battle was fought in one pediment; something having to do with chariots took place in the other. And on the thirty metopes that crowned the four sides of the treasury, Herakles and Theseus performed superhuman feats of strength and destroyed the enemies of civilization.

In the vast range the art of relief occupies between the two dimensions of painting and the three dimensions of sculpture in the round, the Athenian

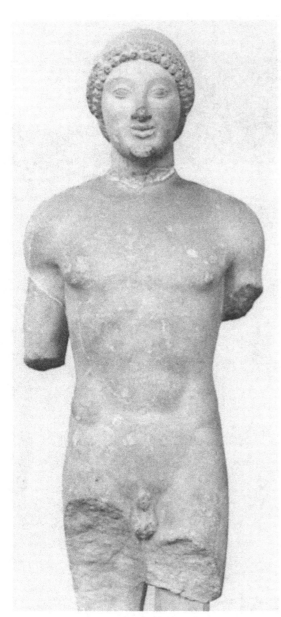

132. *Kouros* from the Ptoon sanctuary (Athens NM 20), around 510–500. Photo: Jeffrey M. Hurwit.

Treasury metopes are as close to the upper limits as Archaic reliefs ever come. A relief is not great just because it is high. But these metopes represent the culmination of the genre in the Archaic period. On the best preserved [134], Herakles captures the golden-horned Keryneian hind (she belonged to Artemis and had to be taken alive). The hero's patterned and lumpy anatomy is not unlike that of some athletes on the ball players' base [131] and his tightly curled hair recalls Herakles' relief-glaze coiffure on

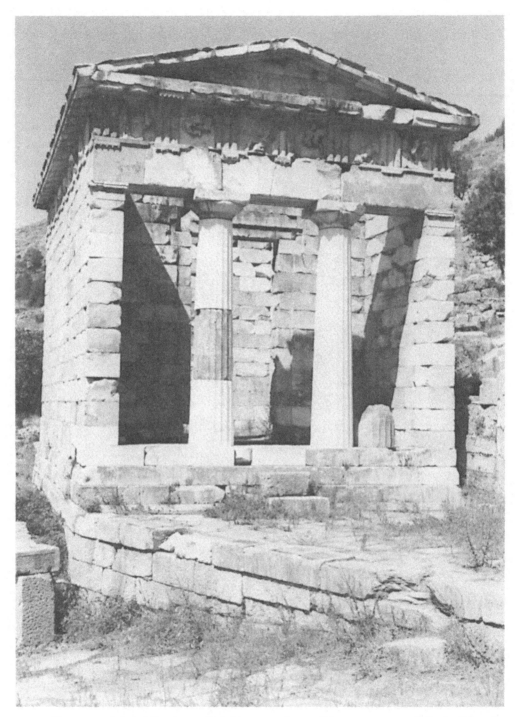

133. Treasury of the Athenians, Delphi, around 490. Photo courtesy of Ecole Française d'Archéologie, Athens.

The Art and Culture of Early Greece, 1100–480 B.C.

134. Metope from Treasury of the Athenians (Delphi Museum), showing Herakles and the hind. Photo: Jeffrey M. Hurwit.

Revolution [305]

Euphronios' krater in the Louvre [123]. But the most striking thing about him is his twisting, acrobatic freedom. He kneels on the back of the hind, having vaulted free—or almost free—of the background. Parts of him are carved completely in the round, other parts are sharply undercut, and the effect, intensified by cast shadows, is that he has leaped off the building that carried him. The conception of relief cannot be more different from that seen on early Archaic works, and the difference can perhaps be suggested by a crude hypothesis. If for some reason we wished to eliminate the figures in, say, a Foce del Sele metope [94], the easiest way would be to fill up the holes dug around them with something like plaster or putty. The figures would disappear as the original smooth surface of the stone and the integrity of the front plane were fully restored. But the easiest way to remove Herakles and the hind would be to chisel them off. It would take only a few well-placed blows, and another continuous surface—the background this time—would be left. In one conception the front plane so controls and restricts the relief that it is a tangible barrier, and the figure is embedded behind it in the block. In the other, it is the background that is solid and architectural—before pouncing on the hind, Herakles even hung his quiver and cloak upon it, as if it were a wall with a peg in it.[23] Herakles nonchalantly relies on the background for support, but he is anchored to it in only a few places and projects boldly outward, free of any other plane.

Parallels between details of the Herakles metope and individual Red Figure vase paintings are not hard to find. But perhaps a more telling comparison is between the spatial freedom of the hero and a kind of composition a number of Red Figure artists developed in the late Archaic period. As early as Euphronios and Oltos, single figures (occasionally tightly unified groups of figures) were suspended in blackness on the sides of amphorae. There are no panels, no frames, and no ornaments except for a short meander strip for the figure to stand on, and often there is not even that. The most accomplished practitioner of "free-field" composition was the Berlin Painter, a pupil of Euthymides or Phintias whose career probably did not begin until after the turn of the century. A few of his active figures—a Herakles stealing the Delphic tripod, for example[24]—have something in common with the style and pose of the hero on the Athenian Treasury metope. But even his less violent images suggest in two dimensions the sense of space and independence of the relief. On a small amphora in New York [135] a kitharode lifts his head and opens his mouth in song. We do not know what he sings—unheard melodies are sweeter anyway—but the notes carry to the other side of the vase, where his tutor beats time or offers advice. The musician is drawn in pure (and perspec-

23. Herakles has done the same thing on Euphronios' Louvre krater [123].
24. Boardman, *ARFV*, fig. 145.

135. Amphora by the Berlin Painter (Metropolitan Museum 56.171.38), around 490. Photo courtesy of the Metropolitan Museum of Art, Fletcher Fund, 1956.

tively correct) profile, yet few Archaic figures match his effortless spatiality. As he plucks the strings he bends his knees and slightly sways. A gentle Keatsean breeze wafts over him, lifting the hem of his robe and catching the apron of the kithara—a single, sinuous line was all that was needed to twist the cloth in the air. The black glaze is a featureless expanse, yet the spotlit youth seems to stand on an imagined stage and to move in an imagined atmosphere. The background is not the solid wall it is on the Herakles metope: its character is more ambiguous. But the Berlin Painter exploited the inherent qualities of Red Figure for the same purpose that the Athenian Treasury sculptor exploited the new conception of relief: to assert the formal freedom of the image.

The Limits of the Revolution

The list of what the late Archaic artist did not know or did not do about the representation of space is very long. He did not eliminate the single base line and he did not make figures meant to be in the distance smaller

than those meant to be in the foreground (the hysterical women on the Antaios krater [123] are probably smaller because they are minor, not because they are distant). When objects such as tables or couches are shown [114], there is no such thing as linear perspective. With a few interesting exceptions (such as the dilute on Antaios' belly and some hatching of the curves of shields), shading is unknown in Archaic Red Figure, and so is the use of highlights: even the foreshortened human figure is basically a silhouette and its corporeality is indicated by lines, not by chiaroscuro. The Red Figure technique naturally made such things as the depiction of cast shadows and the gradation of colors impossible, but there is no reason to believe that Archaic wall painters knew much about them either. Above all, the background of an Archaic vase painting or relief does not itself explicitly *represent* anything, even if we are sometimes tempted to read it as something other than glaze or stone. It never dissolves into sky or landscape or any other kind of setting. There is, in short, no idea of a true pictorial space extending into the distance. The late Archaic sense of space depended on only two things: the ancient and rudimentary device of overlapping (and there is less of it in Red Figure than in Black) and the capacity figures shown in three-quarter view have for generating their own space, independently and almost in isolation. Such figures may seem to exist in space, but they do not seem to share it. Space itself—an indefinite, encompassing milieu of air—does not really exist. But though the list of what late Archaic artists did not do about the representation of space may be long, the reason is probably that their proper study was the human figure, not the space around it.

There is nothing truly illusionistic about late Archaic art, but that does not mean there is nothing truly revolutionary about it. Although it could only do so much, the introduction of the three-quarter view did enough to overthrow the schema and thus begin to transform fundamental assumptions about the representation of reality—assumptions that had governed Archaic art from its Geometric origins [40] and the art of other lands for thousands of years [15]. The Archaic Greek artist did not invent the three-quarter view: Egyptian sculptors and painters had done that.[25] But Egyptian art was ruled by tradition and taboo: the foreshortened figure proved to be an unacceptable deviation from the conceptual norm (the frontal-profile composite that posed the figure for the eternity of the tomb) and was purposefully eliminated. What was revolutionary about Archaic Greek art was that once the three-quarter view was discovered—once the artist hit upon the idea that he could ask the spectator to collaborate with him by imagining the bodily parts that the dancing, throwing, or fighting figure momentarily turned out of sight—it was not given up. The revolution, it is

25. See, for instance, A. Mekhitarian, *Egyptian Painting* (Geneva, 1978), 51.

The Art and Culture of Early Greece, 1100–480 B.C.

true, would not be brought to a successful end until Classical painters eliminated the single ground line, developed perspective, mastered chiaroscuro, and transformed the picture plane into pictorial space. But the meaning and implications of the Archaic figure were not the same at the end of the period as they were at its start. The conquest of appearances—the drive for *mimesis*—had begun.

<div align="right">Seeming</div>

It is not easy (and more than a little dangerous) to place this artistic change in any broader social or intellectual context. It is not altogether likely that the development of the three-quarter view, which struck a blow against the tyranny and conformity of the plane, had anything to do with the rise of Kleisthenic democracy, which introduced a new view of the individual in the polis. Politics and politicians can influence art, but these revolutions had better be kept separate. It is not much more likely that exposure to the natural philosophy of the Milesians promoted the accurate observation of nature (anatomy, for instance) and appearances in art—the Milesians speculated first and observed later. Philosophy does not seem to have been at home in sixth-century Athens anyway. Archaic Athens did not produce any philosopher and none is known to have visited the city before the Classical period. Still, ideas can travel without leaving tracks. And a search through the preserved fragments of late Archaic philosophy, while by no means wholly satisfying, uncovers a few ideas that, if they did not directly influence the visual arts, may at least shed some light on them.

Perhaps the most significant philosophical event of the late Archaic period was the distinction made between "knowing," on the one hand, and "seeming" or opinion, on the other.[26] Xenophanes, the long-lived refugee from Kolophon who is said to have "tossed his thought up and down the Greek land," first stated the idea explicitly: "In all things," he said, "there is seeming [*dokos*]." Judgment is based on sensation, perception, and opinion, and that notion undermined the Milesian insistence that absolute knowledge of the *kosmos* was absolutely attainable. For Xenophanes some opinions were better than others, but no opinion was equivalent to truth. Perception itself can be deceptive, susceptible to the tricks of illusion. And knowledge, which is based on perception, must be relative: "If god had not made yellow honey, men would say figs were far sweeter."[27] The role of perception and the relativity of knowledge also figured in the complex thought of Herakleitos of Ephesos, who, it seems, was in mid-career at the

26. Hesiod, *Theogony* 27–28, distinguished truth from falsehood (cf. *Odyssey*, XIX.203), but this was not quite the same thing.
27. See Kirk and Raven, frags. 189 and 192.

end of the sixth century. Unlike Xenophanes, Herakleitos stayed put in Ionia, and unlike Xenophanes, he believed that knowledge was attainable through the comprehension of the *logos*—the proportion or thought or reason that both orders and constitutes all things. Herakleitos was not called "the Obscure" for nothing, however, and his attitude toward the senses seems ambivalent. Still, he argued that sense perception, if properly used, could be a reliable guide to understanding: "Of whatever there is sight, hearing, and perception, these things I prefer." And, though he sounds typically Archaic in his love of oppositions, he said that "disease makes health sweet and good; hunger, satiety; fatigue, rest."[28] It is possible that the idea of the relativity of human knowledge introduced by these two very different thinkers surfaced again in the fifth century as Protagoras' famous dictum "Man is the measure of all things"[29]—which is, if anything, the epigraph of Classical Greece.

Herakleitos was also commonly given credit for the maxim *panta rhei*, "All things flow" or "All things are in flux." He probably never said those exact words, but he did propose that change, instead of taking place on the surface of reality, was reality's very basis, the fundamental process of the *kosmos*. What Herakleitos did say was "Upon those who step into the same rivers flow different and yet different waters," or "You cannot step in the same river twice."[30] It is unclear whether he meant that the river preserves its sameness through perpetual change or that the river can never be the same. But the idea that change is a principle of existence, that the world order is always in a state of becoming, not being, is clear enough.

To associate this cluster of ideas—the existence of opinion, a certain reliance on sense perception, the relativity of knowledge, the ceaselessness of change—with the discoveries of late Archaic art requires a speculative leap. But it may not after all be simply coincidence that Archaic artists began to explore the realm of appearances, of seeming, around the same time that seeming became a philosophical concern (or, for that matter, that the doctor Alkmaion of Kroton was investigating the anatomy and function of the human eye). Xenophanes and Herakleitos need not have had any sympathy for the products of late Archaic art. Late Archaic artists may have found Herakleitos just as obscure as we do—assuming they had ever heard of him or read his book. But the foreshortened object or figure in three-quarter view is in its way a figure of opinion, a figure of momentary appearance, of transition, of change. The artist who captured the torsion of a reveler or athlete captured what is fleeting, not permanent, what is perceived to be, not what is objectively and conceptually known. In the

28. Kirk and Raven, frags. 200 and 204.
29. W. K. C. Guthrie, *History of Greek Philosophy* (Cambridge, 1962), 1:401.
30. Kirk and Raven, frags. 217 and 218. See C. H. Kahn, *The Art and Thought of Heraclitus* (Cambridge, 1979), L, LI, and 166–69.

broadest sense, then, the late Archaic sense of space, despite its limits, marks a change from the absolute to the relative, from images of being to images of becoming, from, perhaps, the Archaic to the Classical.

Theseus and Athens

Of the two heroes celebrated on the Athenian Treasury, Herakles was seen more often but still ranked second. He wrestled the hind, strangled the Nemean lion, killed Kyknos, and so forth on the nine north metopes, and one myth—his battle against the Siamese triplet Geryon, his two-headed dog, and his normal herdsman—was spread over all six of the west metopes (the *Geryoneis* of Stesichoros was possibly the inspiration) in a revival of the old technique of serial narrative.[31] But the north and west metopes were out of sight of anyone taking the usual route up the Sacred Way. The first metopes one saw were those on the south, which depicted the episodic adventures of Theseus [136], and then those on the east (the front), where Greeks fought Amazons—a serial narrative again. Greeks fought Amazons more than once, but Herakles and Theseus each seem to have battled an Amazon on the easternmost metopes of the north and south sides, so the theme of fighting Amazons, if not the same Amazonomachy, turned the corners of the building.

Though Herakles metopes outnumbered Theseus metopes fifteen to nine (not counting the east reliefs), the presentation of the native Athenian hero on the conspicuous south side of the Treasury—and the fact that Athena is shown only once on the metopes, with Theseus (the honor of meeting Athena had hitherto been accorded in art only to Herakles)—seems at first glance a transparent attempt to promote him over the hero who, though panhellenic (and even middle-class), had been so central to Peisistratid imagery and perhaps propaganda.[32] Athenian artists had nothing against Herakles after the expulsion of the tyrants in 510, and to depict him was not an indication of sympathy for the old regime: the heroic protégé of Athena and the consummate workman of civilization simply could not be ignored no matter how he had been used before. But the young democracy needed a hero it could call its own, even if it had to create one in Herakles' own image.

Early Archaic art and poetry had not been kind to Theseus. He may be

31. Herakles, in one metope, shot his arrow at Geryon, in another, and this is as close as the Doric frieze, given the interruption of triglyphs, can come to looking like an Ionic frieze. It is likely that here on the west (the side, incidentally, that faced the scene of the Geryon myth) the Athenian Treasury sculptor or sculptors tried to emulate the continuous reliefs of the Siphnian Treasury down below, where each side was devoted to a single story.

32. See above, chap. 5, n. 46.

136. Metope from the Treasury of the Athenians (Delphi Museum), showing Theseus and Athena. Photo courtesy of Ecole Française d'Archéologie, Athens.

leading Ariadne astray on a Late Geometric Attic krater, and a bronze Theseus apparently stood across from the Minotaur on the rim of a tripod cauldron made around 700.[33] But Protoattic artists showed no interest in him at all, and early Black Figure vase painters did not show much—some of his adventures were rather sordid affairs, and so it may not be surprising that he was more popular outside early Athens, the land he once ruled, than in. On the François vase [93 top right] Theseus fights with the Lapiths against the centaurs and joins with Ariadne in the dance celebrating the escape from Crete. This probably marks his debut in sixth-century Attic art, but it is not a particularly auspicious one: Akhilleus is the hero of the vase and Theseus plays a supporting role even in the centauromachy. The battle with the Minotaur gets good press after Kleitias—it may even have

33. Coldstream, *GG*, figs. 112 and 41a,b.

been the subject of a marble group set up on Samos around 560–50—but Theseus is still found on vases only a fraction as often as Herakles. Poets did not have much use for him either. He is a mere shadow in Homer: Nestor, who loves to name-drop, drops his only once in the *Iliad* (I.265), and though Theseus is mentioned twice during Odysseus' visit to the Underworld (*Odyssey*, XI.322, 631), Odysseus, having just interviewed Herakles, decides he can afford to leave without speaking to him. Theseus and Ariadne were mentioned in the *Kypria* as unhappy lovers. He fights the centaurs again in the pseudo-Hesiodic *Shield of Herakles*—but there was no *Shield of Theseus*. And although we know there was at least one epic written about him, and can guess the date and circumstances of its composition, we do not know for sure.

As inconsequential as he may have been before the second quarter of the sixth century (at least compared to Herakles and Akhilleus), Theseus had potential, and Peisistratos himself may have begun to explore it. The story is suspect, but the tyrant is said to have tampered with the texts of Hesiod and Homer in order to improve the hero's reputation.[34] When he confiscated the weapons of the Athenian citizenry after the battle of Pallene, he chose to do so at a sanctuary of Theseus southeast of the Agora. Peisistratos may have had something to do with the building of the Theseion or he may not. But Theseus' sudden appearance on Black Figure vases in the 560s suggests that the Athenians then began to pay more attention to his cult, perhaps even establishing new festivals in his honor,[35] and the Greater Panathenaia itself was Peisistratos' elaboration of the annual festival founded, legend said, by Theseus. The legend that said so could have been Peisistratean, and other highlights in the careers of the hero and the tyrant coincide too well not to be the result of mythological manipulation or invention. One of Theseus' great victories, for instance, was over the Pallantids, an aristocratic clan that contested his right to the throne. The contest was apparently settled by force at Pallene; that is, Theseus won his kingship and Peisistratos won his tyranny against other aristocrats on the same battlefield.[36]

Above all there was the story that Theseus had unified Attica, turning a land of separate hamlets into one great polis. There is no telling when the story originated and it could be put to different political purposes. But if the story was as old as the mid-sixth century, it is hard to believe that Peisistratos could have missed using Theseus the Synoikist as his mythical

34. Plutarch, *Life of Theseus*, 20.

35. The Pyanepsia, for instance, which commemorated vows Theseus made to Apollo after landing at Delos with the youths and maids he had rescued from the Labyrinth—the landing pictured on the François vase [93 top right].

36. Pallene was a popular place for battles: one tradition had the gods defeat the giants there, too [cf. 99].

exemplar to legitimize his own policy of strengthening Athenian national self-consciousness. Yet there is no solid evidence that he did so. Theseus' rehabilitation may have begun during the tyranny, but he had a very long way to go before he could be a truly national hero. When Peisistratos felt the urge to impersonate a hero, he impersonated Herakles, and it was Herakles' exploits, not Theseus', that filled the pediments of the Archaic Acropolis [102]. Theseus does not appear in Peisistratid sculpture at all. His image may have improved, but it was still not often seen.[37]

All that changed after the fall of Hippias. It was a time for mythmaking in Athens and it is likely that Kleisthenes and the Alkmeonidai, who would soon set up Harmodios and Aristogeiton as democratic revolutionaries, were also behind the meteoric rise of Theseus in Athenian vase painting, sculpture, and probably poetry after 510. Many of the deeds of Theseus that now became popular in art had rarely or never appeared before, and he performed many of them on the journey from Troizen (his birthplace) to Athens (his inheritance). Along the way he dealt with a series of bullies, sadists, and pests in a rite of passage that may somehow have stood for the obstacles the young democracy faced in its first few years, or else for the difficulties the outcast Alkmeonidai had to overcome before finally return-ing to Athens. Such vase painters as the Kleophrades Painter and One-simos covered cups with portions of the new Theseus cycle [137]—they do so in an unbroken pictorial field, and the new technique might be called cyclical narrative—just as sculptors of the Athenian Treasury metopes seem to have concentrated on the new exploits, throwing in a few familiar ones such as the battle with the Minotaur (both painters and sculptors, however, tactfully avoided Ariadne, the woman Theseus ignominiously jilted on Delos). Just before 500 a marble group of Theseus fighting Pro-krustes (or some other brute) was dedicated on the Acropolis [138], and he also appeared abducting Antiope in the contemporary pediment of the Temple of Apollo at Eretria (which was a close ally of Athens at the time) [139]. The local boy had finally made it big, and his heroism was probably now canonized by the composition of a (or the) *Theseis*—an episodic poem that, if it did not make a particularly good epic, must have made an excel-lent artistic sourcebook.[38] Even if his rough edges had been smoothed by Peisistratos, then, the Theseus that we know was largely a creation of

37. For different views of the importance of Theseus in Peisistratid Athens, see W. R. Connor, "Theseus in Classical Athens," in *The Quest for Theseus*, ed. A. G. Ward (London, 1970), 143–74, and J. Boardman, "Herakles, Peisistratos, and Sons," *RA* (1972), 57–72.

38. Lyrics (and possibly *tragoidiai*) may have been other vehicles for the promotion of Theseus. Simonides wrote a poem about his return from Crete, though only one vivid scrap describing the linen Theseus forgot to change survives: "Purple-red sail dyed in the wet bloom of oak" (*PMG*, 550). Like most of Simonides' poems, this one cannot be given a precise date, but composition after 510 at least makes sense. Simonides' nephew Bacchylides wrote two dithyrambs about Theseus, but they probably date to the early Classical period (c. 475).

137. Cup by Onesimos (Louvre G 104), around 500–490. Photos: M. Chuzeville, by permission of Musée du Louvre.

Kleisthenic Athens. It is not inconceivable that even the legend of the *synoikismos* was invented now to counter memories of and deflect credit from Peisistratid national policy.[39] And that Kleisthenes himself was the

39. A festival called the *Synoikia* celebrated Theseus' unification of Attica, but, again, it is unclear when it was founded. See H. W. Parke, *Festivals of the Athenians* (Ithaca, N.Y., 1977), 31–32.

138. Fragmentary group of Theseus and Prokrustes(?) (Acropolis 145), around 510–500. Photo courtesy of Deutsches Archäologisches Institut, Athens.

principal mythmaker is suggested by an otherwise odd story, preserved in Plutarch's biography of the hero, that Theseus was a man who, in the end, would not be king and turned the city into a democracy.[40]

The Athenian Treasury was constructed in honor of Apollo but in celebration of Theseus and the city that intentionally bestowed Heraklean stature upon him. On one metope he fights the bull of Marathon; according to some sources, Herakles had captured the same bull on Crete and let it loose on the mainland. Like Herakles, Theseus fights brigands. Like

40. Plutarch, *Life of Theseus*, 36. The same passage also has Theseus building a common statehouse and council hall in Athens, which seems to parallel the Kleisthenic building program.

　　　　The Art and Culture of Early Greece, 1100–480 B.C.

139. Fragmentary group of Theseus abducting Antiope, from the Temple of Apollo, Eretria (Chalkis 4), around 510–500. Photo courtesy of Deutsches Archäologisches Institut, Athens.

Herakles, he fights a monster. Like Herakles, he fights an Amazon. Theseus was in fact so much like Herakles that he was called "the second Herakles," and this cloning was the point of the Treasury metopes. They did not oppose the two, but congenially catapulted the pan-Athenian hero to the level of the panhellenic. This was, after all, Delphi.

The point—and the Treasury—must have been made after the enactment of Kleisthenes' reforms. How long after is another matter. Pausanias toured Delphi and states unequivocally that the Treasury was built from the spoils taken from the Persians at the battle of Marathon in 490.[41] The French excavators of Delphi have always believed him. Many others have not, and argue that Pausanias misinterpreted an inscription on a base set against (and partly over the foundations of) the Treasury, which *did* display Persian booty—this would certainly not be the only time Pausanias erred. The base was built after Marathon and after the Treasury was begun, but that still does not tell us the date of the Treasury itself. Some scholars place it just before 500 and make it a kind of architectural and sculptural proclamation to Greece that the tyranny had been overthrown and Kleisthenic *isonomia* established. The preeminence of Theseus in the metopes would thus be in the nature of an immediate anti-Peisistratid communiqué. To be sure, some stylistic and formal parallels can be seen between some of the metopes on the Treasury and vase paintings and reliefs from the last decade of the sixth century. But too many other parallels can be seen in vase paintings of the first (and even the second) decade of the fifth century, and I do not think it very likely that the Athenian Treasury sculptures were carved before the 490s (in which case the importance of Theseus and Herakles as mythological representatives of two opposing political systems would have considerably been diminished, if the point were not lost altogether). What might have occasioned the Treasury then? John Boardman has argued that the Amazonomachy of the eastern metopes commemorated Athens' part in the Ionian Revolt (more on that in chapter 7). Theseus and Herakles were, he argues, enlisted as allies (not competitors) in the fight on the easternmost metopes of their respective sides of the building, and the myth is a metaphor for the expeditionary force Athens sent against Sardis in 499.[42] For the first but hardly the last time, the mythological battle between Greeks and Amazons would allude to the historical conflict between Greeks and Persians, between civilization and barbarity, between order and chaos. But Athens' role in the Ionian Revolt was short-lived and did not turn out to be glorious; the Amazonomachy is only part of the sculptural program of the building any-

41. X.xi.5.
42. "Herakles, Theseus, and Amazons," in *The Eye of Greece: Studies in the Art of Athens* (Cambridge, 1982), 1–28.

way.[43] And the Athenian Treasury could still have been built in the 490s for reasons much less specific. Evelyn Harrison, for instance, once argued that it commemorated a general condition: Athens' economic, social, and political well-being under *isonomia* (though Kleisthenes was probably no longer around).[44] The matter cannot be settled at present, and even if a date after 490 is ultimately proved correct, it should astonish or disturb no one.[45] But in my view the Athenian Treasury still belongs to the 490s. It may belong to the very late 490s and it may not have been finished until after Marathon: Pausanias would then be half right. And whatever the reasons for its inception—the expedition of 499, the domestic tranquillity and health of the 490s—the Athenian Treasury and its sculptures surely came to symbolize a great deal after 490. The base built beside it turned it into a monument to Marathon, too: the Treasury and its Amazonomachy had meaning bestowed upon them.[46] At all events, the building is a monument to the vigor and self-confidence with which the Athenians entered the last decade of the Archaic period—qualities they would desperately need to withstand a Persian onslaught and the destruction of their city.

43. The Athenian mood in the aftermath of the expedition may have been far more fearful than proud (see chap. 7). It may also strike some people as curious that mounted Amazons rode the roof of the Treasury as *akroteria*: that would seem rather unnecessary glorification of the enemy. Cf. B. Ridgway, *Fifth Century Styles in Greek Sculpture* (Princeton, 1981), 18n5.

44. *The Athenian Agora*, vol 11, *Archaic and Archaistic Sculpture* (Princeton, 1965), 9–11.

45. Pausanias' date has been defended by H. H. Büsing in *Studies in Classical Art and Archaeology: A Tribute to P. H. von Blanckenhagen* (New York, 1978), 29–36. See now R. Tölle-Kastenbein, "Bemerkungen zur absoluten Chronologie spätarchaischer und frühklassischer Denkmäler Athens," *AA*, 1983, 573–84, who also places the treasury after Marathon.

46. See also W. Gauer, "Das Athenerschatzhaus und die marathonischen Akrothinia in Delphi," in *Forschungen und Funde: Festschrift Bernard Neutsch*, ed. F. Krinzinger, B. Otto, and E. Walde-Psenner (Innsbruck, 1980), 127–36.

7

The Sense of a Beginning

The Shadow of Persia

Miletos, "the glory of Ionia," began the sixth century with an intellectual revolution. It began the fifth with armed insurrection. Like the rest of East Greece since the fall of King Kroisos, Miletos was well within the Persian sphere. Its tyrant Histiaios was, in fact, deep within it as an involuntary guest of Darius, the Great King, at Susa. In his absence, the sly Aristagoras served as acting tyrant and around 500 thought to ingratiate himself with his Persian overlords by guaranteeing them the capture of Naxos, the largest and richest of the Cycladic islands and thus the largest stepping-stone for Persian expansion across the Aegean. Darius himself approved the plan and lent two hundred ships to carry it out, but after a long and costly siege Aristagoras could not deliver the goods. The consequences of failure were apparently grim, and Aristagoras considered rebellion rather than face them. When a slave sent by the impatient Histiaios fortuitously arrived in Miletos with the word "revolt" tatooed on his scalp, revolt is what Aristagoras decided to do.

So, at least, says Herodotos (V. 30–36), who was prepared to believe the worst of Aristagoras. But the eagerness with which the other cities of East Greece joined Miletos in the struggle suggests that the Ionian Revolt had more profound causes than one man's failure and fear or another's irritation at being held hostage at Susa. Widespread economic discontent was probably one cause. Resentment against the puppet tyrants Persia propped up throughout East Greece was probably another. Aristagoras, in fact, symbolically renounced his tyranny over Miletos and persuaded the other Ionian cities to go along by promising to remove their tyrants as well. That promise he managed to keep. The Ionians had the fresh example of Athens,

their kindred city, before them, and tyranny may have seemed an idea whose time had gone. The chance to rid themselves of it was worth taking on the greatest empire the world had ever known.

But they needed help. In 499 Aristagoras went first to Dorian Sparta to plead the Ionian cause and took with him a bronze plate engraved with a map of the world. The map was probably drawn by Hekataios, a pupil of the first Greek mapmaker, Anaximander. Hekataios was a geographer and ethnographer who knew at firsthand the vast extent and resources of the Persian Empire. His knowledge was useful, but his advice—first, not to revolt at all, second, how to finance the war if it was to be waged—was consistently rejected. His map, like Anaximander's before it [86], was in any case a characteristically Milesian attempt to impose absolute order upon the irregularity of continents, rivers, and seas: the world was circular and symmetrical, Europe was the same size as Asia, Euboia was the same size as Cyprus. But it was not the map's errors that cost Aristagoras Spartan support. In a private seminar on geography, he pointed out to King Kleomenes the riches to be had there, and there, and there on the map and promised easy victory, but he botched his presentation when Kleomenes asked the map's scale. Aristagoras told him it took three months to travel from Ionia to Susa. Kleomenes told Aristagoras to get out of town by sunset. A bribe failed, and Aristagoras tucked his map away and headed for his second choice: Athens.

Athens—the legendary fount of the Dark Age migrations and supposedly the founder of Miletos—was naturally more sympathetic. It was already at odds with Persia besides: Hippias, its old tyrant, was now a Persian lackey, still plotting his return to power. Moreover, these were heady days for the Athenians: they had recently fought off several external threats and the Kleisthenic reforms were settling into place. Aristagoras addressed them en masse (on the newly landscaped Pnyx, perhaps), told them of the spoils to be had in Asia, and belittled the Persian soldier. But he did not, apparently, take out his map again. Won over, the Athenians dispatched twenty ships—their entire fleet numbered only about fifty—to support their Ionian relations. They were joined by five Eretrian triremes, sent to repay Miletos for the aid it had given Eretria during the ancient Lelantine War. Greeks had long memories. So did Persians.

The Ionian Revolt began with a hollow victory. In 499 or 498, the Ionians, Athenians, and Eretrians marched inland and burned lower Sardis, the old Lydian capital and seat of the local Persian satrap. But Sardis was, according to Herodotos (V.101), a city of mud brick and thatch, and hopes for the plunder it held went up in smoke. Soon after, a Persian army thrashed the Ionians at Ephesos. That was enough for the Athenians, and they simply sailed away. Back home the mood grew apprehensive: barbarians could fight after all, and the Athenians wondered if they had not acted hastily in

supporting the rebels, kin or not. A faction willing to placate the Persians had its man elected archon in 496/95. But at Susa Darius wanted revenge, not appeasement. Hippias was there to urge his restoration, and each day a servant delivered Darius' dinner with the words "Sire, remember the Athenians."

The revolt did not end with the Athenian desertion. It lasted, in fact, into its sixth year. But Darius had put down uprisings in his empire before, and he did so again. The cities of the rebellion were taken one by one, and in 494 Miletos itself was besieged and captured—its men slain, its women and children enslaved, the temple at Didyma plundered and fired. The glory of Ionia was gone and the Athenians grew more nervous than ever. They were next.

In the wake of the Milesian disaster a trial and a tragedy aggravated divisions over Athenian policy toward the Persians. The Athenian ruler of the Chersonese, Miltiades (once an ally of Hippias but lately a fervent supporter of the Ionian Revolt), narrowly escaped the Persians and returned to Athens in 493 only to face prosecution for tyranny. That, in any case, was the official charge. The Alkmeonidai probably had a hand in the prosecution and they seem to have led those most willing to placate the Persians. The archon of 493 was, however, not one of them. He was Themistokles, and he probably had a hand in securing Miltiades' acquittal—not because of any friendship between them but because of their common opposition to Persia. Now one of Themistokles' duties as archon was to review entries submitted for the competition of tragedies to be held at the next City Dionysia. One of the plays he approved—it is tempting to think he solicited it—was Phrynichos' *Capture of Miletos*. Whether the origins of tragedy had anything to do with Dionysos or not, Phrynichos' play had nothing to do even with the traditional mythological repertoire: it is the first tragedy we know about that dealt with a historical event (perhaps the Greeks would have said a contemporary historical event, since they did not sharply distinguish myth from history). Phrynichos, in writing this lament for a kindred city, and Themistokles, in accepting it, meant to rebuke the Athenians for their shameful conduct in the revolt: once again art was placed in the service of politics (and this would not be the last time the playwright served the politician's ends). *The Capture of Miletos*, in any case, touched a nerve: it moved its audience to tears, but it moved those eager to avoid provoking Persia in other ways, and Themistokles, this time, could not help. Phrynichos was fined 1,000 drachmai and his tragedy was banned from ever being performed again. Not a word survives.

Darius, if he knew about all this, was not impressed. In 492 he sent an army under Mardonius to begin the conquest of Greece and specifically to punish Athens and Eretria for their support of the Ionians, halfhearted though it was. But Greece had a formidable and unpredictable ally: the

north Aegean. A sudden storm destroyed the fleet attending Mardonios off Mount Athos, and the next year Darius switched tactics. He sent heralds throughout Greece to demand earth and water, tokens of submission, and many mainland and island poleis gave in. But at Athens (as at Sparta) the Persian messengers were tossed in a pit and told to take earth and water for themselves. The Athenians had finally closed ranks and they awaited the inevitable. In 490 it came: a Persian fleet carried an army of about 20,000 straight across the Aegean. Datis and Artaphrenes led the expedition, but an Athenian anachronism went along as guide: Hippias, eighty years old now and as eager to rule Athens as ever. Along the way the Persians captured Naxos (a decade after Aristagoras first promised it), ostentatiously respected sacred Delos, and brutally pillaged Eretria, destroying the new temple of Apollo Daphnephoros and its sculptures in the process [139]. A few days later Hippias led them on the short sail to Marathon, where his father, Peisistratos (with Hippias and Hipparchos at his side), had landed in 546 to begin the march toward his final tyranny. Hippias' choice was not, however, purely sentimental: the plain suited the Persian cavalry and he may have expected to find sympathizers still around. What Hippias and the Persians found instead was an Athenian army half the size of the Persian, with 600 Plataians standing with them in (ironically) a precinct of Herakles, the old Peisistratid hero. The Athenian chief of staff was Kallimachos, but the real strategist was Miltiades. The Spartans said they would come as soon as a waning moon ended a sacred festival and allowed them to march. And for a few days Miltiades was content to wait. On or about August 12, however, the Athenians could wait no longer: they charged the astonished Persians at a run and turned their flanks. Demigods were seen fighting on the Athenian side that day, among them Herakles and Theseus, whom the Athenians had recently paired (or else would soon and gratefully pair) on their treasury at Delphi [133, 134, 136]. By midmorning it was all over. The Athenians lost 192 men as they drove the invaders back into the sea. When the Spartans finally arrived, they counted 6,400 barbarians lying on the plain.

Between the Wars

Commemoration and preparation marked the next decade. The Athenians (with a little help from heroes and the Plataians) had won a stunning, even miraculous victory—some thought Marathon was the only victory they would ever need against Persia—and they publicized it. At Marathon they heaped up a tall earthen mound (the Soros) over the ashes of the Athenian dead and set up a temporary trophy (probably the trophy of

Miltiades that supposedly kept the jealous Themistokles awake at night).[1] At Olympia the Athenians dedicated armor taken from the Persians and Miltiades offered a helmet in thanks. At Delphi the Athenians either built their treasury or built that triangular base against it to hold an exhibit of Persian spoils. And at Athens Simonides—a foreigner, a Peisistratid poet laureate, but evidently a friend of Themistokles—is said to have won the right to honor the Marathonian dead with an epitaph, defeating in the competition the native tragedian Aeschylus, one of those who charged the Persians and whose brother died when his hands were cut off the stern of a fleeing Persian ship.

Monuments to Marathon also appeared on the Acropolis. Kallimachos was killed on the beach, but a winged Nikē (Victory)—perhaps originally commissioned to celebrate a first prize he had won at the Panathenaic games only a month or so before—was finished as a memorial to his valor on the battlefield and dedicated in his name [140].[2] The artistic significance of the Nikē of Kallimachos outweighs even its historical interest, however, for its unknown sculptor broke with the conventional manner of presenting such figures in rapid motion or flight [cf. 5]. The wings, for instance, pointed back, and in that position shattered the flat, planar quality of earlier nikai, who spread their wings out laterally. The angular bent-knee pose has also been relaxed, and the figure strides more naturally. A contemporary running girl (Hekate?) from Eleusis similarly rejects the old formula.[3] Archaic schemata, it seems, no longer do.

The Nikē of Kallimachos perched atop a high column, and that was a common place for Acropolis korai as well. Not long after the nikē was dedicated, a certain Euthydikos put a petite marble maiden on another pedestal [141]. She is not a monument to Marathon, but she suggests that attitudes toward an ancient sculptural type were changing in its aftermath. The Euthydikos korē was originally no less colorful than the other korai attending Athena on her citadel. But a reaction against the textural fantasy and poikilia of earlier korai [e.g., 9] has set in. Ostentation here yields to simplicity, as it does in contemporary vase painting, where artists protest the anatomical pedantry of Euphronios and paint simpler and fewer lines. This new trend toward simplicity is, in fact, anti-archaic, and an intellectual guide for it may perhaps be found in the poetry of Xenophanes.[4] In any case, the surface of the Euthydikos korē has calmed down, and in places—the left breast, the left arm—it is smooth (though four-horse char-

1. Plutarch, *Life of Themistokles*, III.4. See E. V. Vanderpool, "A Monument to the Battle of Marathon," *Hesperia*, 35 (1966), 93–106.

2. The statue could also be Iris, the messenger of the immortals; see Brouskari, 125–26.

3. C. Edwards, "The Running Maiden from Eleusis and the Early Classical Image of Hekate" (abstract), *AJA*, 86 (1982), 263; and Boardman, *GS*, fig. 202.

4. Cf. Fränkel, *EGPP*, 328.

140. Nikē of Kallimachos (Acropolis 690), 490. Photos courtesy of Deutsches Archäologisches Institut, Athens.

iots were painted on the left shoulder, imitating embroidery). There is the sense that some earlier sculptors of *korai* were little more than virtuoso dressmakers and that the young women were high-fashion models there only to display clothing that had an existence of its own. But while the Euthydikos *korē* is still a *korē,* she is no vacuous mannequin. What she wears is secondary to what she is: the drapery clings to the body as it never had clung before, and there is substance and volume beneath. Her barrel chest seems filled with air and her flesh seems soft against the edges of her dress. But she is also somber. Her heavily lidded eyes, set in a squared face, hint at mental activity, and she has stopped smiling. In fact, the corners of her mouth turn down, and so she almost seems to sulk. The statue's old-fashioned schema and costume seem, then, to clash with its own new mood. The Euthydikos *korē* is, in fact, an Early Classical (or "Severe Style") statue in Archaic dress, a masquerade.

The Euthydikos *korē*'s pout is not the sort of thing one might expect to find in the exhilarating years after Marathon. All the same, the public

The Sense of a Beginning

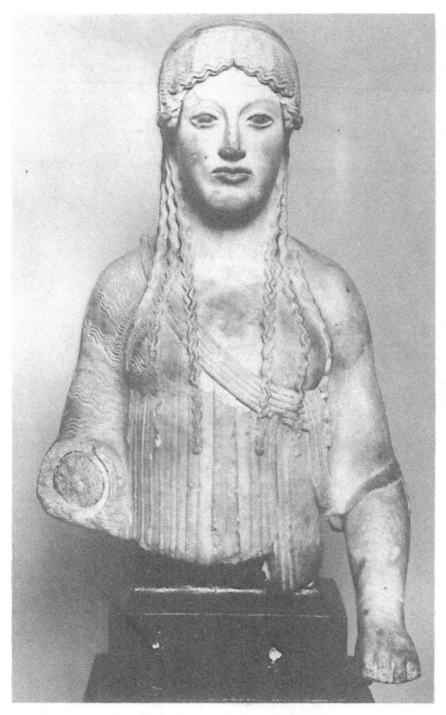

141. *Korē* dedicated by Euthydikos (Acropolis 686 and 609), around 490. Photo courtesy of Deutsches Archäologisches Institut, Athens.

The Art and Culture of Early Greece, 1100–480 B.C.

142. View of the Athenian Acropolis from the southwest. Photo: Jeffrey M. Hurwit.

confidence conceived at Marathon seems to have been the inspiration for the last great architectural effort of Archaic Athens: the construction of the first marble temple on the Acropolis (together with a new forecourt and then a new gateway to the citadel itself).[5] The late-sixth-century Archaios Naos, the house of the heaven-sent *xoanon* of Athena, was left alone. But whatever stood on the south side of the Acropolis (Dinsmoor's Hekatompedon or, more likely, the series of *oikemata* set up there in the middle of the sixth century) was taken down to make room for a new temple of marble quarried from Mount Penteli, with which the young, miraculously saved democracy planned to thank Athena and glorify itself.

The Acropolis looks like a flat-topped rock [142]. It is not. The rock falls off steadily on the south, and most of the Classical (or Periklean) Parthenon actually rests atop a massive platform built of poros limestone blocks [143]. At one point this substructure is twenty-two courses (and nearly eleven meters) deep. It is not pretty, but all of it except the three highest (and most carefully worked) courses was hidden by a great earth-filled terrace some ten meters wide on the south. The terrace itself was held up by a retaining wall that ran nearly parallel to the line of the platform.

5. See W. B. Dinsmoor, Jr., *The Propylaia to the Athenian Akropolis*, vol. 1, *The Predecessors* (Princeton, 1980).

143. View of the foundations of the Parthenon, originally built for the Older Parthenon, 490–80. Photo courtesy of Deutsches Archäologisches Institut, Athens.

The idea that this huge podium was originally built to support a late Archaic predecessor of the Parthenon—an Older Parthenon—is not unanimously held,[6] but it still makes good sense. Now the date of the platform

6. See, for instance, A. Tschira, "Untersuchungen im Süden des Parthenon," *Jdl*, 87 (1972), 158–231; and J. A. Bundgaard, *The Parthenon and the Mycenaean City on the Heights* (Copenhagen, 1976), who dates the Older Parthenon to the 450s. The orthodox theory (fol-

144. Fragment of kalyx krater (Acropolis II 731), around 490. Photo courtesy of Deutsches Archäologisches Institut, Athens.

and the temple planned to sit atop it will roughly be the date of the mass of earth piled against it, and the date of that fill will roughly be the date of the latest object recovered from it. Most of the late potsherds found in the strata between the platform and the retaining wall date to just before or around 500. But a handful of sherds seem to date to the first decade of the fifth century, and one small fragment of a Red Figure vase has usually been dated to around 490 [144], when such artists as the Berlin Painter, the Kleophrades Painter, and Onesimos were in mid-career and the Brygos Painter was beginning his. The sherd was apparently found at the very bottom of the artificial fill, possibly in the V-shaped trench dug to receive the lowest courses of the podium, and that gives a date of around 490 for the project's inception. But the sherd is dated around 490 on stylistic grounds, and stylistic grounds are often not very firm, especially when the only indications of style amount to part of a boy's torso and part of his toy hoop drawn on a fragment five centimeters or so on a side. "Around 490," in any case, really means "490 give or take five years"; and, in addition, there is no telling how long the vase stood whole before it broke. We cannot be sure, then, that this discarded sherd, and thus the bottom level of the terrace, was put in place just before 490 or just after. But of all the years around 490, 490 was the most spectacular, and it still seems best to tie the construction of the Older Parthenon and its platform to the celebration of victory over the Persians. The same podium had, at any rate, carried the Periklean temple for almost a century when the Athenian orator Demosthenes said, somewhat cryptically, that the Parthenon—the present Parthenon—was built from the spoils taken from the barbarians.[7] Demosthenes was not speaking literally: he knew Perikles' Parthenon was built

lowed here) is W. B. Dinsmoor's; see "The Date of the Older Parthenon," *AJA*, 38 (1934), 408–48. A more recent review of the problem is H. Drerup, "Parthenon and Vorparthenon: Zum Stand der Kontroverse," *AntK*, 24 (1981), 21–38.

7. *Against Androtion*, 13. Demosthenes said that the Propylaia, the monumental gateway to the Acropolis, was also built from the Marathonian spoils. In this case, too, he seems to have meant that the Periklean Propylaia had a predecessor begun after 490. See Dinsmoor (n. 5).

from the funds taken not from the Persians but from other Greeks, members of the Delian League. But whether he knew it or not, he was not speaking altogether figuratively either: the Classical Parthenon rests atop Archaic foundations.

That there was such a thing as an Older Parthenon has been known since 1835, and 250 assorted pieces of it still lie about the Acropolis [145] or are built into later walls or are encased beneath or within the Classical temple (its lowest step, for instance, can be traced for virtually its entire length through cracks in the south steps of the present Parthenon). In 1912

145. Unfinished corner column drum from the Older Parthenon, 490–80. Photo: Jeffrey M. Hurwit.

The Art and Culture of Early Greece, 1100–480 B.C.

146. Plan of the Acropolis in 480, with the Archaios Naos on the north side, the Older Parthenon (unfinished) on the south. Reproduced from J. Travlos, *Pictorial Dictionary of Ancient Athens* (New York, 1971), 61, fig. 71, by kind permission of J. Travlos and of Deutsches Archäologisches Institut, Zentrale, Berlin.

B. H. Hill used these remains to determine the Older Parthenon's dimensions and plan [146].[8] It was 26.19 meters wide and 69.616 meters long; and although it did not fill the podium built for it, it was nonetheless the second largest temple yet attempted on the Greek mainland (only the unfinished Olympieion of the Peisistratids was to have been larger). It had six columns on the facades and sixteen along the sides—an elongated and old-fashioned (archaistic?) plan recalling such temples as the Heraion at Olympia [78]. The Periklean Parthenon is a little longer and a lot wider and

8. B. H. Hill, "The Older Parthenon," *AJA*, 16 (1912), 535–58.

its colonnade is eight by seventeen. But in its use of Ionic elements, in the slight but deliberate upward curvature of its podium and steps (an "optional refinement" that Perikles' architects would accentuate), in its slightly thicker corner columns (another refinement), and possibly in its interior arrangement as well, the Older Parthenon anticipated its famous successor. In fact, the two Parthenons are in some dimensions (such as the height of their steps) identical, in other dimensions (such as the lower diameter of their columns) nearly so, so that the later temple seems, to put it simply, a broader or expanded version of the earlier. The list of correspondences even suggests that some blocks originally cut for the Older Parthenon were economically used in the Periklean temple four decades later; if they were, the architects of the greatest of all Classical buildings allowed certain dimensions to be dictated to them by late Archaic stones.

The Older Parthenon, the monumental symbol of victory and the young democracy's confidence in itself, was, however, never finished. Only the base blocks of the cella walls and the lower, unfluted drums of the columns had been set in place when the Persians came back.

The Last Act

Themistokles knew all along they would be coming. From the Persian point of view, Marathon was just a skirmish, and Darius' death in 486 did not mean that Persia had given up the conquest of Greece. With characteristic foresight Themistokles realized that Athens' survival now depended not on the hoplites of Marathon but on men-at-oars. And with characteristic political skill he eliminated his opponents one by one: in 487/86 he dusted off the previously unused Kleisthenic statute on ostracism to rid the city of Megakles, an Alkmeonid and, as it happens, the only Athenian ever celebrated in an ode of Pindar (*Pythian Odes*, VII), written later that year. By 483/82, Themistokles had only one formidable rival left in town: Aristeides. In that year workers at the silver mines at Laurion hit a rich new vein. This was Themistokles' great chance. He proposed a crash shipbuilding program, Aristeides argued against it, and the Assembly sided with Themistokles. In 482 6,000 inscribed potsherds sent Aristeides into exile and Themistokles began to supervise the construction of 100 triremes a year and the training of enough commoners to man them. The first Persian war had been won primarily by Athenians prosperous enough to afford their own armor. This time the defense of the polis was thrown open to anyone who could row: it was to be a democracy's war.

By 482 few Athenians could have mistaken Persian intentions. Intelligence reports had been coming in for some time that Xerxes, Darius' son and successor, was cranking up his war machine and taking measures to

make sure it ran smoothly. To avoid the natural disaster that befell Mardonios in 492, Xerxes' engineers spent three years cutting a canal through the Mount Athos peninsula. At the same time they began building bridges—in particular two great pontoon bridges across the Hellespont, binding Europe and Asia with the works of men. In the tragic vision of the Greeks this was a hybristic act joining what should not be joined, and a tale that Xerxes symbolically fettered the waters and gave them 300 lashes after the first bridges were wrecked in a storm heightened the Great King's reputation for megalomania. The bridges were, in any case, built again, and Persian resources were so vast that 674 spare warships were used as pontoons. In 481 everything was in place, the moon ominously eclipsed the sun, and Xerxes began his march to subjugate Greece and avenge his father's defeat.

He had 3 million men ("three hundred myriads") with him according to a nearly contemporary inscription, 5,283,220 soldiers and support personnel according to Herodotos, 200,000 according to some modern estimates. By any measure it was a huge army, and it had a huge navy sailing with it along the northern rim of the Aegean: there were 1,000 ships according to Aeschylus (who saw them), 1,207 and more according to Herodotos, somewhat fewer according to modern historians. The Greeks (rather, some Greeks) for once banded together to meet this enormous host, though their first line of defense (at the gorge of Tempe) collapsed long before Xerxes approached. In September 480 an allied fleet (including more than a hundred Athenian ships under Themistokles' command) took up a new position near Cape Artemision, at the northern tip of Euboia, and on the mainland an allied army of a few thousand men, led by the Spartan king Leonidas and his select band of 300, blocked the narrow pass named for hot sulphur springs nearby: Hot Gates, Thermopylai. For several days Xerxes hurled his troops against the Greek position. The assault cost him heavily. But a local goatherd named Ephialtes sold the secret of the place to Xerxes and guided a Persian force by night along a mountain pass that led behind the Greek line. In the hours before the dawn of September 19, a Spartan seer prophesied death in the morning, and as the sun rose, observers ran down from the mountains to tell Leonidas of the surprise Persian maneuver. Outflanked, Leonidas sent away whom he could. He and his 300 Spartans stayed to fight and die. The same day the Greek fleet held its own off Artemision, but its losses were severe and with Thermopylai taken it could do nothing more. Campfires were left burning on the shore as the Greek ships limped quietly away in the night. Xerxes' invasion could proceed.[9]

Soon after the Athenians learned of the fall of Thermopylai they received

9. For the chronology of the invasion, see K. S. Sacks, "Herodotus and the Dating of the Battle of Thermopylae," CQ, 70 (1976), 232–48.

more bad news: the allied command had written Attica off. The Persians could have it without a fight. The city of the Athenians was condemned to destruction, and the confidence they had won on the plain of Marathon only ten years before was shattered. Athena's priestess even reported that the sacred snake, the guardian of the Acropolis, had abandoned the rock. And so, whether according to a plan that had already begun to be implemented before Artemision or entirely in panic and haste (the answer depends on the historicity of a third-century inscription that claims to record Themistokles' original decree), Athens and the villages and estates of Attica were evacuated. Even before this emergency, the first of two famous Delphic oracles had grimly told the Athenians to "flee to the ends of the earth." They did not go that far: ships carried some to Athens' old foe Aigina, some to Salamis, and women and children to Troizen. Before they left, a few aristocratic families managed to hide images of their heroized dead: the Anavysos *kouros* [109], for instance, was buried to protect it from Persian blows,[10] and the family never exhumed it. One statue went with the Athenians: the *xoanon* kept in the Archaios Naos. Like the people who worshiped it, the cult image of the goddess was a refugee.

By the last week of September the evacuation was complete. The Peloponnesian army fortified the Isthmus of Corinth. The allied fleet lay at anchor in the straits between Salamis and Attica while its admirals argued over where to take the Persians on. A straggler then reported that the barbarians had entered Attica, burning and plundering as they came. Shrines and cemeteries were desecrated. The immense *kouroi* that had stood at Sounion for a century or more [8, 84] were knocked down; an unfinished temple of Poseidon there was also destroyed. The *kouros* that had stood over Aristodikos' grave at Anavysos for only twenty years [110] was pushed over, its face mutilated. Soon the Persian fleet was off Phaleron Bay, and Xerxes' hordes swarmed triumphantly into the deserted streets of Athens.

The streets were deserted. The Acropolis was not. A curious assortment of priests, temple treasurers, men too poor or too old to leave for Salamis, and probably some proud patriots who remembered that the odds at Marathon had also not been good occupied the citadel. They may not have greatly outnumbered the stone population of the Acropolis—the *korai*, horsemen, offering bearers, heroes, and *nikai* that had been dedicated over the last eight or nine decades—but they were a determined lot. They were also fatally literal-minded: for them "the wooden wall" that the second famous Delphic oracle claimed would prove safe was not Themistokles' fleet but the barricade they built to fortify the Acropolis, particularly on the west and south. Some of the timber was probably taken from the scaffolding of the unfinished Older Parthenon.

10. So, too, Phrasikleia and the *kouros* found at her side; see Boardman, *GS*, fig. 108a.

Xerxes camped on the Areopagos and his archers shot flaming arrows into the barricade: the wooden wall went up in smoke. Though the defenders discovered, too late, that Apollo could speak in metaphors, they refused to surrender when given the chance. Instead they sent "round stones"—Older Parthenon column drums?—down upon the Persians as they tried to reach the gateway. Herodotos tells the rest:

> In time, after many difficulties, the barbarians found a way up: for it was necessary, according to the oracle, that the Persians become master of all the Attic mainland. Toward the front of the Acropolis, but behind the gates and the ascent, where no guard was stationed and where no one expected that any man could climb up, there beside the Sanctuary of Aglauros, the daughter of Kekrops, some Persians made their way up, though the place was steep. When the Athenians saw them upon the Acropolis, some hurled themselves down from the wall and were destroyed, but others took refuge within the megaron [i.e., the Archaios Naos or its cella]. The Persians who had ascended the rock then ran to the gates and having opened them murdered the suppliants. When all lay dead, they pillaged the temple and set all of the Acropolis on fire.
>
> [VIII.53]

Limestone and marble do not burn, they calcine, and pink splotches on the podium of the Older Parthenon and on some of its column drums may be marks left by fallen burning scaffolding—if any scaffolding was left after the defenders of the Acropolis built their wooden wall. A few well-placed flaming arrows would have been enough to kindle the flammable parts and furniture of the Archaios Naos: the cella walls evidently survived the collapse of the roof, but their scorched state was still noteworthy when Herodotos visited the Acropolis decades later (V.77). Many statues (including the Euthydikos *korē*) and vases found mixed with charcoal in the so-called *Perserschutt* (Persian debris) also show clear signs of burning. But most damage was probably done with Persian ropes and mallets. The stone inhabitants of the Acropolis were toppled from their bases or pedestals and smashed; the bronze inhabitants, which may have been almost as numerous as the marble ones, were carried off; and the Persians possibly continued the demolition of the Archaios Naos by pulling down some columns: the east pediment's marble gods and giants [99] stopped fighting and tumbled to the ground. What little of the Older Parthenon could be pulled down, was. And as the fires burned and the marbles broke, Xerxes jubilantly sent a message to Susa that Darius had been avenged. The smoke that billowed high above the Acropolis signaled the same thing to the Athenian refugees who stood on the coast of nearby Salamis and could only helplessly watch.

Themistokles used all his powers of persuasion—and a threat to move his ship-born polis to Italy—to try to persuade the allies to take on the

The Sense of a Beginning

Persians in the straits. When that attempt failed, he forced the battle through deceit and the victory justified his means. Salamis chased the barbarian ships from Greek waters and sent Xerxes back to Asia (in his baggage were Antenor's bronze statues of Harmodios and Aristogeiton from the Agora—the Great King had lost a battle but spitefully struck back by depriving the Athenians of a highly visible symbol of their democracy and freedom). But the Persian invasion was not over yet. A large army under Mardonios stayed in Greece and spent the winter in Thessaly. In the meantime some Athenians went home: according to Herodotos (VIII.109), Themistokles urged his fellow citizens to sow their fields and rebuild their houses. We do not know how many followed his advice or if they repaired any of the dedications on the Acropolis. Certainly they did not have time to do very much: ten months later they had to escape to Salamis once more. The Persians were coming again, and before they left for the last time they burned what had not been burned before—a layer of ash now settled over the Agora—and knocked down what Xerxes had left standing (and what, if anything, the Athenians had set up again). In 479, after the battle of Plataia finally drove the Persians from Greece, the Athenians returned home for good. But technically the war was not over, and it was no time for rejoicing: the exhilaration and confidence they felt after Marathon could not be felt among blackened ruins and marble litter.

Art and Destruction

Archaic history ends with the battles of Salamis and Plataia. What happened next happened in a new age: the Early Classical period. Themistokles stalled Sparta, which was jealous of Athens' central role in the first and second Persian wars and not eager to see it refortified, while the entire population of Athens furiously threw new walls around the city: "Even now it is clear that the building was done in haste. For the foundations were laid with stones of all sorts, some not even worked to fit, but laid as each was brought forward, and many stelai and carved stones taken from tombs were built into it" (Thucydides, I.93). The ball players' base [131], which like other sculptures was found built into the Themistoklean city wall, confirms Thucydides' account that nothing was spared.

It is possible that while the city wall was being rebuilt the Acropolis itself was given a new wall on the north—the side the Persians managed to scale in 480 [147]. It is a strange wall, and its strangeness may have something to do with an oath the Greeks swore before the battle of Plataia. They swore to fight to the death, but reportedly they also pledged not to rebuild the temples the Persians destroyed and to leave them as memorials of barbarian impiety. The Athenians, sometime after they returned home, did even

147. View of the north Acropolis wall, after 480. Photo: Jeffrey M. Hurwit.

better than that: they took triglyphs, metopes, and other blocks from the wrecked Archaios Naos and 177 pieces (including 29 column drums) from the aborted Older Parthenon and prominently displayed them in the new north wall. Thus the Archaic Parthenon, intended as an expression of Athenian gratitude and self-confidence after Marathon, was partly transformed into an Early Classical monument to Athenian suffering and Persian sacrilege.

The north wall, then, could date to the early 470s, when Themistokles was still a leading though declining figure (in 477/76 he produced Phrynichos' *Phoenician Women*, another historical tragedy that, whatever its literary merits, was meant to remind the Athenians of Themistokles' role at Salamis, just as Simonides' poem *The Sea Battle at Salamis* did sometime after 480 and just as Aeschylus' *Persians*, produced by the young Perikles, would do again in 472, a year or so before Themistokles' ostracism). But the wall has also been dated to the mid-460s, when the conservative Kimon, son of Miltiades, was at his height.[11] It is the hastily built city wall that is credited to Themistokles in our sources: no source links him (or anyone

11. Themistokles had his favorite tragedians, and Kimon apparently had his. In 469 Kimon was allowed to choose the winner of the tragic competition at the City Dionysia. He chose Sophokles, in his very first contest, over the seasoned (and pro-Themistoklean) Aeschylus; see Plutarch, *Life of Kimon*, VIII. One wonders whether the choice was political or aesthetic.

The Sense of a Beginning

else, for that matter) to the north citadel wall and its built-in war memorial. It is hard, in any case, to see the wisdom in fortifying only one side of the Acropolis at a time. And since the massive south citadel wall was begun with the proceeds of Kimon's smashing victory over the Persians at Eurymedon, in Asia Minor, around 469, and since it, too, has blocks from the Archaios Naos built into it, the north wall (like some other monuments to the Persian wars set up in the 460s) could be Kimonian as well.

The date of construction of the north wall matters because of the contents of the fill heaped against it as it rose, course by course, layer by layer. Directly behind a section of the wall built with entablature blocks from the Archaios Naos, fourteen statues (including Kallimachos' Nikē [140], the upper half of the Antenor *korē* [107], and seven or eight other *korai*), along with assorted architectural pieces, inscribed statue bases, and a hoard of more than sixty Attic coins, were found buried in a mass grave. The Peplos *korē* [148] was found close by, and the cemetery of statues continued along virtually the entire length of the north wall: another important cache of *korai* was found just east of the Classical Erechtheion. If these statues were buried after 469, the Acropolis had been left strewn with *Perserschutt* for at least a decade. But even if the funeral took place in 479, almost as soon as the Athenians returned home, there was no single clean sweep of the citadel. Archaic debris found its way into the fill of the south wall in the 460s. A few column drums of the Older Parthenon were still around in the 440s, when they were used in the walls of the so-called Workshop of Pheidias, south of the Parthenon. And if the last Acropolis *korē* (Acropolis Museum 688) was carved before 480 (I believe it was, but it is a controversial point), she lay around until she was thrown into the foundations of the Classical Propylaia in 438.[12]

The oath of Plataia may have prevented the reconstruction of the temples on the Acropolis, but it apparently said nothing about the private dedications attacked by the Persians. New statues presumably could have been offered to Athena at once (though there is surprisingly little hard evidence for dedications datable to the 470s). But damaged statues may have been repaired. There was nothing inherently impious about such renovations: Theodoros, the son of the vase painter Onesimos, at some point around 480 restored one of his father's many dedications on the Acropolis, and one or two Acropolis *korai* were certainly repaired in antiquity, though there is no telling just when.[13] Moreover, several dedications

12. Stylistically 688 is Early Classical, and so has often been dated after 480; see Ridgway, *SS*, 31, 34–35; contra, Boardman, *GS*, 86 and fig. 161.

13. *Korē* 670, one of the *korai* found in the mass grave behind the north citadel wall, has a right arm that is in a different marble from the rest of her; see Brouskari, 70–71. The top of the head of *Korē* 643 is also repaired in a different marble (her find spot is uncertain, but if it was not in a deposit of *Perserschutt*, a repair even after 479 is possible); see G. Dickins, *Catalogue of the Acropolis Museum*, vol. 1, *Archaic Sculpture* (Cambridge, 1912), 185.

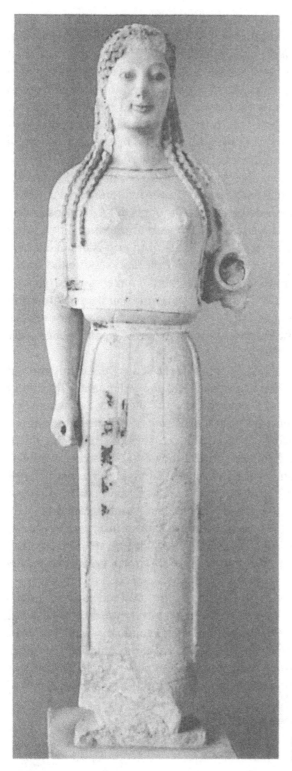

148. The Peplos *korē*
(Acropolis 679), around 530.
Photo: Jeffrey M. Hurwit.

The Sense of a Beginning

that were on the Acropolis when the Persians came were still there when Pausanias visited Athens around A.D. 174. Pausanias says he saw several "old statues" (*agalmata archaia*) of Athena, limbless, friable, and blackened by Persian flames (I.27.6), and a seated Athena carved by a "pupil of Daidalos," Endoios (I.26.4). Pausanias does not mention any damage to Endoios' Athena. Perhaps he forgot to mention it, but perhaps the statue somehow escaped the Persians unharmed or was repaired after they left. Acropolis Museum 625, which shows some signs of repair and whose heavily weathered surface indicates it was exposed to the elements far beyond the year 479, may be she.[14] But even if it is not, an Athena by Endoios was on the Acropolis in the second century of our era: Pausanias knew an Archaic statue when he saw one. Although the Athenians buried most of the statues the Persians broke, it appears from Pausanias' guidebook that a few statues were left as memorials of the disasters of 480 and 479 (just like the column drums and entablature blocks exhibited in the north Acropolis wall), while a few others could have escaped serious damage and been repaired. The Athenian sculptural heritage was not interred all in one place—deposits of *Perserschutt* were found all over the citadel—and it was not interred all at once. A few Archaic images were simply not buried at all.

It is still important to try to assess what effect, if any, the destruction of the Acropolis may have had on the psyche of the Athenian sculptor and the development of Greek art. There are those, for instance, who claim that the Persian destruction relieved Greek artists of a very heavy aesthetic burden—the burden that comes of having to create something new in the shadow of something old. A lot depends on the date of two marble adolescents: the Blond Boy (his hair was still bright gold—and his irises yellow and his lips red—when his head came out of the ground) and the Kritios Boy (so named because of a supposed resemblance to the Harmodios of a new Tyrannicides group cast by Kritios and Nesiotes in 477/76 to replace the Archaic originals Xerxes took from the Agora) [149, 150]. The boys are unquestionably Early Classical in style and spirit. That does not necessarily mean they could not have stood on the Archaic Acropolis.

The statues represent nude youths—the Kritios Boy seems about fifteen or sixteen, the Blond Boy seems more mature—but they are not *kouroi*. The pure frontality of the *kouros* has gone. So has its symmetry, and so has its impassivity. Moreover, the Archaic course in human anatomy has been passed, and the urge to show every muscle with equal, linear clarity gives way to a simplification and smoothing of surfaces. Musculature has ceased

14. Boardman, *GS*, fig. 135; Brouskari, 71–72.

149. The Blond Boy (Acropolis 689), around 485–80. Photo: Jeffrey M. Hurwit.

to be treated primarily as pattern, and has become flesh. The Kritios Boy (who is about two-thirds life-size) turns his head slightly to the right, and

The Sense of a Beginning [341]

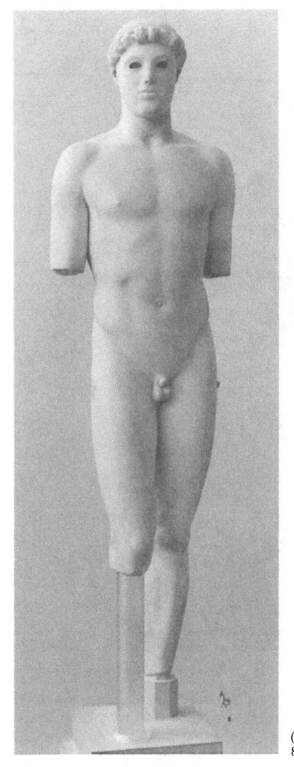

150. The Kritios Boy
(Acropolis 698), around 485–
80. Photo: Jeffrey M. Hurwit.

The Art and Culture of Early Greece, 1100–480 B.C.

as he puffs out his chest he shifts his hips, throwing all his weight on one stiff leg and relaxing the other. There is tension and rest; there is asymmetry, yet there is also balance. The Blond Boy does not merely turn his head, he sensuously tilts it toward a raised right shoulder, and the muscles of the neck distend and compress in response. Fragmentary slanting hips that probably belong to the otherwise bodiless youth indicate that he distributed his weight as unevenly as the Kritios Boy, and another fragment (if it is really his) shows that he even lifted his right heel off the ground.

Now the Athenian sculptor had broken the law of frontality before: the Rampin Rider (and other Acropolis horsemen) turns his head away from the axis of his body and horse [6], and mythological groups [138] and pedimental sculptures [99] naturally display an assortment of poses. Not all statues could face front with hands at their sides: some had to turn and fight and fall. So the asymmetrical stance of the Blond and Kritios boys is not a matter of newly acquired skills—the Archaic sculptor had always been able to relax a *kouros* if he wanted—but of a new attitude, a new meaning bestowed upon the central image of Greek art: the solitary, standing male nude. By shifting his weight and twisting free, the Kritios Boy comes to life. One part of the body affects another, and all parts are subordinated to the curving rhythm of the whole. The block of stone that had always been implicit in the foursquare *kouros* and that had rigidly controlled it is finally shattered, and the barrier between the limited space of the statue and the unconfined space of the beholder falls. The Kritios Boy is not the democratic Everyman some scholars have made him: he is still an aristocratic image. But aristocrats in a democracy must act differently from the way they do in an aristocracy. The rise of democracy in Athens necessitated adjustments in the aristocracy's conception of itself and its values. Adjustments therefore also had to be made in the images the aristocracy used to reflect and present itself. The *kouros* was not merely by now an artistic fossil: it was a politically and socially loaded image, with all the wrong associations, expressing all the wrong ideals. That is why it would no longer do. At all events, the Kritios Boy seems to exercise free will and to occupy the same space we do, in the same way we do, breathing the same air. The aristocratic *kouros* is distant, untouchable. The Kritios Boy is penetrable. He is almost vulnerable.

The Blond Boy or the Kritios Boy represents not the abstract idea of a youth, the way a *kouros* does, but an ideal youth. Yet they brood. The *kouros*, safe in his schema and spatial box, stares past us, transcending human limitations and mutability by paying no attention to them. The Blond Boy and the Kritios Boy pause and seem to pay a great deal of attention. They look not outward but inward, and it is their introversion as much as their pose that makes them Classical. The Blond Boy looks the more intelligent of the two, though the Kritios Boy may have seemed less

vacant when his inlaid eyes were in place. The smiles on the faces of many *kouroi* and *korai* [148] may be there because the Archaic mind considered statues somehow animate, and because the smile was a means of expressing life. But these youths have something the *kouros* lacks: *mental* life, innerness, or character (*ēthos*). Something weighs upon their minds, and it affects the way they stand: the body now has a language. The Blond Boy in particular thinks melancholy thoughts. It is likely that both statues commemorated athletes, and it may seem odd that their meditations on victory—on their personal *aretē*—have elicited not confidence or elation but, apparently, consciousness of their own mortal struggle to be "excellent," of their failure to transcend. They have acted, the world has acted upon them, and they react by withdrawing within themselves. It is as if their sculptors attacked the claims the *kouros* had made—the claim of timelessness and the automatic aristocratic equation of goodness with beauty (*kalokagathia*). It is as if these new self-conscious youths accept limitations, the responsibility for their own actions, the possibility of choice, flux, and impermanence all at once. The Kritios Boy and the Blond Boy, in fact, announce a new ideal, a new virtue: *sophrosynē*, moderation, the doctrine of self-knowledge and the knowledge of human limitations—the Classical doctrine par excellence.

Their mood, their *ēthos*, their *sophrosynē* seem to have affinities with certain poems of Simonides, who spanned the transition not only from the Archaic to the Classical periods but also from Archaic to Classical ways of thinking. He injects a similar note of human responsibility, for instance, into a poem addressed to a Thessalian patron. It is hard, he says, for a man to become truly good in arms, legs, and mind made foursquare without flaw, and, a few lines later, he says only the gods can be truly good, denying man the ability altogether:

> But I praise and love all men,
> whoever of his own free will does
> nothing shameful: but not even
> the gods can fight necessity.
> [*PMG*, 542, ll. 27–30]

The thought is humane, ethical, full of *sophrosynē*, and revolutionary: for if it is *impossible* for a man to be truly good ("foursquare" like a *kouros*?), the foundation of the old aristocratic ideal of *aretē* is removed. *Aretē*, he implies elsewhere (*PMG*, 579), is to be struggled after; it takes sweat, not heredity. Motives and actions freely and individually taken, not birth or wealth or beauty, are the standard of whatever portion of goodness a man can have. Men are to measured against other men, not against the gods. Goodness is relative, and men are responsible because they have will.

Simonides also heard of an epitaph written by Kleoboulos, a wise man, for the tomb of Midas. The verses were, like Phrasikleia's epitaph, in the first person: a bronze maiden speaks and boasts that she, Midas' grave marker, will endure as long as rivers flow and the sun shines. Simonides sharply replied:

> Who, trusting his own mind, would praise Kleoboulos of Lindos,
> who against the ever-flowing rivers and flowers of spring,
> against the flame of the sun and the golden moon,
> against the eddies of the sea, matched the might of a gravestone?
> All things are less than the gods, but even mortal
> hands can smash a stone. This is the thought of a fool.
>
> <div align="right">[PMG, 581]</div>

Art is transitory, and the immutability claimed by Archaic sculpture is directly scorned. In another poem (*PMG, 594*) Simonides even denies men what Homer, the elegiac poet Theognis, and his own younger contemporary Pindar seek to give them through poetry: immortal fame (*kleos*). Fame, like a gravestone, stays awhile, and then ultimately sinks beneath the earth. That is not the message of Kleobis and Biton [85] or the Anavysos *kouros* [109].

All things, including art and fame, may be less than the gods, but it is in their sense of themselves and their ideal proportions that the Blond Boy and the Kritios Boy seem to reveal the godlike within man. And in the paratactic opening of an ode sung (as it happens) in honor of a victorious boy wrestler, Pindar sets the traditional Archaic theme of human powerlessness beside a new elevation of man:

> One race of men,
> one of gods, is there; we both draw breath
> from one mother. But divided power
> separates us, so we are nothing, while the bronze heavens remain their safe
> place
> forever. And yet we are somehow like the gods in our great mind and form,
> though we do not know what course by day or night
> destiny has written for us to run to the end.
>
> <div align="right">[*Nemean Odes*, VI.1–7]</div>

Man is still ephemeral and he is still measured against the gods; but, at least in victory, he is better off than the wind-blown leaf Homer or Mimnermos had made him. Here he belongs to the same race as the gods, and the difference between them is not so much one of kind—Herakleitos had said the wisest man is but an ape next to a god—as of degree. Man's thought and nature, if not his power, approach the divine. Pindar is an

The Sense of a Beginning [345]

Archaic poet in temperament and style—he favors ring composition and antithesis, for example—and he would not have agreed with Simonides about very much. But he has in this ode (its date is uncertain) taken a step toward Classical humanism. It is not too much to suggest that the sculptors of the Kritios and Blond boys took the same step in their medium. The statues seem to sense the gulf between what is man and what is more than man and feel uncertainty, even dejection. We, looking at these introspective youths, sense the kinship between man and the gods and are somehow reassured.

The surfaces of both statues are fresh, and the lack of wear, together with the paint that still clung to the Blond Boy's head when it was lifted from the earth, suggests they did not stand out in the open for very long before they were dismembered and buried. The problem is that they were not found in any clearly homogeneous stratum of *Perserschutt*. If the Acropolis was not swept completely clean in 479 or 478, that is not so great a problem after all: not all Archaic statues *need* have found their way into a pure pocket of Persian debris. The fact remains that the find spots of the youths do not help much chronologically. The archaeological context of the head of the Blond Boy was inconclusive, though his foot (if, again, it *is* his foot) is said to bear traces of fire, presumably from Persian torches.[15] When the torso of the Kritios Boy was found in 1865, an indisputably Classical head (Acropolis Museum 699) dating to the 440s was found with or near it (and in 1880, in fact, this head was mistakenly set atop the Kritios Boy's shoulders, where it stayed until the head now occupying them came to light eight years later). On the other hand, the head of the Kritios Boy was apparently found with an Archaic nikē (Acropolis Museum 694)—it may have served as a roof ornament of the Archaios Naos—that seems to have been restored after 480/79.[16]

If the ambiguous contexts of the Blond Boy's and the Kritios Boy's bodily parts suggest anything, it is only that pre-Persian and post-Persian material could somehow have become mixed together. There would be, then,

15. See Dickins (above, n. 13), 248–50 (but cf. Brouskari, 123); *AMA*, 198–99.

16. An old photograph suggests that the torso of the Kritios Boy was found with two sculptures (the Calf Bearer [104] and the head of Athena the Giant-Killer from the pediment of the Archaios Naos [99]) that are positively Archaic, and one sculpture (an Athena dedicated by Angelitos and made by Euenor) that could be Early Classical; but the photograph does not jibe with the scanty records of early excavation on the Acropolis, which indicate that these sculptures were in fact found in different years (1863–65). For the photograph, see *AMA*, 345, fig. 405; for the records, see Brouskari, 40, 76, 124, and 129. Brouskari also notes that Angelitos' Athena has been partially reworked (130) and so it is not inconceivable that the statue was dedicated before the Persians arrived, suffered minimal damage in 480/79, and was restored after the war; incidentally, the Athena seems to have inspired an Early Classical Red Figure vase painter (Brouskari, 129–30).

For Acropolis 699, see Brouskari, 131; for Acropolis 694, Brouskari, 66, and Ridgway, *AS*, 113.

no reason to be particularly confident that they fall to one side of 480 rather than the other were it not for one more thing: the Kritios Boy was evidently repaired in antiquity. The statue was broken at the neck and at some point someone seems to have chipped away the edges where the head and body join; the broken edges of the arms, in contrast, remain sharp. The damage is so strange that it has led some scholars to conclude that the head and body were *made* to fit—in other words, that the head of the Kritios Boy originally belonged to another statue.[17] If so, the boy must have had a nearly identical twin on the Acropolis. But that is not so impossible: Kleobis, after all, has his Biton [85], and the Rampin Rider [6] had a very similar sidekick.[18] At any rate, the peculiar chipping around the neck may well be the result of a clumsy ancient attempt to put the sculpture—or pieces of two different sculptures—back together again (and perhaps to prepare the edges for some kind of marble-dust mortar to hide the break as neatly as it is hidden today).

Various reconstructions of the Kritios Boy's unhappy fate are believable. But perhaps the least satisfactory claim has been that he must be post-Persian simply because no statue wrecked by the Persians was ever restored. We do not know that, and there is some evidence—Nikē 694, for instance, and even Endoios' very worn Athena—to the contrary. The evidence, admittedly, is circumstantial, but a plausible hypothesis is that the Kritios and Blond boys were dedicated just before or in 480 and that Persians lopped off their heads later that same year. The Kritios Boy could have been repaired when and if the Athenian who had just paid for him returned home after Salamis (if so, he may have been irreparably damaged when Mardonios decimated Athens once more in 479) or after the Persians were driven from Greece once and for all.

The battles of Salamis and Plataia, again, brought Archaic history to an end. But if the Kritios Boy and the Blond Boy stood on the Acropolis when Xerxes came, Archaic sculpture had already ended: in style, pose, self-consciousness, and proportions they have much more in common with Classical statues created decades later [151] than with *kouroi* carved only a few years before [110, 132]. In fact, whether these two youths are pre-Persian or not, the Archaic style had been ending in other ways and in other media for some time. With their paintings of Ajax [115] and Antaios [123], Exekias and Euphronios widened the expressive range of Archaic art: their exploration of psychological depth and the depiction of *pathos* not only break the "law" of impassivity but anticipate two of the leading concerns of Early Classical art. On the exterior of their cyclical "Theseus cups"

17. See H. Payne and G. M. Young, *Archaic Marble Sculpture from the Acropolis* (London, 1950), 44; contra, *AMA*, 192–94.
18. Brouskari, 55–56. For the issue of Greek duplicate statues, see now B. Ridgway, *Roman Copies of Greek Sculpture* (Ann Arbor, 1984), 6–9.

151. The Doryphoros of Polykleitos, Roman copy (Naples), original around 440. Photo: Hirmer Fotoarchiv, Munich.

The Art and Culture of Early Greece, 1100–480 B.C.

[137], where the hero is shown performing his various labors simultaneously in an uninterrupted, unframed field—where, in effect, his life story is narrated continuously—late Archaic artists such as Onesimos foreshadow Early Classical experiments with other narrative techniques (the "progressive narrative" style of Polygnotos, for instance).[19] By devoting all the metopes on one side of a building to the same myth (Herakles-Geryon on the west, the Amazonomachy on the east), the sculptors of the Athenian Treasury [133] not only refined the method of "serial narrative" invented in the seventh century [cf. 75] but also set a late Archaic precedent for the metopes of the Parthenon. On a good vase by a lesser late Archaic artist Theseus and Sinis fight in the kind of V-shaped composition that will predominate in the pediments and not a few of the metopes of the great Periklean temple.[20] A relief of a victorious athlete set up at Sounion just before 480 [152] is as supreme an expression of *ēthos* as anything the Early Classical period will offer. And in the depiction of the individual human figure, a revolution had been under way since the last decade of the sixth century. It began as soon as figures started to twist free of the two dimensions of the plane and explore the third [118], and it continued into the first decades of the fifth century, when such artists as the Kleophrades Painter, the Berlin Painter, the Brygos Painter, and Douris were as often Classical in mood and expression as Archaic in the style of the drapery they drew [135]. In fact, on an important vase in Naples with the sack of Troy on its shoulder [153], the Kleophrades Painter was able to look back upon the Archaic style and so put some distance between it and himself. While around the curve of the vase Priam mourns his dead grandson Astyanax and Akhilleus' son Neoptolemos prepares to kill him, and while other figures grieve or are still, Kassandra grasps the palladion, the statue of Athena. The Athena seems to raise her spear to defend Kassandra from Ajax, but the base she rigidly stands upon and her small size indicate that she is, after all, impotent stone. Moreover, the statue is distinguished from the "live" figures around her by her dress, her Archaic smile, and her frontal eye. The Kleophrades Painter has artistically quoted the Archaic style—one thinks of the Peplos *korē*, for instance [148]—and such a quotation is possible only because the artist has sensed a certain remoteness from his own Archaic tradition. In this respect, the Kleophrades Painter anticipates the allusions of a few metopes of the Periklean Parthenon—on one Helen seeks the protection of a statue of Athena that, when whole, may have resembled the Kleophrades Painter's Athena [154]—and the Bassai frieze [1]. Those Classical works are "archaistic" only in the limited sense that they use the older style to differentiate representations of carved

19. See E. Harrison, "Direction and Time in Monumental Narrative Art of the Fifth Century B.C." (abstract), *AJA*, 87 (1983), 237–38.
20. Robertson, *HGA*, 229, and Boardman, *ARFV*, fig. 115.

152. Relief stele from sanctuary of Athena, Sounion (Athens 3344), around 485–80. Photo: Jeffrey M. Hurwit.

figures from representations of living figures. But that brand of archaism—essentially, the self-conscious recognition and admission of difference between the old and the new—was possible even in the work of a vase painter who is himself labeled Archaic.[21]

21. For archaism in general, see Ridgway, *AS*, 303–19. For the Kleophrades Painter's representational archaism, see Robertson, *HGA*, 234, 358.

The Art and Culture of Early Greece, 1100–480 B.C.

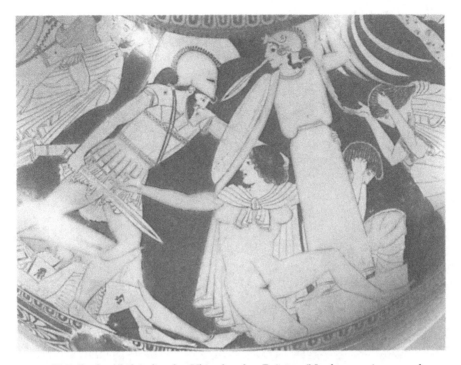

153. Detail of a hydria by the Kleophrades Painter (Naples 2422), around 490. Photo: Hirmer Fotoarchiv, Munich.

In free-standing sculpture some Archaic schemata (such as that of the running or flying figure) were adjusted or repudiated soon after 490 [140], while others (such as that of the *korē*) uneasily tried to accommodate the new conception of the human form and did not quite succeed [141]. Thus, while a lot depends on the date of the Kritios and Blond boys, not everything depends on them. They were almost certainly not even the first statues of their kind. It would, after all, be an extraordinary stroke of luck to possess the very first youths to break completely with the *kouros* formula. The new stance had, in fact, been predicted by Red Figure vase paintings and by athletes on the Themistoklean bases [131]. A youth from the Acropolis (Acropolis Museum 692) had already begun to turn his head, bend his knees, and shift his weight.[22] And certain features of the Kritios Boy—the way his hair is engraved and curled, for instance, and the fact that his eyes were inserted in a different material—strongly suggest he had bronze prototypes (by the time he was made, marble may already have become second to bronze as the medium of choice). Such details do not prove that earlier bronzes adopted the same relaxed and rhythmic pose. But to judge from the cuttings in its base, a lost bronze statue set up in the

22. Brouskari, 131 and fig. 250.

154. North metope 25, Periklean Parthenon, 447–42. Photo courtesy of Deutsches Archäologisches Institut, Athens.

480s beside the Altar of the Twelve Gods in the Agora (Leagros, the same fellow who is so often called *kalos* on late Archaic vases [e.g., 113], dedicated it) probably stood in much the same way.[23] For all we know, bronze statues cast in the new pose may have made the Kritios Boy seem quite ordinary on the pre-Persian Acropolis. The revolution in sculpture in the round evidently took place after Marathon, not after Plataia. If any histor-

23. Harrison, *Archaic and Archaistic Sculpture*, 10n61. See now E. D. Francis and M. Vickers, "Leagros Kalos," *PCPS* 207, (n.s. 27; 1981), 97–136, who argue, among other things, that the Leagros base could well date after 480.

ical event had a liberating effect on the Athenian artistic psychology, it was the victory of 490, not the tumult of 480/79.

The renunciation of the Archaic did not, then, specifically require the Persian destruction of the Acropolis. What the devastations of 480 and 479 did in Athens was to lift the weighty burden of the past (or most of it) from artists who had already decided to throw it off for themselves. The break was conscious and deliberate, if not completely clean. The choice was made when Athenian artists could still confront numerous products of their Archaic heritage (and it was made simultaneously in other parts of Greece where there were no Persian destructions and where *kouroi* and *korai* would long and fairly abundantly stand). It was thus a greater and more radical achievement than if it had been encouraged or compelled by the demolition of the open-air sculpture galleries on the Acropolis, at Sounion, and in the aristocratic cemeteries of rural Attica. Greeks, not Persians, set Greek art on a new course.[24]

If the Early Classical style began in art before the Archaic period was technically over, certain Archaic traits lingered and were exploited in art after the Early Classical period technically began. And in the case of the many vase painters and sculptors who began their careers well before Salamis but ended them long after, it is senseless to claim they were fully Archaic in 481 but fully Classical in 479. Archaic patterns of thought, too, endured long after the Classical period began. Poets as well as sculptors and painters spanned both eras. Simonides, the harbinger of Classical humanism, became the poet laureate of the Persian wars, just as he had been a court poet of the Peisistratids. At Athens he celebrated Artemision and Salamis (and by implication his friend Themistokles) with choral odes performed at the Panathenaia, and at Sparta he heroized Leonidas and the three hundred who fell at Thermopylai defending Archaic Greece:

> They have an altar for a grave; instead of lament, they have remembrance;
> instead of pity, praise.
> Not decay, nor all-subduing time shall obscure
> such an offering to the dead.
>
> [*PMG*, 531, ll. 3–5]

In lines that contradict what he says elsewhere about Midas' grave marker and mortal fame—like Walt Whitman, he contained multitudes—Simonides revives the Archaic insistence on the immortalizing force of *kleos*. And despite his new humanism, Simonides could still compare the swiftness of human mutability to the fluttering of the dragonfly's wings (*PMG*, 521). In 463 Pindar took up the theme of the eclipse Archilochos had

24. I regret that *Greek Art: Archaic into Classical*, ed. C. G. Boulter, Cincinnati Classical Studies 5 (Leiden, 1984), was unavailable to me when this book went to press.

introduced so long before and used it to stress human helplessness again (Paean IX: *To the Thebans*). Pindar composed into the 440s—he was a contemporary not only of Aeschylus but also of Sophokles—yet he remained the quintessentially Archaic poet. In his last extant victory ode he recapitulates a traditional lyric theme as if the Greek victory over the Persians had never happened:

> Creatures of a day are we. What is one? What is one not?
> The dream of a shadow is man.
>
> [*Pythian Odes*, VIII.95–96]

Man is wholly accident, the gods are jealous, no one is to be counted happy until he has happily died, human affairs revolve on a wheel of fortune—these are all principles of an Archaic world view as old as Archilochos, yet they are found in Herodotos' history (written, it seems, in the 430s) and are fittingly put into the mouths of the Archaic poet Solon and his unwitting pupil Kroisos (I.32, 207). Even Sophokles, the great poet of Periklean Athens (but born around the same time as the youth the Kritios Boy commemorates), struck similarly Archilochean notes:

> Misery and joy circle round
> to all, like the revolving
> paths of the heavenly Bear.
>
> The starlit night does not
> last for men, nor does ruin,
> nor wealth, but quickly
> it is gone, and it is another's turn
> to be glad, and be deprived.
>
> [*Trachiniai*, ll. 129–35]

But to point out a certain intellectual continuity between one period and the next, and to claim that Archaic and Classical outlooks could coexist (even within the work of the same poet), is not to say that the Persian wars had no impact on the Greek mind. They may not have put an end to the Archaic style in art, but they surely had a lot to do with the formation of the Classical spirit. One poet who may have been transformed by the battles of Marathon, Salamis, and Plataia was Aeschylus, who is said to have fought in all three. For it was only with Aeschylus that Archaic *tragoidia* was finally transformed into Classical tragedy. He had probably written his first play by 499 (about the time Pindar began his literary production) and he won his first dramatic victory between the wars in 484 (though we do not know for what). But his earliest surviving play—*the* earliest surviving Greek play—is the *Persians*, written in 472. More than sixty years of Athenian

drama had gone by, yet antiquity did not transmit any of it except for some titles and a few lines. The suggestion may seem callous, but it is possible that Archaic tragedies—even those written by Aeschylus—were not preserved because later editors for some reason did not consider them worth preserving, and perhaps the reason was that they were not what Classical tragedies would be. Could it be that the Greek conflict with Persia—a conflict in which Athens played the leading role—sharpened Aeschylus' vision of the human condition, that it sharpened his insistance that suffering leads to knowledge and his confidence that Zeus, whoever he may be, is ultimately just? Could it be that Athens' experience in the wars, marked by the rhythm of Miletos, Marathon, Thermopylai, the destruction of the city, and the city's final victory, shaped the Aeschylean tragic rhythm of conflict, endurance, reconciliation, and triumph?[25] The East had already contributed much to the developing culture of Archaic Greece, particularly by offering the Greeks something to respond to and react against. It would be fitting, though ironic, if Archaic Greece's fight for survival against an eastern empire helped Classical Greek civilization and its greatest poetic form define itself.

No one event, no one year, turned the Archaic into the Classical. But history affects culture after all, and it is hard to put away the stubborn intuition that when the Athenians finally returned to their devastated city, placed the ancient *xoanon* of Athena back on her citadel, and began to clean up, their profound sense of loss was tempered not only by a sense of relief but also by a sense of a beginning.

25. See G. F. Else, *The Origin and Early Form of Greek Tragedy* (Cambridge, Mass., 1967), 101–2.

Glossary of Greek Words
and Technical Terms

agalma	A pleasing gift, particularly for the gods; hence, a statue.
agora	An assembly or place of assembly; a marketplace; usually the social and civic center of a polis (q.v.).
akribeia	Precision, meticulousness, exactness.
akroterion (pl. **akroteria**)	An ornament or statue placed on the corner of a roof or on the apex of a pediment.
amēkhaniē	(literally, lack of a device or resource) Powerlessness, helplessness.
amphora	A two-handled jar for wine, oil, and other liquids; varieties include the belly-handled amphora (cf. fig. 24), the neck-handled amphora (cf. fig. 27), and the belly (or one-piece) amphora (cf. fig. 112).
archaios	Ancient, old-fashioned; also used by ancient authors to designate works of art that we would call pre-Classical or Archaic.
archaistic	Displaying forms or features characteristic of an earlier style or of the Archaic style.
archē	Beginning, origin; in philosophy, the first principle or cause, the source and sustaining substance of the phenomenal world.
archon	Ruler; in Archaic Athens, the chief civic and political official.
aretē	Valor, prowess; excellence.
aryballos	(literally, bag or purse) A small narrow-necked jar for scented oil or perfume (cf. fig. 64).
athyrma (pl. **athyrmata**)	Delight, plaything, trinket.
basileus	A leader; sometimes king, sometimes nobleman or rural lord; one of the ruling elite.
cella	The main room of a temple, where the cult statue was kept.
centauromachy	A battle against a centaur or centaurs.
chiasmos	A kind of antithetical symmetry in which the order of words or elements in a series is inverted or reversed in a parallel series.

cyclical narrative	The depiction of a series or cycle of distinct mythological episodes or exploits in which the same hero appears more than once in an unbroken pictorial field.
deme	A country district, a township; the basic unit in Kleisthenes' reorganization of the Athenian state in 507/6.
dikē	Justice, right.
dinos	A large, round-bottomed, handleless bowl, placed on a stand, used for the holding and mixing of wine (cf. fig. 89).
dipteros	A temple with a double surrounding colonnade or peristyle (q.v.).
dithyramb	A choral song or hymn, originally associated with Dionysos.
dromos	Runway, racecourse.
dynamis	Power, force.
ekphora	The ritual carrying out or transport of a corpse for burial, usually by wagon.
ekphrasis	A literary description of a work of art, real or imagined.
ēthos	Custom, habit; character, inner makeup.
eunomia	A state of good order or good government.
Eupatrids	The wellborn; the small group of aristocrats who controlled early Athens.
fibula	A brooch or safety pin, often with a large catch plate.
frieze	Any decorative or representational continuous horizontal band.
gigantomachy	The battle between gods and giants.
hekatompedon	A temple or precinct 100 ancient feet long.
hektemoroi	"Sixth-parters," a class of poor farmers in early Athens who apparently owed one-sixth of their produce to aristocratic lords and whose debt was secured by their own bodies and freedom.
heroon	A place or shrine for the worship of a hero or heroes.
hydria	A three-handled vessel for water (cf. fig. 125).
isonomia	Equality before the law, equality of rights; applied to Kleisthenic democracy in Athens.
kalokagathia	The ideal union of beauty and goodness or worth; the highest aristocratic excellence; the character of an aristocrat.
kalos	Handsome, fine, beautiful.
kantharos	A deep cup with two vertically set and often high handles.
kleos	Fame, glory.
koinē	A common artistic or stylistic language.
korē	An Archaic statue of a standing clothed maiden.
kosmos	Ornament, then order, then (under the impact of Milesian philosophy) world order, universe.
kotyle	A deep cup with small horizontal handles (cf. fig. 66); see also *skyphos*.
kouros	An Archaic statue of a standing nude youth.
krater	A large, deep bowl for the mixing of wine and water; varieties are distinguished by the form of the handles (e.g., the volute krater, fig. 93) or profile (e.g., the kalyx krater, fig. 123).
megethos	Greatness of spirit; grandeur.
metope	A panel (plain, painted, or sculptured) set between triglyphs (q.v.) in the Doric frieze (cf. fig. 59, left).

mimesis	Imitation.
naos	The house of a god; temple; sometimes also its innermost room or cella (q.v.).
nikē	Victory, or a personification of victory.
oikematon	A small but elaborate building or monument, represented by several fragmentary examples on the Archaic Acropolis (cf. fig. 100).
oikos	House or household; before the rise of the polis (q.v.), the principal sociopolitical unit of early Greece, organized around an aristocratic family, its holdings, and its network of relations.
oinochoe	A wine pitcher (cf. fig. 46).
olpe	A jug with a sagging belly (cf. fig. 67).
parataxis	The clear arrangement of parts or elements (e.g., words or phrases) side by side, without conjunctions or organic transitions.
pathos	Emotion, suffering.
peplos	A woman's heavy, simple robe or dress, with a belt and overfold (cf. fig. 148).
peripteral	Characterized by a continuous colonnade or peristyle (q.v.).
peristyle	A surrounding colonnade.
pithos	A large storage vessel.
poikilia	Decorativeness; ornamentality; embellishment.
polis	City-state; an autonomous political entity incorporating rural lands and an urban center (the seat of government).
prothesis	The lying in state and ritual mourning of a corpse.
protome	The upper or front part (usually consisting of the head and neck, sometimes also the shoulders) of an animal or human being (cf. fig. 11).
rhysmos (rhythmos)	Arrangement, measure, pattern; rhythm.
schēma	Shape, design; standardized or patterned form.
serial narrative	The depiction of one myth or exploit in a series of contiguous but separate panels (such as metopes), in which each character appears but once.
simultaneous narrative	The representation of successive stages of an action or story as if they happened at the same time, making visually coexistent what in the story was consecutive.
skolion	A drinking or party song.
skyphos	A deep cup with small handles (cf. fig. 34); a kotyle (q.v.).
sophrosynē	Moderation, self-restraint; knowledge of the self and of one's limits.
sphyrelaton	A statue made of metal (usually bronze) sheets hammered and riveted together like armor, usually over a wooden core.
stele	An upright slab of stone, often a grave marker decorated with sculpture or paint.
stoa	A long colonnaded hall.
symposium	A (usually aristocratic) drinking party.
synoikismos	The unification of districts or communities into a single polis (q.v.); applied especially to Athens and Attica.

Glossary of Greek Words and Technical Terms [359]

tectonic	Having the character of architecture; clearly constructed of horizontal and vertical elements.
tekhnē	Craft, skill; art.
tragoidia	Goat song; tragedy.
triglyph	A vertically grooved block alternating with metopes (q.v.) in the frieze of the Doric order (cf. fig. 59, left).
xoanon	An image or statue carved of wood.
zeitgeist	(*German*) Spirit of the age.

Index

Page references to illustrations appear in italic type.

Daidalic style, *10*, 131, 133, *187*, *188*, *189*, 190–192
Daidalos, 31–32, 190, 191–193, 196, 257
Darius, king of Persia, 320, 322–323, 332
Dark Age, 33, 36–70, 73, 95, 120, 121, 127, 137, 216
Delos, 137, 141, 186, 208, 247, 323; Naxian Apollo, *192*, 198
Delphi, 44, 74, 83, 126, 133, 200, 213, 230, 245, 246, 274, 293. *See also* Apollo, Temple of: Delphi; Athenian Treasury; Kypselid Treasury; Sikyonian Treasury; Siphnian Treasury
Democracy in Athens, 217, 249, 277–280, 309, 316, 343. *See also* Eunomia; Isonomia
Demosthenes, 329–330
Didyma. *See* Apollo, Temple of: Didyma
Dinsmoor, W. B., 242–243, 245, 248, 327, 329n6
Diodoros Siculus, 191–192, 196
Dionysos Eleuthereus, Temple of (Athens), 270
Dipoinis, 193
Dipteros, 210–211
Dipylon goddess, 127, *128*, 133
Dipylon Master, 32, *92*, 93–94, 96, *98–99*, *105*, 110–111, 127, 135, 140, 151, 165, 208; and Homeric poetry, 97–106
Dipylon Workshop, 89, *90*, 99, 109, *110*
Dithyramb, 159, 265, 268–269
Doric order, 131, 133, 159, 182–186; vs. Ionic, *134*, 210–211
Dörpfeld foundations. *See* Acropolis: Archaios Naos
Douris, 349
Drakon, 140, 214–215, 217
Dynamis, 165, 169, 176, 179, 220, 224

Egypt: art of, 27, 29, *30*, 67, 79, 130, 141, *193*, 199, 206, 308; Greek exposure to, 134, 179–182, 184–185, 188, 205, 218
—influence of: on Archaic architecture, 131–132, 133, 135, 181–186, 202, 210n11; on Archaic sculpture, 131, 133, 135, 186, 190–191, 193–197, 202
Ekphantos of Corinth, 157, 162
Ekphora, 58, 107
Ekphrasis, 46–47, 230
Eleusis, 42, 121, 324; Middle Geometric II cup from, *82*, 95; Protoattic amphora from, 165–167, *168*, 169, 173–174, 289; Telesterion of Peisistratos, 247
Else, Gerald F., 269
Emotion in Archaic art, 25–26, 27, 169, 176, 272, 288. *See also Pathos*
Endoios, 248–249, 301n22; seated Athena by, 340, 347
Ephesos, 212, 249, 321; Temple of Artemis, 184, 210, *211*, 213, 249
Epic cycle, 123, 138, 139n18, 170, 233

Epic poetry. *See* Hesiod; Homer; Mycenaean civilization, poetry of; Oral poetry
Eretria, 44, 79, 81, 321–323; Building H, 44, *45*, 74; Temple of Apollo, 314, *317*, 323
Ergotimos. *See* François vase
Ethos, 344, 349
Euboia, 43, 54, 73, 79, 81, 89
Eumaros of Athens, 284
Eumelos, 137, 140, 156
Eunomia, 216, 277
Eupatrids, 214–217, 234–235, 277
Euphronios, 172, 263, 271n75, *281*, 287, 291, 300, 306, 324. *See also* Antaios krater; Sarpedon krater
Euthydikos *korē*, 324–325, *326*, 335
Euthykartides of Naxos, 141, *142*, 143
Euthymides, *280*, 281–282, 284, *285*, 287, 290, 291, 300, 302, 306
Exekias, 250–252, *259*, 260–261, 263, 271, 272, 282, 287, 290, 347

Foce del Sele, metopes from, 172–173, 227, *228*, 230, 293, 295, 306
Foreshortening, 299–302, 308–311
Formulaic composition: in Athenian Black Figure, 178; in Dipylon style, 97–98; in Homer, 47–48, 97–98
François vase, 171, 224, *225*, 226–231, 233, 242, 299, 312
Free painting, 157, 159, 161, *162*, 163, 283–285, 308

Geometric period, 39–40, 61, 127, 151. *See also* Athenian vase painting: Early Geometric, Middle Geometric, *and* Late Geometric; Closure in Geometric art and poetry; Late Geometric period; Protogeometric period
Gorgon Painter, 219, *220*, 221

Harmodios and Aristogeiton, 273–274, 276–277, 314;
—statues of: by Antenor, 276–277, 336; by Kritios and Nesiotes, 340
Harrison, Evelyn, 319
Hekataios, 321
Hekatompedon (Samos), 74–75, *76*, 77, 188, 210. *See also* Acropolis: Hekatompedon
Hektemoroi, 44, 216–217, 235
Hektor, 52, 71, 102, 119, 152, 227
Hephaistos, 47, 71–73, 87, 147, 226, 231, 257
Herakleitos, 209, 213, 309–311, 345
Herakles, 25, 61, 106, 108, 113–115, 123, 127, 133, 137, 155–156, 173, 174, 176–177, 227, 233, 238, 247, 287, 323; as Peisistratid hero, 235, 247n56, 248, 262, 311, 314, 323; shield of, 168n52, 208, 230, 313. *See also* Athenian Treasury: Delphi
Hero cults, 121

Lydos, 250, 253, 299n17
Lyric poetry, 135–140, 142, 144–150, 264–268, 269

MacMillan Painter. *See* Chigi vase
Marathon, 236, 263, 323–324; battle of, 318, 323, 324–326, 332, 334, 336, 337, 352, 354, 355
Mardonios, 322–323, 333, 336
Megakles (5th century), 332
Megakles (6th century), 234–236, 246, 274
Megakles (7th century), 140, 214
Megara, 81, 214–215, 233, 234. *See also* Nisaia
Megethos, 232–234, 261, 272
Melian amphorae, 151–152, *153*, 172n62, 186
Menidi, 49
Metagenes, 210
Miletos, 39, 81, 180, 203–205, 210, 212, 320–322, 355; philosophy in, 22, 203–209, 257, 309. *See also* Anaximander; Anaximenes; Didyma; Thales
Milon of Croton, statue of, 15–16
Miltiades, 322–324, 337
Mimesis, 259, 261, 271, 309
Mimnermos, 138, 140, 146, 262, 345
Mycenae, 35, 51, 120, 121; Lion Gate, *35*, 184
Mycenaean civilization, 33–36, 78, 119–122, 133, 236; and Archaic architecture, 183–184; art of, *49*, *53*, *54*, 68–69, 115, *117*, *118*; decline of, 33–36; poetry of, 48–51; vase painting of, 35
Mykonos pithos, *173*, *174*, *175*, *176*, 224

Nagy, Gregory, 50–51
Narrative: cyclical, 314, 347–349; origins of mythological, 106–124; progressive, 176; serial, 172–174, 311, 349; simultaneous, 170–172, 174, 263, 296
Naturalism, 20–22, 255–259
Naukratis, 180, 182, 184, 196, 204, 252
Naxian Apollo, *192*, 198
Naxos (island), 131, 151, 186, 191, 198, 199, 244, 320, 323
Naxos (Sicily), 80, 83
Nearchos, 231, *232*, 233–234, 250, 261, 271–272, 274
Near East, 37–42, 83, 115, 117, 118, 124, 125–135, 141, 184, 202, 205; imports from, 37, 66–67, 69, 127, 133, 180
Nemea, 245, 247
Nesiotes, 340
Nessos, 61, 137, 165, 174, 176
Nessos amphora (New York), 165, *167*, 174, *177*, 224
Nestor, Palace of (Pylos), 49
Nestor's cup: in Homer, 50, 91; from Ischia, 89–91, 122, 257
Nettos Painter, *19*, 176, *177*, 178–179, 182n79, 219, 288

New York *kouros*, *21*, 199, 255
Nikandrē *korē*, 186, *187*, 188–191, 196
Nikē by Archermos, *20*
Nikē of Kallimachos, 324, *325*, 338
Nisaia, 234, 245, 246, 247n46

Odysseus, 51, 73–74, 77–78, 79, 86–87, 100, 103, 124, 147, 148, 169–171, 233. *See also* Homer
Oikos, 42, 69, 74, 123, 149
Old Smyrna, 43, 51, 132, 141, 143
Olive Tree Pediment, 238, *240*, 245
Oltos, 263, 266, 306
Olympia, 15, 83, 159, 184, 197, 227, 246, 324; Temple of Hera at, 182, *183*, 185, 227, 331
Olympian Zeus (Olympieion) (Athens), 249, 274–275, *276*, 331
Olympic games, 83, 127, 245, 246
Onesimos, 314, *315*, 329, 338, 349
Oral poetry, 46–53, 85–86, 91–93, 97–98, 139–140. *See also* Hesiod; Homer
Orient, 66, 125–126, 202. *See also* Near East
Orientalizing period, 125–202; pottery of, 151–176; sculpture of, 126, 189–190
Ostracism, 278, 332

Painter of Athens 894, 111, *112*
Pallene, 236, 260, 313
Panathenaia, 245–248, 262–264, 273, 292, 313, 324, 353
Panathenaic amphorae, 246, 250, 292
Panhellenism, 82–85, 246–247
Parataxis: in art, 102–104, 165, 297; in Homer, 102–103
Parian marble, 39, 268
Parry, Milman, 47–48, 85, 93
Parthenon. *See* Acropolis: Older Parthenon *and* Periklean Parthenon
Pathos, 27, 288, 347. *See also* Emotion in Archaic art
Pausanias, 16–18, 25, 184, 190n94, 227–230, 277, 318–319, 340
Peisistratos, 234–236, 245–248, 249, 253, 260, 262–263, 270–271, 274, 277, 282, 313–314, 323
Peplos *korē*, 338, *339*, 349
Perachora, terra-cotta model from, 74, *75*
Perati, 35, 36
Periander, 140, 159, 163, 178, 180, 183, 230
Perikles, 276, 337
Perserschutt, 335, 338, 340, 346
Perseus, 129, 156, 161–162, *163*, 166–167, *168*, 169, 172, 177–178, 219, 220, 230, 265
Persia, 213, 236, 247, 252, 274, 320–323, 332, 355
Persian Wars, 31–32, 322–323, 332–336, 354–355. *See also* Acropolis, destruction of; Marathon; Plataia; Salamis; Thermopylai
Phaiakia, 51, 73–74, 77–78

CPSIA information can be obtained
at www.ICGtesting.com
Printed in the USA
LVHW061952190219
608043LV00008BA/231/P